Beginning AutoCAD® 2025

EXERCISE WORKBOOK

Beginning AutoCAD® 2025

EXERCISE WORKBOOK

Cheryl R. Shrock

Professor, retired,
Drafting Technology
Orange Coast College, California.
Autodesk Authorized Author

Updated for AutoCAD® 2025 and Revised by Steve Heather

Former Lecturer of
Machine Shop Engineering and
Computer Aided Design.
AutoCAD Beta Tester

INDUSTRIAL PRESS, INC.

Industrial Press, Inc.

1 Chestnut Street
South Norwalk, Connecticut 06854 U.S.A.
Phone: 203-956-5593
Toll-Free in USA: 888-528-7852
Email: info@industrialpress.com

Title: Beginning AutoCAD® 2025 Exercise Workbook

Authors: Cheryl Shrock and Steve Heather

Library of Congress Control Number: On file with the Library of Congress

Copyright

Published 2024 © by Cheryl R. Shrock and Industrial Press, Inc. All rights reserved.

ISBN (print): 978-0-8311-3693-2 ISBN (eBook): 978-0-8311-9647-9 ISBN (ePub): 978-0-8311-9648-6 ISBN (eMobi): 978-0-8311-9649-3

Publisher: Judy Bass Editor: Laura Brengelman Cover Designer: Jeff Weeks

No part of this book may be reproduced or transmitted in any form or by any means, electronic or mechanical, including photocopying, recording, or by any information storage and retrieval system, without written permission from the publisher.

Limits of Liability and Disclaimer of Warranty

While every possible effort has been made to ensure the accuracy of all information presented herein, the publisher expresses no guarantee of the same, does not offer any warrant or guarantee that omissions or errors have not occurred, and may not be held liable for any damages resulting from use of this text. Readers accept full responsibility for their own safety and that of the equipment used in conjunction with this text.

Autodesk, Autodesk 360, AutoCAD, Design Web Format, and DWF are either registered trademarks or trademarks of Autodesk, Inc., in the United States and/or certain other countries. Certain content provided courtesy of Autodesk, Inc., © 2024. All rights reserved.

Printed and bound in the United States of America

Beginning AutoCAD® 2025

First Printing

books.industrialpress.com ebooks.industrialpress.com

As always, many thanks are due to Cheryl Shrock for allowing me to continue on with her Exercise Workbook series. I also thank all at Industrial Press and Autodesk who support my efforts in updating and revising these invaluable teaching and learning texts.

Steve Heather

AutoCAD® Books and eBooks from Industrial Press

Beginning AutoCAD 2018 Beginning AutoCAD 2018 eBook Advanced AutoCAD 2018 Advanced AutoCAD 2018 eBook	ISBN 978-0-8311-9437-6 ISBN 978-0-8311-3616-1
Beginning AutoCAD 2019 Beginning AutoCAD 2019 eBook	ISBN 978-0-8311-3626-0 ISBN 978-0-8311-9473-4
Beginning AutoCAD 2020 Beginning AutoCAD 2020 eBook	
Beginning AutoCAD 2021 Beginning AutoCAD 2021 eBook	ISBN 978-0-8311-3659-8 ISBN 978-0-8311-9579-3
Beginning AutoCAD 2022 Beginning AutoCAD 2022 eBook Advanced AutoCAD 2022 eBook Advanced AutoCAD 2022 eBook	ISBN 978-0-8311-9591-5 ISBN 978-0-8311-3667-3
Beginning AutoCAD 2023 Beginning AutoCAD 2023 eBook	ISBN 978-0-8311-3679-6 ISBN 978-0-8311-9609-7
Beginning AutoCAD 2024 Beginning AutoCAD 2024 eBook	ISBN 978-0-8311-3686-4 ISBN 978-0-8311-9627-1
Beginning AutoCAD 2025 Beginning AutoCAD 2025 eBook	
AutoCAD Pocket Reference 7th Edition, Releases 2015–2016 AutoCAD Pocket Reference 7th Edition, eBook	
AutoCAD Pocket Reference 8th Edition, Releases 2018–2019 AutoCAD Pocket Reference 8th Edition, eBook	
AutoCAD 3D ModelingAutoCAD 3D Modeling eBook	ISBN 978-0-8311-3613-0 ISBN 978-0-8311-9428-4
AutoCAD 2D Resource Kit Digital Edition eBook	ISBN 978-0-8311-9503-8

For information about these and other bestselling titles, visit: https://books.industrialpress.com
https://ebooks.industrialpress.com

Table of Contents

Introduction	
About this Workbook	
About the Authors	
Configuring Your System	
Customizing Your Wheel Mouse	Intro-6
Lesson 1	
Starting AutoCAD	1-2
AutoCAD Application Window	
ToolTip Help	1-22
Autodesk Assistant	
Lesson 2	
Creating a Template	2-2
Using a Template	
Selecting a Command	
Drawing Lines	
Methods for Selecting Objects	2-10
Erase	
Undo and Redo	
Starting a New Drawing	
Opening an Existing Drawing File	
Opening Multiple Files	
Using Floating File Tabs	2-18
Saving a Drawing File	2-22
Automatic Save	
Back Up Files and Recover	
Exiting AutoCAD	
Exercises for Lesson 2	
Lesson 3	
Circle	3-2
Rectangle	
Grid and Increment Snap	
Layers	
Lineweights	3-10
Transparency	3-11
Creating New Layers	3-12
Loading and Selecting Layer Linetypes	
Exercises for Lesson 3	3-15
Lannan	
Lesson 4	4.0
Object Snap	. 4-2
Running Object Snap	. 4-5
Zoom	
Drawing Setup	
Exercises for Lesson 4	. 4-14
Lesson 5	
Polygon	. 5-2
Ellipse	. 5-3
Donut	
Point	
More Object Snaps	
Exercises for Lesson 5	. 5-9

Lesson 6	
Break	
Trim	
Extend	
Move	
Drag	
Nudge	. 6-9
Explode	
Exercises for Lesson 6	6-11
1 7	
Lesson 7	
Copy Multiple Copies	
Copy "Array" Option	
Mirror	
Fillet	
Chamfer	
Exercises for Lesson 7	. 7-10
Lesson 8	
Single Line Text	0.0
Multiline Text	
Tabs, Indents, and Spell Check	
Columns	. 8-7
Paragraph and Line Spacing	. 8-8
Editing Text	8-9
Exercises for Lesson 8	8-11
Lesson 9	
Coordinate Input	• •
Direct Distance Entry (DDE)	9-5
Measure Tools	
ID Point	
Exercise: Creating a Border	
Basic Plotting from Model Space	
More Exercises for Lesson 9	9-15
Lesson 10	
Moving the Origin	10-2
Displaying the UCS Icon	10-2
Exercises for Lesson 10	
Exercises for Lesson 10	10-5
Lesson 11	
Polar Coordinate Input	11-2
Dynamic Input	
Using Dynamic Input and Polar Coordinates	11-5
Polar Tracking	
Using Polar Tracking and DDE	11.0
Polar SnapUsing Polar Tracking and Polar Snap	11-9
Exercises for Lesson 11	11-10
Lesson 12	
Offset	
Properties Palette	
Quick Properties Panel	
Offsetgaptype	12-7
Exercises for Lesson 12	12-8

Lesson 13	
Array Exercises for Lesson 13	. 13-2
Exercises for Lesson 13	. 13-10
Lesson 14	
Scale	. 14-2
Stretch	
Rotate	
Exercises for Lesson 14	. 14-7
Lesson 15	
Hatch	. 15-2
Hatch Properties	
Hatch Types	
Editing Hatch Set Properties	
Hatch without Boundaries	
Exercises for Lesson 15	. 15-14
Lesson 16	
Dimensioning	
Linear Dimensioning	
Continue Dimensioning	
Baseline Dimensioning	
Dimension Styles	. 16-6
Ignoring Hatch Objects	16 10
Exercises for Lesson 16	. 10-12
Lesson 17	
Editing Dimension Text Values	. 17-2
Editing the Dimension Position	. 17-2
Modifying an Entire Dimension Style	. 17-3
Overriding a Dimension Style	
Editing an Individual Existing Dimension	
Dimension BreaksJogging a Dimension Line	
Adjusting the Distance Between Dimensions	17-9
Exercises for Lesson 17	. 17-11
Lesson 18	10.0
Dimensioning Diameters	10-2
Dimensioning RadiiAngular Dimensioning	
Center Mark – Automatic	
Center Mark – Automatic	
Centerline	
Flip Arrow	
Creating a Dimension Sub-Style	. 18-9
Exercises for Lesson 18	. 18-11
Lesson 19	
Multileader	. 19-2
Creating a Multileader Style	. 19-4
Aligned Dimensioning	. 19-6
Special Text Characters	. 19-7
Prefix and Suffix	. 19-8
Exercises for Lesson 19	. 19-9

Lesson 20	
Dim Command	
Exercises for Lesson 20	20-6
Lesson 21	
	04.0
Match Properties	
Match Layer	
Creating a Revision Cloud	21-3
Converting an Object to a Revision Cloud	21-6
Selecting the Revision Cloud Style	21-7
Wipeout	
Exercises for Lesson 21	21 10
Excluses for Ecosoff 21	21-10
1	
Lesson 22	
Drawing an Arc	
Dimensioning Arc Lengths	22-2
Dimensioning a Large Curve	
Exercises for Lesson 22	
Lesson 23	
Understanding and Creating Polylines	23-2
Exercises for Lesson 23	23-6
Lesson 24	
Editing Polylines	24.2
Join Command	
Join Command	24-3
Exercises for Lesson 24	24-5
Lesson 25	
Creating New Text Styles	25-2
Selecting a Text Style	25.3
Deleting a Text Style	25-3
Deleting a Text Style	25-4
Changing the Effects of a Text Style	25-5
Divide Command	
Measure Command	
Exercises for Lesson 25	25-8
Lesson 26	
	00.0
Serious Business	
Model and Layout Options	
Model and Layout Tabs	
Viewports	26-5
How to Reach Into a Viewport	26-7
Pan	
Locking a Viewport	26-9
Creating a Page Setup	26.0
Using the Layout	26-12
Plotting from a Layout Tab	
Annotative Property	26-16
Exercises for Lesson 26	26-17
Lesson 27	
Creating Scaled Drawings	27.2
Adjusting the Viewport Scale	
Annotative Objects	
Paper Space Dimensioning	
Exercises for Lesson 27	27-9

Lesson 28	
Assigning Multiple Annotative Scales	28-2
Removing an Annotative Scale	
Annotative Hatch	28-6
Exercises for Lesson 28	28-10
Lesson 29	
Blocks	29-2
Inserting Blocks	29-5
Automatic Block Placement	
Re-Defining a Block	29-11
Count the Number of Blocks in a Drawing	29-12
Purge Unwanted and Unused Blocks	
Multileader and Blocks	29-16
Collect Multileader	29-19
Exercises for Lesson 29	
Lesson 30	
Text – Arc Aligned	30-2
Text - Modify Text	30-3
Text - Convert to MText and Auto Number	
Text - Enclose in Object	30-5
Draw - Break-Line Symbol	30-6
Tools - Command Aliases	
Creating a Group	30-8
Import a PDF File into AutoCAD	
Import a PDF File with SHX Fonts	20.42
IIIIpuit a FDF FIIE WILLI STA FULLS	30-13
Drawing Compare	
Drawing Compare	30-15 30-21
Drawing CompareShared Views	30-15 30-21

- B Dynamic InputC Frequently Asked Questions

Index

Final Notes about AutoCAD®

serionano l

- Addie Prigter Filese Dyddynd fel felad Yfer Legter Askud Dweetlons

wann

Final Mores about AutoCAD

INTRODUCTION

SETTING UP AUTOCAD

After reading and completing the instructions in this introductory chapter, you will have:

- 1. Downloaded and saved the provided preset drawing files, so you can get started right away practicing drawing commands.
- 2. Configured your system for using AutoCAD 2025.
- 3. Customized your wheel mouse for efficiency in navigating and using the many AutoCAD commands and features.

CADOTON TO CAUTOR

- PARTICULAR OF THE PARTICULAR O
- Bawnigaded ana sayen an artvidad presidarawing lifes, so added as ago added as a sayen so and a sayen sayen and a sayen a sayen a sayen and a sayen a
 - Configured voor system is candeAutoCAD 2025.
 - ens presulvas in vorecifia edice e los dycholy. Posta samuest basedinaciones de pouveymentes pelaci

Introduction Intro-1

Introduction

About this Workbook

The Beginning AutoCAD® 2025 Exercise Workbook is designed for classroom instruction or self-study. It is suitable for both inch and metric users. There are 30 lessons. Each lesson starts with step-by-step instructions followed by exercises designed for practicing the commands you learned within that lesson.

You may find the order of instruction in this Workbook somewhat different from most textbooks. The approach we take is to first familiarize you with the drawing commands. After you are comfortable with the drawing commands, you will then be taught to create your own setup drawings. This method is accomplished by supplying you with preset drawings, "inch-helper.dwg" and "metric-helper.dwg." These drawings are ready for you to open and use as templates for your initial practice exercises. For the first eight lessons, you do not need to worry about settings, you just learn how to use the commands you need to draw.

How to get the supplied drawings?

The file "workbook-helper.zip" should be downloaded from our website:

https://books.industrialpress.com/autocad/workbook-helper.zip

Enter the address into your web browser and the download will start automatically. Once the file has been downloaded, you can unzip it to extract both drawing files.

Printing

The exercises in this Workbook have been designed to be printed on any 8-1/2" X 11" (letter size) or 210mm X 297mm (A4 size) paper. You will be able to print your exercises and view your results as you progress through the lessons. If you would like to configure a large format printer, refer to Appendix-A to "Add a Printer / Plotter."

About the Authors

Cheryl R. Shrock is a retired Professor and Chairperson of Computer Aided Design at Orange Coast College in Costa Mesa, California, where she had taught since 1990. Previous to teaching, Cheryl owned and operated a commercial product and machine design company, where designs were created and documented using CAD. She also is an Autodesk® registered author. This Workbook was created with ground-breaking instructive materials based on a combination of her extensive teaching skills and industry experience.

Steve Heather is a former Lecturer of Mechanical Engineering and Computer Aided Design in England, UK. Previous to teaching and for more than 30 years, he worked as a Precision Engineer in the aerospace and defense industries. For more than a dozen years, Steve has been a Beta Tester for Autodesk®, testing the latest AutoCAD® software. He also is a member of the AutoCAD Customer Council. Steve can be contacted for questions or comments about this book at info@industrialpress.com.

Configuring Your System

AutoCAD allows you to customize its configuration. While you are using this Workbook, it is necessary for you to make some simple changes to your configuration so our configurations are the same. This will ensure that the commands and exercises work as expected. The following instructions will guide you through these changes.

- Start AutoCAD
 - A. To start AutoCAD, follow the instructions on pages 1-2 through 1-4. Then return to this page and go to **Step 2**.
- 2.
- A. Type options (not case sensitive) anywhere within the main drawing area then press the <Enter> key.
- B. Type *options* on the Command Line then press the *<Enter>* key.

The text that you type will appear in the **Dynamic Input box** or on the **Command Line**, as shown below:

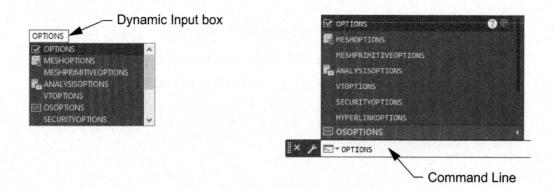

AutoCAD LT users:

You may find that some of the settings appear slightly different. But they are mostly the same.

3. Select the **Display** Tab and change the settings on your screen to match the dialog box below.

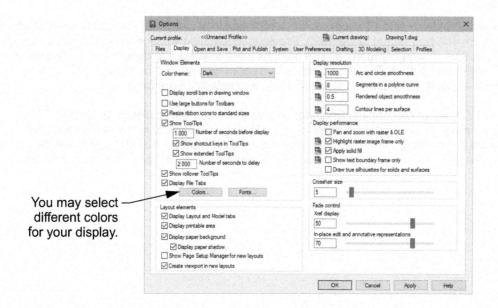

4. Select the Open and Save Tab and change the settings on your screen to match the dialog box below.

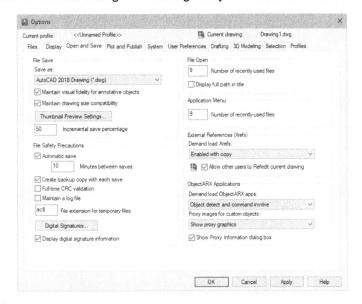

5. Select the Plot and Publish Tab and change the settings on your screen to match the dialog box below.

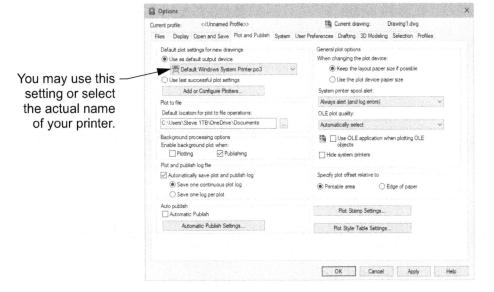

6. Select the System Tab and change the settings on your screen to match the dialog box below.

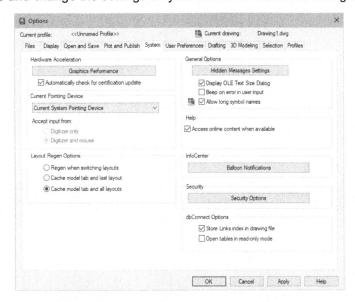

7. Select the User Preferences Tab and change the settings on your screen to match the dialog box below.

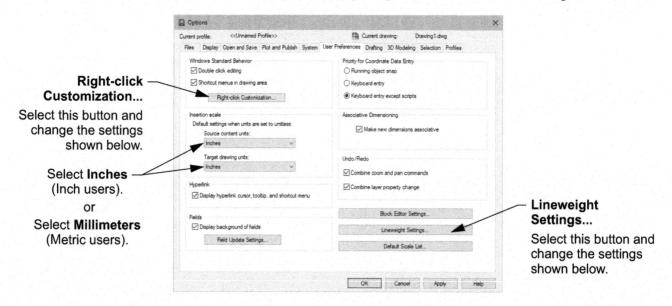

8. After making the setting changes shown below, select the Apply & Close button.

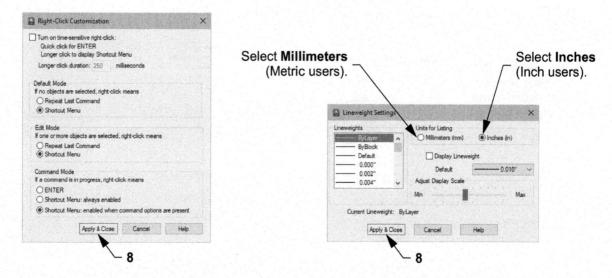

9. Select the **Drafting** Tab and change the settings on your screen to match the dialog box below.

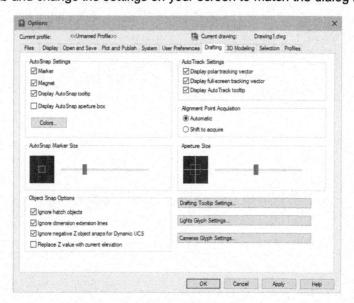

10. Select the **Selection** Tab and change the settings on your screen to match the dialog box below. (**Note:** The 3D Modeling Tab was skipped. For more on 3-dimensional modeling, see the *Advanced AutoCAD® Exercise Workbook* and *AutoCAD® 3D Modeling Exercise Workbook*.)

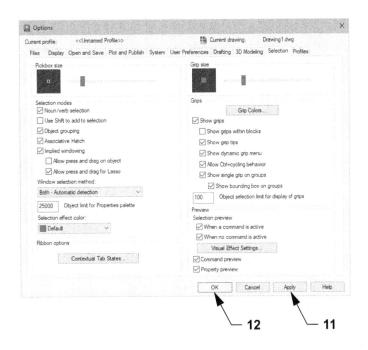

- 11. Select the Apply button.
- 12. Select the **OK** button.
- 13. Now you should be back to the main AutoCAD screen.

Note: If you select the "X" in the top right corner of the **Options** dialog box before you select the **Apply** button and then the **OK** button, the **Options - Changes Not Saved** dialog box will appear.

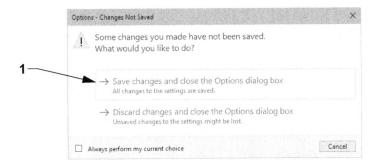

If you selected the "x" instead of the Apply and then the OK buttons and see this box, do the following:

- 1. Select Save changes and close the Options dialog box.
- 2. The changes you made in the Options dialog box will be saved and the Options dialog box will close. If you want to recheck the changes have been saved, reopen the Options dialog box.

Customizing Your Wheel Mouse

Using a wheel mouse is by far the easiest and most efficient method of navigating your way around AutoCAD and for creating 2-dimensional (2D) drawings.

The standard wheel mouse has left and right buttons and a central wheel that also doubles as a button. The default functions for the buttons and wheel are as follows.

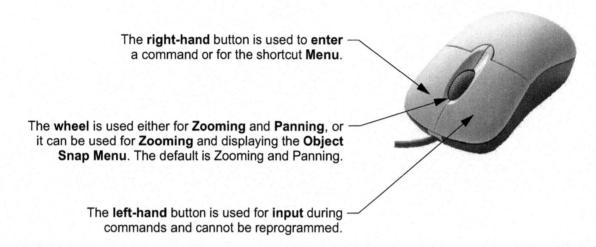

The following describes how to select the wheel functions. After you understand the functions, you may choose to change the setting.

To change the setting you must use the MBUTTONPAN variable.

MBUTTONPAN setting 1: (This is the factory setting.)

Zoom: Rotate the wheel forward to zoom in.

Rotate the wheel backward to zoom out.

Zoom Extents: Double click the wheel to view entire drawing.

Pan: Press the wheel and drag the mouse to move the drawing on the screen.

MBUTTONPAN setting 0:

Zoom: Rotate the wheel forward to zoom in.

Rotate the wheel backward to zoom out.

Object Snap: The Object Snap Menu will appear when you press the wheel.

To change the setting:

- 1. Type *mbuttonpan* and then press <*Enter*>.
- 2. Enter 0 or 1 and then press < Enter>.

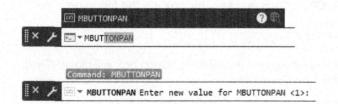

MBUTTONPAN

Enter new value for MBUTTONPAN <1>:

Command Line

Dynamic Input

LESSONS

LESSON 1

LEARNING OBJECTIVES

After completing this lesson, you will be able to:

- 1. Start the AutoCAD program.
- 2. Understand AutoCAD workspaces.
- 3. Recognize all of the features in the AutoCAD Window.
- 4. Understand what the keyboard function keys are used for.
- 5. Use the Artificial Intelligence Autodesk Assistant help system.

Starting AutoCAD

To Start AutoCAD use one of the two methods below. (Be patient it may take a few minutes to load. It is a large program.)

- Select Start / AutoCAD 2025 (folder) / AutoCAD 2025 or Double click on the AutoCAD 2025 desktop shortcut icon.
- 2. The "Start" page should appear.

Note: Your computer should be connected to the internet.

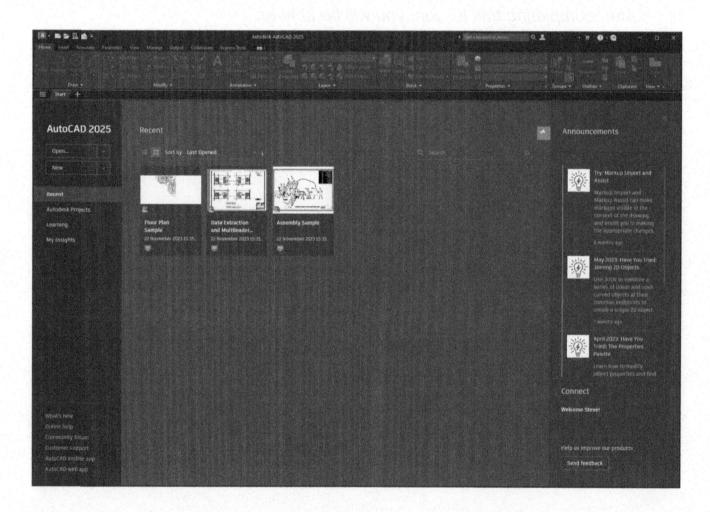

The left-hand panel contains the **Open** drop-down list where you can open an existing drawing file, sheet set, or explore sample drawing files that come pre-loaded. It also contains the **New** drop-down list where you can start a new drawing file using a recent drawing template, browse for existing templates, or get more templates online.

The center panel contains thumbnails of recently opened drawing files. There are three examples of recently opened drawing files shown in the **Recent** panel above.

The right-hand panel contains announcements for product updates, surveys you can take part in, and helpful tips and suggestions on using AutoCAD.

You can start a new drawing by selecting the New drop-down list and then selecting Browse templates...

- 1. Select the New drop-down list.
- 2. Select Browse templates...

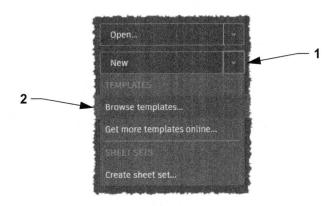

- 3. In the **Select Template** dialog box, select a drawing template file.
- 4. Select Open.

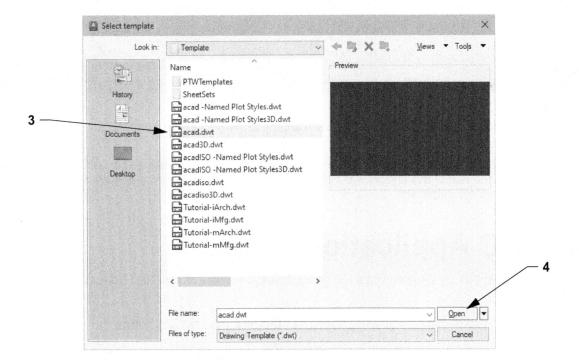

Note:

The drawing template **acad.dwt** is for inch measurements.

The drawing template **acadiso.dwt** is for metric measurements.

Note: If your screen does not appear as shown below, go to the **Intro** section of this Workbook and follow the steps for configuring AutoCAD to match the Workbook configuration.

The following section will describe each area and element of the AutoCAD interface.

While you probably would like to jump ahead to start drawing, please be patient and go through the rest of this lesson. It is very important that you understand and are familiar with AutoCAD's interface.

AutoCAD Application Window

Important: I have changed my 2-dimensional (2D) background color to white for this Workbook. Yours may be another color.

You may change the color of many areas using: Options / Display Tab / Colors button

AutoCAD comes with Dark and Light Color themes. I have changed to the Light theme, this is just for clarity. You may choose the Light theme.

You may change the Color theme by using: Options / Display Tab / Color theme

If the remainder of your screen does not appear as shown on the next page, go to the **Intro** section of this Workbook and follow the steps for configuring AutoCAD to match the Workbook configuration.

The following pages discuss the elements of the AutoCAD interface and application window, providing an introduction to workspaces, documents, display options, and various features, terms, options, and ways to find and use different commands.

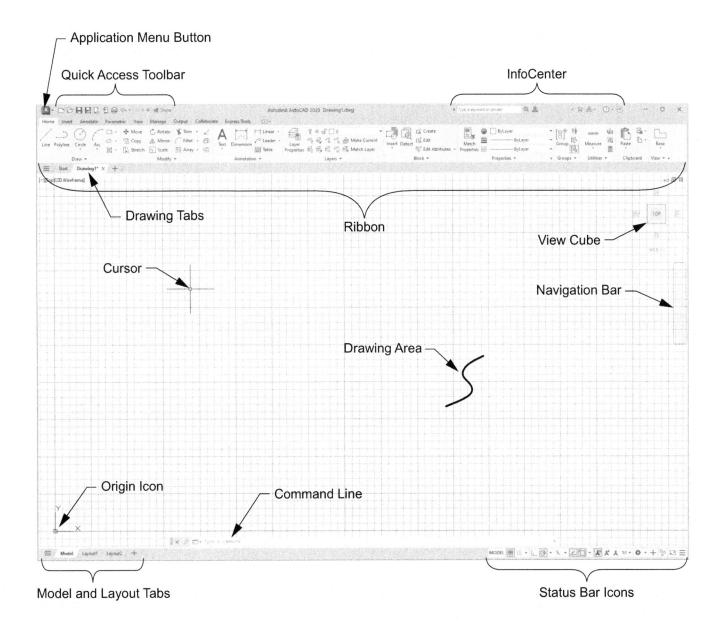

Workspace

Workspaces control the display of Ribbons, Tabs, Menus, Toolbars, and Palettes. AutoCAD gives you the option of deciding how you would like them displayed. When you use a workspace, only the Menus, Toolbars, and Palettes that are relevant to a task are displayed. For example, if you selected the 3D Modeling workspace, only 3D Menus, Toolbars, and Palettes would be displayed.

There are 3 preset workspaces.

Drafting & Annotation (shown above)

This workspace is the default display. It displays the necessary Ribbons, Tabs, Menus, Toolbars, and Palettes for 2D drafting. We will be using this workspace for all lessons within this Workbook.

3D Basics

This 3D Basics workspace provides a simple workspace with the most basic tools for creating and visualizing 3D models.

3D Modeling

The 3D Modeling workspace provides access to the vast array of 3D tools in AutoCAD. (For more on 3D modeling, see the *Advanced AutoCAD*® and *AutoCAD*® 3D Modeling Exercise Workbooks.)

How to select a workspace

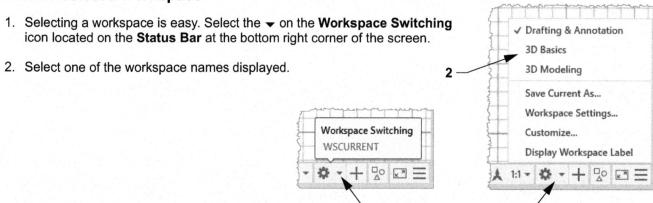

Note: The "Drafting & Annotation" workspace will be used in this Workbook.

Application Menu

The Application Menu provides easy access to common tools. Each of the tools will be discussed later in the Workbook.

1. Click on the Application Menu button in the upper left corner of the AutoCAD display screen ("A").

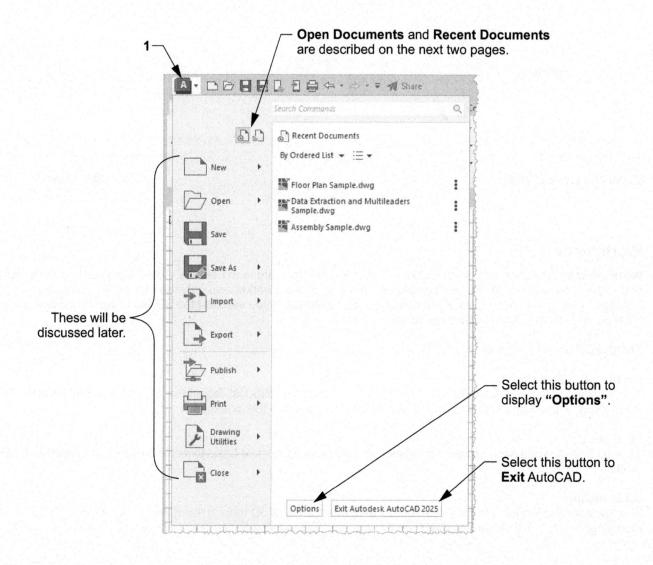

Open Documents

First let me emphasize, this is **not** a method to "**open**" a drawing file.

Open Documents is a list of all documents that are already open within AutoCAD.

Display choices: The list of documents may be displayed as icons or images. If you hover the cursor over a document name, a preview image will appear.

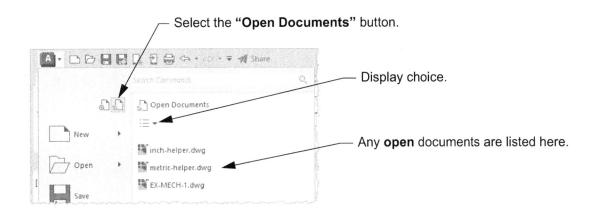

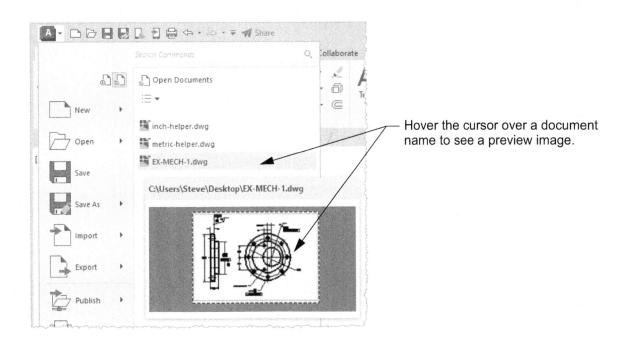

View Recent Documents

When you select Recent Documents button, a list of the recently viewed documents will appear.

Display choices: This list may be displayed as icons or images and may be sorted in an ordered list or grouped by date or file type. If you hover the cursor over a document name, a preview image will appear.

Pinned Files: You can keep a file listed, regardless of files that you save later, by using the push pin button to the right (shown on the next page). The file is displayed at the bottom of the list until you turn off the push pin button.

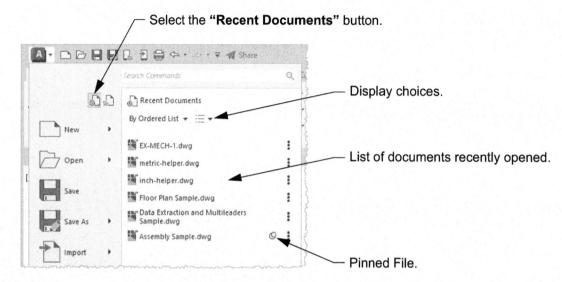

How to Pin a File to the Recent Documents List

- 1. Select the Recent Documents button.
- 2. Move the Cursor to the right-hand side of the file you want to pin. The push pin will appear.
- 3. Left click on the push pin button.
- 4. The file will now be pinned to the Recent Documents List.

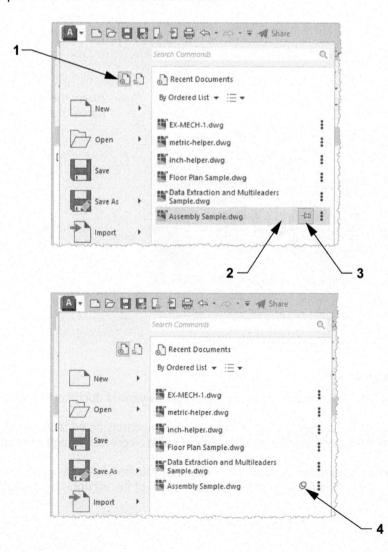

You can also remove a file from the Recent Documents List if you no longer need it.

How to Remove a File from the Recent Documents List

- 1. Select the Recent Documents button.
- 2. Move the Cursor to the right-hand side of the file you want to remove.
- 3. Left click on the button with the three vertical filled circles. A menu will appear
- 4. Left click on Remove from List.

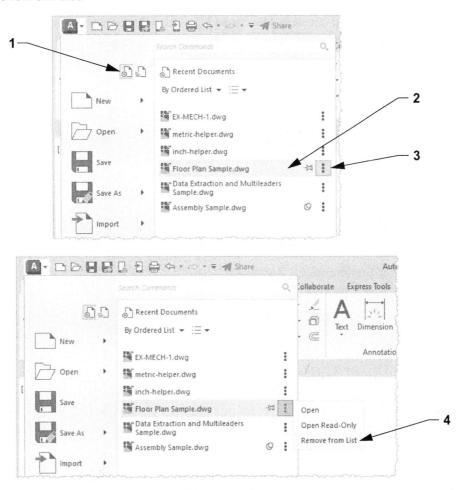

5. The selected file has been removed from the Recent Documents List.

Note: You also can remove a pinned file from the Recent Documents list. You do not have to unpin it first.

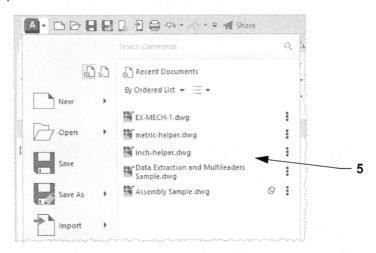

Quick Access Toolbar

The **Quick Access Toolbar** is located in the top left-hand corner of the AutoCAD Window. It includes the most commonly used tools, such as New, Open, Save, Save as, Print, Undo, and Redo.

How to Customize the Quick Access Toolbar

You can add tools with the Customize User Interface dialog box.

Example:

After you have completed Lesson 4, you will find that you will be using "Zoom All" often. So I added the Zoom All tool to the Quick Access Toolbar. If you would like to add the Zoom All tool, or any other tool, to your Quick Access Toolbar, follow the steps below.

- 1. Place the Cursor on the Quick Access Toolbar and press the right mouse button.
- 2. Select "Customize Quick Access Toolbar" from the menu.

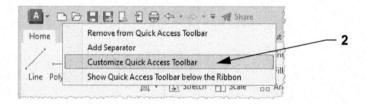

3. Scroll through the list of Commands to "Zoom, All".

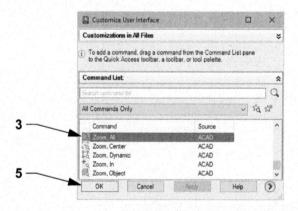

- 4. Press the Left mouse button on "Zoom, All" and drag it to a location on the Quick Access Toolbar and drop it by releasing the left mouse button.
- 5. Select the **OK** button at the bottom of the Customize User Interface dialog box.

The Customize User Interface dialog box will disappear and the new Quick Access Toolbar is saved to the current workspace.

日日に日日中・今・〒

To Remove a Tool:

Place the cursor on the tool to remove and press the right mouse button. Select "Remove from Quick Access Toolbar".

Ribbon

The **Ribbon** provides access to the AutoCAD tools. The **Tabs** contain multiple **Panels**. Each **Panel** contains multiple tools. When you select a **Tab**, a new set of **Panels** will appear.

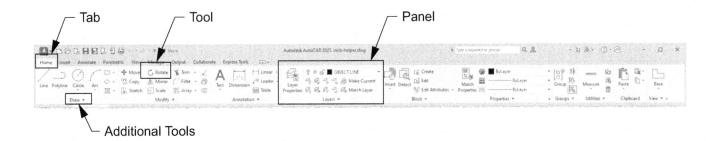

Additional Tools: If you select the ▼ symbol at the bottom of the Panel, the Panel will expand to access "Additional Tools".

Control the display of Tabs and Panels

Right click on the Ribbon and select which Tabs or Panels you choose to display. The check mark confirms the Tab or Panel is already displayed.

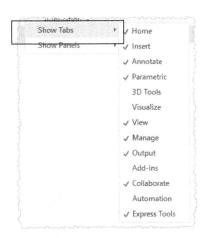

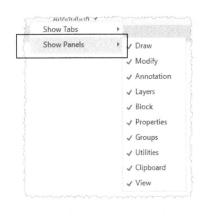

Control the Tab order

If you would like to change the order of the Tabs, click and drag the Tab horizontally to the new location.

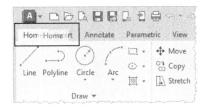

Floating Panels

If you prefer to separate a Panel from the Ribbon, you may drag the Panel off the Ribbon to a new location on the screen.

Status Bar

The **Status Bar** is located on the bottom of the screen. It displays the current settings. These settings can be turned **on** or **off** by clicking on one of the buttons or by pressing a corresponding function key. For example, <**F2>**, <**F3>**, etc.

When an icon is turned on, it will be displayed in blue.

Status Bar Icons

The Status Bar provides you with a set of commonly used drawing tools like Grid Display, Snap, Object Snap, and Isometric Drafting. You can choose to remove some or all of them, or you can choose to add more tools.

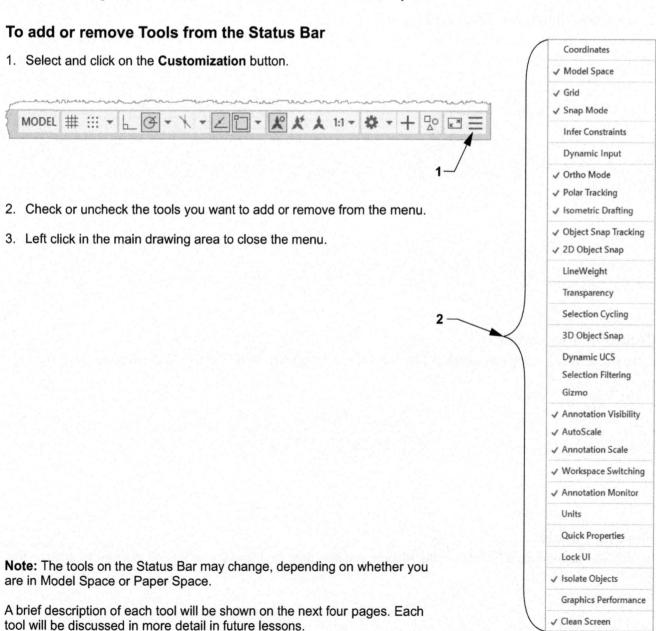

Status Bar Tool Button Descriptions

18,2620, 4,7509, 0,0000

I have enabled all the tool buttons and broken them down into two sections starting from the left-hand side.

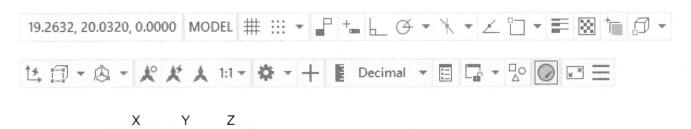

Coordinates

The coordinates display the location of the cursor in reference to the Origin. The Origin is currently in the lower left corner of the drawing area. These numbers will change as you move the cursor.

First set of numbers represents the horizontal movement of the cursor (X axis).

Second set of numbers represents the vertical movement of the cursor (Y axis).

Third set of numbers represents the Z axis, which is used for 3D and not discussed in this book.

Model MODEL

The **Model** / **Paper** button allows you to work in either Model Space or Paper Space without leaving the Layout Tab. When you switch to a Layout Tab, this button automatically switches to **Paper**.

Grid (You may also use <F7> to toggle on or off.)
The criss-cross lines in the Drawing Area are called the Grid. It is only a drawing aid and will not print. The default

The criss-cross lines in the Drawing Area are called the Grid. It is only a drawing aid and will not print. The default spacing is 1 unit of measurement. You may change the Grid spacing at any time by typing **DS**, then press **<Enter>**, and then select the **Snap and Grid** Tab from the **Drafting Settings** dialog box.

Snap Mode (You may also use <F9> to toggle on or off.)
Increment Snap controls the incremental movement of the cursor. If it is on, the cursor will "snap" in an incremental movement. If it is off, the cursor will move smoothly. You may set the increments by clicking on the down ▼ arrow and selecting Snap Settings...

You can also choose whether to use

Grid Snap or Polar Snap on the same menu.

Polar Snap

✓ Grid Snap

Snap Settings...

Infer Constraints (Note: Not used in this Workbook.)
Inferred Geometric Constraints automatically applies coincident constraints for Endpoint, Midpoint, Center, Node, and Insertion Object Snaps.

Dynamic Input (You may also use <F12> to toggle on or off.)

When Dynamic Input is on, you can enter coordinate values in tooltips near the cursor. More on this in Lesson 11.

Ortho Mode (You may also use <F8> to toggle on or off.)
Ortho restricts the movement of the cursor to horizontal or vertical. When Ortho is on, the cursor moves only horizontally or vertically. When Ortho is off, the cursor moves freely in any direction.

Polar Tracking (You may also use <F10> to toggle on or off.)
Polar Tracking restricts cursor movement to specified increments along a Polar angle. More on this in Lesson 11.

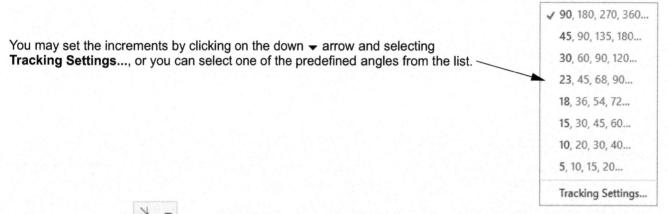

Isometric Drafting

Isometric drawing allows you to simulate a 3D object by aligning along 3 axes; these are **Top**, **Right**, and **Left**, and are called **Isoplanes**. When the button is enabled, you can toggle through the Isoplanes by pressing the **<F5>** key. Isometric Drafting is discussed in the *Advanced AutoCAD® Exercise Workbook*.

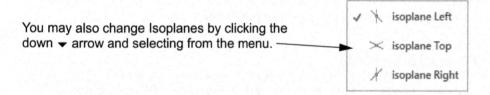

Object Snap Tracking (You may also use <F11> to toggle on or off.)
Object Snap Tracking controls the display of Object Snap reference lines, AutoSnap marker, tooltip, and magnet.

2D Object Snap (You may also use **<**F3> to toggle **on** or **off**.)
When 2D Object Snap is **on**, the cursor will "snap" to preset locations on 2D objects. More on this in Lesson 4.

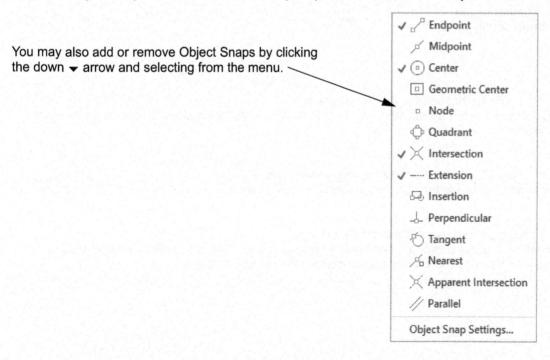

Lineweight

Lineweight displays the width assigned to each object. When it is **on**, the lineweights are visible. You can change the lineweight settings by right clicking on the button and selecting **Lineweight Settings**. More on this in Lesson 3.

Transparency

When Transparency Show/Hide is **on**, all transparent layers will be displayed. If it is **off**, no transparent layers will be displayed. More on this in Lesson 3.

Selection Cycling

Selection cycling allows you to select objects that are overlapping. This is most useful when creating 3D models as discussed in the *Advanced AutoCAD® Exercise Workbook*.

3D Object Snap (You may also use **<F4>** to toggle **on** or **off**.) When 3DOsnap is **on**, the cursor will "snap" to preset locations on 3D objects. This option is discussed in the *Advanced AutoCAD® Exercise Workbook*.

Dynamic UCS (You may also use **<F6>** to toggle **on** or **off**.)

Dynamic User Coordinate System changes the grid plane to follow the XY plane of the dynamic UCS. It is used for 3D; refer to the *Advanced AutoCAD® Exercise Workbook* and *AutoCAD® 3D Modeling Exercise Workbook*.

Selection Filtering

Selection filtering allows you to filter whether certain faces, edges, vertices, or solid history subobjects are highlighted when you roll over them, very useful in complex 3D.

Gizmo

Gizmo tools help you move, rotate, or scale an object or set of objects along a 3D Plane, and are discussed in the Advanced AutoCAD® Exercise Workbook.

Annotation Visibility

When switched **on**, the Annotation Visibility tool displays or hides the visibility of annotative objects at the current scale.

AutoScale

When switched **on**, the AutoScale tool automatically updates annotative objects to support the annotation scale when the annotation scale is changed.

Annotation Scale

1:1 -

The Annotation Scale tool displays the current annotation scale. You can change the scale by clicking on the down ▼ arrow and selecting from the list of predefined scales or you may create a custom scale. You can also display the scale in percentages by selecting **Percentages** from the list.

Workspace Switching

Workspace Switching allows you to change the workspace environment: you can choose between Drafting & Annotation, 3D Basics, and 3D Modeling. You can change the workspace by clicking on the down ▼ arrow and selecting from the list.

Annotation Monitor

Provides feedback regarding the state of Associative annotations when using parametric dimensioning; it is discussed in the Advanced AutoCAD® Exercise Workbook.

Units Decimal •

The Units tool allows you to change the display style of the Drawing Units. You can choose between Decimal, Architectural, Engineering, Fractional, and Scientific. You can change the drawing unit display by clicking on the down ▼ arrow and selecting from the list.

Quick Properties

Lock User Interface

The Lock User Interface tool allows you to lock or unlock Toolbars, Panels, Windows, and Floating Toolbars, Panels, and Windows. Click on the down arrow to select from the 4 options.

Floating Toolbars/Panels
Docked Toolbars/Panels
Floating Windows
Docked Windows

Isolate Objects

You can choose to isolate objects by keeping them visible on the screen, all other objects will be hidden. Or you can choose to hide objects. To isolate or hide objects, left click on the **Isolate Objects** tool button and select either **Isolate Objects** or **Hide Objects** from the list. To restore all hidden objects, left click on the **Isolate Objects** tool button and select **End Object Isolation** from the list.

Graphics Performance

The Graphics Performance tool examines your graphics card and 3D display driver and determines whether to use software acceleration or hardware acceleration. You can change the performance settings by right clicking on the tool button and selecting **Graphics Performance**, then changing any settings required in the dialog box.

Clean Screen (You may also use <Ctrl+0> to toggle on or off.)

When Clean Screen is selected, it will hide all tool Palettes, Windows, and Ribbons from the screen, leaving you with a larger drawing area to work with. You can restore all the Palettes, Windows, and Ribbons by selecting the Clean Screen tool button again.

Keyboard function keys and what they are used for.

- F1 Opens the Help Window.
- F2 Displays an Extended Command History list.
- F3 Turns the 2D Object Snaps on or off.
- F4 Turns the 3D Object Snaps on or off.
- **F5** Toggles Isoplanes between Top, Right, or Left.
- F6 Turns the Dynamic UCS on or off.
- F7 Turns the Grid on or off.
- F8 Turns Orthographic Mode on or off.
- F9 Turns Snap Mode on or off.
- F10 Turns Polar Tracking on or off.
- F11 Turns Object Snap Tracking on or off.
- F12 Turns Dynamic Input on or off.

Floating Command Line

When you first start AutoCAD, if the software has not been modified, the **Command Line** will be displayed at the bottom of the screen, as shown below.

This is where AutoCAD will prompt you for information and you will enter commands, values, and select options. Basically, this is how you communicate with AutoCAD.

You may "dock" the Command Line at the top or bottom of the AutoCAD Window or let it float in the drawing area.

To move the Command Line, place the cursor on the left end grip, press the left mouse button, and drag the Command Line to a desired location.

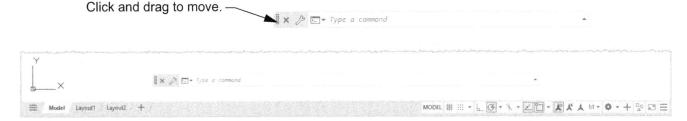

To "dock" the Command Line, drag it to the top or bottom of the drawing area. It will snap to the edge. You can't dock the Command Line to the sides. You may also drag it below the drawing area as shown below.

Command Line

How to enter a command on the Command Line

1. Type the first letter of a command, such as **c** for **circle**.

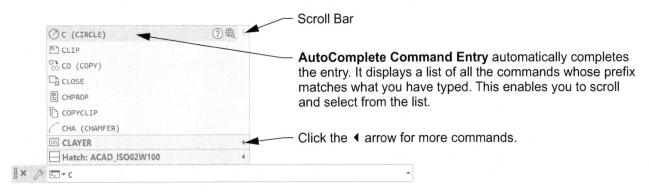

2. A list of commands that begin with the letter C will appear. Select the desired command from the list.

- 3. When you enter a command such as Circle, the **prompt** and **options** will be displayed on the Command Line.
- 4. The prompt for the Circle command asks you to:

"Specify center point for circle" or [3P 2P Ttr (tan tan radius)]:

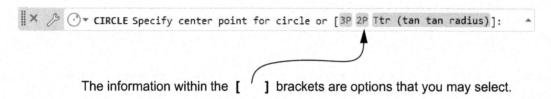

Clickable options are displayed in blue. Options displayed in black must be typed or selected from the option menu.

This will be discussed more in Lesson 2.

Command and Prompt History

As you enter commands, AutoCAD records them as "history". You may display this history by pressing **<F2>** or by selecting the up arrow at the right-hand end of the Command Line.

```
Command: CLIPROMPTLINES
           Enter new value for CLIPROMPTLINES <1>: 3
Command: '_.zoom
           Command: '_.zoom

Specify corner of window, enter a scale factor (nX or nXP), or

[All/Center/Dynamic/Extents/Previous/Scale/Window/Object] <real time>: _e Regenerating model.
           Command: Specify opposite corner or [Fence/WPolygon/CPolygon]:
Command: "Cancel"
           Command: Specify opposite corner or [Fence/WPolygon/CPolygon]:
           Command:
           Command:
           Command: _circle
           Specify center point for circle or [3P/2P/Ttr (tan tan radius)]:
Specify radius of circle or [Diameter]: "Cancel"
Automatic save to C:\Users\Steve\AppData\Local\Temp\Drawing1_1_11328_8c6f3b2b.sv$ ...
           Command:
           Command:
           Command: _circle
           Specify center point for circle or [3P/2P/Ttr (tan tan radius)]: *Cancel*
                                                                                                                                                                          Select the up
X & =-
                                                                                                                                                                          arrow to display
                                                                                                                                                                         the history.
```

Command Line Tools

The Recent Commands tool displays recently selected commands.

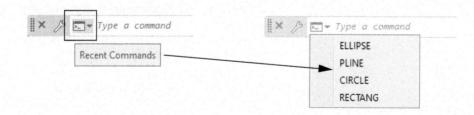

The **Customize** tool allows you to select options for the AutoComplete by selecting "**Input Settings**". You can also control how many lines of history are displayed and the degree of transparency for the Command Line.

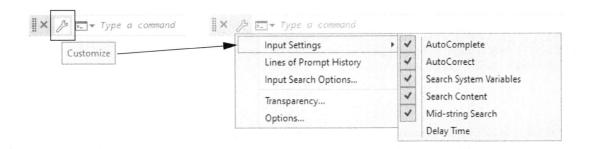

Dynamic Input

Dynamic Input is another method of inputting commands and values and selecting options. To use Dynamic Input, you must turn on the **Dynamic Input** button in the Status Bar, shown on page 1-12.

If you choose to use Dynamic Input, the command will be entered in the tooltip box beside the cursor.

How to enter a command using Dynamic Input

- 1. Place the cursor in the Drawing Area.
- 2. Type the first letter of a command, such as **c** for circle.
- 3. A list of commands that begin with the letter C will appear. Select the command from the list.

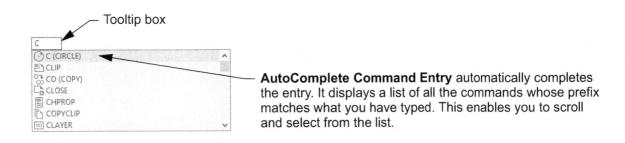

4. If you press the ↓ arrow, the options will appear below the prompt.

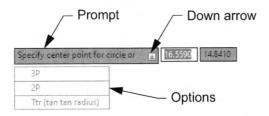

Notice that the command entry also is being displayed on the Command Line. Whether to use the Command Line or Dynamic Input is your choice. This will be discussed more in Lesson 2.

Drawing Area

The Drawing Area is the large open area of the screen. This is where you will draw. Consider this your paper. The color of this area can be changed using **Options / Display Tab / Color**.

Origin Icon

The Origin icon or UCS icon indicates the location of the Origin. The Origin is where the coordinates X, Y, and Z originate. The X and Y coordinates for the Origin is 0,0. This will be discussed more in future Lessons.

Cursor

The Cursor is located within the Drawing Area. The movement of the pointing device, such as a mouse, controls the movement of the cursor. You will use the cursor to locate points, make selections and draw objects. The size can be changed using **Options / Display Tab / Crosshair Size**.

InfoCenter

The InfoCenter is a tool to search for information. It is located in the upper right corner of the screen.

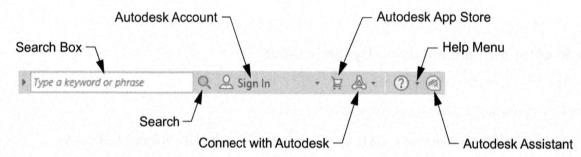

Search Box

The InfoCenter allows you to search for information by typing key words or a question in the "Help Box". After typing, press <*Enter*>.

Search

Displays multiple search options.

Autodesk Account

Sign in to your Autodesk online account to access services that integrate with your desktop software.

Autodesk App Store

Launches the Autodesk App Store website.

Connect with Autodesk

Allows you to connect to the Autodesk online community.

Help Menu

Displays the Help Window.

Autodesk Assistant

Opens the Autodesk Assistant Palette.

ViewCube and Navigation Bar

The ViewCube and the Navigation Bar are used primarily in the 3D mode. They enable you to view and rotate the 3D model. We will not be using these tools in this Workbook. Refer to the *Advanced AutoCAD® Exercise Workbook* and *AutoCAD® 3D Modeling Exercise Workbook*.

Since we are not using these tools, you may choose to turn their display off. Follow the easy instructions below to turn the display **off** or **on**.

How to turn off the ViewCube and Navigation Bar

There are 2 methods.

Method 1.

- 1. Type navbardisplay and then press <Enter>.
- 2. Type $\mathbf{0}$ and then press $\langle \mathbf{Enter} \rangle$. [0 = off 1 = on]
- 3. Type navvcubedisplay and then press <Enter>.
- 4. Type 1 and then press < Enter>.

Note: navvcubedisplay has 4 settings:

- 0 = Not displayed in 2D or 3D.
- 1 = Displayed in 3D only (Select this one for the Workbook).
- 2 = Displayed in 2D only.
- 3 = Displayed in both 2D and 3D.

Method 2.

- 1. Select the View Tab.
- 2. Left click on the ViewCube and Navigation Bar buttons.

Note: The buttons will be displayed in blue when switched on.

ToolTip Help

Basic ToolTip

When you hover your cursor over a tool, an initial ToolTip will appear telling you the name of the tool with a brief description.

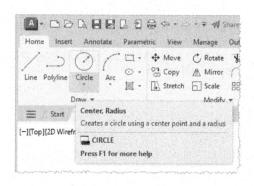

Extended ToolTip

If you hover just a little longer, a graphic display, directly from the Help system, will appear.

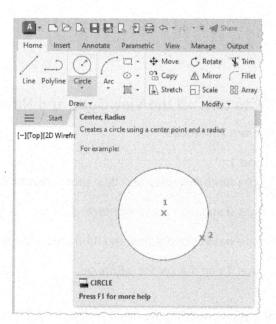

How to turn off ToolTips

After you become familiar with AutoCAD, you will want to turn these off. Or you may just want to delay the extended ToolTips.

- Type options and then press <Enter>.
- 2. Select the Display Tab.
- 3. Uncheck boxes.

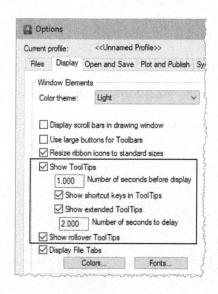

Autodesk Assistant

Autodesk® has added to AutoCAD® a smarter interactive help system called **Autodesk Assistant**. This artificial intelligence (AI) driven feature can be used to answer AutoCAD-related questions that you might have, such as "How to create a Construction Line?" If the Autodesk Assistant cannot or does not sufficiently answer your question, you can choose to connect online with an Autodesk agent for further assistance.

When you start AutoCAD, a **Meet the Autodesk Assistant** balloon notification will appear at the top of the Application Window for a few seconds. You can choose to open Autodesk Assistant at this time by clicking on the **Launch the Assistant now** text in this notification. You also can open the Autodesk Assistant at any other time while using AutoCAD.

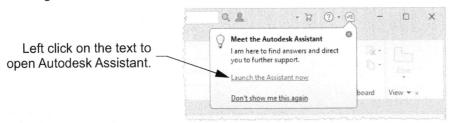

How to Open the Autodesk Assistant from the InfoCenter Toolbar

1. Left click on the Autodesk Assistant button on the InfoCenter Toolbar.

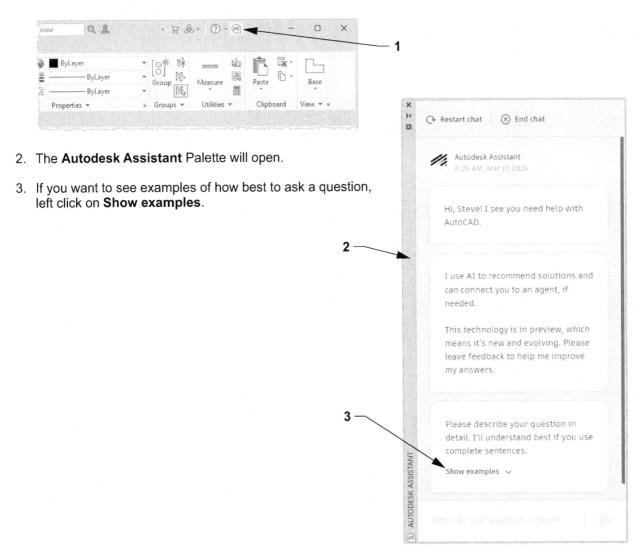

- 4. Some examples of how to ask a question will be displayed in the window.
- 5. You can hide the question examples by left clicking on **Hide examples**.
- 6. When you are ready, type a question in the bottom window, for example, "How to create a Construction Line?"
- 7. Left click on the chevron or press < Enter>.

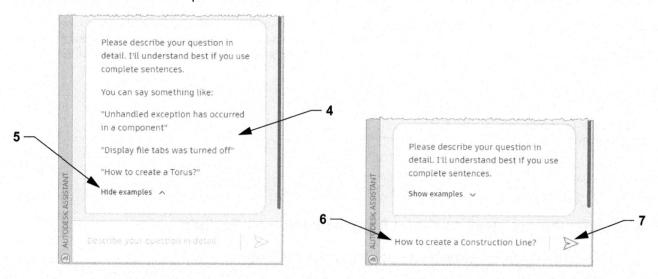

8. The Autodesk Assistant will display an answer to your question. It also may provide links to find other information related to your question.

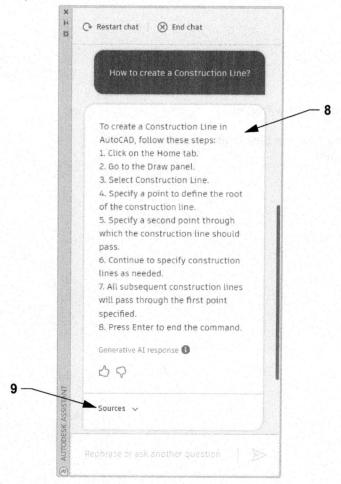

9. If you require more information based on the question you asked, left click on Sources.

- 10. A list of other sources are displayed in the window.
- 11. You can also connect with an Autodesk Agent by left clicking on Connect with an agent.

Note: Your ability to connect with and receive additional information from an Autodesk agent may depend on the type and level of your AutoCAD subscription.

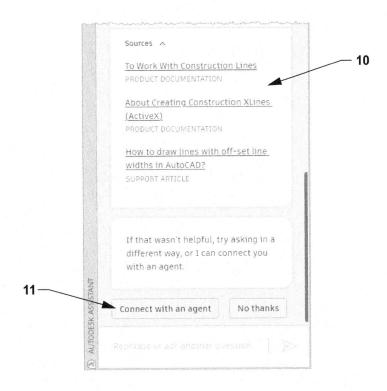

- 12. If you are satisfied with the answer(s) to the question you asked, select **End chat**.
- 13. You also can ask the AutoCAD Assistant another question by selecting **Restart chat**.

14. After selecting End chat, the End chat window will appear. Left click on Yes to end the current chat session.

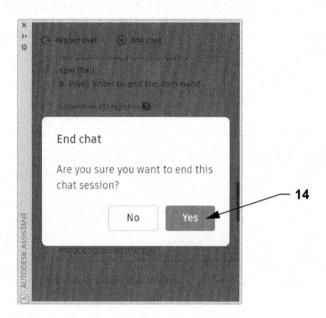

15. Select the Close Window text to close the Autodesk Assistant Palette.

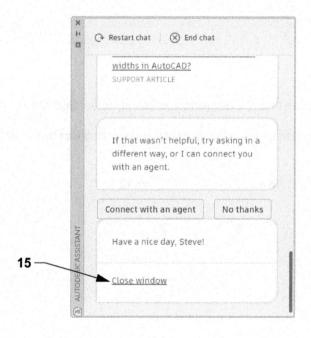

LESSON 2

LEARNING OBJECTIVES

After completing this lesson, you will be able to:

- 1. Create and use a Template.
- 2. Select a Command.
- 3. Draw, Select, and Erase Objects.
- 4. Start a New Drawing.
- 5. Open an Existing Drawing.
- 6. Open Multiple Drawings.
- 7. Using Floating File Tabs.
- 8. Save, Backup, and Recover a Drawing.
- 9. Exit AutoCAD.

Creating a Template

The first item on the learning agenda is **how to create a template file** from a drawing file. **This is important:** You will need this template to complete Lessons 2 through 8.

First you need to download a drawing file.

A. Type the website address shown below into your web browser, then press < Enter>.

https://books.industrialpress.com/autocad/workbook-helper.zip

- B. The workbook-helper file will download automatically.
- C. Save the downloaded file to your desktop, then unzip the file to extract both drawings.

Now you will create a template. (This will be a very easy task.)

- 1. Start AutoCAD, if you haven't already. (Refer to page 1-2.)
- 2. Select the Open tool from the Quick Access Toolbar. (Refer to page 1-10.)

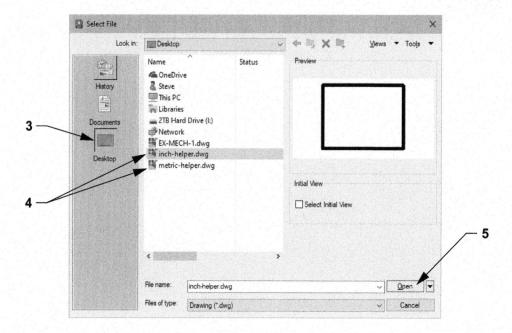

- 3. Select the **Desktop** directory
- 4. Select either the inch-helper or metric-helper drawing.
- 5. Select the **Open** button located in the lower right corner.

Your screen should appear as shown below.

I created the **Rectangular shape** that appears in the drawing area. I have designed the exercises that follow to fit on a 11" X 8-1/2" sheet of paper for inch users, or to fit on a 297mm x 210mm sheet of paper for metric users. This will enable you to easily print them on any letter or A4 size printer. The rectangle represents an 11" X 8-1/2" or 297mm x 210mm sheet of paper, depending on which file you use. While completing the exercises within this Workbook, please try to draw all objects within this rectangle.

The criss-cross lines are **Grids**. I have set them to display every 1 inch vertically and horizontally for inch users, and every 25mm for metric users. You will learn more about Grids in Lesson 3. For now, notice that the grids are 11 horizontally and 8.5 vertically for inch users, and 11.88 horizontally and 8.4 vertically for metric users. Grids are merely a visual aid and will not print. The size may be changed at any time and they may be turned **on** or **off** easily by selecting the "**Grid**" button on the Status Bar, or by pressing the **F7**> key. (Refer to page 1-13.)

The next step is to create a template from this drawing.

Continue on to Step 6.

- 6. Select the "Application Menu" button.
- 7. Select Save As ▶ (Click on the arrow not the words "Save As", as shown on the next page.)
- 8. Select "Drawing Template".

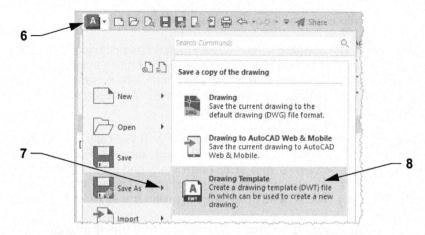

The name of the new file should already be highlighted in the "File name" box; if it's not, just type in inch-helper or metric-helper in the File name box. Do not type the extension .dwt. AutoCAD will add it automatically.

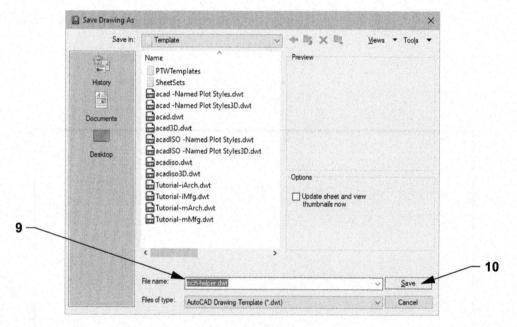

- 10. Select the Save button.
- 11. Type the description and make the selections as shown below.
- 12. Select the OK button.

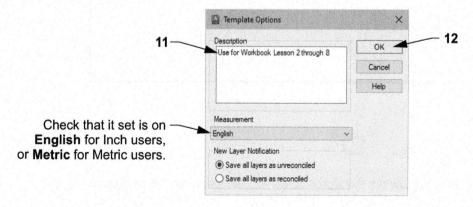

Now you have a template to use for Lessons 2 through 8. At the beginning of each exercise, you will be instructed to start a **new** drawing using either the **inch-helper.dwt** or **metric-helper.dwt**. Using a template as a master setup drawing is very good CAD management.

Using a Template

The template that you created following the instructions on the previous pages will be used for Lessons 2 through 8. Many variables have been preset in this template. This will allow you to start drawing immediately. You will learn how to set those variables before you complete this Workbook, but for now you will concentrate on learning the AutoCAD commands and hopefully have some fun.

To use a Template

1. Select the New tool from the Quick Access Toolbar.

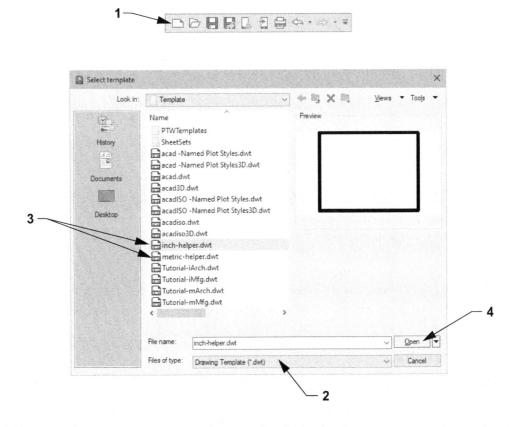

- 2. Select Drawing Template (*.dwt) from the "Files of type" if not already selected.
- Select either the inch-helper.dwt or metric-helper.dwt from the list of templates.

Note: If you do not have these templates, refer to page 2-2 for instructions.

4. Select the Open button.

Selecting a Command

AutoCAD provides you with two different methods for selecting commands. One is **selecting a tool from the Ribbon**, the other is **typing the command**. Both methods will accomplish the same end result. You decide which method you prefer.

An example of Method 1 is shown on the next page, followed by Method 2.

Method 1. Selecting a tool from the Ribbon

- 1. First select a Tab such as Home.
- 2. Locate the correct Panel such as Draw.
- 3. Select a tool such as Circle.

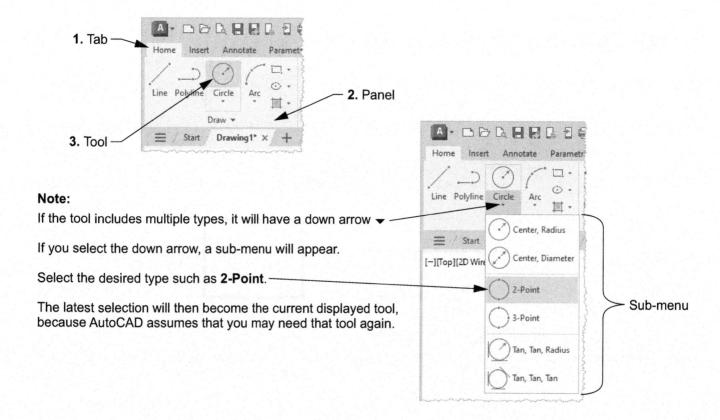

Method 2. Keyboard entry

Command Line

You may type commands on the **Command Line** (shown below) or in the **Dynamic Input Tooltip** box (shown on the next page). It depends on whether you have Dynamic Input turned **on** or **off**.

How to enter a command on the Command Line

- 1. Important: Place the cursor in the Command Line area.
- 2. Type the first letter of a command, such as **c** for **circle**.

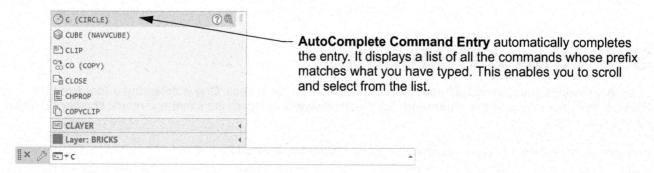

- 3. A list of commands that begin with the letter C will appear. Scroll down and select a command from the list.
- 4. When you select a command such as **Circle**, the **prompt** and **options** will be displayed on the Command Line.

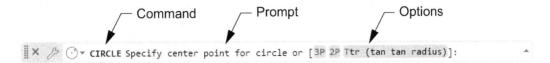

5. The **prompt** for the Circle command asks you to:

"Specify center point for circle" or [3P 2P Ttr (tan tan radius)]:

The information within the [] brackets are options that you may select.

Method 2. Keyboard entry

Dynamic Input

Dynamic Input is another method of inputting commands, values, and select options. To use Dynamic Input, you must turn **on** the **Dynamic Input** button in the Status Bar, shown on page 1-13.

If you choose to use Dynamic Input, the command will be entered in the Tooltip box beside the cursor.

How to enter a command using Dynamic Input

- 1. Important: Place the cursor in the Drawing Area.
- 2. Type the first letter of a command, such as **c** for **circle**.
- 3. A list of commands that begin with the letter C will appear. Select the command from the list.

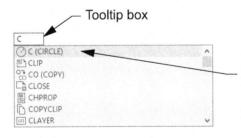

AutoComplete Command Entry automatically completes the entry. It displays a list of all the commands whose prefix matches what you have typed. This enables you to scroll and select from the list.

4. If you press the \downarrow arrow, the options will appear below the prompt.

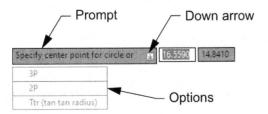

Notice that the command entry also is being displayed on the Command Line. Whether you use the Command Line or Dynamic Input is your choice.

Drawing Lines

A Line can be one segment or a series of connected segments. But each segment is an individual object.

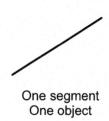

Start the Line command using one of the following methods:

Ribbon = Home Tab / Draw Panel / or Keyboard = L <Enter>

Lines are drawn by specifying the locations for each endpoint.

Move the cursor to the location of the "first" endpoint (1), then press the left mouse button and release. (Click and release, do not Click and Drag.) Move the cursor again to the "next" endpoint (2) and press the left mouse button. Continue locating "next" endpoints until you want to stop drawing lines.

There are 2 ways to stop drawing a line: press the <Enter> key or press the <Spacebar>.

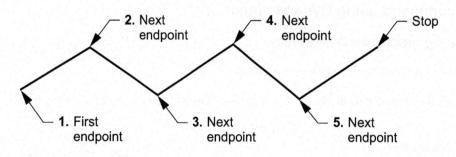

Horizontal and Vertical Lines

To draw a Line perfectly horizontal or vertical, select the **Ortho** mode by selecting the **Ortho** button on the Status Bar or pressing the **<F8>** key.

Try the following example:

- 1. Select the Line command.
- 2. Place the first endpoint anywhere in the drawing area.
- 3. Turn **Ortho on** by selecting the **Ortho** button or **<F8>**. (The "**Ortho**" button will change to a neon blue when **on**.)

- 4. Move the cursor to the right and press the left mouse button to place the **next endpoint**. (The line should appear perfectly horizontal.)
- 5. Move the cursor down and press the left mouse button to place the **next endpoint**. (The line should appear perfectly vertical.)
- 6. Now turn Ortho off by selecting the Ortho button. (The "Ortho" button will change to gray when off.)
- 7. Now move the cursor up and to the right on an angle (the line should move freely now) and press the left mouse button to place the **next endpoint**.

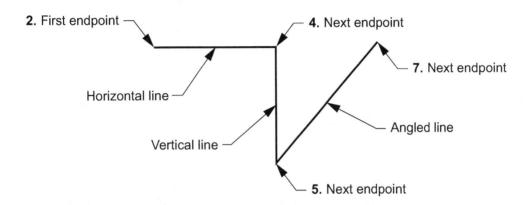

Ortho can be turned **on** or **off** at any time while you are drawing. It can also be turned **on** or **off** temporarily by holding down the **<Shift>** key.

Closing Lines

If you have drawn two or more line segments, **the endpoint of the last line segment** can be automatically connected to the **first endpoint**, with the space between them closed up, by using the **Close** option.

Try the following example:

- 1. Select the Line command.
- Place the first endpoint.
- 3. Place the next endpoint.
- 4. Place the next endpoint.
- 5. Type **C <Enter>**.

Or

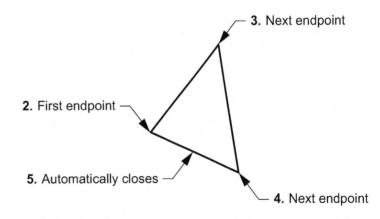

5. Press the **right** mouse button and select **Close** from the **Shortcut Menu**.

What is the Shortcut Menu?

The Shortcut Menu gives you quick access to command options.

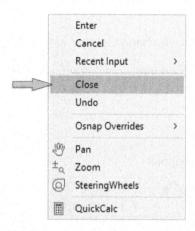

Using the Shortcut Menu:

Press the right mouse button. The Shortcut Menu will appear. Select an option.

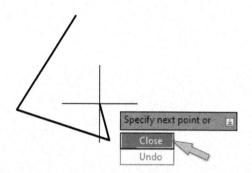

Using the Dynamic Input down arrow:

You may use the right mouse button or press the down arrow ↓ and the options will appear below the Dynamic Input prompt.

Methods for Selecting Objects

Many AutoCAD commands prompt you to "select objects". This means selecting the objects that you want the command to affect. There are 3 methods:

Method 1. Pick, is very easy and should be used if you have only 1 or 2 objects to select.

Method 2. Window selection, is a little more difficult, but once mastered it is extremely helpful and time saving.

Method 3. Lasso selection, is a little more difficult than Window selection, but again, once mastered it is very useful and will save you time. Practice the following examples.

Method 1. Pick

Place the cursor on the object, but do not press the mouse button yet. The object will highlight. This appearance change is called "Rollover Highlighting". It gives you a preview of which object AutoCAD is recognizing. Press the left mouse button to actually select the highlighted object.

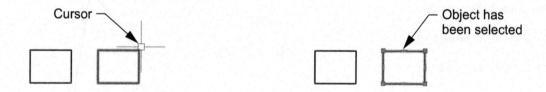

Method 2. Window selection, Crossing and Window

Crossing:

Place your cursor in the area **up** and to the **right** of the objects that you want to select (**P1**) and press the left mouse button. (**Do not** hold the mouse button down. Just press and release.) Then move the cursor **down** and to the **left** (**P2**) and press the left mouse button again. (**Note:** The Window will be **green** and the outer line will be **dashed**.) **Only** the objects that this Window **crosses** will be selected.

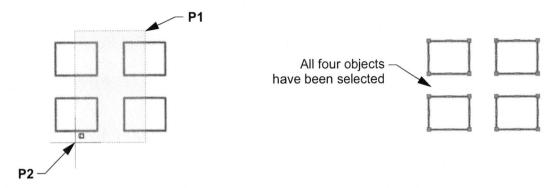

In the example above, all four rectangles have been selected because the Crossing Window **crosses** a portion of each.

Window:

Place your cursor in the area **up** and to the **left** of the objects that you want to select (**P1**) and press the left mouse button. (**Do not** hold the mouse button down. Just press and release.) Then move the cursor **down** and to the **right** of the objects (**P2**) and press the left mouse button again. (**Note:** The Window will be **blue** and the outer line will be **solid**.) **Only** the objects that this Window **completely encloses** will be selected.

In the example below, only two rectangles have been selected. (The other two rectangles are **not** completely enclosed in the **Window**.)

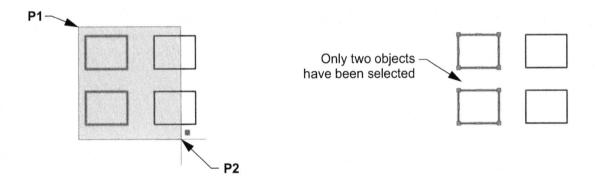

Method 3. Lasso selection, Crossing, Window, and Fence

Crossing:

Place your cursor in the area **up** and to the **right** of the objects that you want to select (**P1**), then press and hold the left mouse button. (**Do not** release the mouse button.) Then move the cursor in an counter-clockwise direction until you have crossed the objects you want to select (**P2**) and then release the left mouse button. (**Note:** The Lasso Window will be **green** and the outer line will be **dashed**.) **Only** the objects that the Lasso Window **crosses** will be selected.

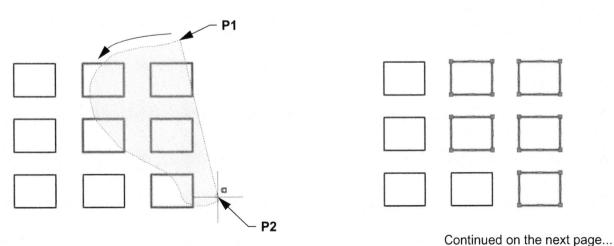

Window:

Place your cursor in the area **up** and to the **left** of the objects that you want to select (**P1**), then press and **hold** the left mouse button. (**Do not** release the mouse button.) Then move the cursor in a clockwise direction until you have completely enclosed the objects you want to select (**P2**), and then release the left mouse button. (**Note:** The Window will be **blue** and outer line will be **solid**.) Only the objects that this Window **completely encloses** will be selected.

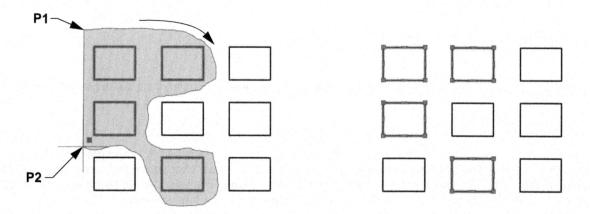

Fence:

With the **Fence** option of the **Lasso** selection you can place the mouse cursor in any position you choose. For this example, place your cursor at (**P1**), then press and **hold** the left mouse button. (**Do not** release the mouse button.) Move the mouse until you see either the green or blue lasso, then press the **<Spacebar>** until you see just a **Dashed Fence Line**. Move the mouse over the objects you want to select (**P2**), and then release the left mouse button. Only the objects that the Fence line crosses will be selected.

Note: You may have to press the <Spacebar> twice to activate the Fence Line option.

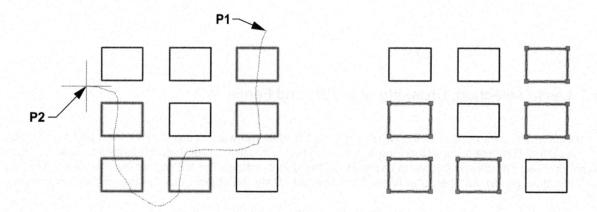

Erase

There are three methods to erase (delete) objects from the drawing. They all work equally well. You decide which one you prefer to use.

Method 1.

Select the **Erase** command first and then select the objects.

Example:

1. Start the **Erase** command using one of the following:

2. The following will appear on the Command Line:

3. Select one or more objects and then press < Enter> to erase the object(s).

Method 2.

Select the objects first and then press the <Delete> key.

Example:

- 1. Select the object(s) to be erased.
- 2. Press the <Delete> key.

Method 3.

Select the objects first and then select **Erase** from the Shortcut Menu.

Example:

- 1. Select the object(s) to be erased.
- 2. Press the right mouse button.
- 3. Select **Erase** from the Shortcut Menu using the left mouse button.

Very Important:

If you want the erased objects to return, select the **Undo tool** from the **Quick Access Toolbar**. This will **Undo** the last command.

Undo and Redo

The **Undo** and **Redo** tools allow you to undo or redo **previous commands**. For example, if you erase an object by mistake, you can **undo** the previous "erase" command and the object will reappear. So don't panic if you do something wrong. Just use the **Undo** command to remove the previous commands.

The Undo and Redo tools are located in the Quick Access Toolbar.

Note: You may undo commands used during a work session until you close the drawing.

How to use the Undo tool

1. Draw a line, circle, and a rectangle.

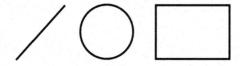

Your drawing should look approximately like this.

2. Next erase the circle and the rectangle.

(The circle and the rectangle disappear.)

3. Select the **Undo** arrow.

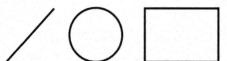

You have now deleted the Erase command operation. As a result, the erased objects reappear.

How to use the Redo tool:

Select the **Redo** arrow and the circle and rectangle will disappear again.

Starting a New Drawing

Starting a new drawing means that you want to start with a previously created Template file. That is why I taught you "How to create a template" at the beginning of this lesson. You will use either the **inch-helper.dwt** or the **metric-helper.dwt** template each time you are instructed to start a new drawing.

Note: Do not use the **New** tool if you want to **open** an **existing drawing**. Refer to the next page to open an existing drawing file.

How to start a new drawing

1. Select the New tool from the Quick Access Toolbar.

2. Select either the inch-helper.dwt or the metric-helper.dwt from the list of templates.

Note: If you do not have these templates, refer to page 2-2 for instructions.

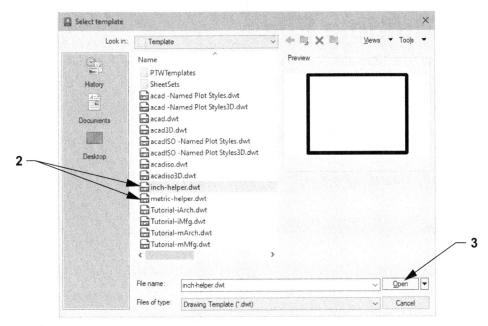

3. Select the Open button.

Opening an Existing Drawing File

Opening an **Existing Drawing File** means that you would like to open, on the screen, a drawing that has been previously created and saved. Usually you are opening it to continue working on it or to make some changes.

1. Select the Open tool from the Quick Access Toolbar.

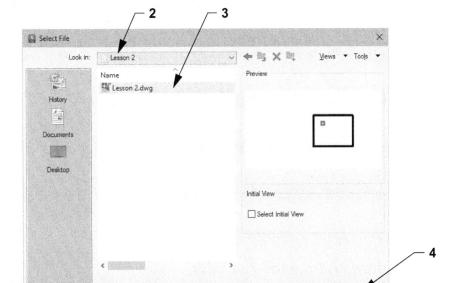

2. Locate the Directory and Folder in which the file had previously been saved.

Lesson 2.dwg

Drawing (*.dwg)

- Select the file that you want to open.
- 4. Select the Open button.

Opening Multiple Files

The **File Tabs** tool allows you to have multiple drawings open at the same time. If the File Tabs tool is switched **on** (on by default), you can open existing saved drawings or create new ones.

The File Tabs tool is located on the Interface Panel of the View Tab, and is a neon blue color when switched on.

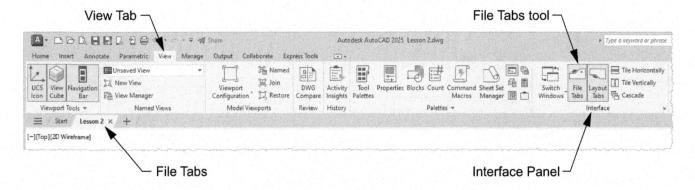

How to open an existing saved drawing from the File Tabs

- Right mouse click on the + icon.
- Select Open from the menu.

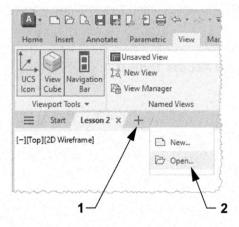

- 3. Locate the Directory and Folder for the previously saved file. (Refer to page 2-15.)
- 4. Select the file that you want to open.
- 5. Select the Open button.

How to open a new drawing from the File Tabs

- 1. Right mouse click on any File Tab and select New from the menu.
- Select Drawing Template (*.dwt) from the Files of type drop-down list (as shown on the next page).
- 3. Select the Template you require.
- 4. Select the Open button.

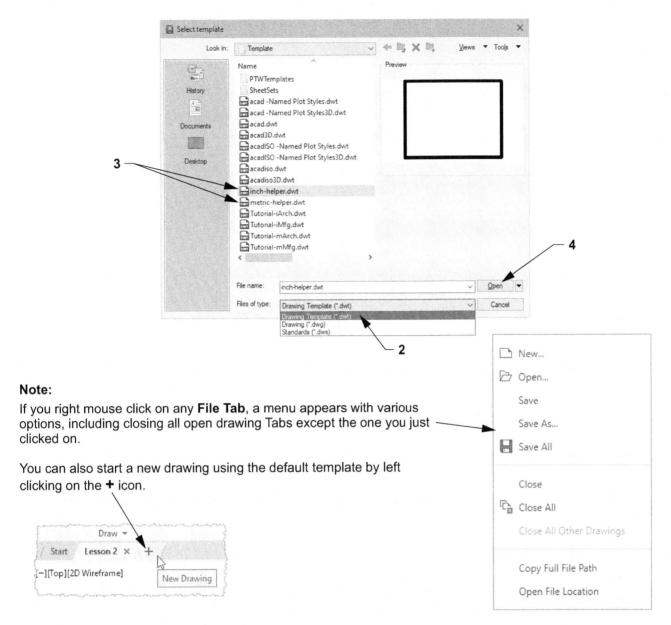

The **File Tabs** drawing previews allow you to quickly change between open drawings. If you hover your mouse over any open File Tab, a preview of the Model and the Layout Tabs are displayed. You can click on any of the previews to take you to that particular open drawing or view, as shown in the example below.

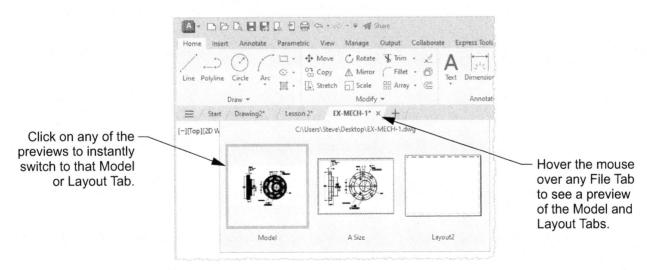

If an asterisk is displayed on a File Tab, it means that particular drawing has not been saved since it was last modified. The asterisk will disappear when the drawing has been saved. An example of having two separate drawings open that have not been saved is shown below.

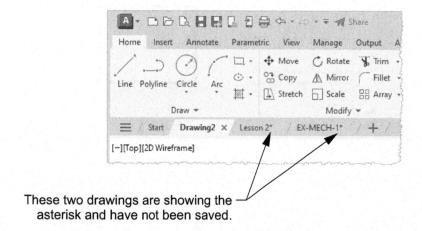

Using Floating File Tabs

You can drag a File Tab off the main AutoCAD Application Window to make it a separate drawing window. This means that you could have several drawing files open at the same time with each file in its own drawing window, without having to switch between File Tabs. The floating File Tabs are particularly useful if you have two or more monitors, because you can have a different drawing file open on each monitor.

You can switch between the main AutoCAD Application Window and any floating File Tab by left-clicking inside the drawing area of that separate file's drawing window. A floating File Tab window also can be resized to make it larger or smaller.

How to create a floating File Tab

 Left click and hold down the left mouse button (do not release the button) on the File Tab you want as a floating File Tab.

2. Drag the File Tab away from the main AutoCAD Application Window.

- 3. Drag the File Tab to the location you want for the floating File Tab. This could be on the same screen or on a second monitor.
- 4. When you are happy with the location of the floating File Tab, release the left mouse button.

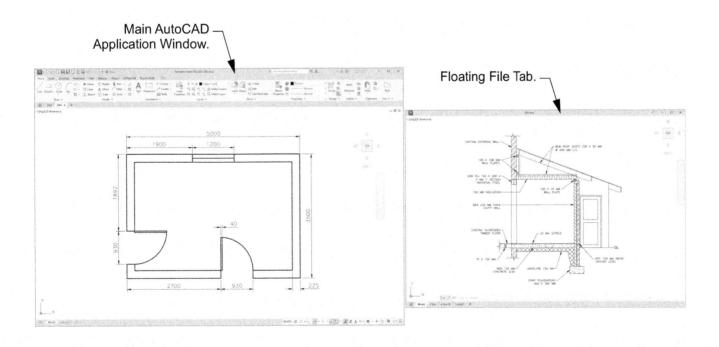

How to move a floating File Tab back to the main AutoCAD Application Window

 Left click and hold down the left mouse button (do not release the button) on the Title Bar of the floating File Tab you want to move back to the main AutoCAD Application Window.

Drag the File Tab back to the main AutoCAD Application Window, until you see the entire drawing area turn a translucent blue in color.

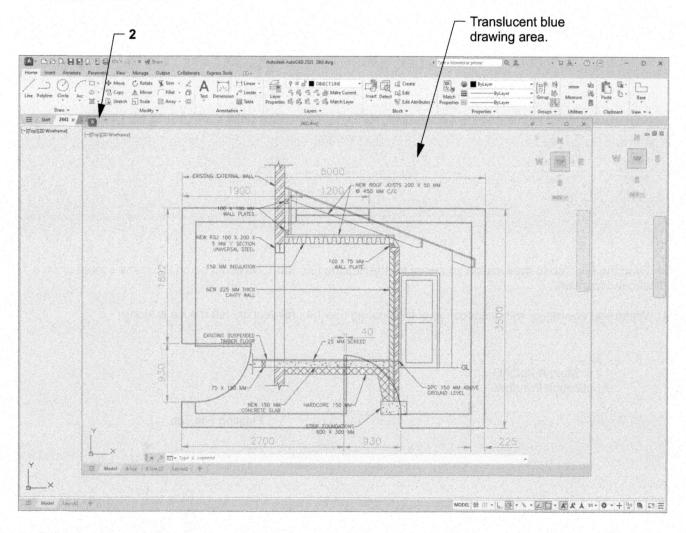

- 3. Release the left mouse button.
- 4. The floating File Tab will now be back on the main AutoCAD Application Window.

You also can move a floating File Tab back to the main AutoCAD Application Window by right clicking on the Title Bar of the floating File Tab, and then selecting **Move to File Tab** from the menu.

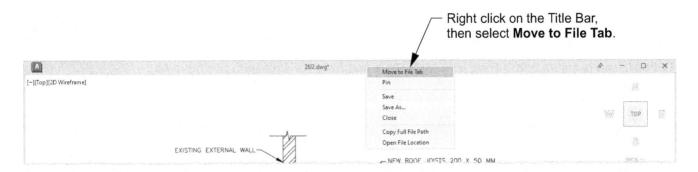

You can Pin a floating File Tab so that it remains on top of any other open or overlapping drawing file windows.

How to Pin a floating File Tab

- 1. Right click on the Title Bar of the floating File Tab you want to Pin.
- 2. Select Pin from the menu.

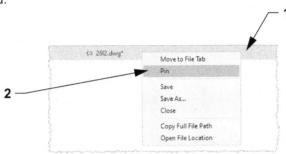

3. The floating File Tab is now pinned so that it remains on top of any other open or overlapping drawing file windows.

How to Unpin a floating File Tab

- 1. Right click on the Title Bar of the floating File Tab you want to Unpin.
- 2. Select Unpin from the menu.

3. The floating File Tab is now unpinned. It will only remain on top of any other open or overlapping drawing file windows if you left click inside the file's drawing area.

Saving a Drawing File

After starting a new drawing, it is best practice to save it immediately. Learning how to save a drawing correctly is almost more important than making the drawing. If you can't save correctly, you will lose the drawing and hours of work.

There are two commands for saving a drawing: Save and Save As. I prefer to use Save As.

The **Save As** command always pauses to allow you to choose where you want to store the file and what name to assign to the file. This may seem like a small thing, but it has saved me many times from saving a drawing on top of another drawing by mistake.

The **Save** command will automatically save the file either back to where you retrieved it or where you last saved a previous drawing. Neither may be the correct destination. And the file you are saving may replace a file with the same name. So play it safe, use **Save As** for now.

1. Select the Save As command using one of the following:

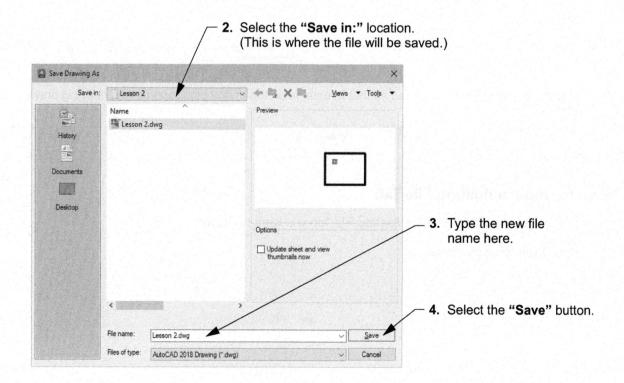

Automatic Save

If you turn the **Automatic save** option **on**, your drawing is saved at specified time intervals. These temporary files are automatically deleted when a drawing closes normally. The default save time is every 10 minutes. You may change the save time intervals and where you would prefer the Automatic Save files to be saved.

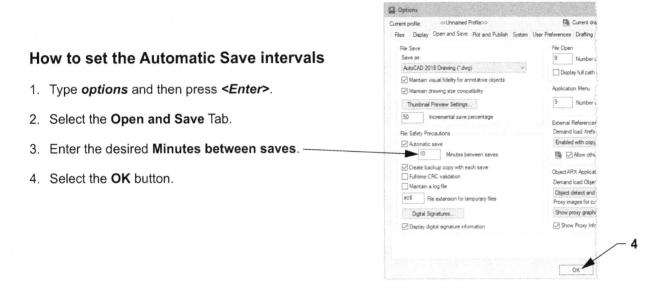

How to change the Automatic Save location

- 1. Type options and then press < Enter>.
- 2. Select the Files Tab.
- 3. Locate the **Automatic Save File Location** and click on the + to display the path.
- 4. Double click on the path.
- 5. Browse to locate the Automatic Save Location desired and highlight it.
- 6. Select OK.

(The browse box will disappear and the new location path should be displayed under the Automatic Save File Location heading.)

7. Select **OK** to accept the change.

Back Up Files and Recover

When you save a drawing file, AutoCAD creates a file with a .dwg extension. For example, if you save a drawing as 12b, AutoCAD saves it as 12b.dwg.

The next time you save that same drawing, AutoCAD replaces the old version of the file with the new version and renames the old version 12b.bak. The old version is now a back up file. (Only 1 backup file for each drawing file is stored.)

How to open a back up file

You can't open a ".bak" file. It must first be renamed with a ".dwg" file extension.

How to view the list of back up files

The backup files will be saved in the same location as the drawing file. You must use Windows Explorer to locate the **.bak** files.

How to rename a back up file

- 1. Right click on the file name.
- 2. Select "Rename".
- 3. Change the .bak extension to .dwg and then press < Enter>.

Recovering a Drawing

In the event of a program failure or a power failure, any open files should be saved automatically. (Refer to page 2-23.)

When you attempt to re-open the drawing, the **Drawing Recovery Manager** will display a list of all drawing files that were open at the time of a program or system failure. You can preview and open each **.dwg** or **.bak** file to choose which one should be saved as the primary file.

Exiting AutoCAD

To safely exit AutoCAD, follow the instructions below.

- Save all open drawings using Save or Save As.
- 2. Start the **Exit** procedure using one of the following:

```
Ribbon = None
or
Application Menu = Exit Autodesk AutoCAD 2025
or
Keyboard = Exit <Enter>
```

If any changes have been made to the drawing since the last **Save** or **Save As**, the warning box shown below will appear asking if you want to Save the changes?

Select Yes, No, or Cancel.

Exercise 2A

Instructions:

- Start a New file using either the inch-helper.dwt or the metric-helper.dwt
- 2. Draw the objects at right using:
 - A. Line command.
 - B. **Ortho <F8> on** when drawing horizontal and vertical lines.
 - C. Ortho <F8> off when drawing lines on an angle.
 - D. Turn Increment Snap <F9> on.
 - E. Turn Osnap <F3> off.
 - F. Turn Grid <F7> on.
 - G. Use the Close option.
- 3. Save the drawing as: Ex-2A

Exercise 2B

Instructions:

- 1. Open Ex-2A, if not already open.
- 2. Erase the missing lines as shown.
 - A. Turn **Osnap <F3> off** (it will be easier to move the cursor around accurately).
- 3. Save the drawing as: Ex-2B

Exercise 2C

Instructions:

- Start a New file using either the inch-helper.dwt or the metric-helper.dwt
- 2. Draw the objects at right using:
 - A. Line command.
 - B. Ortho <F8> on when drawing horizontal and vertical lines.
 - C. Ortho <F8> off when drawing lines on an angle.
 - D. Turn Increment Snap <F9> on.
 - E. Turn Osnap <F3> off.
 - F. Turn Grid <F7> on.
 - G. Use the <Shift> key to toggle Ortho on and off.
- 3. Save the drawing as: Ex-2C

Exercise 2D

Instructions:

- Start a New file using either the inch-helper.dwt or the metric-helper.dwt
- 2. Draw the objects at right using:
 - A. Line command.
 - B. Ortho <F8> on when drawing horizontal and vertical lines.
 - C. Ortho <F8> off when drawing lines on an angle.
 - D. Turn Increment Snap <F9> on.
 - E. Turn Osnap <F3> off.
 - F. Turn Grid <F7> on.
 - G. Use the <Shift> key to toggle Ortho on and off.
- 3. Save the drawing as: Ex-2D

LESSON 3

LEARNING OBJECTIVES

After completing this lesson, you will be able to:

- 1. Create a Circle using 6 different methods.
- 2. Create Rectangles with Chamfers, Fillets, Width, and Rotation.
- 3. Set Grids and Increment Snap.
- 4. Draw using Layers.
- 5. Control Layers.
- 6. Create Layers.

3-2 Circle

Circle

There are six options to create a circle.

The default option is "Center, Radius". (Probably because that is the most common method of creating a circle.)

We will try the "Center, Radius" option first.

1. Start the Circle command by using one of the following:

Ribbon = Home Tab / Draw Panel / or Keyboard = C <Enter>

2. The following will appear on the Command Line:

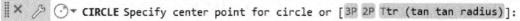

- 3. Locate the center point for the circle by moving the cursor to the desired location in the drawing area (P1) and then press the left mouse button.
- 4. Now move the cursor away from the center point and you should see a circle forming.
- 5. When the circle is the size desired (**P2**), press the left mouse button, or type the radius and then press *<Enter>*.

Note: To use one of the other methods described below, first select the Circle command, then select one of the other Circle options.

Center, Radius: (Default option)

- 1. Specify the center location (P1).
- 2. Specify the radius (**P2**). (Define the radius by moving the cursor or by typing the radius.)

Center, Diameter:

- 1. Specify the center location (P1).
- Specify the diameter (P2). (Define the diameter by moving the cursor or by typing the diameter.)

2-Point:

- 1. Select the 2-Point option.
- 2. Specify the 2 points (P1 and P2) that will determine the diameter.

3-Point:

- 1. Select the 3-Point option.
- 2. Specify the 3 points (P1, P2, and P3) on the circumference. The circle will pass through all three points.

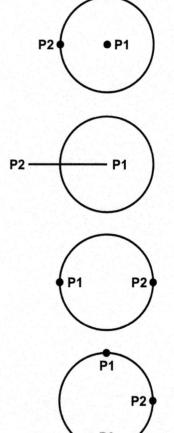

Tan, Tan, Radius:

- 1. Select the Tan, Tan, Radius option.
- Select two objects (P1 and P2) for the circle to be tangent to by placing the cursor on each of the objects and pressing the left mouse button.
- 3. Specify the radius.

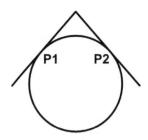

Tan, Tan, Tan:

- 1. Select the Tan, Tan, Tan option.
- 2. Select three objects (P1, P2, and P3) for the circle to be tangent to by placing the cursor on each of the objects and pressing the left mouse button.

(AutoCAD will calculate the diameter automatically.)

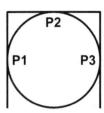

Rectangle

A rectangle is a closed rectangular shape. It is one object not four lines.

You can specify the length, width, area, and rotation options.

You can also control the type of corners on the rectangle—fillet, chamfer, or square—and the width of the line.

First, let's start with a simple rectangle using the cursor to select the corners.

1. Start the Rectangle command by using one of the following:

Ribbon = Home Tab / Draw Panel / or Keyboard = REC <Enter>

2. The following will appear on the Command Line:

- 3. Specify the location of the first corner by moving the cursor to a location (P1) and then press the left mouse button.
- 4. The following will appear on the Command Line:

5. Specify the location of the diagonal corner (**P2**) by moving the cursor diagonally away from the first corner (**P1**) and then pressing the left mouse button.

If you know the dimensions for the length and width of the rectangle, refer to the next page for an alternative to Step 5.

5. Type **D <Enter>** (or click on the blue letter "D").

Specify length for rectangles <0.000>: Type the desired length and then press <Enter>.

Specify width for rectangles <0.000>: Type the desired width and then press <Enter>.

Specify other corner point or [Area Dimensions Rotation]: Move the cursor up, down, right or left to specify where you want the second corner relative to the first corner and then press <Enter> or press the left mouse button.

Options: Chamfer, Fillet, and Width

The following options are only available before you place the first corner of the rectangle.

Note: Sizes shown in brackets [...] are for metric users. Enter the numbers without the brackets. **Example:** [12.7] just enter 12.7

Chamfer

A chamfer is an angled corner. The Chamfer option automatically draws all 4 corners with chamfers simultaneously and all the same size. You must specify the distance for each side of the corner as distance 1 and distance 2.

Example: Rectangle with Dist1 = 0.50" [12.7 mm] and Dist2 = 0.25" [6.35 mm].

- 1. Select the Rectangle command.
- 2. Type C < Enter > (or click on the blue letter "C").
- 3. Enter 0.50 [12.7] for the first distance.
- 4. Enter 0.25 [6.35] for the second distance.
- 5. Place the first corner (P1).
- 6. Place the diagonal corner (P2).

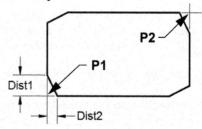

Fillet

A fillet is a rounded corner. The Fillet option automatically draws all 4 corners with fillets (all the same size). You must specify the radius for the rounded corners.

Example: Rectangle with 0.50" [12.7 mm] radius corners.

- Select the Rectangle command.
- 2. Type F <Enter> (or click on the blue letter "F").
- 3. Enter 0.50 [12.7] for the radius.
- 4. Place the first corner (P1).
- 5. Place the diagonal corner (P2).

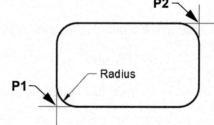

Note: You must set Chamfer and Fillet back to "0" before defining the width. Unless you want fat lines and Chamfered or Filleted corners.

Width

The Width option defines the width of the rectangle lines.

Note: Do not confuse this with the "Dimensions" option where you specify the Length and Width of a rectangle. Width makes the lines appear fatter.

Example: Rectangle with a line width of 0.50" [12.7 mm].

- 1. Select the Rectangle command.
- 2. Type W <Enter> (or click on the blue letter "W").
- 3. Enter 0.50 [12.7] for the width.
- Place the first corner (P1).
- 5. Place the diagonal corner (P2).

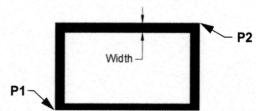

Options: Area and Rotation

Note: The following options are available after you place the first corner of the rectangle.

Area

Area creates a rectangle using the area and either a length or a width. If the Chamfer or Fillet option is active, the area includes the effect of the chamfers or fillets on the corners of the rectangle.

Example: Rectangle with an area of 6" [152.4 mm] and a length of 2" [50.8 mm].

- 1. Select the Rectangle command.
- 2. Place the first corner (P1).
- 3. Type A < Enter > (or click on the blue letter "A").
- 4. Enter 6 [152.4] < Enter > for the area.
- 5. Select *L* <*Enter*> for the length (or click the blue letter "L").
- 6. Enter 2 [50.8] < Enter > for the length.

(The width will be calculated automatically.)

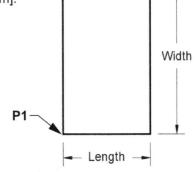

Rotation

You may select the desired rotation angle after you place the first corner and before you place the second corner. The basepoint (pivot point) is the first corner.

Note: All new rectangles within the drawing will also be rotated unless you reset the rotation to **0**. This option will not affect rectangles already in the drawing.

Example: Rectangle with a rotation angle of 45 degrees.

- 1. Select the Rectangle command.
- 2. Place the first corner (P1).
- 3. Type *R <Enter>* (or click on the blue letter "R").
- 4. Enter 45 < Enter >.
- 5. Place the diagonal corner (P2).

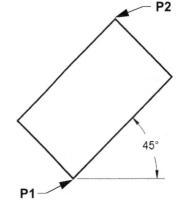

Grid and Increment Snap

Grid is the criss-cross lines in the drawing area. The grid is only a drawing aid to assist you in aligning objects and visualizing the distances between them. **The Grid will not plot**. (Refer to page 1-13.)

Increment Snap controls the movement of the cursor. If it is **off**, the cursor will move smoothly. If it is **on**, the cursor will jump in an **incremental** movement. (Refer to page 1-13.)

The **Drafting Settings** dialog box allows you to set **Increment Snap** and **Grid** spacing. You may change the Grid spacing and Increment Snap at anytime while creating a drawing. The settings are only drawing aids to help you visualize the size of the drawing and control the movement of the cursor.

1. Select **Drafting Settings** by using one of the following:

Keyboard = DS <Enter>

or

Status Bar = Right click on the Snap or Grid button and select Settings.

2. The dialog box shown below will appear showing inch or metric units depending on whether you selected an **inch** or **metric template**.

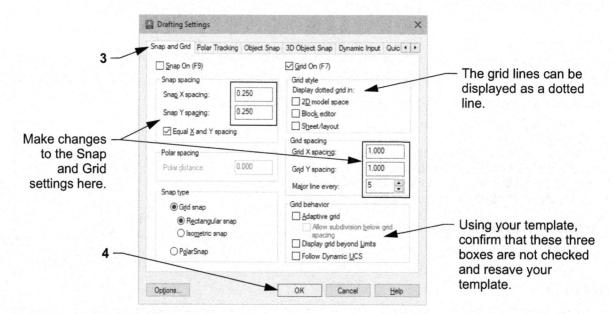

- 3. Select the "Snap and Grid" Tab.
- Make your changes and select the OK button to save them. If you select the Cancel button, your changes will not be saved.

Layers

A **Layer** is like a transparency. Have you ever used an overhead light projector? Remember those transparencies that are laid on top of the light projector? You could stack multiple sheets, but the projected image would have the appearance of one document. Layers are basically the same. Multiple layers can be used within one drawing.

The example, on the right, shows three layers. One for annotations (text), one for dimensions, and one for objects.

How to use Layers

First you select the layer and then you draw the objects. Always select the layer first and then draw the objects.

It is good "drawing management" to draw related objects on the same layer. For example, in an architectural drawing, you would select the "Walls" layer and then draw the floor plan.

Then you would select the "Electrical" layer and draw the electrical objects.

Then you would select the "Plumbing" layer and draw the plumbing objects.

Each layer can then be controlled independently. If a layer is **Frozen**, it is **not visible**. When you **Thaw** the layer, it becomes **visible** again. (Refer to the following pages for detailed instructions on controlling layers.)

How to select a Layer

- 1. Go to Ribbon = Home Tab / Layers Panel.
- 2. Select the drop-down arrow ▼.
- Highlight the desired layer and press the left mouse button.

The selected layer becomes the **current** layer. All objects will be located on this layer until you select a different layer.

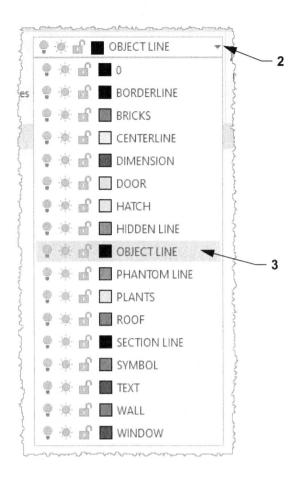

Controlling Layers

The following controls can be accessed using the Layer drop-down arrow ▼.

On or Off

If a layer is on, it is visible. If a layer is off, it is not visible. Only layers that are on can be edited or plotted.

Freeze or Thaw

Freeze and Thaw are very similar to **on** and **off**. A Frozen layer is **not visible** and a Thawed layer **is visible**. Only Thawed layers can be edited or plotted.

Additionally:

- A. Objects on a Frozen layer **cannot** be accidentally erased.
- B. When working with large and complex drawings, freezing saves time because Frozen layers are not **regenerated** when you zoom in and out.

Lock or Unlock

Locked layers are visible but cannot be edited. They are visible so they will be plotted.

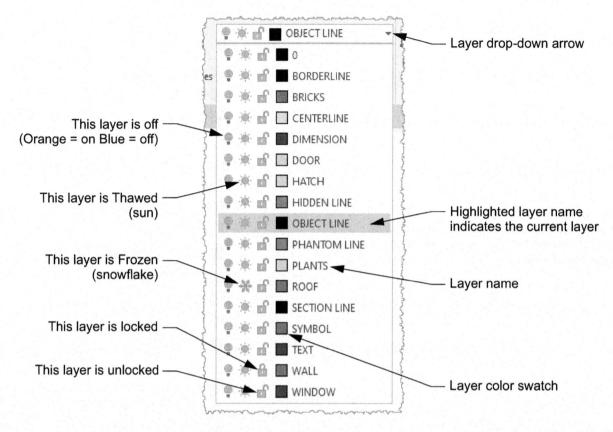

To access the following options you must use the **Layer Properties Manager**. You may also access the options listed on the previous page within this dialog box.

To open the Layer Properties Manager use one of the following.

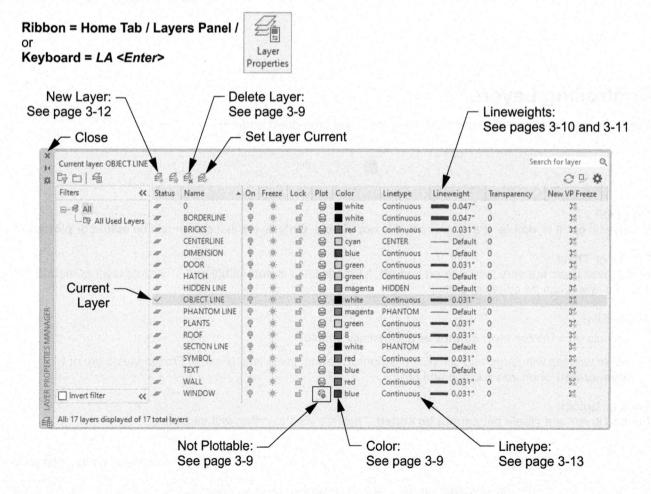

How to delete an existing layer

- 1. Highlight the layer name to be deleted.
- Select the **Delete Layer** tool.
- 1. Highlight the layer name to be deleted.
- 2. Right click and select Delete Layer.

Plot or Not Plottable

This tool prevents a layer from plotting even though it is visible within the Drawing Area. A **Not Plottable** layer will not be displayed when using **Plot Preview**. If the Plot tool has a slash, the layer will not plot.

Layer Color

Color is not merely to make a pretty display on the screen. Layer colors can help define objects. For example, you may assign green for all doors. Then, at a glance, you could identify the door and the layer by its color.

Here are some additional things to consider when selecting the colors for your layers.

Consider how the colors will appear on the paper. (Pastels do not display well on white paper.)

Consider how the colors will appear on the screen. (Yellow appears well on a black background but not on white.)

How to change the color of a layer

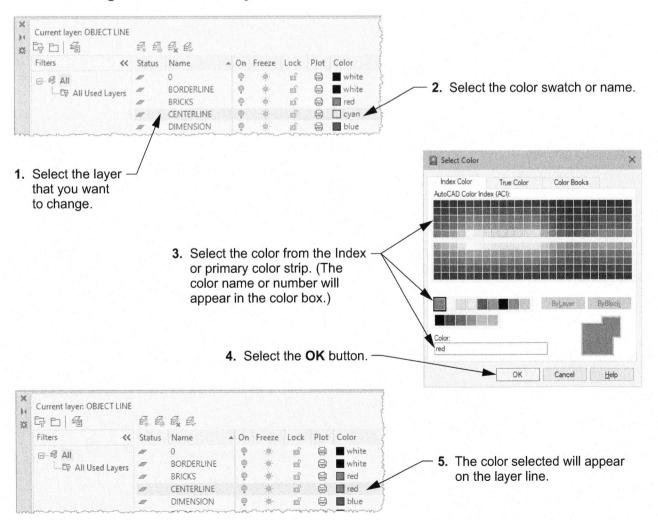

Lineweights

Lineweight refers to "how heavy or thin is the object line".

It is "good drawing management" to establish a contrast in the lineweights of entities.

In the example below, the rectangle has a heavier lineweight than the dimensions. The contrast in lineweights makes it easier to distinguish between entities.

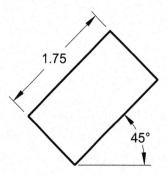

Lineweight Settings

Lineweights are plotted with the exact width of the lineweight assigned. But you may adjust how they are **displayed on the screen**. (Refer to Step 4 below.)

Important: Before assigning lineweights you should first select the **Units for Listing** and **Adjust Display Scale** as shown below.

1. Select the Lineweight Settings box using one of the following:

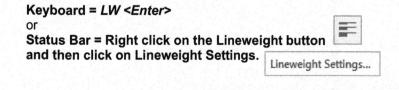

Note: These settings will be saved to the computer not the drawing, and will remain until you change them. You may have to shut down AutoCAD and then restart the program for the changes to take effect.

Assigning Lineweights

Note: Before assigning Lineweights to layers, make sure your Lineweight settings (Units for Listing and Adjust Display Scale) are correct. (See above.)

Assigning Lineweights to Layers

1. Select the Layer Properties Manager using one of the following:

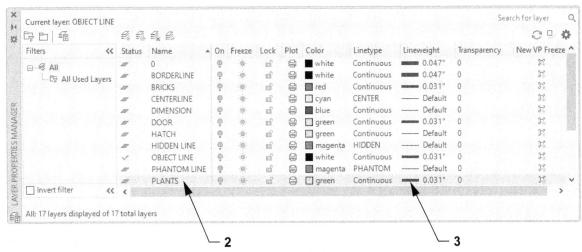

- 2. Highlight a layer (click on the name).
- Click on the Lineweight for that layer.
- Scroll and select a Lineweight from the list.
- 5. Select the **OK** button.

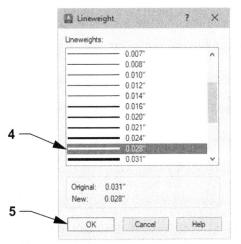

Note: Lineweight selections will be saved within the current drawing and will not affect any other drawing. The images above show lineweight sizes for the inch-helper.dwt. Metric sizes will appear if you are using the metrichelper.dwt.

Transparency

Each layer may be assigned a transparency percentage from 0 to 90 percent. 0 would not be transparent at all and **90** would be **90** percent transparent.

Layer

Assigning Transparency to Layers

1. Select the Layer Properties Manager using one of the following:

Ribbon = Home Tab / Layers Panel / Keyboard = LA <Enter> Properties

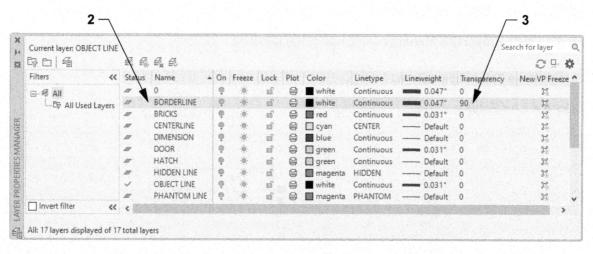

- 2. Highlight a layer (click on the name).
- 3. Click on Transparency for that layer.
- 4. Select a Transparency value from the list.
- 5. Select the OK button.

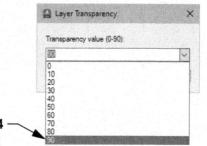

Controlling Transparent display

You may toggle the display of Transparent objects on or off by selecting the Transparency button on the Status Bar.

Note: Transparency selections will be saved within the current drawing and will not affect any other drawing.

Plotting Transparent Objects

Plotting transparency is disabled by default. To plot transparent objects, check the Plot transparency option in either the Plot dialog box or the Page Setup dialog box. This will be discussed in Lesson 26.

Creating New Layers

Using layers is an important part of managing and controlling your drawing. It is better to have too many layers than too few. You should draw like objects on the same layer. For example, place all doors on the "door" layer or Centerlines on the "Centerline" layer.

When you create a new layer, you will assign a name, color, linetype, lineweight, transparency and whether or not it should plot.

1. Select the Layer Properties Manager using one of the following:

Ribbon = Home Tab / Layers Panel / or Keyboard = LA <Enter>

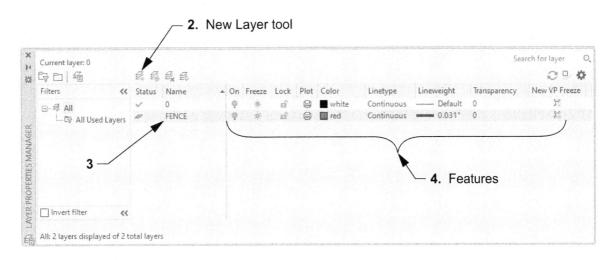

- Select the New Layer tool and a new layer will appear.
- 3. Type the new layer name and press **<Enter>**.
- 4. Select any of the features and a dialog box will appear.

Features:

Refer to the previous pages for controlling and selecting layer colors, lineweights, and transparency.

Loading and Selecting Layer Linetypes

In an effort to conserve data within a drawing file, AutoCAD automatically loads only one linetype called "continuous". If you would like to use other linetypes, such as "DASHED" or "FENCELINE1", you must Load them into the drawing as follows:

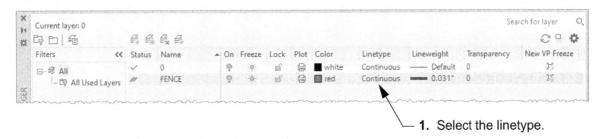

2. Select the Load... button.

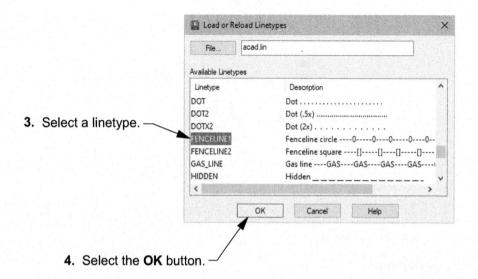

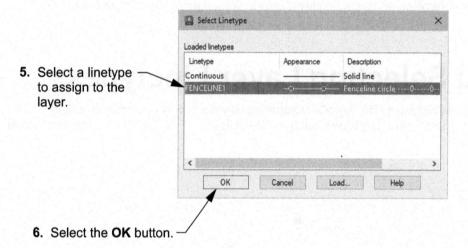

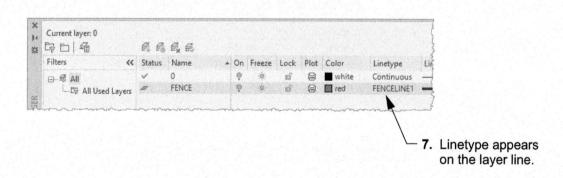

Exercise 3A

Instructions:

- Start a New file using either the inch-helper.dwt or the metric-helper.dwt
- 2. Draw the Lines using:
 - A. Line command.
 - B. Ortho <F8> on.
 - C. Turn Increment Snap <F9> on.

(Do not enter the text. You will learn text soon.)

- 3. Select the appropriate layer, then select the Line command, then draw a line.
- 4. Select the appropriate layer, then select the Line command, then draw a line.
- 5. Select the appropriate layer, then select the Line command, then draw a line.

Are you noticing a pattern here?

6. Save the drawing as: Ex-3A

BORDERLINE	
CENTERLINE	
DIMENSION	
DOOR	
HATCH	
HIDDEN LINE	
OBJECT LINE	
PHANTOM LINE	
PLANTS	
ROOF	
SECTION LINE	
TEXT	
WALL	
WINDOW	

Exercise 3B

Instructions:

- Start a New file using either the inch-helper.dwt or the metric-helper.dwt
- Change the Increment Snap to 0.20" [5.08 mm] and Grid spacing to 0.40" [10.16 mm]. If you have the Snap and Grids set correctly, it will be easy.
- Make sure Snap and Grid Status Bar buttons are on.
- Draw the objects using Layer Object Line.
 Review pages 3-2 through 3-5 for Circle and Rectangle options.
- 5. **Do not dimension** (you will learn dimensioning soon).
- 6. Save the drawing as: Ex-3B

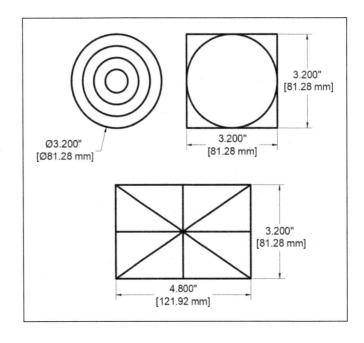

Exercise 3C

Instructions:

- 1. Start a New file using either the inch-helper.dwt or the metric-helper.dwt
- 2. Draw the Rectangles below using the options:

Dimension, Chamfer, Fillet, Width, and Rotation

- 3. Use Layer Object Line.
- 4. Save the drawing as: Ex-3C

Rectangle Dimensions:

Length = 3" [76.2 mm] Width = 2" [50.8 mm] Chamfer = Dist1 = 0.50" [12.7 mm] Dist2 = 0.50" [12.7 mm]

Rectangle Dimensions:

Length = 3" [76.2 mm] Width = 2" [50.8 mm] Fillet = 0.50" [12.7 mm]

Rectangle Dimensions:

Length = 3" [76.2 mm] Width = 2" [50.8 mm] Rotation = 45° Chamfer = 0 Fillet = 0

Rectangle Dimensions:

Length = 3" [76.2 mm] Width = 2" [50.8 mm] Line Width = 0.200" [5.08 mm] Rotation = 0° Chamfer = 0 Fillet = 0

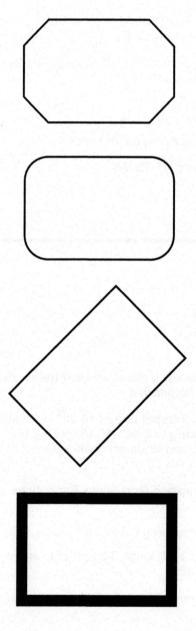

Exercise 3D

Instructions:

- Start a New file using either the inch-helper.dwt or the metric-helper.dwt
- 2. Important: Draw the objects using the following layers:

Roof, Wall, Window, Door, and Plants.

- 3. You can change Snap and Grid settings to whatever you like.
- You decide when to turn Ortho and Snap on or off.
- 5. All objects must be placed accurately. All lines must intersect exactly.
- 6. Save the drawing as: Ex-3D

Exercise 3E

Instructions:

- 1. Open **Ex-3D**. (Use **Open** not **New** to open an existing drawing.)
- 2. Make Layer Object Line current.

(I am having you do that because you can't Freeze or Lock a layer that is current and I want to make sure that none of the layers that you used in the drawing are current.)

- 3. **Freeze** the following layers: **Window** and **Plants** (Do not use erase).
- 4. Lock Layer Roof.
- 5. Try to erase any of the roof lines.

You can't because the Roof layer is **Locked**.

6. Save the drawing as: Ex-3E

Exercise 3F

Instructions:

- 1. Start a new file using template: acad.dwt (inch) or acadiso.dwt (metric).
- 2. Load linetypes ZIGZAG, GAS_LINE, and DASHED. (Refer to page 3-13.)

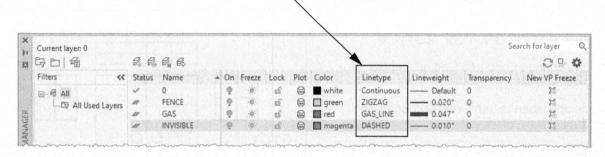

3. Create 3 layers named Fence, Gas, and Invisible. (Refer to page 3-12.)

Assign the name, color, linetype, and lineweight as shown above.

Note: Lineweights for metric users are: ZIGZAG = 0.5 mm, GAS_LINE = 1.2 mm, DASHED = 0.25 mm.

- 4. Draw the Lines below using the new layers:
 - A. Select the layer.
 - B. Select the Line command.
 - C. Draw the lines approximately 5 inches [127 mm] long.
 - D. Ortho <F8> on.

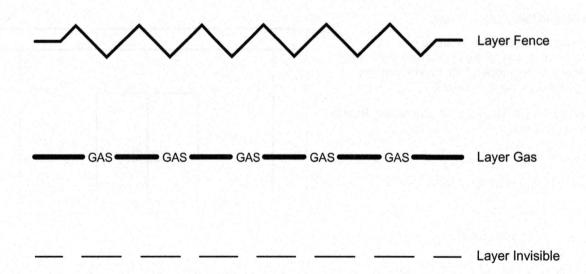

LESSON 4

LEARNING OBJECTIVES

After completing this lesson, you will be able to:

- 1. Understand Object Snap.
- 2. Use Running Object Snap.
- 3. Use the Zoom options to view the Drawing.
- 4. Change the Drawing Limits.
- 5. Select the Units of Measurement and Precision.

Object Snap

In Lesson 3, you learned about **Increment Snap**. Increment Snap enables the cursor to move in an incremental movement. So you could say your cursor is "snapping to increments" preset by you.

Now you will learn about **Object Snap**. If Increment Snap snaps to increments, what do you think Object Snap snaps to? That's right: "objects". Object Snap enables you to snap to objects in very specific and accurate locations on the objects. For example, the endpoint of a line or the center of a circle.

How to select from the Object Snap Menu

- You must select a command, such as Line, before you can select Object Snap.
- While holding down the **Shift>** key, press the right mouse button. The menu shown at right should appear.
- 3. Highlight and press the left mouse button to select an Object Snap.

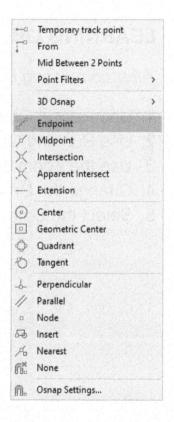

The following Object Snaps will be discussed in this Lesson:

Endpoint, Midpoint, Intersection, Center, Geometric Center, Quadrant, Tangent, and Perpendicular. The remaining Object Snaps will be discussed in future lessons.

Object Snap Definitions

Object Snap is used when AutoCAD prompts you to place an object. Object Snap allows you to place objects very accurately. A step-by-step example of "**How to use Object Snap**" is shown on the next page.

Snaps to the closest endpoint of a line, arc, or polygon segment. Place the cursor on the object close to the end and the cursor will snap like a magnet to the end of the line.

Snaps to the middle of a line, arc, or polygon segment. Place the cursor anywhere on the object and the cursor will snap like a magnet to the midpoint of the line.

Snaps to the intersections of any two objects. Place the cursor directly on top of the intersection or select one object and then the other and AutoCAD will locate the intersection.

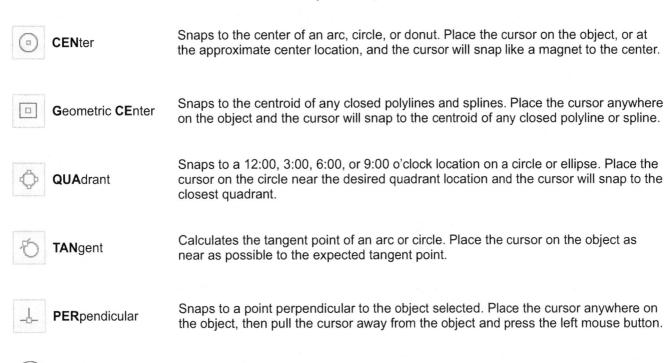

The following is an example of attaching a line segment to previously drawn vertical lines. The new line will go from the upper endpoint, to the midpoint, to the lower endpoint.

1. Turn off SnapMode, OrthoMode, and Object Snap on the Status Bar. (Gray is off.)

You may also type the 3 bold letters shown rather than selecting from the menu.

For example, type in *CEN* and then press *Enter* for the Center Snap.

- 2. Select the Line command.
- 3. Draw two vertical lines as shown below (they don't have to be perfectly straight).

- 4. Select the **Line** command again.
- 5. Hold the **<Shift>** key down and press the right mouse button.

6. Select the Object Snap Endpoint from the Object Snap Menu.

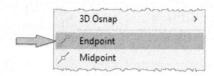

7. Place the cursor close to the upper endpoint of the left-hand line.

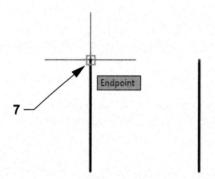

The cursor should snap to the end of the line like a magnet. A little square and an "Endpoint" tooltip will be displayed.

- 8. Press the left mouse button to attach the new line to the upper endpoint of the previously drawn vertical line. (Do not end the Line command yet.)
- Now hold the <Shift> key down and press the right mouse button and select the Midpoint Object Snap option.

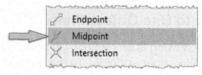

10. Move the cursor to approximately the middle of the right-hand vertical line.

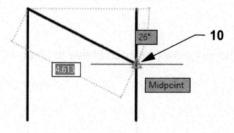

The cursor should snap to the midpoint of the line like a magnet. A little triangle with a "Midpoint" tooltip will be displayed.

- 11. Press the left mouse button to **attach** the new line to the midpoint of the previously drawn vertical line. (Do not end the Line command yet.)
- 12. Now hold the **<Shift>** key down and press the right mouse button and select the Object Snap **Endpoint** again.
- 13. Move the cursor close to the lower endpoint of the left-hand vertical line.

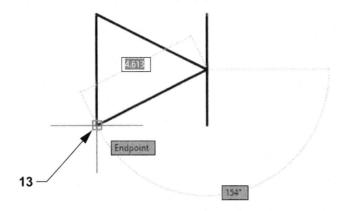

The cursor should snap to the end of the line like a magnet. A little square and a "**Endpoint**" tooltip will be displayed.

- 14. Press the left mouse button to attach the new line to the endpoint of the previously drawn vertical line.
- 15. Stop the Line command and disconnect by pressing < Enter>.

Running Object Snap

Selecting Object Snap is not difficult, but AutoCAD has provided you with an additional method to increase your efficiency by allowing you to preset frequently used Object Snap options. This method is called **Running Object Snap**.

When **Running Object Snap** is active, the cursor will automatically snap to any preset Object Snap locations thus eliminating the necessity of invoking the Object Snap Menu for each locations.

First, you must set the running Object Snaps, and second, you must turn on the Running Object Snap option.

Setting Running Object Snap

1. Select the Running Object Snap dialog box using one of the following:

- 2. Select the Object Snap Tab.
- 3. Select the Object Snaps desired.

(In the example on the next page, Object Snap Endpoint, Midpoint, and Intersection have been selected.)

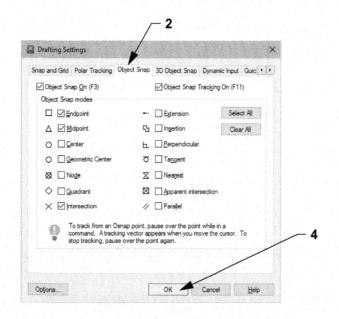

Note:

Try not to select more than three or four Object Snaps at one time.

If you select too many, the cursor will flit around trying to snap to multiple snap locations. And possibly snap to the wrong location.

You will lose control and it will confuse you.

- 4. Select the OK button.
- 5. Turn on the Object Snap button on the Status Bar. (Blue is on.)

6. Now try drawing the line from the endpoint to the midpoint again, **but this time do not select the "Object Snap Menu**". Just move the cursor close to the endpoint and the cursor will automatically snap to the end of the line.

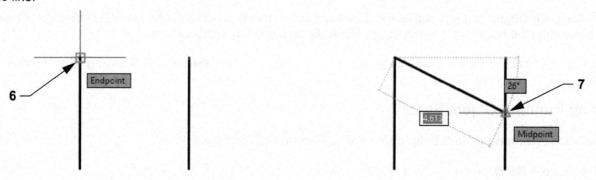

- 7. Move the cursor to approximately the middle of the right-hand vertical line and the cursor will automatically snap to the midpoint of the line.
- 8. Move the cursor close to the lower endpoint of the left-hand vertical line and the cursor will automatically snap to the lower endpoint of the left line.

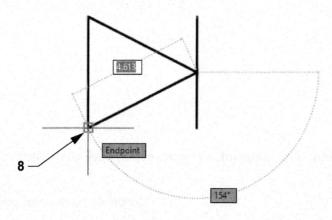

Running Object Snap is very handy. But remember not to select more than three or four at a time. The selections will fight each other, and you may end up snapping to a location that you did not want.

If you want to snap to a location that is not preset, just select the Object Snap Menu, as shown on page 4-2, and select the one you want. Running Object Snap and Object Snap work together very well, but it may take a little practice.

Zoom 4-7

Zoom

The **Zoom** command is used to move closer to or farther away from an object. This is called Zooming In and Out.

The Zoom commands are located on the **Navigate** Panel of the **View** Tab and are **off** by default. Select the **View** Tab, then right click on any Panel, select **Show Panels**, and activate the **Navigate** Panel. (To Show Panels, refer to page 1-11.)

1. Select the **Zoom** command by using the following:

Ribbon = View Tab / Navigate Panel

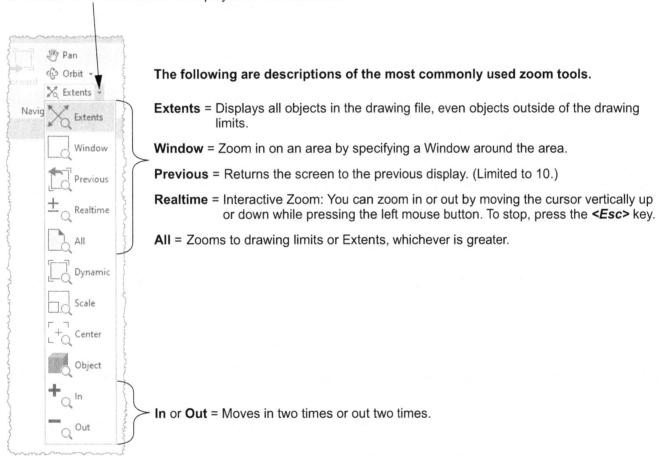

You may also select the **Zoom** commands using one of the following:

Right click and select Zoom from the Shortcut Menu. (Refer to page Intro-4 for right click settings.)

Keyboard = *Z* **<***Enter***>.** Select from the options listed.

How to use Zoom / Window

- 1. Select Zoom / Window.
- 2. Create a Window around the objects you want to enlarge. (Creating a Window is a similar process to drawing a rectangle. It requires a first corner and then a diagonal corner.)

4-8 Zoom

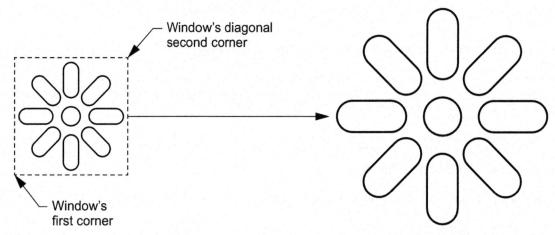

Magnified to this view

Note: The objects have been magnified, but the actual size has not changed.

How to return to Original View

Type Z <Enter> A <Enter> (this is a shortcut for Zoom / All).

Drawing Setup

When drawing with a computer, you must "set up your drawing area" just as you would on your drawing board if you were drawing with pencil and paper. You must decide what size paper you will need, what Units of measurement you will use (feet and inches or decimals, etc.) and how precise you need to be. In AutoCAD these decisions are called "Setting the Drawing Limits, Units, and Precision".

Drawing Limits

Consider the drawing limits as the **size of the paper** you will be drawing on. You will first be asked to define where the lower left corner should be placed, then the upper right corner, similar to drawing a rectangle. An 11" x 8.5" or 297 mm x 210 mm piece of paper would have a **lower left corner** of **0,0** and an **upper right corner** of **11, 8.5**, or 297, 210. (11 or 297 is the horizontal measurement X axis, and 8.5 or 210 is the vertical measurement Y axis.)

How to Set the Drawing Limits

Example:

1. Start a New drawing using either the inch-helper.dwt or the metric-helper.dwt. (Refer to page 2-5.)

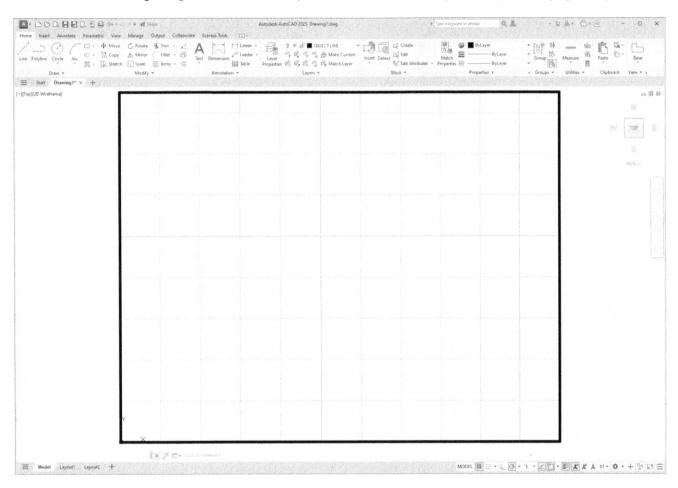

- 2. Select the Drawing Limits command by typing Limits and then press < Enter>.
- 3. The following prompt will appear:

- 4. Type the X,Y coordinates **0,0 <Enter>** for the new lower left corner location of your piece of paper. Make sure you separate the two figures with a comma.
- 5. The following prompt will appear:

6. Type the X,Y coordinates 36,24 < Enter> if you are using the inch template, or 914.4,609.6 < Enter> if you are using the metric template, for the new upper right corner of your piece of paper. Make sure you separate the two figures with a comma.

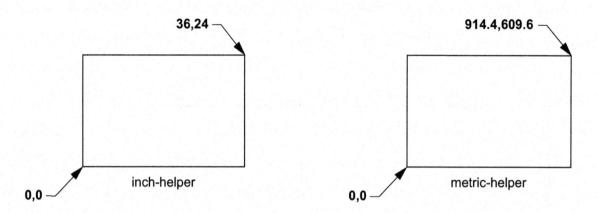

Note: Visually the screen has not changed. Do the next step and it will.

7. This next step is very important:

Type **Z <Enter>** A **<Enter>** to make the screen display the new drawing limits. (This is the shortcut for **Zoom / All**. Refer to page 4-8.)

The drawing limits (area) are now 36" or 914.4 mm wide X 24" or 609.6 mm high. The rectangle did not change size or location, but the drawing area around it got larger so the rectangle appears to have moved and gotten smaller. Think about it.

Display Grid within Limits

If the Grid behavior setting is \square **Display grid beyond Limits** (no check mark), it is turned **off** and the grid will only be displayed within the Limits that you set.

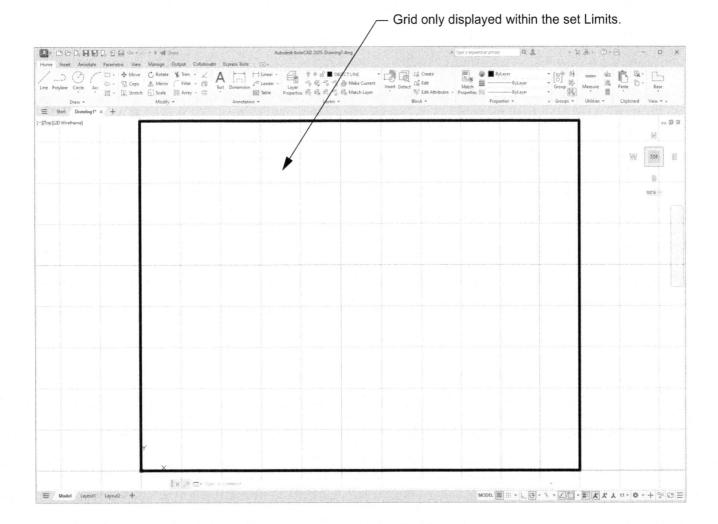

Display Grid beyond Limits

If the Grid behavior setting is **Display grid beyond Limits** (check mark), it is turned **on** and the grid will be displayed beyond the Limits that you set.

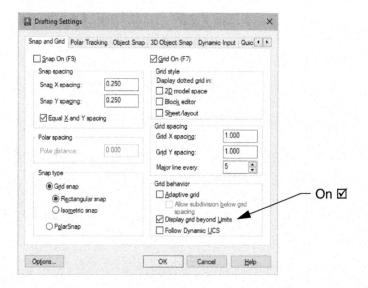

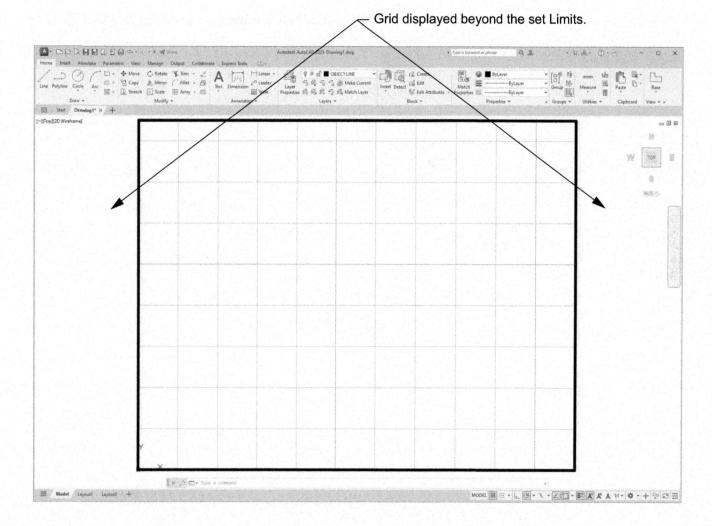

Units and Precision

You now need to select what unit of measurement with which you want to work. Such as: Decimal (0.000) or Architectural (0'-0"). Next you should select how precise you want the measurements. For example, do you want the measurement limited to a 3-place decimal or the nearest 1/8".

How to Set the Units and Precision

1. Select the **Units** command using one of the following:

Application Menu = Drawing Utilities / Units or Keyboard = *Units <Enter>*

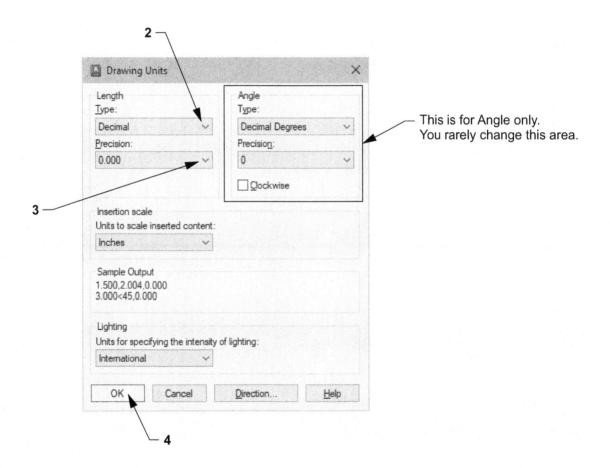

- 2. Type: Select the down arrow and select: Decimal or Architectural.
- 3. **Precision:** Select the down arrow and select the appropriate **Precision** associated with the "type". Examples: 0.000 for Decimals or 1/16" for Architectural.
- 4. Select the **OK** button to save your selections.

Easy, yes?

Exercise 4A

Instructions:

- Start a New file using either the inch-helper.dwt or the metric-helper.dwt
- 2. Set Units and Precision:

Units = Fractional for inch users or **Decimal** for metric users.

Precision = 1/2" for inch users or 0 for metric users.

3. Set Drawing Limits:

Lower Left corner = 0,0 Upper Right Corner = 20,15 [508,381 metric users].

- Make sure you use **Zoom / All** after setting Drawing Limits.
- Erase the rectangle that appears with the template. It will appear too small.
- 6. Turn **off** the **Snap** and **Ortho**. (Your cursor should move freely.)
- Draw the objects shown using:
 Circle, Center Radius, and Line (Use Layer = Object Line) Object Snap = Center and Tangent
- 8. Save the drawing as: Ex-4A

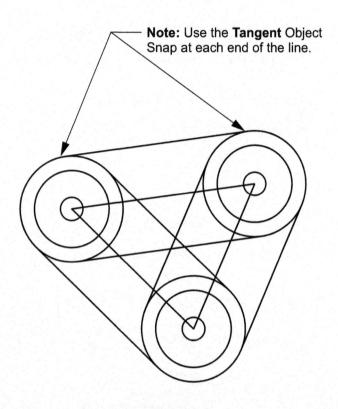

Exercise 4B

Instructions:

- Start a New file using either the inch-helper.dwt or the metric-helper.dwt
- 2. Set Units and Precision:

Units = Fractional for inch users or **Decimal** for metric users.

Precision = 1/4" for inch users or 0 for metric users.

3. Set Drawing Limits:

Lower Left corner = 0,0 Upper Right Corner = 12,9 [304.8,228.6 metric users].

- Make sure you use Zoom / All after setting Drawing Limits
- 5. Turn **off** the **Snap** and **Ortho**. (Your cursor should move freely.)
- Draw the objects shown using:
 Circle, Center Radius (Use Layer = Object Line)
 Line (Use Layer = Hidden Line)
 Object Snap = Quadrant
- 7. Save the drawing as: Ex-4B

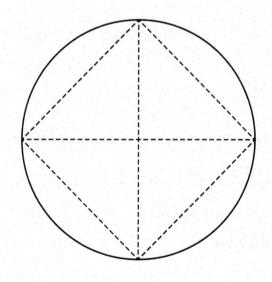

Exercise 4C

Instructions:

- Start a New file using either the inch-helper.dwt or the metric-helper.dwt
- 2. Set Units and Precision:

Units = Architectural for inch users or **Decimal** for metric users.

Precision = 1/2" for inch users or 0 for metric users.

3. Set Drawing Limits:

Lower Left corner = **0,0** Upper Right Corner = **25,20** [**635,508** metric users].

- 4. Make sure you use **Zoom / All** after setting Drawing Limits.
- 5. Erase the rectangle that appears with the template.
- 6. Turn off the Snap and Ortho.
- Draw the objects showne using: Line (Use Layer = Object Line)
 Object Snap = Perpendicular
- 8. Save the drawing as: Ex-4C

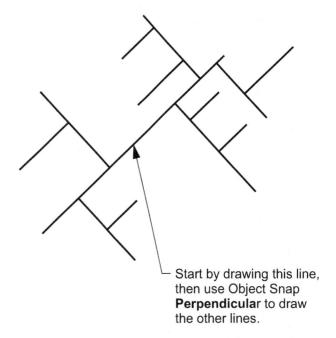

Exercise 4D

Instructions:

- Start a New file using either the inch-helper.dwt or the metric-helper.dwt
- 2. Set Units and Precision:

Units = Decimal

Precision = 0.00

3. Set Drawing Limits:

Lower Left corner = 0,0 Upper Right Corner = 12,9 [304.8,228.6 metric users].

- Make sure you use **Zoom / All** after setting Drawing Limits.
- 5. Turn off the Snap and Ortho.
- Draw the objects showne using:
 Line (Use Layer = Object Line)
 Object Snap = Midpoint
- 7. Save the drawing as: Ex-4D

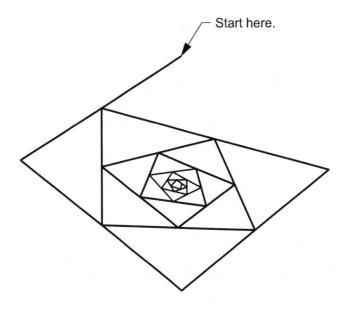

Exercise 4E

Instructions:

- Start a New file using either the inch-helper.dwt or the metric-helper.dwt
- 2. Turn off the Snap and Ortho.
- Draw the objects shown using:
 Line (Use Layer = Object Line)
 Object Snap = Intersection
- 4. Save the drawing as: Ex-4E

Exercise 4F

Instructions:

- Start a New file using either the inch-helper.dwt or the metric-helper.dwt
- 2. Turn off the Snap and Ortho.
- Draw the 2 circles on Layer Object Line with the following radii: 1.5" [38.1 mm] and 3.5" [88.9 mm] (Use Object Snap Center so both circles will have the same center.)
- 4. Draw the lines using Layers Object Line and Centerline
- 5. Use Object Snaps Quadrant and Tangent
- Save the drawing as: Ex-4F

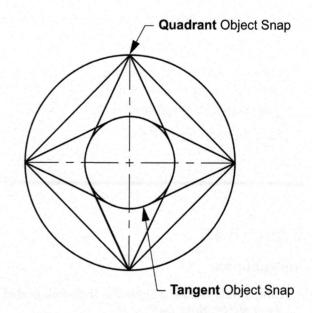

Exercise 4G

Instructions:

- Start a New file using either the inch-helper.dwt or the metric-helper.dwt
- 2. Turn off the Snap and Ortho.
- 3. Draw the rectangle on Layer Object Line with Length 6.5" [165.1 mm] and Width 4.5" [114.3 mm]
- Draw the circle using Layer Object Line with a radius of 1.5" [38.1 mm]
- 5. Draw the lines using Layer Centerline
- 6. Save the drawing as: Ex-4G

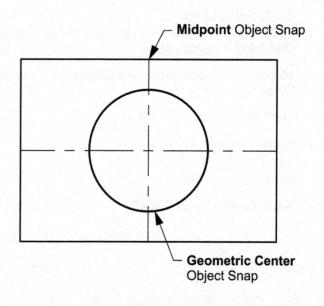

LESSON 5

LEARNING OBJECTIVES

After completing this lesson, you will be able to:

- 1. Draw an Inscribed or Circumscribed Polygon.
- 2. Create an Ellipse using two different methods.
- 3. Define an Elliptical Arc.
- 4. Create Donuts.
- 5. Define a Location with a Point.
- 6. Select various Point Styles.
- 7. Use 3 new Object Snap modes.

Polygon

A polygon is an object with multiple edges (flat sides) of equal length. You may specify from 3 to 1024 sides. A polygon appears to be multiple lines, but in fact it is one object. You can specify the **center** and a **radius** or the **edge length**. The **radius** size can be specified **Inscribed** or **Circumscribed**.

Center, Radius method

1. Select the **Polygon** command using one of the following:

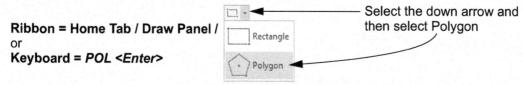

The following prompt will appear on the Command Line:

2. Type the number of sides and then press **<Enter>**.

The following prompt will appear on the Command Line:

3. Specify the center location (P1).

The following prompt will appear on the Command Line:

4. Type I or C and then press < Enter>.

The following prompt will appear on the Command Line:

```
|| × / Polygon Specify radius of circle:
```

5. Type the radius or locate with the cursor (P2).

Note:

The dashed circle is shown only as a reference to help you visualize the difference between Inscribed and Circumscribed. Notice that the radius is the same (2") [50.8 mm], but the polygons are different sizes. Selecting Inscribed or Circumscribed is important.

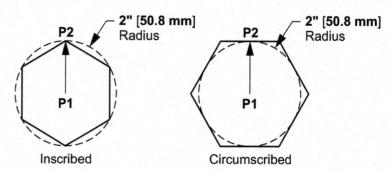

Edge method

1. Select the Polygon command using one of the options shown above:

The following prompt will appear on the Command Line:

2. Type the number of sides and then press < Enter>.

The following prompt will appear on the Command Line:

|| × / □ · POLYGON Specify center of polygon or [Edge]:

3. Type *E* and then press <*Enter*>.

The following prompt will appear on the Command Line:

★ POLYGON Specify first endpoint of edge:
 ★

4. Place the first endpoint of edge (P1).

The following prompt will appear on the Command Line:

|| × / D · POLYGON Specify first endpoint of edge: Specify second endpoint of edge:

5. Place the second endpoint of edge (P2).

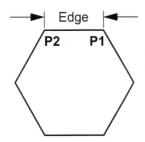

Ellipse

There are three methods to draw an ellipse. You may (1) specify 3 points of the axes, (2) define the center point and the axis points or (3) define an elliptical arc. The following 3 examples illustrate each of the methods.

Method 1: Axis, End

1. Select the Ellipse command using one of the following:

Ribbon = Home Tab / Draw Panel / or Keyboard = EL <Enter>

The following prompt will appear on the Command Line:

2. Place the first endpoint of either the major or minor axis (P1).

The following prompt will appear on the Command Line:

|| X / D · ▼ ELLIPSE Specify other endpoint of axis:

3. Place the other endpoint of the first axis (P2).

The following prompt will appear on the Command Line:

4. Place the point perpendicular to the first axis (P3).

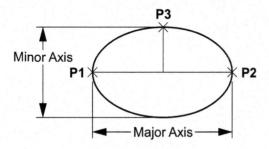

Specifying the Major Axis first (P1/P2), and then the Minor Axis (P3).

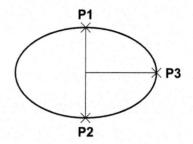

Specifying the Minor Axis first (P1/P2), and then the Major Axis (P3).

Method 2: Center

1. Select the Ellipse command using one of the following:

Ribbon = Home Tab / Draw Panel / or Keyboard = *EL* <*Enter*>

The following prompt will appear on the Command Line:

2. Place the center of the ellipse (P1).

The following prompt will appear on the Command Line:

× / ○ ▼ ELLIPSE Specify endpoint of axis:

3. Place the first axis endpoint (either axis) (P2).

The following prompt will appear on the Command Line:

4. Place the point perpendicular to the first axis (P3).

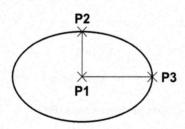

Method 3: Elliptical Arc

1. Select the Ellipse command using one of the following:

Ribbon = Home Tab / Draw Panel / or Keyboard = EL <Enter>

The following prompt will appear on the Command Line:

2. Type in C and then press < Enter>.

The following prompt will appear on the Command Line:

3. Place the center of the elliptical arc (P1).

The following prompt will appear on the Command Line:

X / ○ ▼ ELLIPSE Specify endpoint of axis:

4. Place endpoint of the first axis (P2).

The following prompt will appear on the Command Line:

5. Place the endpoint perpendicular to the first axis (P3).

The following prompt will appear on the Command Line:

6. Place the start angle (P4).

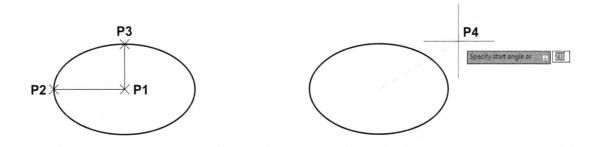

The following prompt will appear on the Command Line:

```
X / ○ ▼ ELLIPSE Specify end angle or [Parameter Included angle]:
```

7. Place the end angle (P5).

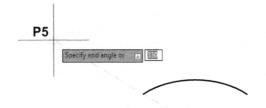

5-6 Donut

Donut

A Donut is a circle with width. You will define the Inside and Outside diameters.

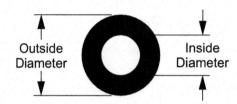

1. Select the **Donut** command using one of the following:

The following prompt will appear on the Command Line:

2. Type the inside diameter and then press < Enter>.

The following prompt will appear on the Command Line:

3. Type the outside diameter and then press < Enter>.

The following prompt will appear on the Command Line:

4. Place the center of the first donut.

The following prompt will appear on the Command Line:

5. Place the center of the second donut or press < Enter> to stop.

Note: AutoCAD will continue to create more donuts until you press < Enter> to stop the command.

Controlling the "Fill Mode"

- Command: Type Fill and then press <Enter>.
- 2. FILL Enter mode [ON OFF] <on>: Type on or off and then press <Enter>.
- 3. Type **Regen** and then press **<Enter>** to regenerate the drawing to show the latest setting of the **Fill** mode.

Point 5-7

Point

Points are used to locate a point of reference or location. A point may be represented by one of many Point Styles shown below in the Point Style box.

The only Object Snap option that can be used with Point is Node. (Refer to the next page for more information on Node Object Snap.)

How to Use the Point Command

1. Select the Point command using one of the following:

2. The following prompt will appear on the Command Line:

```
|| × / D ··· ▼ POINT Specify a point:
```

3. Place the point location.

The following prompt will appear on the Command Line:

```
|| × /³ ··· ▼ POINT Specify a point:
```

4. Place another point or press the **<Esc>** key to stop placing points.

How to Select a "Point Style"

1. Open the Point Style dialog box:

```
Ribbon = Home Tab / Utilities Panel ▼ / Point Style... or 
Keyboard = ddptype <Enter>
```

- 2. The Point Style dialog box will appear.
- 3. Select a Point Style tile.
- 4. Select the OK button.

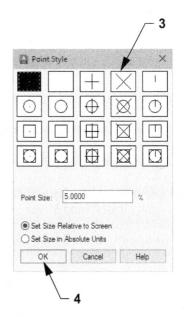

Point Size:

Set Size Relative to Screen

Sets the point display size as a percentage of the screen size. The point display does not change when you zoom in or out.

Set Size in Absolute Units

Sets the point display size as the actual units you specify under Point Size. Points are displayed larger or smaller when you zoom in or out.

More Object Snaps

This option snaps to the object "Point" described on the previous page. Select **Node** Object Snap and place the cursor on the **Point**. The cursor will snap to the **Point**.

Note: This is the only Object Snap that you can use with the object Point.

NEArest

Snaps to the nearest location on an object. For example, if you want to attach a line somewhere on a circle between quadrants:

Select the **Line** command and then select **Nearest** Object Snap. Place the cursor anywhere on the circumference of the circle and press the left mouse button. The line will now be accurately attached to the circle at the location you selected.

M₂P

Mid Between 2 Points

Locates a midpoint between two points.

You may select the **M2P** option from the Object Snap Menu using **<Shift> + right click**, or you may type **M2P <Enter>** when prompted for an endpoint.

How to use "M2P"

1. Select the Line command and draw 2 parallel lines.

- 2. Select the Line command again.
- 3. Type M2P and then press <Enter>. Or hold down the <Shift> key and right click, and select Mid Between 2 Points from the Object Snap Menu.
- 4. Using the Endpoint Object Snap, select each of the 2 endpoints (P1) and (P2).

5. The new line's first endpoint should start exactly midpoint between those 2 endpoints.

Exercise 5A

Instructions:

- Start a New file using either the inch-helper.dwt or the metric-helper.dwt
- 2. Draw the circle first using the **Center**, **Radius** option.
- Draw the Circumscribed polygon next using
 Object Snap Center to locate the center of the
 polygon at the center of the circle, and Quadrant
 Object Snap to locate the radius of the polygon on
 the circle.
- 4. Draw the lines last using Object Snaps **Midpoint** and **Endpoint**.
- 5. Ortho <F8> on.
- 6. Increment Snap <F9> off (it will get in your way).
- 7. Use Layer Object Line.
- 8. Save the drawing as: Ex-5A

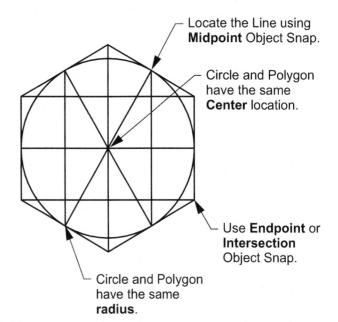

Exercise 5B

Instructions:

- Start a New file using either the inch-helper.dwt or the metric-helper.dwt
- 2. Select the Point Style shown.
- 3. Draw the Point first.
- 4. Draw the Inscribed polygons.
 - A. Locate the center of each polygon using Object Snap **Node**.
- 5. Ortho <F8> on.
- 6. Increment Snap <F9> off.
- 7. Use Layer Object Line.

Note: Place the polygon points with the cursor. If you type a radius, the polygon will automatically rotate and locate the flat at the bottom.

8. Save the drawing as: Ex-5B

Exercise 5C

Instructions:

- Start a New file using either the inch-helper.dwt or the metric-helper.dwt
- Draw the objects shown using Ellipse, Line, and Donut.
- Use Object Snaps Quadrant, Center, and Nearest.
- 4. Ortho <F8> on
- 5. Increment Snap <F9> off.
- 6. Use any layer you like.
- 7. Save the drawing as: Ex-5C

Note:

This is the **"eye"** of the tornado. (Just a little fun.)

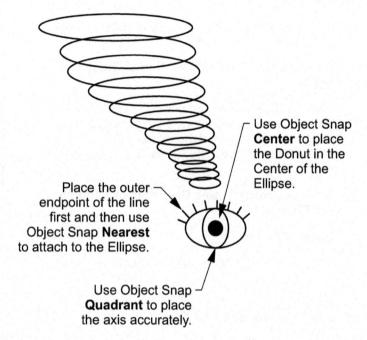

Exercise 5D

- Start a New file using either the inch-helper.dwt or the metric-helper.dwt
- 2. Select the Point Style shown.
- 3. Draw the Point first.
- 4. Draw the Ellipses.
 - A. Locate the center of each ellipse using Object Snap **Node**.
 - B. Locate the axis using Object Snap Quadrant.
- 5. Ortho <F8> on.
- 6. Increment Snap <F9> off.
- 7. Use Layer Object Line.
- 8. Save the drawing as: Ex-5D

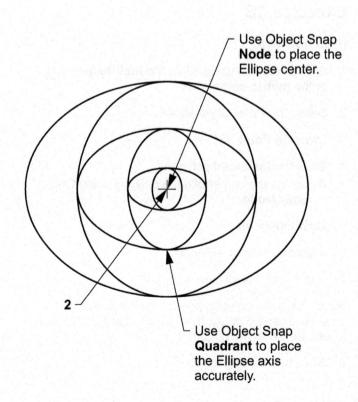

Exercise 5E

Instructions:

Step 1.

- 1. Start a New file using either the inch-helper.dwt or the metric-helper.dwt
- 2. Draw the 3 **Donuts** shown.
- 3. Use Object Snap Center to place the donut centers accurately.
- 4. Increment Snap <F9> off.
- 5. Use Layer Object Line.

Donut sizes

A. ID = 0

OD = 1" [25.4 mm]

B. ID = 1.5" [38.1 mm] OD = 2" [50.8 mm]

C. ID = 2.5" [63.5 mm] OD = 3.5" [88.9 mm]

Step 2.

- 6. Turn the Fill mode off.
- Type Regen <Enter>.
- 8. Save the drawing as: Ex-5E

Exercise 5F

- 1. Start a New file using either the inch-helper.dwt or the metric-helper.dwt
- 2. Draw the objects using Point, Polygon, Ellipse, and Donut.
- 5. Ortho <F8> on.
- 6. Increment Snap <F9> off.
- 7. Use whatever layers you like.
- 8. Save the drawing as: Ex-5F

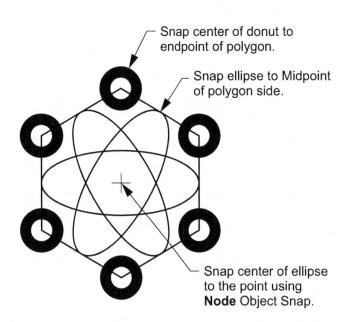

Exercise 5G

Instructions:

- Start a New file using either the inch-helper.dwt or the metric-helper.dwt
- 2. Draw the zig zag lines approximately as shown.
- 3. Set Running Object Snap to Endpoint.
- 4. Ortho <F8> on.
- 5. Increment Snap <F9> off.
- Draw the circles at the "Midpoint Between 2 Points" (P1 and P2).
- 7. Use Layer Object Line.
- 8. Save the drawing as: Ex-5G

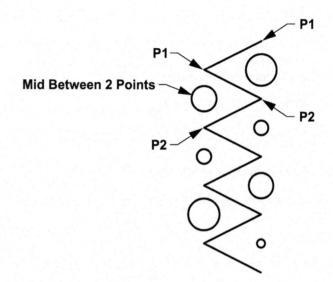

Exercise 5H

- Start a New file using either the inch-helper.dwt or the metric-helper.dwt
- 2. Draw the Rectangle on the left first. (Any size.)
- 3. Draw the Polygon next using the "Edge" option.
- 4. Draw the Ellipses.
 - A. Use Object Snap Endpoint to place the Edge points accurately.
- 5. Ortho <F8> on.
- 6. Use Layer Object Line.
- 7. Save the drawing as: Ex-5H

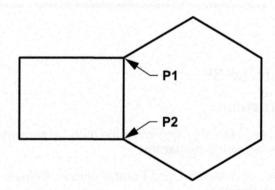

LESSON 6

LEARNING OBJECTIVES

After completing this lesson, you will be able to:

- 1. Use the Break Command.
- 2. Trim objects to other objects.
- 3. Extend objects to other objects.
- 4. Move an object to a new location.
- 5. Explode objects to their primitive entities.

6-2 Break

Break

The **Break** command allows you to break an object at a single point (Break at Point) or between two points (Break). I think of it as breaking a single line segment into two segments or taking a bite out of an object.

Method 1: Break at a Single Point

How to break one line into two seperate objects with no visible space in between.

1. Select the Break at Point command by using:

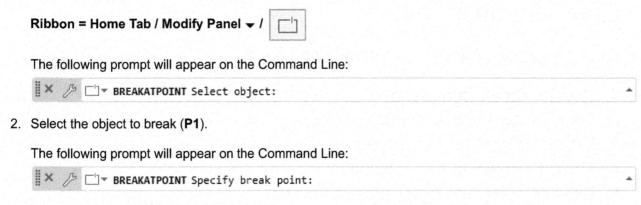

3. Select the break location (P2) accurately.

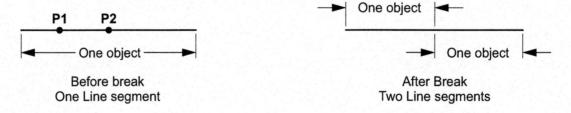

Note: The single line is now two lines, but there is no gap in between the two lines. For example, if you break a 2 inch long line at its center, it would become two 1 inch lines butted together.

Method 2: Break between two Points

Take a bite out of an object. Use this method if the location of the break is not important.

X BREAK Specify second break point or [First point]:

1. Select the Break command using one of the following:

3. Pick the second break location (P2).

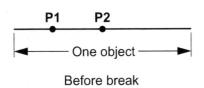

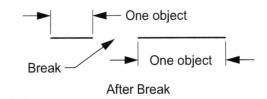

Note:

- A. Circles break counter-clockwise (ccw).
- B. Circles cannot be broken with one point. You must use two points.

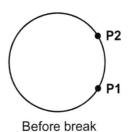

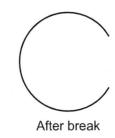

Method 3: Break between two Points

The following method is the same as Method 2 above; however, use this method if the location of the break is **very specific**.

Select the Break command.

The following prompt will appear on the Command Line:

2. Select the object to break (P1) anywhere on the object.

The following prompt will appear on the Command Line:

3. Type **F** and then press **<Enter>**.

The following prompt will appear on the Command Line:

```
■ ★ BREAK Specify first break point:
```

4. Select the first break location (P2) accurately.

The following prompt will appear on the Command Line:

5. Select the second break location (P3) accurately.

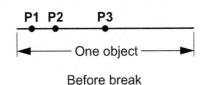

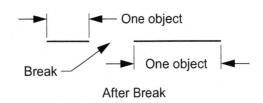

6-4

Trim

The **Trim** command is used to trim objects to other objects. You can **select objects individually**, or by using a **crossing fence** by picking two locations, or you can use **press and drag** to start a **freehand selection path**.

Method 1: Selecting objects to trim individually

1. Select the **Trim** command using one of the following:

The following prompt will appear on the Command Line:

2. Select the object that you want to trim (P1).

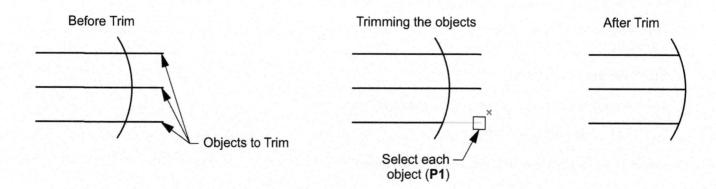

After you select your first object to Trim, a new Command Line will appear.

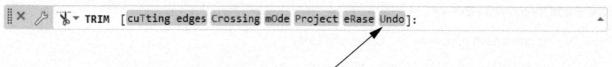

If you have trimmed an object by mistake, you can use the **Undo** command to "undo" the trimmed object and place it back to its original length before it was trimmed.

How to use the Undo command during Trim

- 1. Type *U* and then press <*Enter*>.
- 2. The last object you trimmed will reappear.

Trim 6-5

Method 2: Selecting objects to trim using a crossing fence

- 1. Select the Trim command.
- 2. Select the objects that you want to trim by selecting the first point at (P1), by left clicking and then releasing the mouse button.
- 3. Select a second point at (P2). Again, left click and release.

Note: You will see a dashed fence line when moving the cursor to (P2).

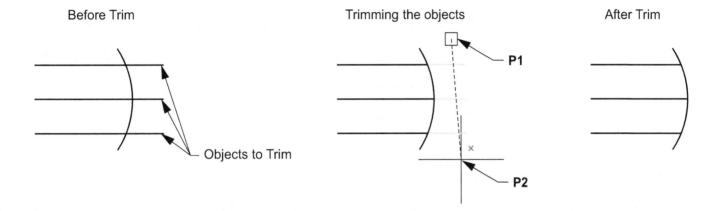

Method 3: Selecting objects to trim using a press and drag freehand path

1. Select the **Trim** command.

outer circles need to be trimmed.

- 2. Select the objects that you want to trim by selecting the first point at (P1), by left clicking and holding down the mouse button, but do not release it yet.
- 3. Drag the cursor around the area of the objects you wish to trim, to (P2), then release the left mouse button.

Note: You will see a dashed fence line when dragging the cursor around the objects. In the example below, you could drag the cursor clockwise or counter-clockwise, whichever way you prefer.

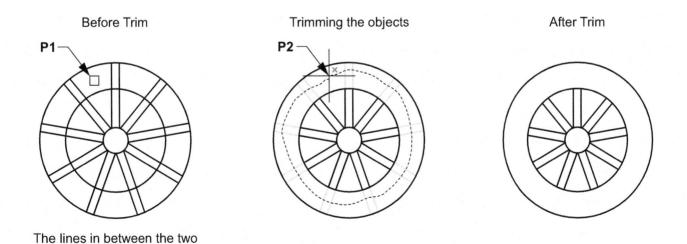

6-6 Extend

Extend

The **Extend** command is used to extend objects to other objects. You can **select objects individually**, or by using a **crossing fence** by picking two locations, or you can use **press and drag** to start a **freehand selection path**.

Method 1: Selecting objects to extend individually

1. Select the **Extend** command using one of the following:

The following prompt will appear on the Command Line:

2. Select near the end of the object that you want to extend (P1).

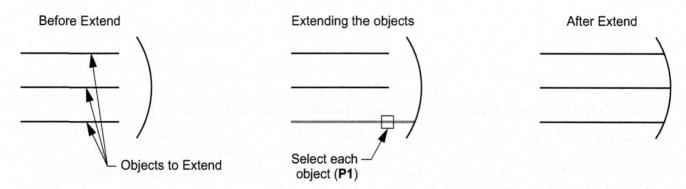

Note: Make sure you select the object near the end you want to extend. If you select the other end, AutoCAD will try to find another object to extend to.

Method 2: Selecting objects to extend using a crossing fence

- 1. Select the Extend command.
- 2. Select the objects that you want to extend by selecting the first point at (P1). by left clicking and then releasing the mouse button.
- 3. Select a second point at (P2). Again, left click and release.

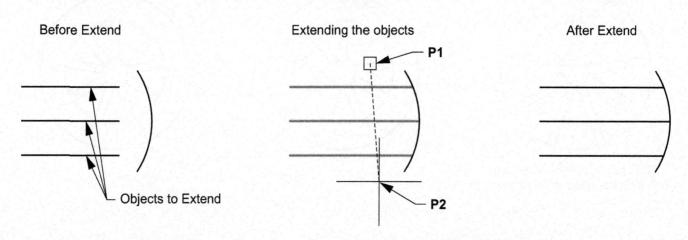

Extend 6-7

Method 3: Selecting objects to extend using a press and drag freehand path

- 1. Select the Extend command.
- 2. Select the objects that you want to extend by selecting the first point at (P1), by left clicking and **holding** down the mouse button, but do not release it yet.
- 3. Drag the cursor around the area of the objects you wish to extend, to (P2), then release the left mouse button.

Note: You will see a dashed fence line when dragging the cursor around the objects. In the example below, you could drag the cursor clockwise or counter-clockwise, whichever way you prefer.

All the lines need to be extended to the outer circle.

After Extend

Note: In the example above, if your freehand path was closer to the smaller inner circle, AutoCAD will extend the lines inside that inner circle instead of extending them to the outer circle.

Note: If you extend an object by mistake, you can use the **Undo** command to "undo" the extended object and place it back to its original length before it was extended. (Refer to page 6-4.)

You may toggle between **Extend** and **Trim** (page 6-4). Hold down the **<Shift>** key and the **Trim** command will activate. Release the **<Shift>** key and you return to **Extend**.

Move

The **Move** command is used to move object(s) from their current location (basepoint) to a new location (second displacement point).

1. Select the Move command using one of the following:

Ribbon = Home Tab / Modify Panel / or
Keyboard = M <Enter>

The following prompt will appear on the Command Line:

6-8 Move

- 2. Select the object(s) that you want to move (P1).
- 3. Select more objects or to stop selecting objects, select < Enter>.

The following prompt will appear on the Command Line:

4. Select a location (P2) (usually a point on the object).

The following prompt will appear on the Command Line:

× B ♣ ▼ MOVE Specify second point or <use first point as displacement>:

5. Move the object to its new location (P3) and press the left mouse button.

Warning: If you press *Enter* instead of actually picking a new location (P3) with the mouse, AutoCAD will send it into **Outer Space**. If this happens, just select the **Undo** tool and try again.

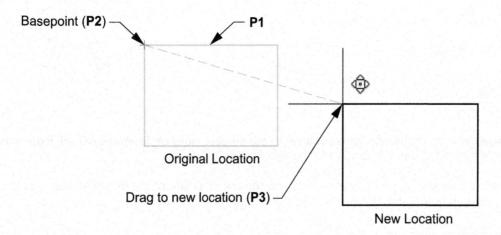

Drag

The **Drag** option allows you to quickly **move** or **copy** one or more objects.

Example:

- 1. Draw a circle.
- 2. Select the circle.

Five little boxes appear. These are called grips and allow you to edit the object. Grips will be discussed more in future lessons.

3. Click on the circle and hold the right-hand mouse button down as you drag the circle to the right.

4. When the dragged circle is in the desired location, release the right mouse button.

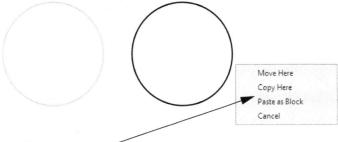

5. Select from any of the four options in the menu.

Nudge

The Nudge option allows you to nudge objects in orthogonal increments.

Note: Snap mode affects the distance and direction in which the objects are nudged.

Nudge objects with **Snap** mode turned **off**: Objects move two pixels at a time.

Nudge objects with **Snap** mode turned **on**: Objects are moved in increments specified by the current **Snap** spacing.

Note: To set the Increment Snap spacing refer to page 3-5.

Example:

- 1. Draw a circle.
- 2. Select the circle.

Five little boxes appear. These are called grips and allow you to edit the object. Grips will be discussed more in future lessons.

3. Hold down the **<Ctrl>** key and press one of the Arrow keys $\leftarrow \rightarrow \uparrow \downarrow$

6-10 Nudge

Remember: The distance the object moves depends on whether you have the **Snap** mode **on** or **off**. (Refer to the note on the previous page.)

If you want to nudge an object precise distances, set the distance in the **Snap** and **Grid** Tab of the **Drafting Settings** dialog box and turn on **Snap** mode **<F9>**.

Explode

The **Explode** command changes (explodes) an object into its primitive objects. For example, a rectangle is originally one object. If you explode it, it changes into four lines. Visually, you will not be able to see the change unless you select one of the lines.

1. Select the Explode command using one of the following:

The following prompt will appear on the Command Line:

2. Select the object(s) you want to explode and then press < Enter>.

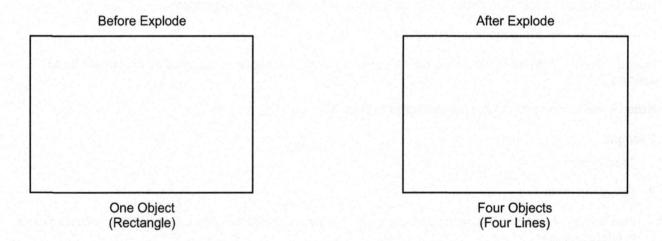

(Notice there is no visible difference. But now you have four lines instead of one rectangle).

Try this:

Draw a rectangle and then click on it. The entire object highlights. Now explode the rectangle, then click on it again. Only the line you clicked on should be highlighted. Each line that forms the rectangular shape is now an individual object.

Exercise 6A

Instructions:

- Start a New file using either the inch-helper.dwt or the metric-helper.dwt
- 2. Draw the objects.
 - A. Use Object Snap **Midpoint** to locate the center for the circles.
 - B. **Ortho <F8> on** when drawing horizontal and vertical lines.
 - C. Turn Increment Snap <F9> on.
 - D. Use Layer Object Line.

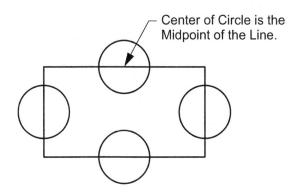

- 3. **Trim** the circles and rectangle to match the illustration.
- 4. Save the drawing as: Ex-6A

Exercise 6B

- Start a New file using either the inch-helper.dwt or the metric-helper.dwt
- 2. Draw the objects.
 - A. Circles should have the same center.
 - B. Ortho <F8> on when drawing horizontal and vertical lines.
 - C. **Ortho <F8> off** when drawing lines on an angle.
 - D. Turn Increment Snap <F9> off.
 - E. Use Layer Object Line.

- Trim the lines to match the illustration at right.
 Note: You can trim the lines individually or by using the press and drag freehand path method.
- 4. Save the drawing as: Ex-6B

Exercise 6C

Instructions:

- Start a New file using either the inch-helper.dwt or the metric-helper.dwt
- 2. Draw the lines exactly as shown.
 - A. Ortho <F8> on when drawing horizontal and vertical lines.
 - B. Turn Increment Snap <F9> on.
 - C. Turn Osnap <F3> off.
 - D. Use Layer Object Line.

- 3. **Extend** the vertical lines **individually** to intersect with the horizontal line as shown.
- 4. Save the drawing as: Ex-6C

Exercise 6D

- Start a New file using either the inch-helper.dwt or the metric-helper.dwt
- 2. Draw the lines exactly as shown.

- Extend the vertical lines to intersect with both horizontal lines using the crossing fence method by selecting the points at P1 and P2.
- 4. Save the drawing as: Ex-6D

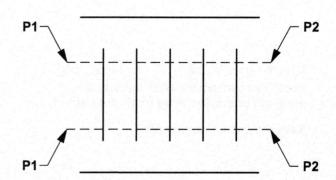

Exercise 6E

Instructions:

- Start a New file using either the inch-helper.dwt or the metric-helper.dwt
- 2. Draw the lines using rectangles, circles, and lines (for the X's). Use Layer Object Line.

3. Modify the drawing to appear as shown using: **Explode** and **Erase**.

Note: You must **Explode** a rectangle before you can **Erase** an individual line.

4. Save the drawing as: Ex-6E

Exercise 6F

Instructions:

- 1. Start a New file using either the inch-helper.dwt or the metric-helper.dwt
- 2. Draw the objects below using all of the commands you have learned in the previous lessons. Use whatever layers you desire.
- 3. Save the drawing as: Ex-6F

Have some fun with this one but be very accurate. All objects must intersect exactly. Zoom in and take a look to make sure.

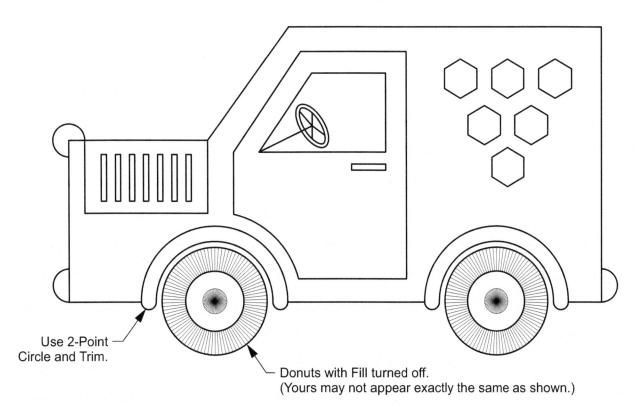

Notes:

iz animalism

tivit, jääjisikon ja matrigitti ja tu on ostoriviteitti onti kuto gyjället tiivolikse ja ka

e Brata, tha consists below againg ball of the boards you include Benedian the recycling for

The Succession of the vice

. Matematica de la compania de la c La compania de la compania del compania del compania de la compania del la compania de la compania del la compania del

LESSON 7

LEARNING OBJECTIVES

After completing this lesson, you will be able to:

- 1. Copy objects.
- 2. Create a Mirrored Image.
- 3. Add Rounded Corners.
- 4. Add Chamfered Corners.

Copy Multiple Copies

The **Copy** command creates a duplicate set of the objects selected. The **Copy** command is similar to the **Move** command. (Also refer to page 6-9 for an optional copy method using Drag and then Copy Here.)

The steps required are:

- 1. Select the objects to be copied.
- 2. Select a basepoint.
- 3. Select a new location for the new copy.

The difference between Copy and Move commands:

The **Move** command **merely moves** the objects to a new location.

The **Copy** command **makes a copy**, and you select the location for the new copy.

1. Select the Copy command using one of the following:

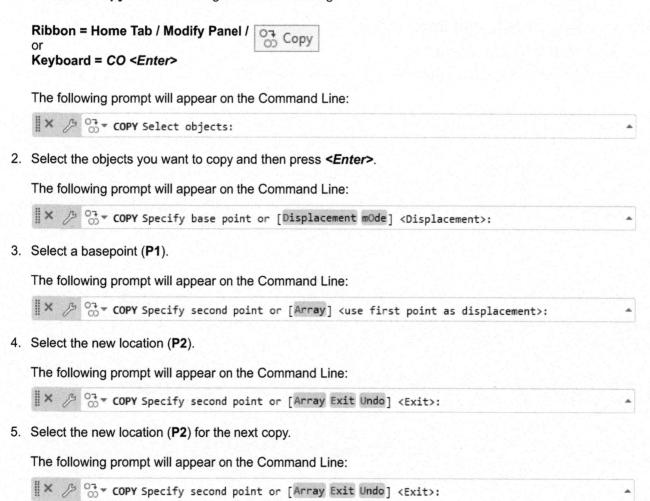

6. Select the new location (P2) for the next copy, or press **<**Enter> to stop selecting more copies.

Refer to the example on the next page.

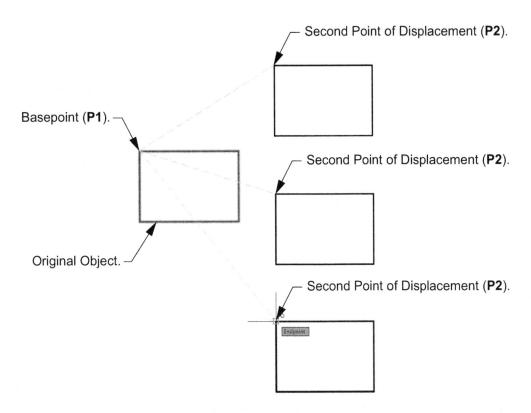

Note: The Copy command continues to make copies until you press < Enter> to exit.

Changing the "Mode"

You may change the "Mode" to **Single** if you prefer to have AutoCAD stop the Copy command automatically after a single copy.

After you have selected the object(s) to copy, the following prompt will appear on the Command Line:

If you select the option mOde, you may select Single or Multiple copy mode.

Copy "Array" Option

The Copy command allows you to make an Array of copies.

After you have selected the basepoint (P1), the following prompt appears:

If you select the option Array, the following prompt will appear on the Command Line:

1. Enter the number of items to Array and then press *Enter*.

The following prompt will appear on the Command Line:

2. Place the second point (**P2**) or select **F** and then press **<Enter>**.

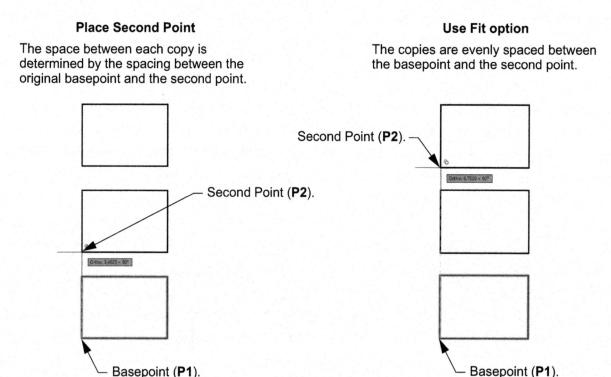

Note: The Array option within the Copy command is a quick method to create multiple copies. But AutoCAD has a more powerful and accurate Array command described in Lesson 13.

Mirror

The **Mirror** command allows you to make a mirrored image of any objects you select. You can use this command for creating right- or left-hand parts, or to draw half of a symmetrical object and mirror it to save drawing time.

Select the Mirror command using one of the following:

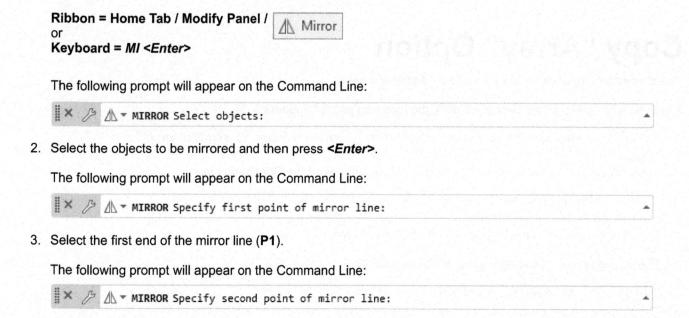

4. Select the second end of the mirror line (P2).

The following prompt will appear on the Command Line:

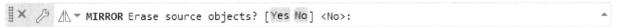

5. Select Y if you want to erase the original object, or N if you want to keep the original object.

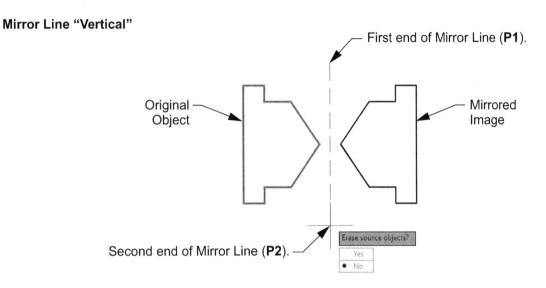

Note: The placement of the "Mirror Line" is important. You may make a mirrored copy **horizontally**, **vertically**, or on an **angle**.

Mirror Line "Horizontal"

Mirror Line "Angled"

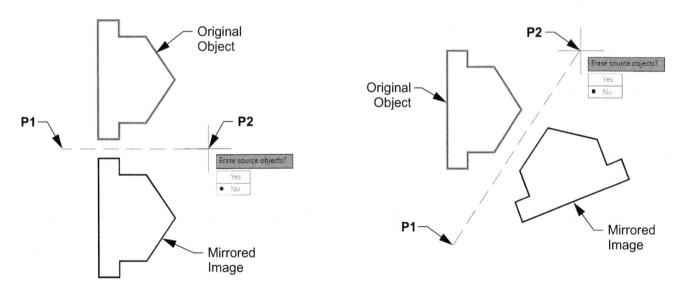

How to control text when using the Mirror command

(Do the following **before** you use the Mirror command.)

- 1. At the Command Line type: *mirrtext* and then press *Enter>*.
- 2. If you want the text to mirror (reverse reading), type: 1 and then press < Enter>. If you do not want the text to mirror, type: 0 and then press < Enter>.

7-6 Fillet

Fillet

The **Fillet** command will create a radius between two objects. The objects do not have to be touching. If two parallel lines are selected, it will construct a full radius.

Radius a corner

Select the Fillet command using one of the following:

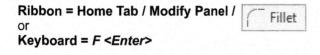

The following prompt will appear on the Command Line:

2. Type R and then press < Enter>.

The following prompt will appear on the Command Line:

```
# X B ( ▼ FILLET Specify fillet radius <0.0000>:
```

3. Type the radius you require and then press < Enter>.

The following prompt will appear on the Command Line:

```
    ★ FILLET Select first object or [Undo Polyline Radius Trim Multiple]:
    ★
```

4. Select the first object to be filleted (left click).

The following prompt will appear on the Command Line:

5. Select the second object to be filleted (left click).

Note: When you place the Cursor on the second object, AutoCAD displays the Fillet and allows you to change the radius before it is actually drawn. If you choose to change the radius, select the **Radius** option, enter a new radius value, and then select the second object.

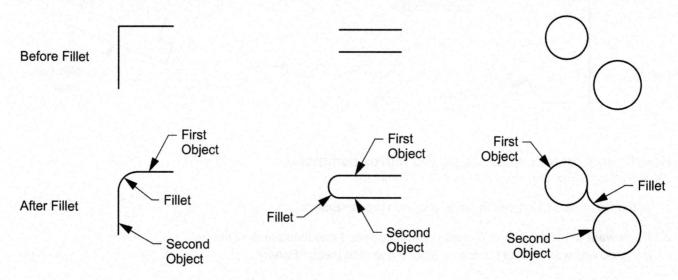

The **Fillet** command may also be used to create a square corner.

Square corner

1. Select the Fillet command.

The following prompt will appear on the Command Line:

```
X & FILLET Select first object or [Undo Polyline Radius Trim Multiple]:
```

2. Select the first object (P1).

The following prompt will appear on the Command Line:

3. Hold down the **<Shift>** key while selecting the second object (**P2**).

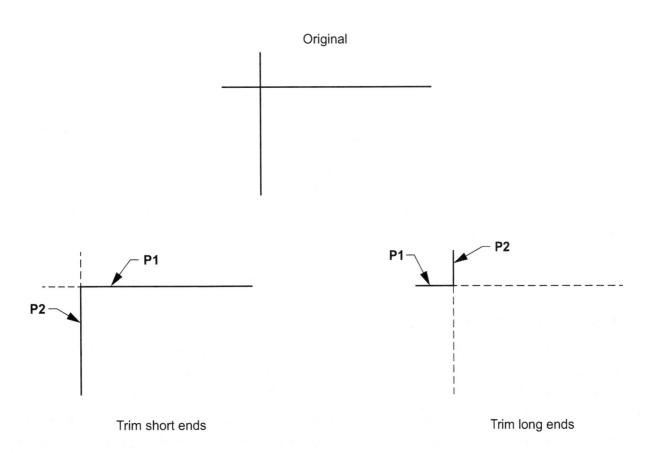

Note: The corner trim direction depends on which end of the object you select. Select the ends that you want to keep.

Options:

Polyline: This option allows you to fillet all intersections of a polyline in one operation, such as all four corners of a rectangle.

Trim: This option controls whether the original lines are trimmed to the end of the arc or remain the original length. (Set to Trim or No trim.)

Multiple: Repeats the fillet command until you press < Enter > or the < Esc > key.

7-8 Chamfer

Chamfer

The **Chamfer** command allows you to create a chamfered corner on two lines. There are two methods: **Distance** and **Angle**.

Distance method

Distance method requires input of a distance for each side of the corner.

1. Select the **Chamfer** command using one of the following:

The following prompt will appear on the Command Line:

2. Select D and then press < Enter>.

The following prompt will appear on the Command Line:

3. Type the distance for the first side and then press **<Enter>**.

The following prompt will appear on the Command Line:

4. Type the distance for the second side and then press < Enter>.

The following prompt will appear on the Command Line:

```
| × / C+ CHAMFER Select first line or [Undo Polyline Distance Angle Trim mEthod Multiple]: ▲
```

5. Select the first line to be chamfered (Distance 1).

The following prompt will appear on the Command Line:

6. Select the second line to be chamfered (Distance 2).

Note: When you place the cursor on the second line, AutoCAD displays the chamfer and allows you to change the distances before it is actually drawn.

If you choose to change the distance, select the Distance option, enter new distance values, and then select the second line.

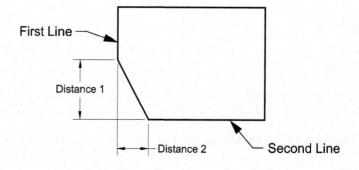

Chamfer 7-9

Angle method

Angle method requires input for the length of the line and an angle.

1. Select the Chamfer command.

The following prompt will appear on the Command Line:

```
X / (→ CHAMFER Select first line or [Undo Polyline Distance Angle Trim mEthod Multiple]: •
```

2. Select A and then press < Enter>.

The following prompt will appear on the Command Line:

```
    ★ CHAMFER Specify chamfer length on the first line <0.000>:
    ★
```

3. Type the chamfer length and then press < Enter>.

The following prompt will appear on the Command Line:

```
|| × /³ / ▼ CHAMFER Specify chamfer angle from the first line <0>:
```

4. Type the angle and then press < Enter>.

The following prompt will appear on the Command Line:

```
| X / (→ CHAMFER Select first line or [Undo Polyline Distance Angle Trim mEthod Multiple]: ▲
```

5. Select the first line to be chamfered (the length side).

The following prompt will appear on the Command Line:

```
X & CHAMFER Select second line or shift-select to apply corner or [Distance Angle Method]: *
```

6. Select the second line to be chamfered (the angle side).

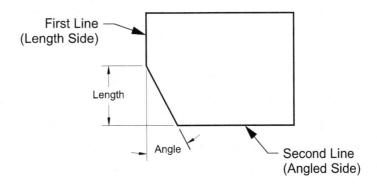

Options:

Polyline: This option allows you to chamfer all intersections of a polyline in one operation, such as all four corners of a rectangle.

Trim: This option controls whether the original lines are trimmed or remain after the corners are chamfered. (Set to Trim or No trim.)

mEthod: Allows you to switch between **Distance** and **Angle** method. The distance or angle must have been set previously.

Multiple: Repeats the Chamfer command until you press < Enter> or the < Esc> key.

Exercise 7A

Instructions:

- 1. Start a New file using either the inch-helper.dwt or the metric-helper.dwt
- 2. Draw the lines and one circle shown below.

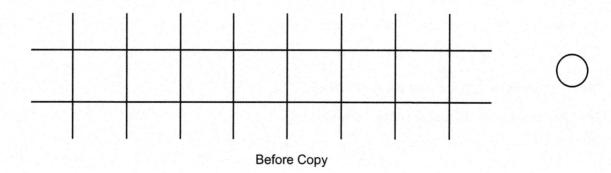

- 3. Copy the circle to all the other locations shown below.
 - A. Select the Copy command.
 - B. Select the circle.
 - C. Select the basepoint on the original circle.

Note: The basepoints are different.

D. Select the new location (second point of displacement).

After Copy

4. Save the drawing as: Ex-7A

Note: Step-by-step instructions are shown on the next page.

Exercise 7A Helper

- 1. Select the Copy command and then select the circle to copy.
- 2. Select the basepoint: the center of the circle (use Object Snap Center).
- 3. Set Running Object Snap to Endpoint and Intersection and place all 24 circles.

- 1. Select the Copy command and then select the circle to copy.
- 2. Select the basepoint: the quadrant (12 o'clock) this time.
- 3. Place the eight bottom circles accurately using the **Endpoint** Object Snap.

- 1. Select the Copy command and then select the circle to copy.
- 2. Select the basepoint: the quadrant (3 o'clock) this time.
- 3. Place the two circles on the left accurately using the **Endpoint** Object Snap.

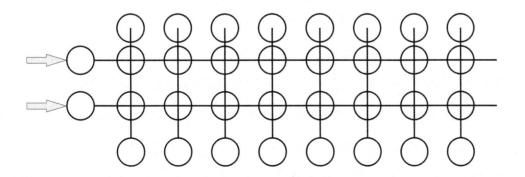

Exercise 7B

Instructions:

- Start a New file using either the inch-helper.dwt or the metric-helper.dwt
- 2. Draw the rectangle shown.

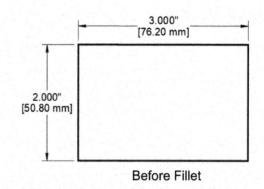

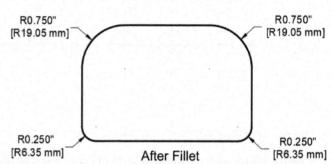

- 3. Radius the corners using the Fillet command.
- 4. Save the drawing as: Ex-7B

Exercise 7C

Instructions:

- 1. Start a New file using either the inch-helper.dwt or the metric-helper.dwt
- 2. Draw the three rectangles shown below.
- 3. Chamfer the corners using the Chamfer command.
- 4. Save the drawing as: Ex-7C

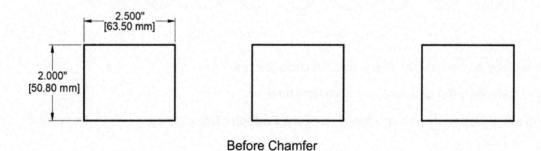

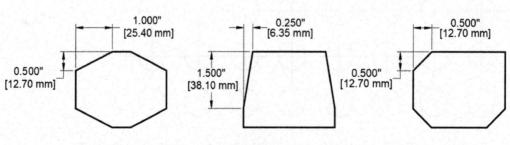

After Chamfer

Exercise 7D

Instructions:

- 1. Start a New file using either the inch-helper.dwt or the metric-helper.dwt
- 2. Draw the rectangle shown below.
- 3. Chamfer the corners using the **Chamfer** command.
- 4. Save the drawing as: Ex-7D

Before Chamfer

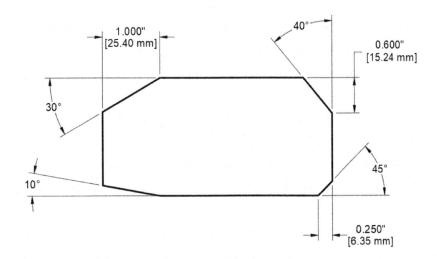

After Chamfer

Exercise 7E

Instructions:

- 1. Start a New file using either the inch-helper.dwt or the metric-helper.dwt
- 2. Draw the half the house shown below.

Use Layers Roof, Wall, Window, Door, Plants, and Bricks.

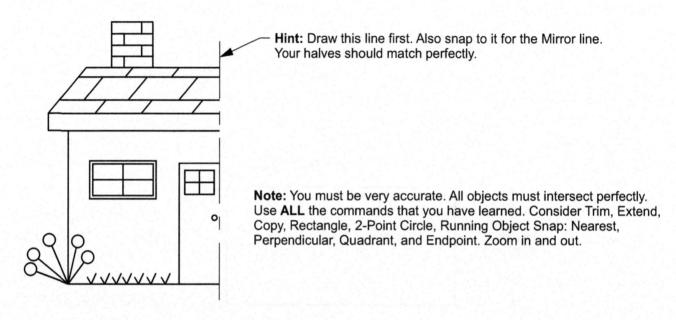

- 3. Now create a Mirrored image of the half house:
 - A. Select the Mirror command.
 - B. Select the objects to be Mirrored (you could use Window selection).
 - C. Select the first endpoint of the Mirror line (Ortho ON).
 - D. Select the second endpoint of the Mirror line.
 - E. Answer NO to "Erase Source Objects?"
- 4. Save the drawing as: Ex-7E

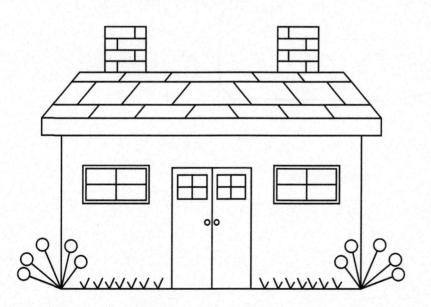

Can you imagine how this might save you valuable time?

LESSON 8

LEARNING OBJECTIVES

After completing this lesson, you will be able to:

- 1. Add a Single Line of text to the drawing.
- 2. Add a paragraph using Multiline Text.
- 3. Control Tabs, Indents, and use the Spell Checker.
- 4. Add Columns.
- 5. Edit existing Single Line Text and Multiline Text.

Single Line Text

Single Line Text allows you to draw one or more lines of text. The text is visible as you type. To place the text in the drawing, you may use the default **start point** (the lower left corner of the text), or use one of the many styles of justification described on the next page. Each line of text is treated as a separate object.

Using the default start point

1. Select the Single Line Text command using one of the following:

The following prompt will appear on the Command Line:

2. Place the cursor where the text should start and then left click.

The following prompt will appear on the Command Line:

3. Type the height of your text and then press < Enter>.

The following prompt will appear on the Command Line:

- 4. Type the rotation angle of your text and then press **<Enter>**.
- 5. Type the text you require and then press **<Enter>** at the end of the sentence.
- 6. Type the next sentence you require or press **<Enter>** to stop the Single Line Text command.

Using justification

If you need to be very specific, where your text is located, you must use the justification option. For example, if you want your text in the middle of a rectangular box, you would use the justification option "Middle".

The following is an example of Middle justification. (Use the inch or metric template.)

- 1. Draw a rectangle 6" [152.4 mm] wide and 3" [76.2 mm] high.
- 2. Draw a diagonal line from one corner to the other corner.

3. Select the Single Line Text command.

The following prompt will appear on the Command Line:

4. Type J and then press < Enter>.

The following prompt will appear on the Command Line:

X / A TEXT Enter an option [Left Center Right Align Middle Fit TL TC TR ML MC MR BL BC BR]:

5. Type **M** and then press **<Enter>**.

The following prompt will appear on the Command Line:

 $\| \times \mathcal{P} \underline{A} + TEXT$ Specify middle point of text:

6. Snap to the midpoint of the diagonal line (left click).

The following prompt will appear on the Command Line:

7. Type in 1 [25.4] and then press < Enter>.

The following prompt will appear on the Command Line:

- 8. Type in **0** and then press **<**Enter>.
- 9. Type the text HHHH and press < Enter> and then press < Enter> again to stop the command.

Also refer to Exercise 8C for "Mid Between 2 Points" method.

Other justification options

Align HHHHH

Aligns the line of text between two points specified. The height is adjusted automatically.

Fits the text between two points specified. The height is specified by you and does not change.

Center HyyHHyyHHyy

This is a tricky one. Center is located at the bottom center of uppercase letters.

Middle HHHHHHHHH HHyyHH

If only uppercase letters are used, **Middle** is located in the middle, horizontally, and vertically. If both uppercase and lowercase letters are used, **Middle** is located in the middle, horizontally, and vertically, but considers the lowercase letters as part of the height.

Right HyyHHyyHHyy

Bottom right of uppercase text.

ть, тс, тк НууННууННуу

Top left, Top center, and Top right of uppercase and lowercase text.

ML, MC, MR HYYHHYYHHYY

Middle left, Middle center, and Middle right of uppercase text. (Notice the difference between "Middle" and "MC".)

BL, BC, BR HyyHHyyHHyy

Bottom left, Bottom center, and Bottom right of lowercase text. Notice the different location for **BR** and **Right** shown above. **BR** considers the lowercase letters with tails as part of the height.

Multiline Text

Multiline Text command allows you to easily add a sentence, paragraph, or tables. The Mtext editor has most of the text editing features of a word processing program. You can underline, bold, italic, add tabs for indenting, change the font, line spacing, and adjust the length and width of the paragraph.

When using Mtext, you must first define a text boundary box. The text boundary box is defined by entering where you want to start the text (first corner) and approximately where you want to end the text (opposite corner). It is very similar to drawing a rectangle. The paragraph text is considered one object rather than several individual sentences.

Using Multiline Text

1. Select the Multiline Text command using one of the following:

Ribbon = Annotate Tab / Text Panel /

Keyboard = MT <Enter>

The Command Line will list the current style, text height, and annotative setting.

Current text style: "Standard" Text height: 0.200 Annotative: No

Note: You will not see these settings as they move up into the Command Prompt History. **Annotative** will be discussed in Lessons 26 and 27.

The cursor will then appear as crosshairs with the letters "abc" attached. These letters indicate how the text will appear using the current font and text height.

The following prompt will appear on the Command Line:

2. Place the cursor at the upper left corner of the area where you want to start the new text boundary box and press the left mouse button (**P1**).

The following prompt will appear on the Command Line:

```
|| × / A - MTEXT Specify opposite corner or [Height Justify Line spacing Rotation Style Width Columns]: -
```

3. Move the cursor to the right and down (P2) and press left mouse button.

The Text Editor Ribbon will appear.

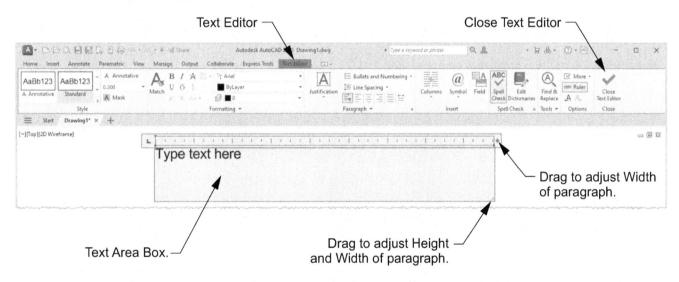

The **Text Editor** allows you to select the Text Style, Font, Height, etc. You can add features such as bold, italics, underline, and color.

The **Text Area Box** allows you to enter the text, add tabs, indent, adjust left-hand margins, and change the width and height of the paragraph.

4. After you have entered the text in the Text Area box, select the Close Text Editor tool.

How to change the "abc", on the crosshairs, to other letters

You can personalize the letters that appear attached to the crosshairs using the "MTJIGSTRING" system variable (10 characters max). The letters will simulate the appearance of the font and height selected but will disappear after you place the lower right corner (P2).

- 1. Type *mtjigstring* and then press *<Enter>* on the Command Line.
- 2. Type the new letters and then press < Enter>.

The letters will be saved to the computer, not the drawing. They will appear anytime you use Multiline Text and will remain until you change them again.

Tabs, Indents, and Spell Check

Tabs

Setting and removing Tabs is very easy.

The increments are determined by the text height. (Example: If the text height is 1", you may quickly place a Tab at any 1" mark on the ruler.) To be more specific refer to page 8-8.

Set or change the stop positions at anytime, using one of the following methods:

Place the cursor on the "Ruler" where you want the Tab and left click. A little dark "L" will appear. The Tab is set. If you would like to remove a Tab, just click and drag it off the ruler and it will disappear.

Indents

Sliders on the ruler show indention relative to the left side of the text boundary box. The top slider indents the first line of the paragraph, and the bottom slider indents the other lines of the paragraph. (Also refer to page 8-8.)

You may change their positions at anytime, using the following method:

Place the cursor on the "Slider" and click and drag it to the new location.

Spell Check

If you have Spell Check **on**, you will be alerted as you enter text with a red line under the misspelled word. Right click on the word and AutoCAD will give you some choices.

- 1. Select the text that you want to Spell Check. (Click once on the sentence.)
- 2. Select the Annotate Tab / Text Panel /

The Check Spelling dialog box will appear.

3. Select Start.

If AutoCAD finds any words misspelled, it will suggest a change. You may select **Change** or **Ignore**. When finished, a message will appear stating **"Spelling check complete"**.

- 4. Select OK.
- Select Close to close the Check Spelling dialog box.

Columns

Static Columns

- 1. Right click in the Text Box Area and select Columns.
- 2. Select Column Settings...

The Column Settings dialog box will appear.

- 3. Select Static Columns.
- 4. Select:
 - A. Column Number.
 - B. Height.
 - C. Width of Column.
 - D. Width of Gutter.

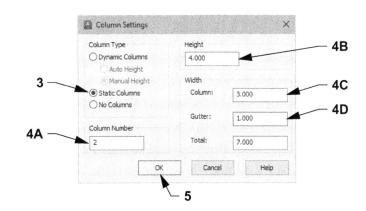

- 5. Select the **OK** button.
- 6. The Text Area should appear as shown below with two columns divided with a gutter.
- 7. Start typing in the left-hand box. When you fill the left-hand box, the text will start to spill over into the right-hand box.

You may also adjust and make changes to the width and height using the drag tools.

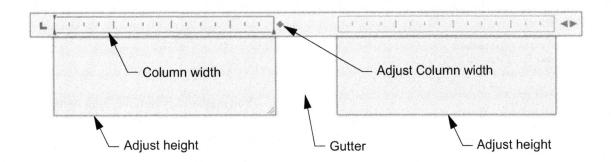

Dynamic Columns

- 1. Right click in the **Text Box Area** and select **Columns**.
- 2. Select Column Settings... (Refer to Static Columns above.)

8-8 Columns

The Column Settings dialog box will appear.

- 3. Select Dynamic Columns.
- 4. Select Auto Height.
- 5. Select:
 - A. Height.
 - B. Width of Column.
 - C. Width of Gutter.
- 6. Select the OK button.
- 7. The Text Area will first appear with one column with the width and height you set.

8. When the text fills the first column, another column will appear.

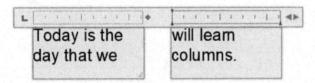

When the second column fills, another column will appear. You may also adjust and make changes to the width and height using the drag tools.

Paragraph and Line Spacing

You may set the Tabs, Indent, and Line Spacing for individual paragraphs.

1. Right click in the Text Box Area and select Paragraph...

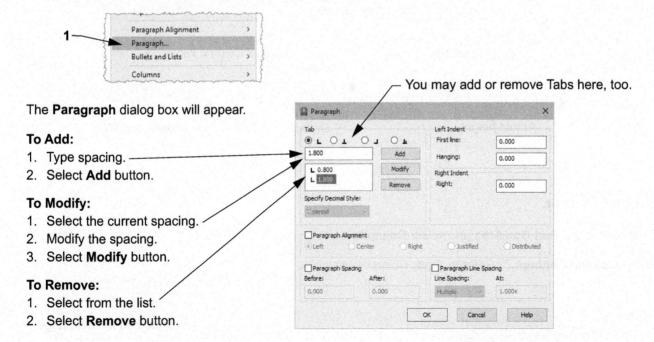

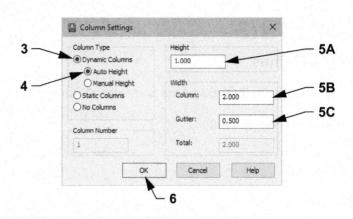

Editing Text

Single Line Text

Editing **Single Line Text** is somewhat limited compared to Multiline Text. In the example below, you will learn how to edit the text within a Single Line Text sentence. (In Lesson 12, you will learn additional options for editing Single Line text by using the **Properties** command.)

1. Double click on the Single Line Text you want to edit. The text will highlight.

This is Single Line Text

2. Make the changes in place and then press **<Enter> <Enter>**.

Multiline Text

Multiline Text is as easy to edit as it is to input originally. You may use any of the text options shown on the Text Editor Tab.

- 1. Double click on the Multiline text you want to edit.
- 2. Highlight the text that you want to change, using click and drag.

This is Multiline Text. Double click on the Multiline Text you want to edit, then highlight the text that you want to change using click and drag.

3. Make the changes, then select the Close Text Editor tool.

You may edit many other Multiline Text features.

- 1. Double click on the Multiline Text that you want to edit.
- 2. Right click in the Text Box Area.

The menu shown below will appear.

This is Multiline Text. Double click on the Multiline Text you want to edit, then highlight the text that you want to change using click and drag. Select All Cut Ctrl+X Copy Ctrl+C Paste Ctrl+V Paste Special Insert Field... Import Text... Paragraph Alignment Paragraph... **Bullets and Lists** Find and Replace... Change Case All CAPS ✓ Autocorrect cAPS Lock Character Set Combine Paragraphs

You may also add a border around Multiline Text. (Not available for Single Line Text.)

- 1. Left click on the Multiline Text that you want to edit.
- Right click and select Properties from the menu.

In the Properties dialog box, select Yes in the Text Frame drop-down list. You can also change the Color, Linetype, and Lineweight of the text border.

- 4. A border will be placed around the selected Multiline Text.
- 5. You can resize the border by selecting either of the two arrow grips, or you can move the Multiline Text and border by selecting the square grip.

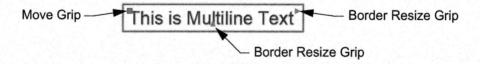

6. Close the Properties dialog box and then press the **Esc>** key to cancel the grips.

This is Multiline Text

Exercise 8A-Inch

Exercise 8A-Inch

Instructions:

- 1. Start a New file using either the inch-helper.dwt
- 2. Duplicate the text shown below using Single Line Text.
- 3. Use Layer Text.
- 4. Follow the instructions in each block of text. To start the text in the correct location that is stated in each example, move the cursor while watching the coordinate display.
- 5. Save the drawing as: Ex-8A-I

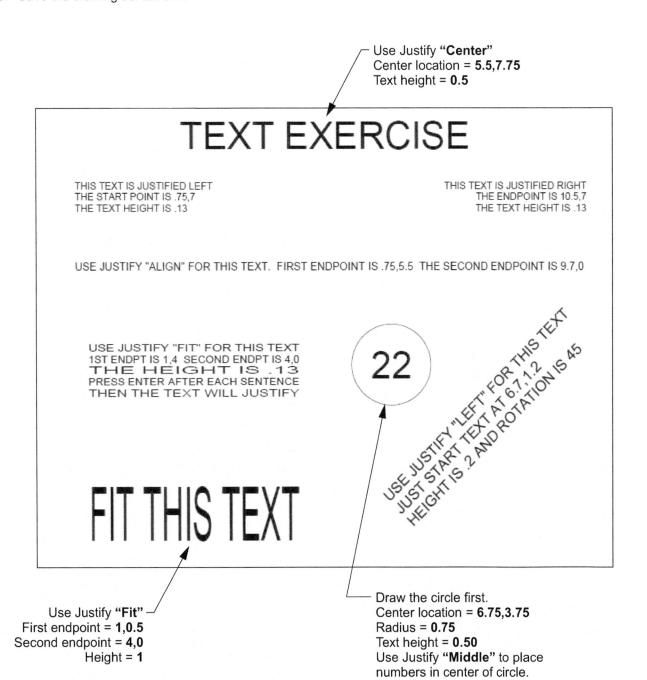

Exercise 8A-Metric

Instructions:

- 1. Start a New file using either the metric-helper.dwt
- 2. Duplicate the text shown below using Single Line Text.
- 3. Use Layer Text.
- 4. Follow the instructions in each block of text. To start the text in the correct location that is stated in each example, move the cursor while watching the coordinate display.
- Save the drawing as: Ex-8A-M

Use Justify "Center" Center location = 148.5,191 Text height = 12.7

TEXT EXERCISE

THIS TEXT IS JUSTIFIED LEFT. THE START POINT IS 19,178 THE TEXT HEIGHT IS 3.3

THIS TEXT IS JUSTIFIED RIGHT THE ENDPOINT IS 278,178 THE TEXT HEIGHT IS 3.3

USE JUSTIFY "ALIGN" FOR THIS TEXT. FIRST ENDPOINT IS 19.140 THE SECOND ENDPOINT IS 259.0

USE JUSTIFY "FIT" FOR THIS TEXT 1ST ENDPT IS 25,102 SECOND ENDPT IS 102,0 THE HEIGHT IS 3.3 PRESS ENTER AFTER EACH SENTENCE THEN THE TEXT WILL JUSTIFY

FIT THIS TEXT

Use Justify "Fit"

First endpoint = 25,12.7 Second endpoint = 102,0

Height = 25

Draw the circle first. Center location = 171.95 Radius = 19 Text height = 12.7

Use Justify "Middle" to place numbers in center of circle.

Exercise 8B

Exercise 8B

Instructions:

- 1. Start a New file using either the inch-helper.dwt or the metric-helper.dwt
- 2. Duplicate the text shown below using Multiline Text.
- 3. Use Layer Text.
- 4. Select Multiline Text.
- 5. Use Text Style: Standard.
- 6. Use font: SansSerif.
- 7. Text Height: 0.250" [6.35 mm]
- 8. Follow the directions below. You may make changes to the settings as you type or you may enter all of the text and then go back and edit it. Your choice.
- 9. Enter all text shown below.
- 10. Save the drawing as: Ex-8B

The following is an exercise for Tabs, Indent, Bold and Underline.

- 1. This sentence should be indented 1" [25.4 mm].
 - a. This sentence should be indented 1.5" [38.1 mm].

And now back to the left margin.

Isn't this fun?

STUDENT NAME	STUDENT ID	GRADE
Susie Que	1234567	Α
John Smith	8910116	В
	Set Tabs to 4.5" [114.3 mm] and 8"Clear all previous Tabs.	[203.2 mm]

Exercise 8C

Instructions:

1. Start a New file using either the inch-helper.dwt or the metric-helper.dwt

The following exercise is designed to teach you how to insert text into the exact middle of a rectangular area using **Single Line Text**.

- 2. Draw a 6" [152.4 mm] wide by 3" [76.2 mm] high rectangle.
- 3. Select "Single Line Text".
- 4. Use Justify: Middle.
- 5. Use "M2P" Object Snap to locate the middle of the rectangle. (Refer to page 5-8.)
 - A. Type m2p <Enter> on the Command Line.
 - B. Using Object Snap "Endpoint", snap to (P1) corner and the diagonal corner (P2).
- 6. Use Text Height: 1" [25.4 mm]
- 7. Rotation: 0
- 8. Type the word Middle and then press < Enter> < Enter>.
- 9. Save the drawing as: Ex-8C

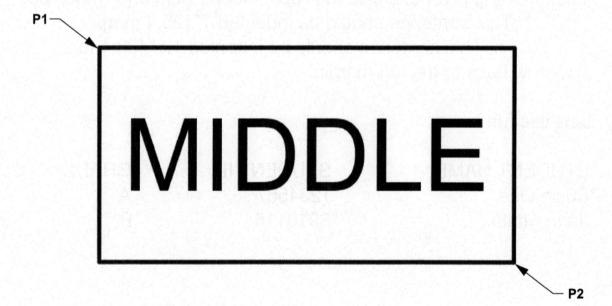

Exercise 8D

Instructions:

1. Start a New file using either the inch-helper.dwt or the metric-helper.dwt

The following exercise is designed to teach you how to insert text into the exact middle of a rectangular area using **Multiline Text**.

- 2. Draw a 6" [152.4 mm] wide by 3" [76.2 mm] high rectangle.
- 3. Select "Multiline Text".
- 4. Start the text boundary box at the upper left corner (P1) of the rectangle. Place the opposite corner at the lower right corner (P2) of the rectangle. (Use "Endpoint" Object Snap to be accurate.)
- 5. Select Text Style Standard: 1" [25.4 mm], Sans Serif and Middle Center.
- 6. Type the word **Middle** and then select **Close Text Editor**.
- 7. Save the drawing as: Ex-8D

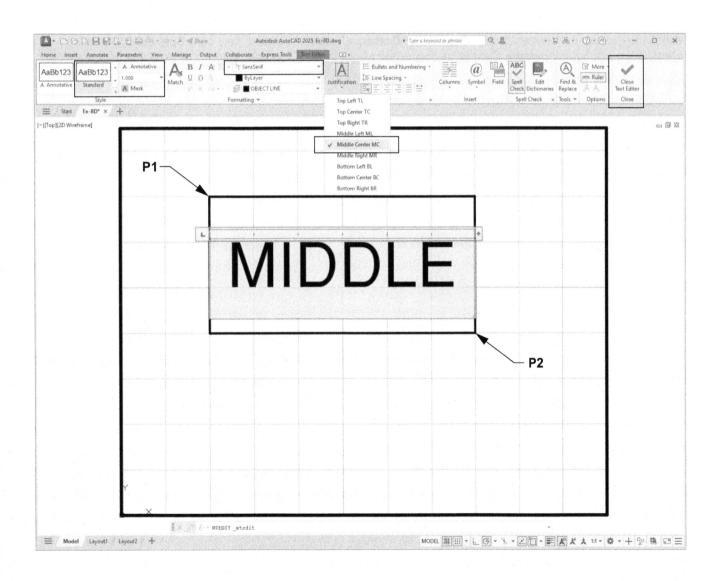

Exercises 8E & 8F

Exercise 8E

Instructions:

- Start a New file using either the inch-helper.dwt or the metric-helper.dwt
- 2. Draw two 6" [152.4 mm] long lines as shown.
- 3. Select Single Line Text.
 - A. Select Justify Center.
 - B. Use "Midpoint" Snap to place the justification point at the midpoint of the line.
 - C. Use text height 1" [25.4 mm] and rotation angle 0.
 - D. Type the word **Happy** (use uppercase and lowercase) and then press **<**Enter> **<**Enter>.
- Select Single Line Text again and type the same word on the second line but this time use Justify - BC (Bottom Center).

Notice the difference between Justify: Center and Bottom Center? "Center" only considers the uppercase letters when justifying. "Bottom Center" is concerned about those lowercase letters. Can you see how you could accidentally place your text too high or too low?

5. Save the drawing as: Ex-8E

Exercise 8F

Instructions:

 Start a New file using either the inch-helper.dwt or the metric-helper.dwt

Draw the two sentences using Single Line text. (Use Layer Text.)

3. Change the Mirrtext setting:

A. Type mirrtext <Enter>

B. Type 1 < Enter>

4. Using the Mirror command, mirror the first sentence using a vertical mirror line (P1 and P2).

Mirror Text setting 1 | 1 pnitted 1 | 1 pnit

Mirror Text setting 1

Mirror Text setting 0

5. Now change the Mirrtext command setting to 0

6. Mirror the second sentence.

Original P1 Mirror Copy
Mirror Text setting 0
P2

Notice the difference in the mirrored copy. Sometimes you will want the mirrored text to be reversed and sometimes you will not. Now you know how to control it.

7. Save the drawing as Ex-8F

LESSON 9

LEARNING OBJECTIVES

After completing this lesson, you will be able to:

- 1. Understand the Origin.
- 2. Draw objects accurately using coordinate input.
- 3. Input Absolute and Relative coordinates.
- 4. Input using Direct Distance Entry.
- 5. Measure the Distance, Angles, and Areas of objects.
- 6. Identify a Location within the drawing.
- 7. Create your own Master Border Template.
- 8. Print from Model Space.

Coordinate Input

In the previous lessons, you have been using the cursor to place objects. In this lesson, you will learn how to place objects in **specific locations** by entering coordinates. This process is called **coordinate input**. This is not difficult, so do not start to worry.

AutoCAD uses the Cartesian Coordinate System. The Cartesian Coordinate System has three axes, X, Y, and Z.

The X is the horizontal axis. (Right and Left.)

The **Y** is the vertical axis. (Up and Down.)

The **Z** is perpendicular to the X and Y plane.

(The **Z** axis is discussed in the *Advanced AutoCAD*® *Exercise Workbook* and *AutoCAD*® *3D Modeling Exercise Workbook*.)

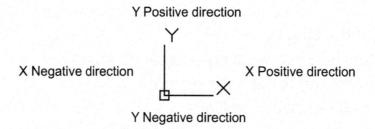

Look at the User Coordinate System (**UCS**) icon in the lower left corner of your screen. The X and Y are pointing in the positive direction.

The location where the X, Y, and Z axes intersect is called the **Origin**. The Origin always has a coordinate value of X = 0, Y = 0, and Z = 0 (0,0,0).

When you move the **cursor** away from the Origin, in the positive direction, the X and Y coordinates are positive. When you move the **cursor** in the opposite direction, the X and Y coordinates are negative.

Using this system, every point on the screen can be specified using positive or negative X and Y coordinates.

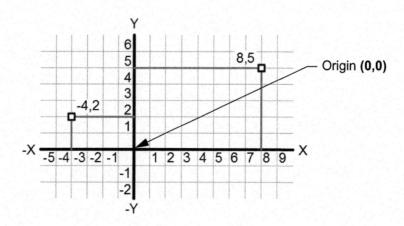

There are three types of Coordinate Input: **absolute**, **relative**, and **Polar**. (Absolute and relative coordinates are discussed in this lesson, and Polar coordinates will be discussed in Lesson 11.)

Absolute Coordinates

When inputting absolute coordinates, the input format is: **X,Y** (that is: **X comma** Y). Absolute coordinates come **from the Origin** and are typed as follows: **8,5**

The first number (8) represents the **X** axis (horizontal) distance from the Origin, and the second number (5) represents the **Y** axis (vertical) distance from the Origin. The two numbers must be separated by a comma.

An absolute coordinate of **4,2** will be **4** units to the **right** (horizontal) and **2** units **up** (vertical) **from the current location of the Origin**.

An absolute coordinate of -4, -2 will be 4 units to the **left** (horizontal) and 2 units **down** (vertical) **from the current location of the Origin**.

The following are examples of absolute coordinate input. Notice where the **Origin** is located in each example.

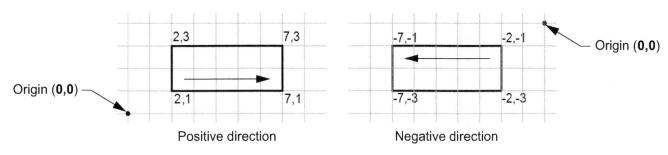

Relative Coordinates

Relative coordinates come from the last point entered. (Not from the Origin.)

The first number represents the **X axis** (horizontal) and the second number represents the **Y axis** (vertical) just like the absolute coordinates.

To distinguish the relative coordinates from absolute coordinates, the two numbers must be preceded by an @ symbol in addition to being separated by a **comma**.

A relative coordinate of @5,2 will go to the right 5 units and up 2 units from the last point entered.

A relative coordinate of @-5, -2 will go to the left 5 units and down 2 units from the last point entered.

The following is an example of relative coordinate input.

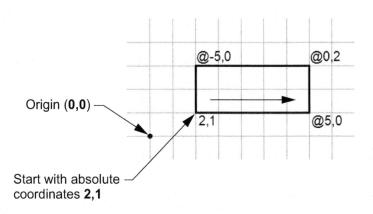

Examples of Coordinate Input

Scenario 1.

If you want to draw a line with the first endpoint "at the Origin" and the second endpoint 3 units in the positive X direction:

- 1. Select the Line command.
- 2. You are prompted for the first endpoint: Type 0,0 <Enter>.

0.0 ----- 3.0

3. You are then prompted for the second endpoint: Type 3,0 <Enter>.

What did you do?

The first endpoint coordinate input, **0,0** means that you do not want to move away from the Origin. You want to start "on" the Origin.

The second endpoint coordinate input, **3,0** means that you want to move **3** units in the positive X axis. The "**0**" means you do not want to move in the Y axis. So the line will be exactly horizontal.

Scenario 2.

If you want to start a line 1 unit to the right of the origin and 1 unit above and the line will be 4 units in length, perfectly vertical:

- 1. Select the Line command.
- 2. You are prompted for the first endpoint: Type 1,1 <Enter>.
- 3. You are prompted for the second endpoint: Type @0,4 <Enter>.

4.4

What did you do?

The first endpoint coordinate input, **1,1** means you want to move **1** unit in the X axis direction and **1** unit in the Y axis direction.

The second endpoint coordinate input **@0,4** means you do not want to move in the X axis "from the last point entered". But you do want to move in the Y axis "from the last point entered". (Remember the **@** symbol is only necessary if you are not using **Dynamic Input**.)

Scenario 3.

Now try drawing five connecting line segments. (Watch for the negatives.)

- 1. Select the Line command.
- 2. First endpoint: 2,4 <Enter>.
- 3. Second endpoint: @ 2, -3 <Enter>.
- 4. Second endpoint: @ 0, -1 <Enter>.
- 5. Second endpoint: @ -1,0 <Enter>.
- 6. Second endpoint: @ -2,2 <Enter>.
- 7. Second endpoint: @ 0,2 <Enter> <Enter>.

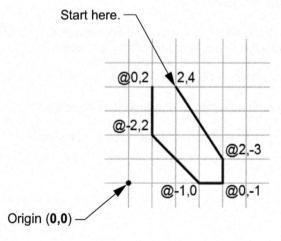

If you enter an incorrect coordinate, just hold down the **<Shift>** key and press **U** then **<Enter>**. The last segment will disappear, and you will have another chance at entering the correct coordinate.

Direct Distance Entry (DDE)

<u>Direct Distance Entry</u> is a combination of keyboard entry and cursor movement. **DDE** is used to specify distances in the horizontal or vertical axes from the **last point entered**. DDE is a **Relative Input**. Since it is used for horizontal and vertical movements, **Orthomode** must be **on**.

Note: To specify distances on an angle, refer to Polar Coordinate Input in Lesson 11.

Using DDE is simple. Just move the cursor and type the distance. Negative and positive is understood automatically by moving the cursor up (positive), down (negative), right (positive) or left (negative) from the last point entered. No **minus** or @ sign necessary.

Moving the cursor to the right and typing 5 < Enter> tells AutoCAD that the 5 is positive and horizontal.

Moving the cursor to the left and typing 5 < Enter> tells AutoCAD that the 5 is negative and horizontal.

Moving the cursor up and typing 5 < Enter> tells AutoCAD that the 5 is positive and vertical.

Moving the cursor down and typing 5 < Enter> tells AutoCAD that the 5 is negative and vertical.

Example:

- 1. Orthomode must be on. Grid off.
- 2. Select the Line command.
- 3. Type: **1,2 <Enter>** to enter the first endpoint using absolute coordinates.
- 4. Now move your cursor to the right and type: 5 < Enter>.
- 5. Now move your cursor up and type: 4 < Enter>.
- 6. Now move your cursor to the left and type: 5 < Enter> (the second < Enter> ends the Line command).

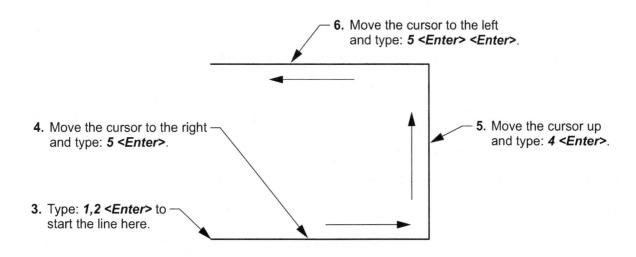

Measure Tools

The following tools are very useful to confirm the location or size of objects.

The **Measure** tools enables you to measure the **Distance**, **Radius**, **Angle**, **Area**, or **Volume** of a selected object. You may wish to use the individual measuring tools or the **Quick Measure** tool, which allows you to measure the dimensions, distances, angles, radii, and areas of objects in a 2-dimensional drawing. The default option is **Quick**.

1. Select the Measure tools using one of the following:

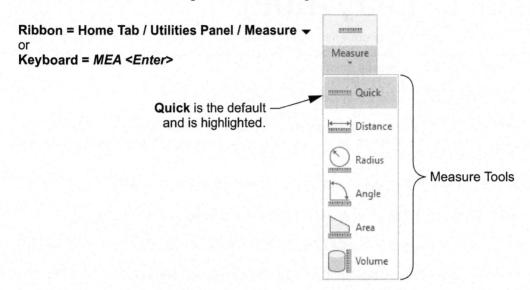

2. Select one of the tools and follow the instructions on the Command Line.

Example using the Quick Measure tool:

1. Create a right-angled triangle as shown.

- 2. Select the Quick option of the Measure tools.
- 3. Place the yellow crosshair cursor inside the triangle.

4. The dimensions are displayed for the three sides of the triangle along with two angles. The yellow square in the bottom left corner represents a 90 degree angle (right angle).

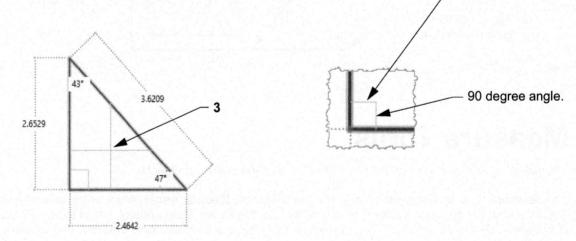

5. To close the Quick Measure option of the Measure tools, press the <Esc> key.

The **Quick Measure** option of the Measure tools can also measure the distance between two objects or the radius of a corner.

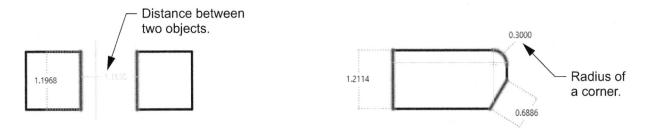

The Quick Measure option of the Measure tools can also measure the Area and Perimeter of a closed object.

How to measure the Area and Perimeter of a closed object using Quick Measure

- 1. Select the Quick option of the Measure tools.
- 2. Place the yellow crosshair cursor inside the closed object and then left click.
- 3. The closed object will highlight green and the Area and Perimeter dimensions will be displayed in a rectangular box.

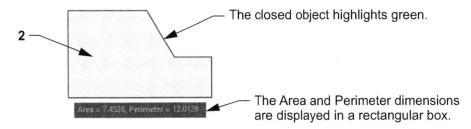

You may also select multiple closed objects to obtain the combined Area and Perimeter of those objects.

How to measure the Area and Perimeter of multiple closed objects

- 1. Select the Quick option of the Measure tools.
- 2. Place the yellow crosshair cursor inside the first closed object and then left click.
- 3. Hold down the <Shift> key and then left click inside the next closed object.
- 4. The closed objects will highlight green and the **combined** Area and Perimeter dimensions will be displayed in a rectangular box.

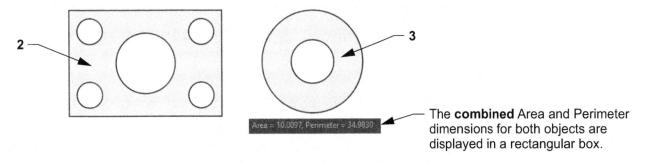

To improve performance or to prevent any confusion when using the **Quick** option of the Measure tools, zoom into complex areas or objects.

9-8 ID Point

ID Point

The **ID Point** command will list the **X**, **Y**, and **Z** coordinates of the point that you select. The coordinates listed will be from the **Origin**.

1. Select the ID Point command using one of the following:

The following will appear on the Command Line:

- 2. Select a location point, such as the center of a circle.
- The X, Y, and Z location coordinates for the center of the circle will be displayed above the Command Line and in the Dynamic Input box.

Example using the ID Point tool:

- 1. Select the ID Point tool.
- 2. Snap to the center of the circle.

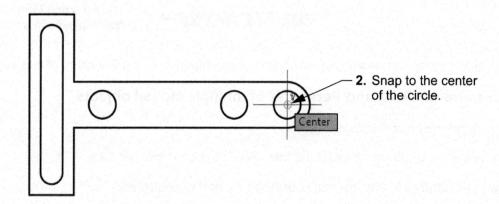

3. Coordinates, from the Origin, are displayed above the Command Line and in the Dynamic Input box.

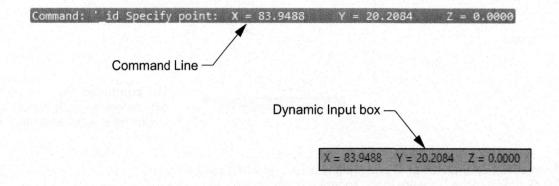

Exercise 9A

Exercise 9A: Creating a Border

In this exercise, you will create a master template named "Border A-Inch" for inch users, or "Border A-Metric" for metric users. This template will be used for the exercises in Lessons 9 through 25. Follow the easy steps below. Do not skip any.

Step 1. (Select the Settings)

- 1. Start a New file using either the inch-helper.dwt or the metric-helper.dwt
- 2. Set **Units** (Refer to page 4-13.)
 Units = Decimal
 Precision = **0.000**
- Set Drawing Limits (Refer to page 4-9.)
 Lower Left Corner = 0,0
 Upper Right Corner = 11,8.5 for inch users. 297,210 for metric users.
- 4. Show the new limits using: (Refer to page 4-7.) **Zoom / All**
- 5. **Important:** Change Lineweight settings to **Inches** for inch users and to **Millimeters** for metric users. Then **Adjust Display Scale**. (Refer to the bottom of page 3-10.)
- 6. Set **Grids** and **Snap** (Refer to page 3-5, 4-11, and 4-12.)
 Snap = **0.125"** [5 mm] (This is important, it will make it easier to draw the lines.)
 Grids = **1.000"** [25 mm]

Step 2. (Draw the Border Lines)

- 1. Select Layer Borderline.
- 2. Draw the border below using the dimensions shown.

Note: When complete, your **Border A-Inch** or **Border A-Metric** template will have an all around border of **3/8**" for inch users, and a border of **10 mm** for metric users.

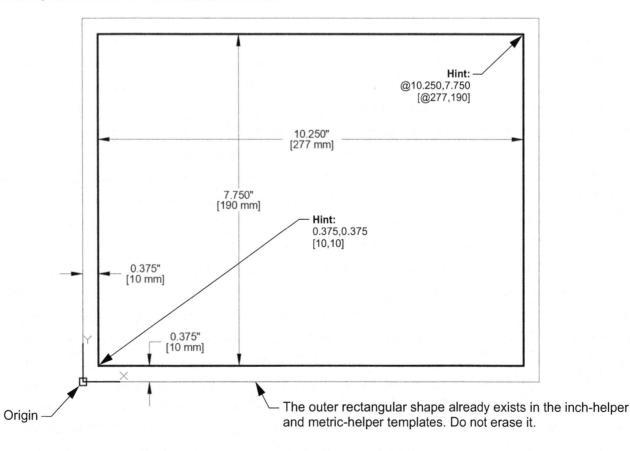

Step 3. (Draw the Title Block Lines)

- 1. Select Layer Borderline.
- 2. Draw the three Title Block lines as shown below using the dimensions shown.

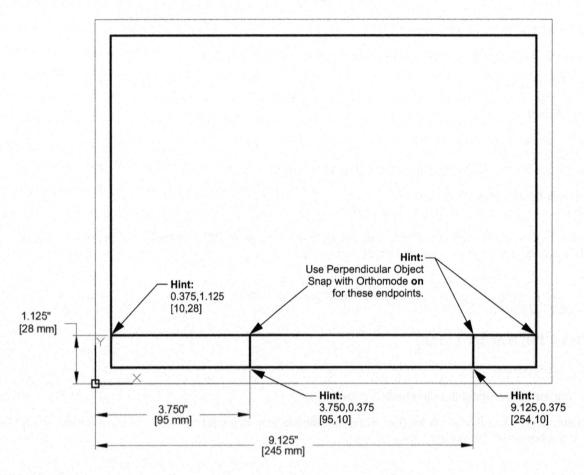

Step 4. (Enter the Text)

- 1. Select Layer Text.
- 2. Select the Multiline Text command.
- 3. Select the upper left corner and then the opposite corner.

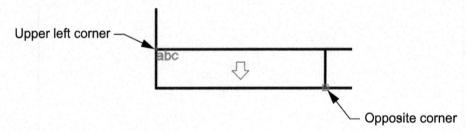

- 4. Change the text size to 0.250" [6.5 mm]
- 5. Select Bold.
- 6. Select justification Middle Center.
- 7. Type the text shown on the next page.
- 8. Repeat the above for the remaining two title boxes.

Exercise 9A...continued

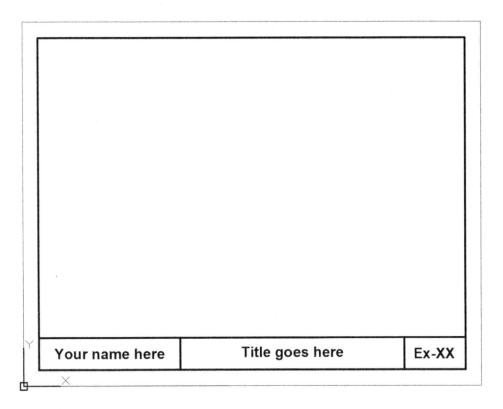

Step 5. (Save the border as a Template)

- 1. Select the Application Menu. (Refer to page 2-3.)
- 2. Select Save As >
- 3. Select Drawing Template.
- 4. Enter the new template name: **Border A-Inch** for inch users, or **Border A-Metric** for metric users.
- 5. Select Save button.
- 6. Enter the description: Use for Lessons 9 through 25
- 7. Select the **OK** button.

You now have a template to use for Lessons 9 through 25. At the beginning of each exercise, you will be instructed to start a **New** drawing using **Border A-Inch.dwt** for inch users, or **Border A-Metric.dwt** for metric users.

You will **edit** the **Title** and the **Ex-XX** to match the exercise. Editing makes it much easier. You will not need to change the location of the text, just edit it.

If you would like to print this border, follow the steps on the following pages.

Basic Plotting from Model Space

Note: More Advance plotting methods will be explained in Lessons 26 and 27.

- Important: Open the drawing you want to plot, if it is not already open.
- 2. Select: **Zoom / All** to center the drawing within the plot area.
- 3. Select the Plot command using one of the following:

The Plot - Model dialog box will appear.

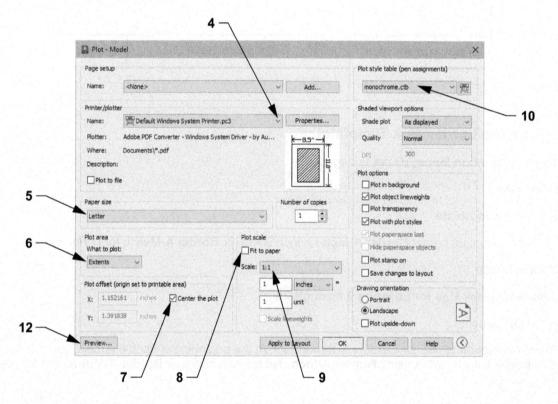

- Select your printer from the drop-down list or use the settings for "Default Windows System Printer.pc3".
 Note: If your printer is not shown in the list, you should configure your printer within AutoCAD. This is not difficult. (Refer to Appendix-A for step-by-step instructions.)
- Select the Paper size: Letter for inch users or A4 for metric users.
- 6. Select the Plot Area: Extents
- Select the Plot Offset: Center the plot
- Uncheck the Fit to paper box
- 9. Select Plot Scale 1:1
- Select the Plot Style table: monochrome.ctb (for all black) acad.ctb (for color)

11. If the following dialog box appears, select Yes

12. Select the Preview... button.

Does your display appear as shown above? If yes, press **<**Enter> and proceed to Step 13. If not, go back and review Steps 1 through 11.

You have just created a **Page Setup**. All of the settings you have selected can now be saved. You will be able to recall these settings for future plots using this Page Setup. To save the Page Setup you need to **Add** it to the Model Tab within this drawing.

13. Select the Add... button.

14. Type the new Page Setup name Class Model A

16. Select the Apply to Layout button.

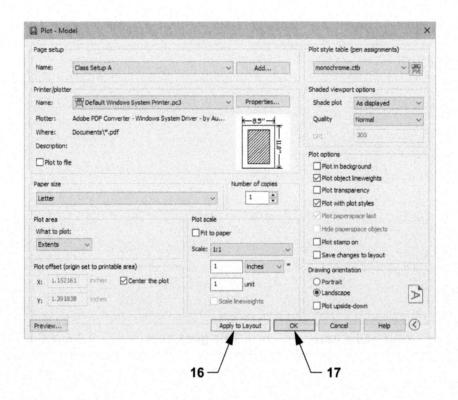

- 17. Select the **OK** button to send the drawing to the printer or select **Cancel** if you do not want to print the drawing at this time. The Page Setup will still be saved.
- 18. Save the entire drawing again as a template using **Save as Drawing Template**: **Border A-Inch** for inch users, or **Border A-Metric** for metric users. (Refer to page 9-11.)

The Page Setup will be saved to the drawing and available to select in the future. You will not have to select all the individual settings again unless you choose to change them.

Now go tape your printout to the refrigerator door.
This is quite an accomplishment.

Exercise 9B

Exercise 9B

Instructions:

- 1. Start a New file using the Border A-Inch.dwt or the Border A-Metric.dwt
- 2. Draw the objects below using absolute and relative coordinates.
- 3. Use Layer Object Line.
- 4. Edit the **Title** and **Ex-XX** by double clicking on the text. Do not erase and replace.
- 5. Do not dimension (we will get to that soon).
- 6. Save as Ex-9B
- 7. Plot using Page Setup Class Model A. (Refer to pages 9-12 through 9-14.)

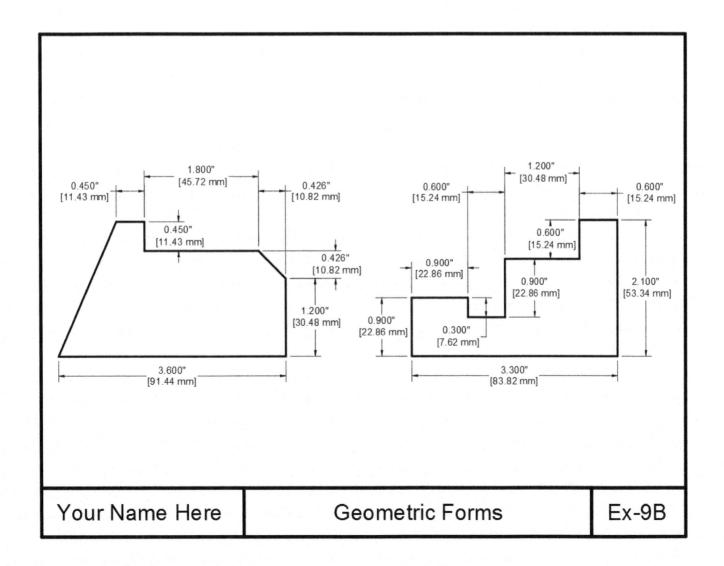

Exercise 9C

Instructions:

- 1. Start a New file using the Border A-Inch.dwt or the Border A-Metric.dwt
- 2. Draw the objects below using Direct Distance Entry (DDE).
- 3. Use Layer Object Line.
- 4. Edit the Title and Ex-XX by double clicking on the text. Do not erase and replace.
- 5. Do not dimension (we will get to that soon).
- 6. Save as Ex-9C
- 7. Plot using Page Setup Class Model A. (Refer to pages 9-12 through 9-14.)

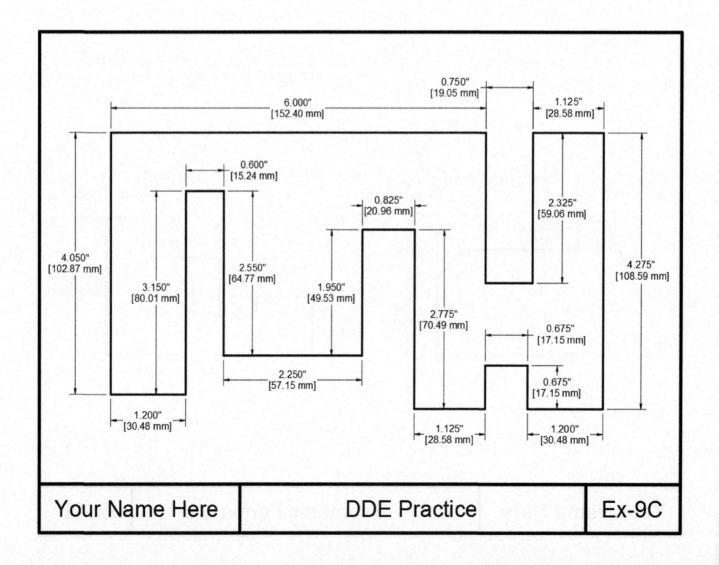

LESSON 10

LEARNING OBJECTIVES

After completing this lesson, you will be able to:

- 1. Move the Origin.
- 2. Control the display of the UCS icon.

Moving the Origin

As previously stated in Lesson 9, the **Origin** is where the X, Y, and Z-axes intersect. The Origin's (0,0,0) default location is in the lower left corner of the drawing area. But you can move the Origin anywhere on the screen using the UCS command. (The default location is designated as the "**World**" option or **WCS**, World Coordinate System. When it is moved, it is UCS, User Coordinate System.)

You may move the Origin many times while creating a drawing. This is not difficult and will make it much easier to draw objects in specific locations.

Refer to the examples on page 10-3.

How to move the Origin

- 1. Right click on the Origin icon.
- 2. Select Origin from the Shortcut Menu.
- 3. Place the new Origin location by entering coordinates or pressing the left mouse button.

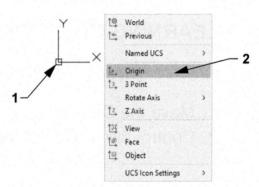

How to return the Origin

To the default "World" location (the lower left corner)

- 1. Right click on the Origin icon.
- 2. Select World from the Shortcut Menu.

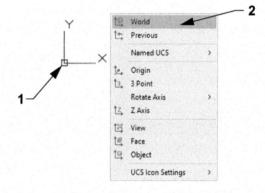

You can quickly return to the default "World" or WCS location by typing in *UCS <Enter>* and then *W <Enter>*.

There is also another method of moving the UCS Origin to a new location.

How to move the Origin

- 1. Left click on the Origin icon.
- 2. Hover your mouse over the blue square base grip until it turns red. A Shortcut Menu will appear.

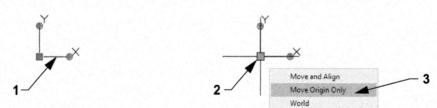

- 3. Select Move Origin Only from the Shortcut Menu.
- 4. Place the new Origin location by entering coordinates or pressing the left mouse button.

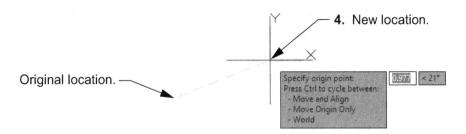

5. Press the **<**Esc> key to deselect the Origin icon.

Why move the Origin?

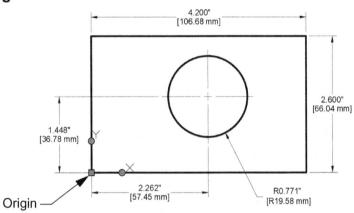

If you move the Origin to the lower left corner of the rectangle, it will make it very easy to accurately place the center of the circle.

How to place the Circle accurately

- 1. Select "Origin" from the Shortcut Menu as shown on the previous page.
- 2. Snap to the lower left corner of the rectangle using Object Snap Endpoint. The UCS icon should now be displayed as shown above.
- 3. Select the Circle command.
- 4. Enter the coordinates to the center of the circle: **2.262,1.448 <Enter>** for inch users, or **57.45,36.78 <Enter>** for metric users.
- 5. Enter the radius: 0.771 <Enter> for inch users, or 19.58 <Enter> for metric users.
- 6. Select "World" from the Shortcut Menu to return the UCS icon to its default location. (Refer to page 10-2.)

More examples of why you would move the Origin

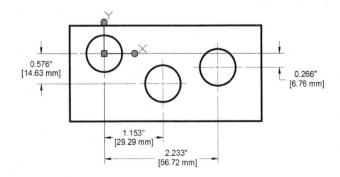

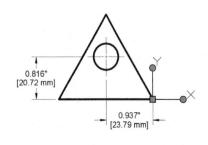

Displaying the UCS Icon

The **UCS icon** is merely a drawing aid that displays the location of the **Origin**. It can move with the Origin or stay in the default location. You can even change its appearance.

Show UCS Icon at Origin

- Right click on the Origin icon.
- 2. Select UCS Icon Settings from the Shortcut Menu.

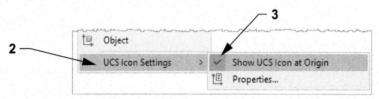

3. Show UCS Icon at Origin

- ☑ The UCS icon will follow the Origin as you move it. You will be able to see the Origin location at a glance.
- ☐ The UCS icon will not follow the Origin. It will stay in its default location.

How to change the UCS icon appearance

- 1. Right click on the Origin icon.
- 2. Select UCS Icon Settings from the Shortcut Menu.

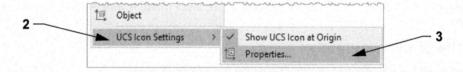

3. Select Properties...

When you select this option, the dialog box shown below will appear. You may change the style, size, and color of the icon at any time. Changing the appearance is a personal preference and will not affect the drawing or commands.

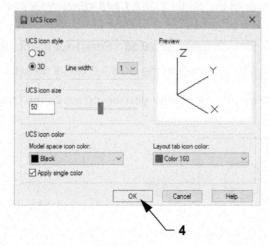

4. When complete, select the **OK** button.

Exercise 10A

Exercise 10A

Instructions:

- 1. Start a New file using the Border A-Inch.dwt or the Border A-Metric.dwt
- 2. Move the Origin to the locations noted before you draw the objects.
- 3. Use Layer Object Line.
- 4. Edit the **Title** and **Ex-XX** by double clicking on the text. Do not erase and replace.
- 5. Do not dimension.
- 6. Save as Ex-10A
- 7. Plot using Page Setup Class Model A. (Refer to pages 9-12 through 9-14.)

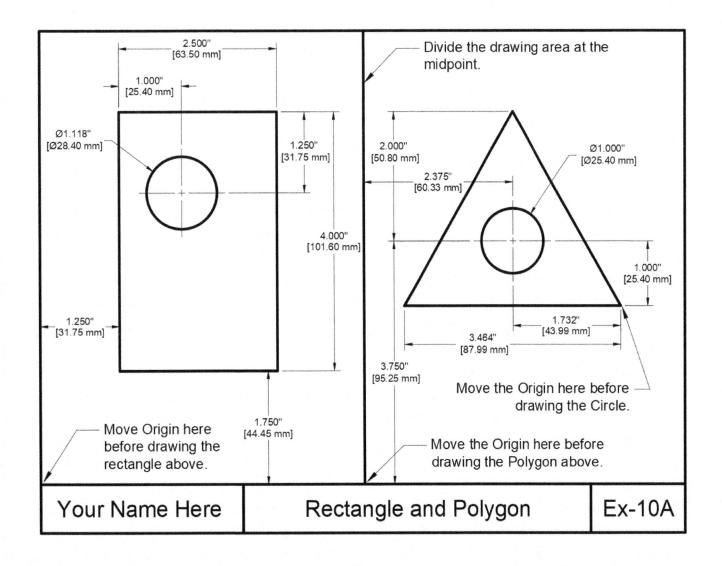

Exercise 10B

Instructions:

- 1. Start a New file using the Border A-Inch.dwt or the Border A-Metric.dwt
- 2. Move the Origin to the locations noted before you draw the objects.
- 3. Use Layer Object Line.
- 4. Edit the Title and Ex-XX by double clicking on the text. Do not erase and replace.
- 5. Do not dimension.
- 6. Save as Ex-10B
- 7. Plot using Page Setup Class Model A. (Refer to pages 9-12 through 9-14.)

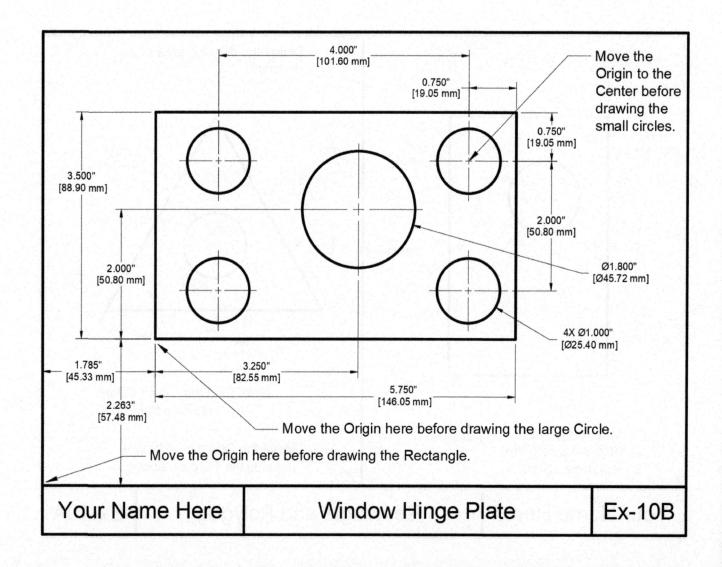

LESSON 11

LEARNING OBJECTIVES

After completing this lesson, you will be able to:

- 1. Understand the Polar Degree Clock.
- 2. Draw Lines to a specific length and angle.
- 3. Draw objects using Polar coordinate input.
- 4. Use Dynamic Input.
- 5. Use Polar Tracking and Polar Snap.

Polar Coordinate Input

In Lesson 9, you learned to control the length and direction of horizontal and vertical lines using Relative Input and Direct Distance Entry. Now you will learn how to control the length and **angle** of a line using **Polar coordinate** input.

Understanding the "Polar Degree Clock"

Previously when drawing horizontal and vertical lines, you controlled the direction using a **Positive** or **Negative** input. **Polar coordinate input is different**. The angle of the line will determine the direction.

Example: If you wanted to draw a line at a 45 degree angle toward the upper right corner, you would use the angle 45. But if you wanted to draw a line at a 45 degree angle toward the lower left corner, you would use the angle 225.

You may also use Polar coordinate input for horizontal and vertical lines using the angles 0, 90, 180, and 270. No negative input is required.

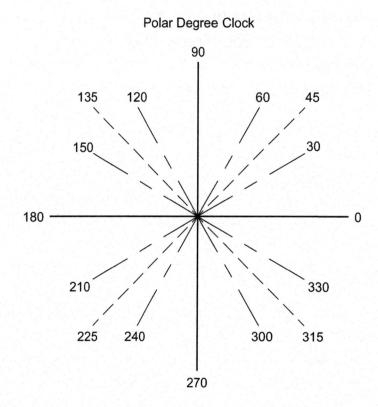

Drawing with Polar Coordinate Input

When entering Polar coordinates, the first number represents the **distance** and the second number represents the **angle**. The two numbers are separated by the **less than (<)** symbol. The input format is: **distance < angle**.

A Polar coordinate of @6<45 will be a distance of 6 units and an angle of 45 degrees from the last point entered.

Here is an example of Polar coordinate input for four line segments.

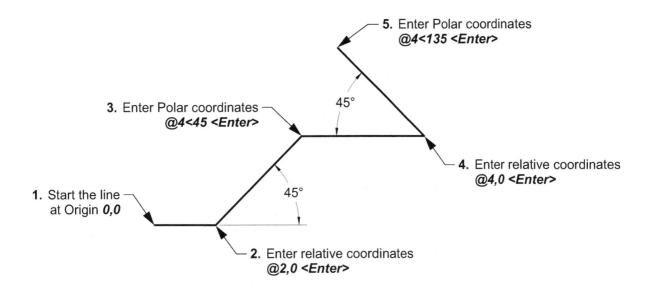

Dynamic Input

To help you keep your focus in the "drawing area", AutoCAD has provided a command interface called **Dynamic Input**. You may input information within the Dynamic Input tooltip box instead of on the Command Line.

When AutoCAD prompts you for the **first point**, the Dynamic Input tooltip displays the **absolute: X**, **Y** distance from the Origin.

Enter the **X** dimension, press the **<***Tab***>** key, enter the **Y** dimension, and then press **<***Enter***>**.

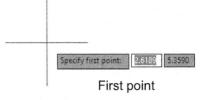

When AutoCAD prompts you for the **second** and all **next points**, the Dynamic Input tooltip displays the **relative: distance and angle** from the last point entered.

Enter the **distance**, press the **<Tab>** key, move the cursor in the approximate desired angle, enter the **angle**, and then press **<Enter>**.

(Note: The @ is not necessary.)

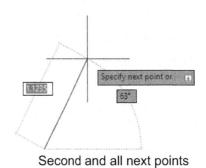

How to turn Dynamic Input on or off

Select the **Dynamic Input** button on the Status Bar or use the **<F12>** key.

Here is an example of Dynamic Input for four line segments.

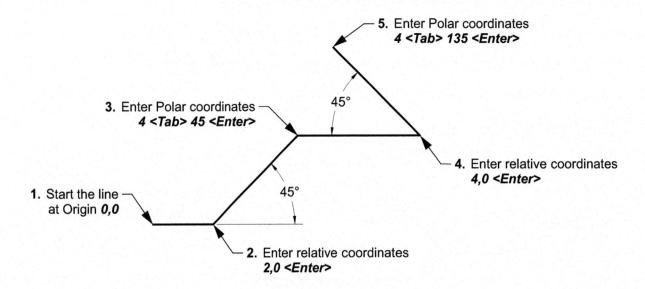

To enter Cartesian coordinates (X and Y)

- 1. Enter an "X" coordinate value and a comma.
- 2. Enter a "Y" coordinate value < Enter>.

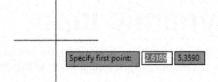

To enter Polar coordinates (from the last point entered)

- 1. Enter the distance value from the last point entered.
- 2. Press the <Tab> key.
- 3. Move the cursor in the approximate direction and enter the angle value <*Enter>*.

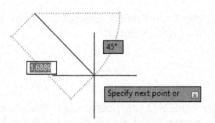

Note: Move the cursor in the approximate direction and enter an angle value of **0-180 only**. Dynamic Input does not use 360 degrees. (Refer to the example on the next page.)

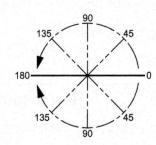

How to specify absolute or relative coordinates while using Dynamic Input

To enter **absolute** coordinates when relative coordinate format is displayed in the tooltip: Enter # to temporarily override the setting.

To enter **relative** coordinates when absolute coordinate format is displayed in the tooltip: Enter **@** to temporarily override the setting.

You may toggle OrthoMode **on** and **off** by holding down the **<Shift>** key. This is an easy method for using Direct Distance Entry while using Dynamic Input.

Using Dynamic Input and Polar Coordinates

The following is a simple drawing to practice Dynamic Input and Polar coordinates. Think about how this differs from the basic Polar coordinate input on page 11-2 and 11-3.

See the example on the next page.

1. Set the Status Bar as follows:

Dynamic Input = on All others = off

- 2. Select the Line command.
- 3. Start the line near the lower left corner of the drawing area.
- **Line A** 4. Move the cursor to the right.
 - 5. Type 2 [50.8] <Tab> 0 <Enter> (Note: Sizes in [....] are for metric users.)
- **Line B** 6. Move the cursor up and to the right.
 - 7. Type 3 [76.2] <Tab> 45 <Enter>.
- **Line C** 8. Move the cursor up.
 - 9. Type 2 [50.8] <Tab> 90 <Enter>.
- **Line D** 10. Move the cursor down and to the left.
 - 11. Type 4 [101.6] <Tab> 135 <Enter>. (Note: 180 45 = 135)

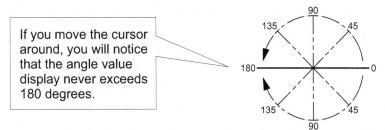

- Line E 12. Move the cursor to the left.
 - 13. Type 1.293 [32.84] <Tab> 180 <Enter>.
- Line F 14. Move the cursor down.
 - 15. Type 1.293 [32.84] <Tab> 90 <Enter>.
 - 16. Press **<Enter>** to stop.

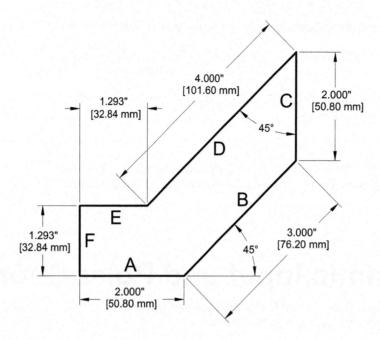

Note: For more on Dynamic Input, see Appendix B.

Polar Tracking

Polar Tracking can be used **instead** of **Dynamic Input**. When **Polar Tracking** is **"on"**, a dotted **"tracking"** line and a **"tooltip"** box appear. The tracking line **"snaps"** to a **preset angle increment** when the cursor approaches one of the preset angles. The word **"Polar"**, followed by the **"distance"** and **"angle"** from the last point appears in the box. (A step-by-step example is described on the next page.)

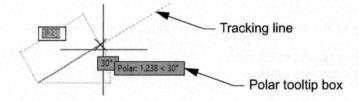

How to set the Increment Angle

 Left click on the Polar Tracking button down arrow → on the Status Bar and select "Tracking Settings", or select an angle from the list.

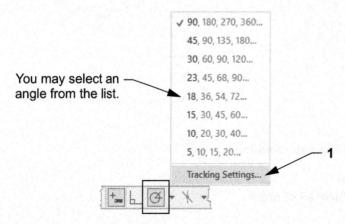

- 2. The **Drafting Settings** dialog box will appear.
- 3. Select the Polar Tracking Tab.

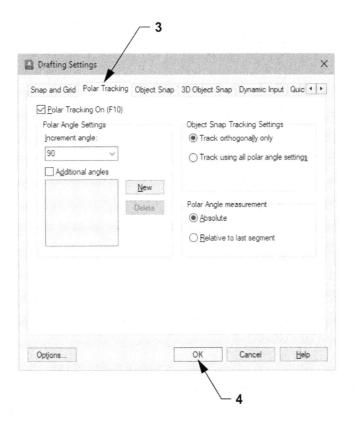

Polar Tracking Tab descriptions

Polar Angle Settings

Increment angle: Choose from the Increment angle list including 90, 45, 30, 22.5, 18, 15,10, and 5. It will also snap to the selected angles multiples. For example, if you choose 30, it will snap to 30, 60, 90, 120, 150, 180, 210, 240, 270, 300, 330, and, 0.

Additional angles: Check this box if you would like to use an angle other than one in the Increment angle list. For example, 12.5.

New: You may add an angle by selecting the "**New**" button. You will be able to snap to this new angle in addition to the incremental angle selected. **But you will not be able to snap to its multiple**. For example, if you selected 7, you would not be able to snap to 14.

Delete: Deletes an Additional angle. Select the Additional angle to be deleted and then the **Delete** button.

Polar Angle Measurement

Absolute: Polar Tracking angles are relative to the UCS.

Relative to last segment: Polar Tracking angles are relative to the last segment.

4. Make any necessary changes and then select the **OK** button to close the **Drafting Settings** dialog box.

Using Polar Tracking and DDE

- 1. Set the Polar Tracking Increment angle to 15.
- 2. Turn all the Status Bar buttons to **off** except **Polar**. (**Note**: Dynamic Input should be **off**, but you may wish to leave it on.)

- 3. Select the Line command.
- P1 4. Start the line in the lower left area of the drawing area.
- P2 5. Move the cursor in the direction of P2 until the tooltip box displays 30 degrees.
 - 6. Type 2 [50.8] <Enter> (for the length). (Note: Sizes in [....] are for metric users.)
- P3 7. Move the cursor in the direction of P3 until the tooltip box displays 90 degrees.
 - 8. Type 2 [50.8] < Enter > (for the length).
- P4 9. Move the cursor in the direction of P4 until the tooltip box displays 0 degrees.
 - 10. Type 2 [50.8] <Enter> (for the length).
- P5 11. Move the cursor in the direction of P5 until the tooltip box displays 150 degrees.
 - 12. Type 2 [50.8] <Enter> (for the length).
- P6 13. Move the cursor in the direction of P6 until the tooltip box displays 180 degrees.
 - 14. Type 2 [50.8] < Enter > (for the length).
 - 15. Then type C for Close.

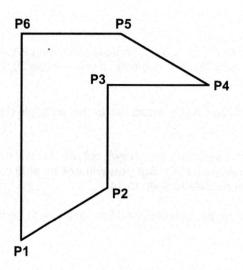

You may toggle Polar Tracking **on** or **off** by using one of the following methods: either left click on the **Polar** button on the Status Bar or press **<F10>**.

Polar Snap

Polar Snap is used with **Polar Tracking** to make the cursor snap to specific **distances** and **angles**. If you set **Polar Snap distance** to **1** and **Polar Tracking** to **angle 30**, you can draw lines 1, 2, 3, or 4 units long at an angle of 30, 60, 90, etc. without typing anything. You just move the cursor and watch the tooltips.

(A step-by-step example is described on the next page.)

Setting the Polar Snap

- 1. Set the **Polar Tracking Increment angle** as shown on page 11-7.
- Left click on the Snap button down arrow ✓ on the Status Bar and select "Snap Settings".

3. Select the Snap and Grid Tab.

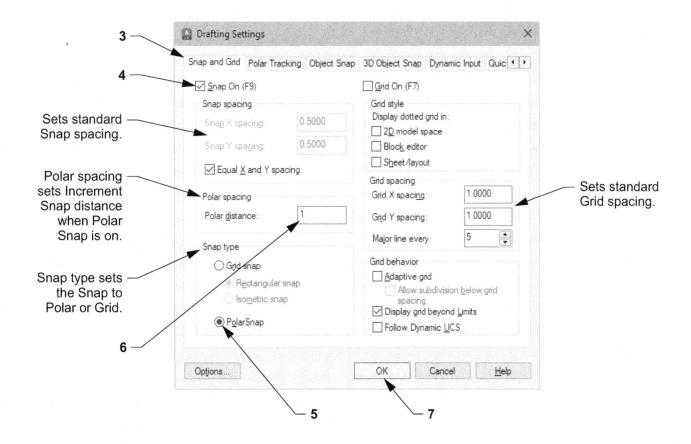

- 4. Select Snap On.
- Select PolarSnap.
- 6. Set the Polar distance.
- 7. Select the OK button.

Using Polar Tracking and Polar Snap

Now let's draw the objects below again, but this time let's use "Polar Snap".

- 1. Set Polar Tracking Increment angle to 30 and Polar Snap to 1.000 [25.4]
- 2. Turn all the Status Bar buttons to off except Snap and Polar.

- 3. Select the Line command.
- P1 4. Start the line in the lower left area of the drawing area.
- P2 5. Move the cursor in the direction of P2 until the tooltip box displays Polar 2.000 [50.8] <30° and then left click.</p>
- P3 6. Move the cursor in the direction of P3 until the tooltip box displays Polar 2.000 [50.8] <90° and then left click.
- P4 7. Move the cursor in the direction of P4 until the tooltip box displays Polar 2.000 [50.8] <0° and then left click.</p>
- P5 8. Move the cursor in the direction of P5 until the tooltip box displays Polar 2.000 [50.8] <150° and then left click.
- P6 9. Move the cursor in the direction of P6 until the tooltip box displays Polar 2.000 [50.8] <180° and then left click.
 - 10. Then type C for Close.

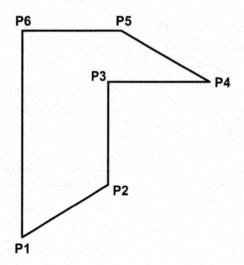

Exercise 11A-Inch

Exercise 11A-Inch

Instructions:

- 1. Start a New file using the Border A-Inch.dwt
- 2. After reviewing the lengths and angles below, set the Polar Tracking Increment angle and Polar Snap distance.

Note: You may have to "override" a few of the lengths. (See bottom of 11-10.)

- 3. Use Layer Object Line.
- 4. Edit the **Title** and **Ex-XX** by double clicking on the text. Do not erase and replace.
- 5. Do not dimension.
- 6. Save as Ex-11A-I
- 7. Plot using Page Setup Class Model A

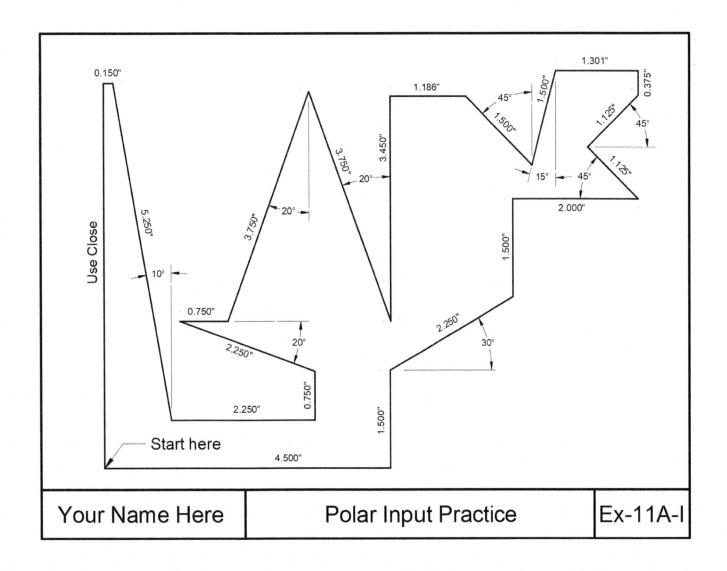

Exercise 11A-Metric

Exercise 11A-Metric

Instructions:

- 1. Start a New file using the Border A-Metric.dwt
- After reviewing the lengths and angles below, set the Polar Tracking Increment angle and Polar Snap distance.

Note: You may have to "override" a few of the lengths. (See bottom of 11-10.)

- 3. Use Layer Object Line.
- 4. Edit the **Title** and **Ex-XX** by double clicking on the text. Do not erase and replace.
- 5. Do not dimension.
- 6. Save as Ex-11A-M
- 7. Plot using Page Setup Class Model A

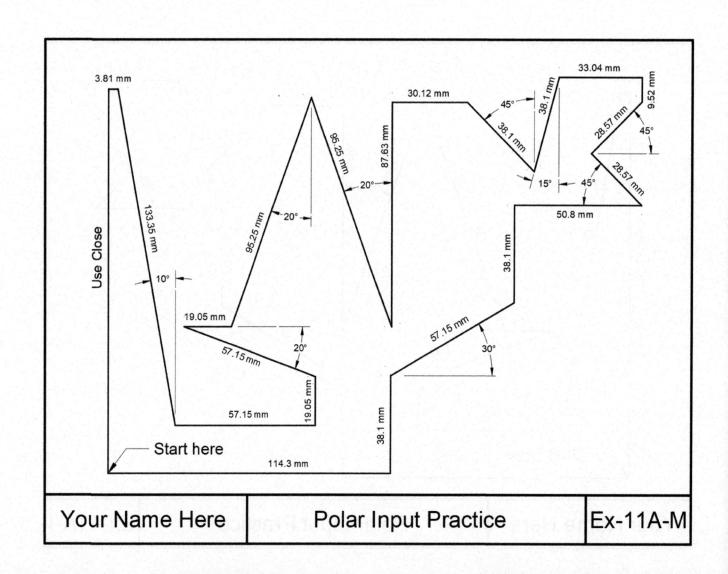

Exercise 11B-Inch

Instructions:

- 1. Start a New file using the Border A-Inch.dwt
- 2. After reviewing the lengths and angles below, set the Polar Tracking Increment angle to **30**, and the Polar Snap distance to **0.125**

Note: The isometric lines are 30, 90, 150, 210, 270, and 330. (Refer to page 11-2.)

- 3. Use Layer Object Line.
- 4. Edit the Title and Ex-XX by double clicking on the text. Do not erase and replace.
- 5. Do not dimension.
- 6. Save as Ex-11B-I
- 7. Plot using Page Setup Class Model A

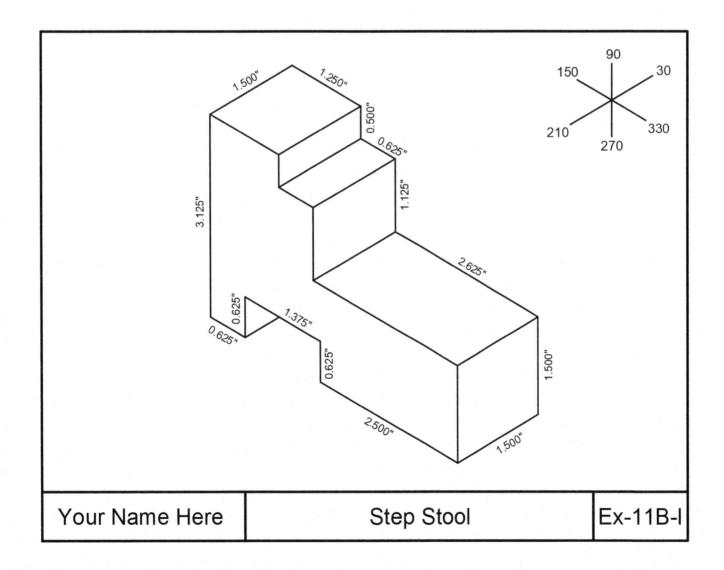

Exercise 11B-Metric

Exercise 11B-Metric

Instructions:

- 1. Start a New file using the Border A-Metric.dwt
- 2. After reviewing the lengths and angles below, set the Polar Tracking Increment angle to **30**, and the Polar Snap distance to **5**

Note: The isometric lines are 30, 90, 150, 210, 270, and 330. (Refer to page 11-2.)

- 3. Use Layer Object Line.
- 4. Edit the Title and Ex-XX by double clicking on the text. Do not erase and replace.
- 5. Do not dimension.
- 6. Save as Ex-11B-M
- 7. Plot using Page Setup Class Model A

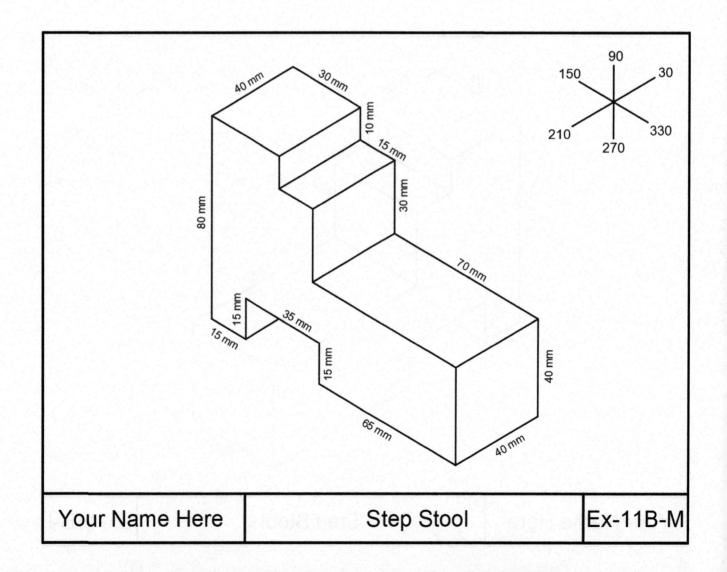

Exercise 11C

Exercise 11C

Instructions:

- 1. Start a New file using the Border A-Inch.dwt or the Border A-Metric.dwt
 - Note: You will have to do some adding and subtracting on this one.
- 2. Draw the 5.000" [127 mm] diameter circle using Layer Object Line.
- 3. Draw the 4.000" [101.6 mm] diameter circle using Layer Centerline.
- 4. Draw each Polar line on Layer Centerline using the following example: For example, the line marked "X" is drawn as follows:
 - A. Place first endpoint in the center of the circle.
 - B. Enter Polar coordinates for second endpoint (distance 2.750" [69.85 mm] angle 138). (Refer to the Polar Degree Clock on page 11-2.)
- 5. Draw the 0.500" [12.7 mm] diameter circles. Locate their center using Object Snap Intersection.
- 6. Edit the Title and Ex-XX by double clicking on the text. Do not erase and replace.
- 7. Do not dimension.
- 8. Save as Ex-11C
- 9. Plot using Page Setup Class Model A

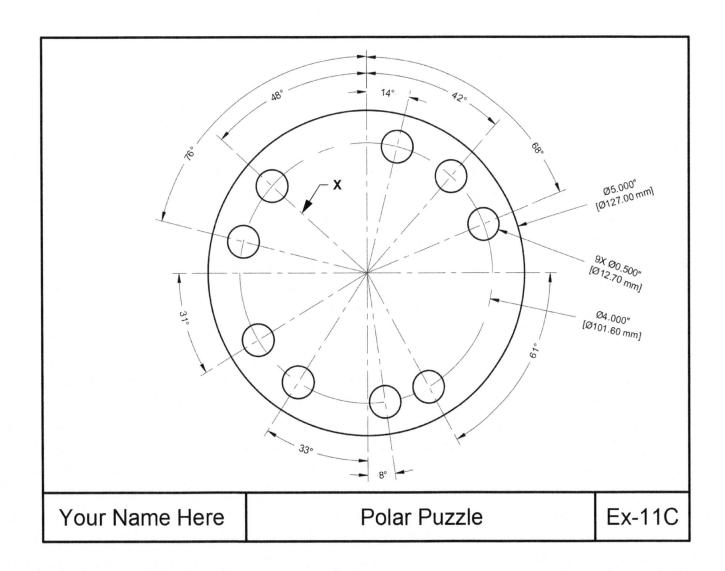

Notes:

LESSON 12

LEARNING OBJECTIVES

After completing this lesson, you will be able to:

- 1. Duplicate an object at a specified distance away.
- 2. Make changes to an object's properties.
- 3. Use the Quick Properties Panel.

12-2 Offset

Offset

The **Offset** command duplicates an object parallel to the original object at a specified distance. You can offset lines, arcs, circles, ellipses, 2D polylines, and splines. You may duplicate the original object or assign the offset copy to another layer.

Examples of Offset objects:

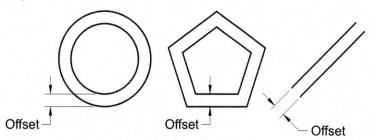

How to use the Offset command

Method 1: (Duplicate the original object.)

1. Select the Offset command using one of the following:

The following will appear on the Command Line:

2. Type the offset distance you require and then press **<Enter>**. (Also see **Offset Options** on the next page.)

The following will appear on the Command Line:

3. Select the object to offset (left click).

The following will appear on the Command Line:

- Select which side of the original you want the duplicate to appear on by placing your cursor and left clicking. (Also see Offset Options on the next page.)
- 5. Continue to offset objects or press < Enter> to end the command.

Method 2: (Duplicate the original object but assign the Offset **copy** to a different layer.)

To automatically place the offset copy on a different layer than the original, you must first change the "current" layer to the layer you want the offset copy to be placed on.

- Select the layer that you want the offset copy placed on from the list of layers.
- 2. Select the Offset command.

Offset

The following will appear on the Command Line:

3. Type *L* and then press *<Enter>*.

The following will appear on the Command Line:

- 4. Type C and then press < Enter>.
- 5. Now follow Step 2 through Step 5 on the previous page to finish the Offset command.

Offset Options

Through: Creates an object passing through a specified point.

Erase: Erases the source object after it is offset.

Layer: Determines whether offset objects are created on the **current** layer or on the layer of the **source** object. Select **Layer** and then select **current** or **source**. (Source is the default.)

Multiple: Turns on the multiple offset mode, which allows you to continue creating duplicates of the original without reselecting the original.

Exit: Exits the Offset command.

Undo: Removes the previous offset copy.

Properties Palette

The **Properties Palette**, shown below, makes it possible to change an object's properties. You simply open the Properties Palette, select an object, and you can change any of the properties that are listed.

How to open the Properties Palette

1. Open the Properties Palette using one of the following:

Ribbon = Home Tab / Properties Panel / → or Keyboard = <Ctrl + 1>

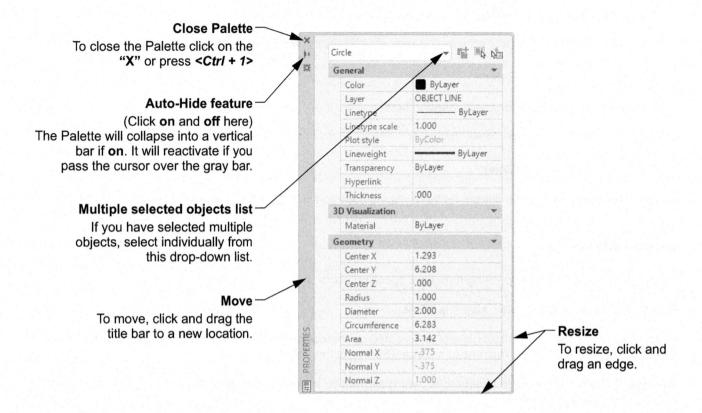

Example of editing an object using the Properties Palette

- 1. Draw a 2.000" [50.8 mm] radius circle.
- Open the Properties Palette and select the Circle. (The Properties for the circle should appear. You may
 change any of the properties listed in the Properties Palette for this object. When you press < Enter>, the circle
 will change.)

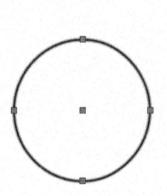

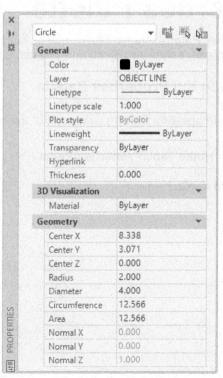

3. Highlight and change the "Radius" to 1.000" [25.4 mm] and the "Layer" to Hidden Line and then press <*Enter>*. The circle got smaller and the layer changed as shown below.

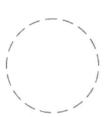

Note: The Properties Palette will show different sizes for metric users.

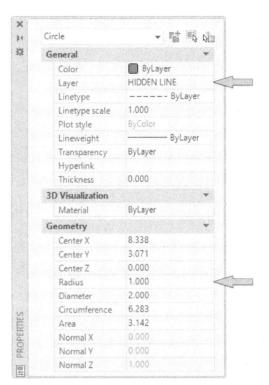

Quick Properties Panel

The **Quick Properties Panel**, shown below, will only appear if you have it set to **o**n. The Quick Properties Panel displays fewer properties and appears when you click once on an object. You may make changes to the objects properties using Quick Properties just as you would using the Properties Palette. (AutoCAD is just giving you another option.)

How to turn Quick Properties Panel on or off

Select the **Quick Properties** button on the Status Bar. **Note:** The Quick Properties button is not displayed by default, to display the button, refer to pages 1-12 and 1-16.

1. Select an object.

2. The Quick Properties Panel appears.

Note: The list depends on the type of object you have selected, such as: circle, line, rectangle, etc.

Customizing the Quick Properties Panel

You may add or remove properties from the Quick Properties Panel. And it is easy.

1. Select the Customize User Interface button.

- 2. Select the object, from the list, that you would like to customize.
- 3. Check the boxes for the properties that you want to appear. Uncheck the boxes that you do not want to appear.
- Select Apply and then OK

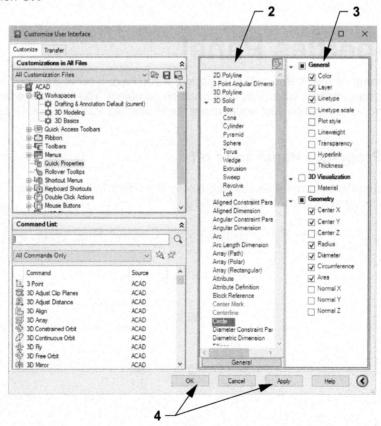

Note: The customizing is saved to the computer not the drawing file.

Offsetgaptype

When you offset a closed 2D object, such as a rectangle, to create a larger object, it results in potential gaps between the segments. The **offsetgaptype** system variable controls how these gaps are closed.

To set the offsetgaptype

4	T	offsetgaptype			15-4
	LVDe	onseroantvoe	and then	nress	<-nter>

The following will appear on the Command Line:

X	. A.

- 2. Enter one of the following variables:
 - **0** = Fills the gap by extending the polyline segments (default setting).

1 = Fills the gap with **filleted arc segments**. The radius of each arc segment is equal to the offset distance.

2 = Fills the gap with **chamfered line segments**. The perpendicular distance to each chamfer is equal to the offset distance.

Exercise 12A

Instructions:

- 1. Start a New file using the Border A-Inch.dwt or the Border A-Metric.dwt
- 2. Draw the objects below using circles, rectangles, and lines.
- 3. Use the Offset command to offset the objects.
- 4. Use Layers Object Line and Hidden Line.
- 5. Edit the **Title** and **Ex-XX** by double clicking on the text. Do not erase and replace.
- 6. Do not dimension.
- 7. Save as Ex-12A
- 8. Plot using Page Setup Class Model A

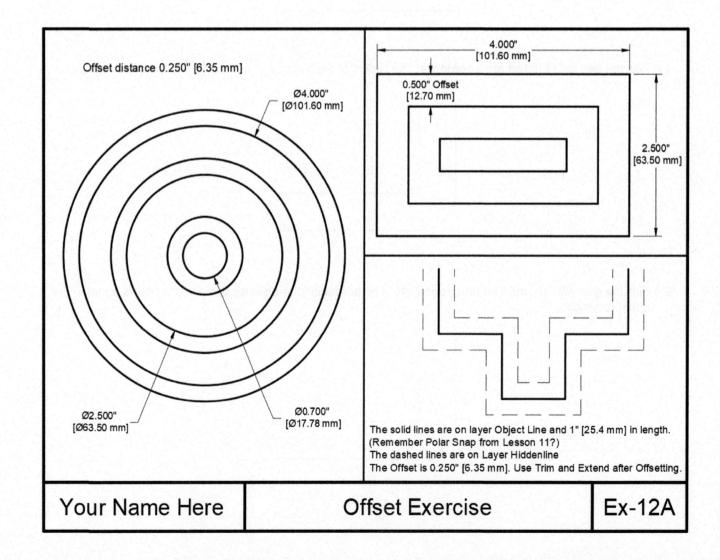

Exercise 12B-Inch

Exercise 12B-Inch

Instructions:

- 1. Start a New file using the Border A-Inch.dwt
- 2. Follow the steps shown on the next page to draw the Window Schedule shown below.
- 3. Use Layers Object Line and Text (change the Object Line lineweight to 0.020").
- 4. Edit the **Title** and **Ex-XX** by double clicking on the text. Do not erase and replace.
- 5. Do not dimension.
- 6. Save as Ex-12B-I
- 7. Plot using Page Setup Class Model A

Follow the instructions on the next page.

		MNDOW	SCHEDULE		
	SYM	SIZE	TYPE		
	A	5'-0" X 4'-0"	WOOD FIXED		
	B	3'-0" X 4'-0"	WOOD FIXED		
	0	3'-0" X 3'-0"	WOOD FIXED		
	(D)	2'-0" X 3'-0"	ALUMINUM SLIDER		
Your Name Here		Wi	ndow Sched	ule	Ex-12B-

Exercise 12B-Inch Helper

Exercise 12B-Inch Helper

- Step 1. Draw the Window Schedule using the Offset command.
- **Step 2.** Draw four diagonal guidelines using the "Intersection" Snap. Then draw four circles with a diameter of **0.250"** using the "Midpoint" Snap. Then change the lineweight of the circles to **0.010"**.

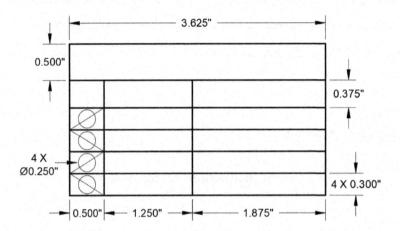

Step 3. Draw the guidelines as shown using Object Snap "Intersection" for the diagonal lines. Use the Offset command for the horizontal and vertical lines.

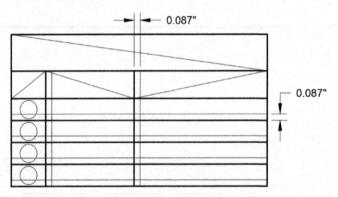

Step 4. Using "Single Line Text" and place text as shown. All text height is 0.125" except the title. Title height is 0.188".

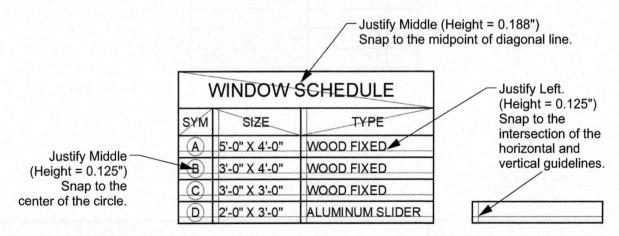

Step 5. Erase all the guidelines.

Exercise 12B-Metric

Instructions:

- 1. Start a New file using the Border A-Metric.dwt
- 2. Follow the steps shown on the next page to draw the Window Schedule shown below.
- 3. Use Layers Object Line and Text (change the Object Line lineweight to **0.5 mm**).
- 4. Edit the **Title** and **Ex-XX** by double clicking on the text. Do not erase and replace.
- 5. Do not dimension.
- 6. Save as Ex-12B-M
- 7. Plot using Page Setup Class Model A

Follow the instructions on the next page.

	10/11	NDOW 9	SCHEDULE		
	SYM	SIZE	TYPE		
		I X 1.5M	WOOD FIXED		
		I X 1.5M	WOOD FIXED		
	© 1M	I X 1M	WOOD FIXED		
	D 0.5	SM X 1M	ALUMINIUM SLIDER		
Your Name Here		Win	dow Schedul	е	Ex-12B-M

Exercise 12B-Metric Helper

Exercise 12B-Metric Helper

- Step 1. Draw the Window Schedule using the Offset command.
- **Step 2.** Draw four diagonal guidelines using the "Intersection" Snap. Then draw four circles with a diameter of **6.35 mm** using the "Midpoint" Snap. Then change the lineweight of the circles to **0.25 mm**.

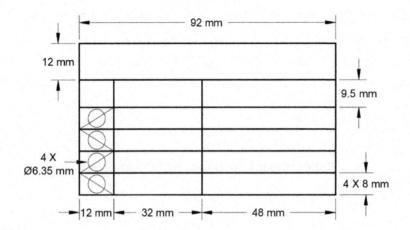

Step 3. Draw the guidelines as shown using Object Snap "Intersection" for the diagonal lines. Use the Offset command for the horizontal and vertical lines.

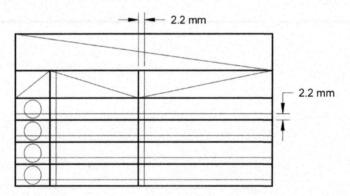

Step 4. Using "Single Line Text" and place text as shown. All text height is **3.2 mm** except the title. Title height is **5 mm**.

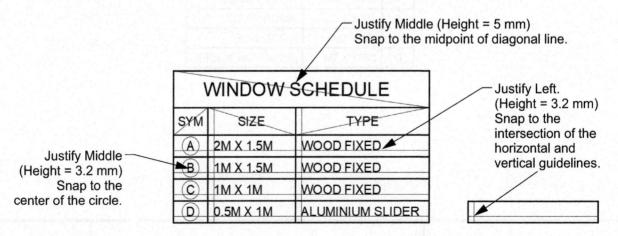

Step 5. Erase all the guidelines.

Exercise 12C

Instructions:

- 1. Start a New file using the Border A-Inch.dwt or the Border A-Metric.dwt
- 2. Draw a horizontal and vertical line on Layer Object Line.

3. Draw the upper half using the Offset command.

- 4. Mirror the upper half. (Do not include the horizontal Centerline.)
- 5. Change the horizontal line to Layer Centerline using Properties Palette or Quick Properties.
- 6. Edit the **Title** and **Ex-XX** by double clicking on the text. Do not erase and replace.
- 7. Do not dimension.
- 8. Save as Ex-12C
- 9. Plot using Page Setup Class Model A

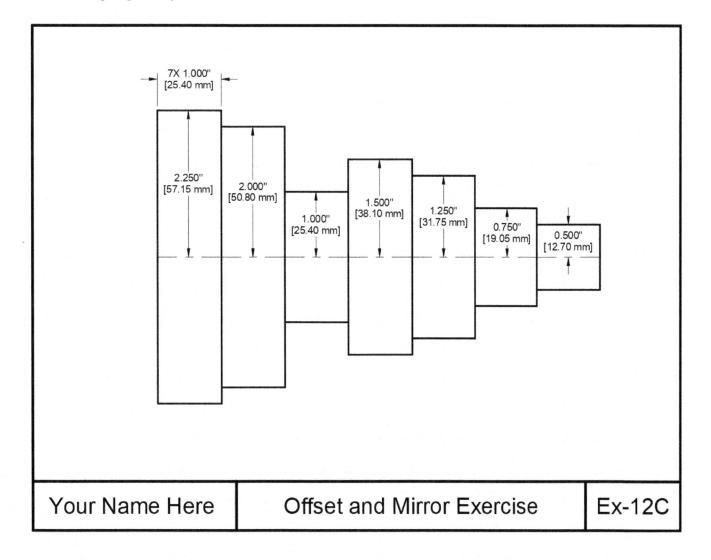

Exercise 12D

Exercise 12D

Instructions:

- 1. Start a New file using the Border A-Inch.dwt or the Border A-Metric.dwt
- 2. Draw the lamp base below.
- 3. Practice using the "Layer method" when offsetting the hidden lines. Or use the Properties Palette or Quick Properties.
- 4. Notice that the part is symmetrical. Consider the **Mirror** command.
- 5. Use Layers Object line, Hidden Line, and Centerline.
- 6. Edit the Title and Ex-XX by double clicking on the text. Do not erase and replace.
- 7. Do not dimension.
- 8. Save as Ex-12D
- 9. Plot using Page Setup Class Model A

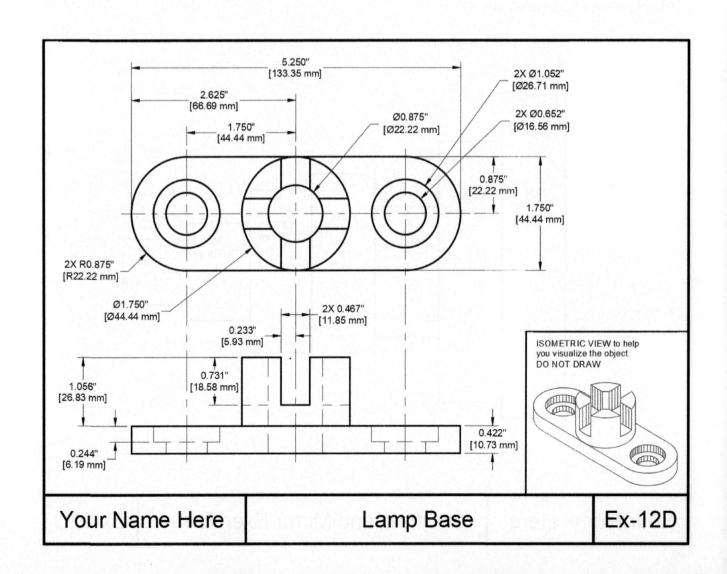

LESSON 13

LEARNING OBJECTIVES

After completing this lesson, you will be able to:

- 1. Create multiple copies in a Rectangular or Circular pattern or Path.
- 2. Understand how to Array objects.

13-2 Array

Array

The Array command allows you to make multiple copies in a Rectangular or Polar (circular) pattern and even on a Path. The maximum limit of copies per array is 100,000. This limit can be changed but should accommodate most users. (Refer to the Autodesk Assistant or AutoCAD Help Menu if you choose to change the limit.)

Rectangular Array

This method allows you to make multiple copies of object(s) in a rectangular pattern. You specify the number of rows (horizontal), columns (vertical) and the spacing between the rows and columns. The spacing will be equally spaced between copies.

Spacing is sometimes tricky to understand. Read this carefully. The spacing is the distance from a specific location on the original to that same location on the future copy. It is not just the space in between the two. Refer to the example below.

To use the Rectangular Array command, you will select the object(s) and specify how many rows and columns are desired, and the spacing for the rows and the columns.

Example of a Rectangular Array:

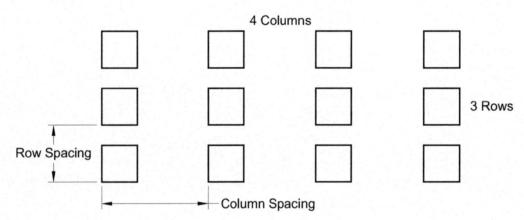

How to create a Rectangular Array

- 1. Draw a 1" [25.4 mm] square rectangle.
- Select the Array command using one of the following:

Ribbon = Home Tab / Modify Panel / ▼

3. Select Rectanguar Array.

The following will appear on the Command Line:

4. Select the object(s) to be arrayed and then press **Enter>**.

The Array Creation Tab appears and a 3 x 4 default grid array of the object(s) selected.

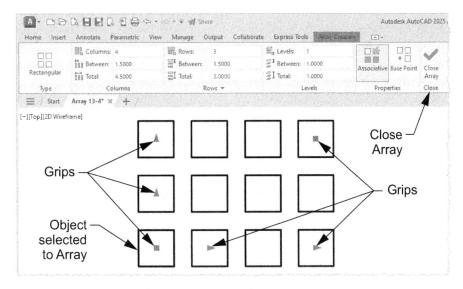

- 5. Make any changes necessary in the Array Creation Tab, then press < Enter> to display any changes.
- 6. If the display is correct, select Close Array.

How to edit a Rectangular Array

1. Select the Array to edit.

The **Array** Tab is displayed. (The **Quick Properties** will also be displayed if you have the Quick Properties button **on** in the Status Bar.)

- 2. Make any changes necessary in the Array Tab, then press < Enter> to display any changes.
- 3. If the display is correct, select **Close Array**.

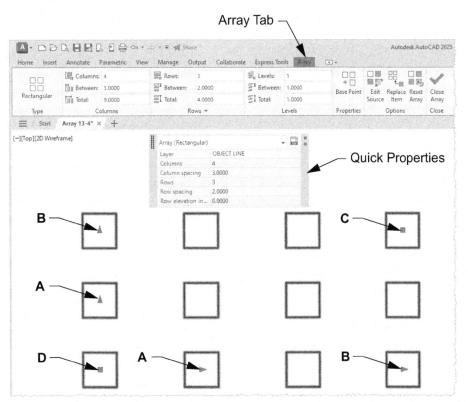

13-4 Array

How to edit a Rectangular Array

Using Grips to edit.

You may also use the grips to edit the spacing. Just click on a grip and drag.

- A. The first ▶ or ▲ allows you to change the spacing between the columns or rows.
- B. The last ➤ or ▲ allows you to change the total spacing between the basepoint
 and the last ➤ or ▲ and also to add extra columns or rows, or change the axis angle.
- C. The allows you to change the total row and column spacing simultaneously, and also to add extra columns and rows simultaneously.
- D. Use the basepoint grip

 to Move the entire Array.

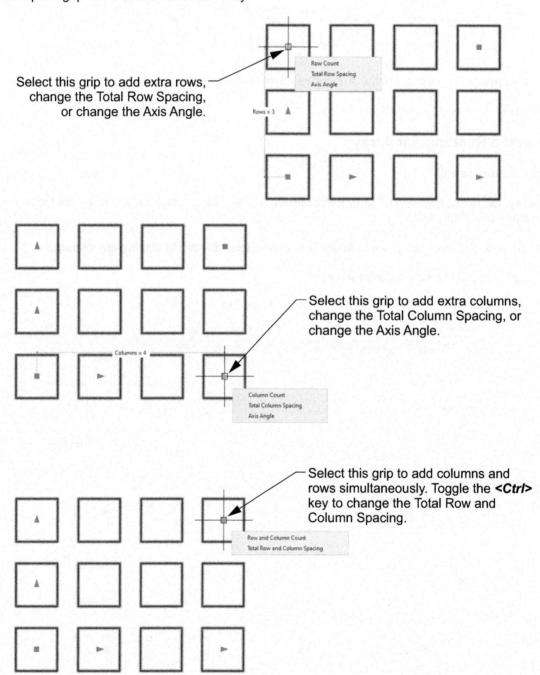

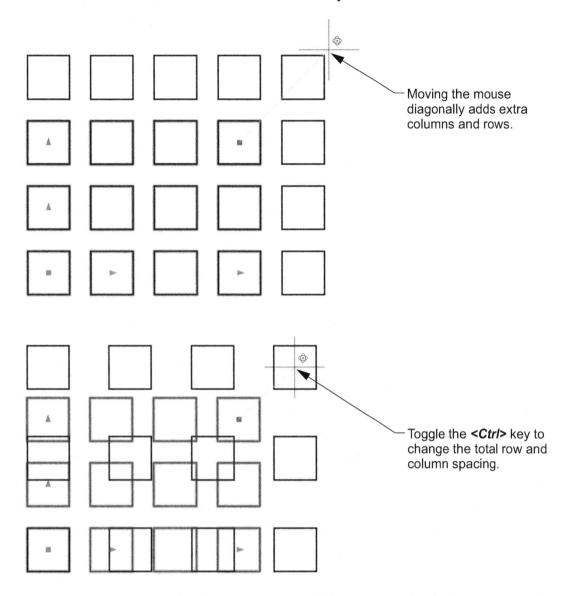

Polar Array

This method allows you to make multiple copies in a **circular pattern**. You specify the total number of copies to fill a specific angle or specify the angle between each copy and angle to fill.

To use the Polar Array command, you select the object(s) to array and specify the center of the array, the number of copies or the angle between the copies, the angle to fill, and if you would like the copies to rotate as they are copied, or not rotate as they are copied.

Example of a Polar Array:

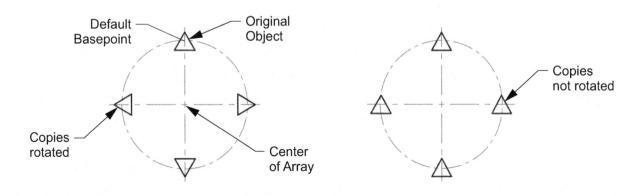

Note: The two examples shown on the previous page use the **objects default basepoint**. The examples below displays what happens if you **specify a basepoint**.

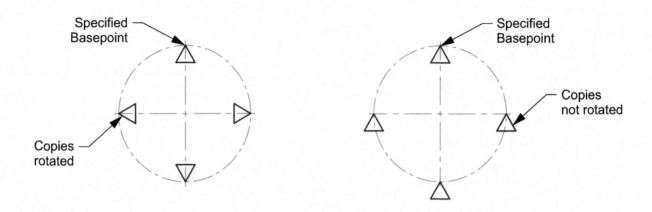

How to create a Polar Array

Using "Number of Items".

- 1. Draw a 3" [76.2mm] radius circle.
- 2. Add a 0.50" [12.7 mm] radius three-sided polygon and place as shown.

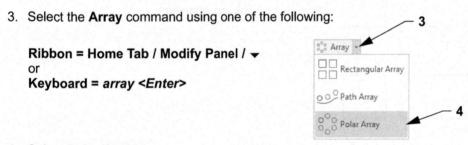

4. Select Polar Array.

The following will appear on the Command Line:

5. Select the object to be arrayed (the polygon) and then press < Enter>.

The following will appear on the Command Line:

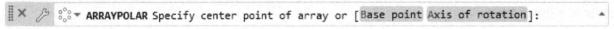

6. Select the center point of the circle.

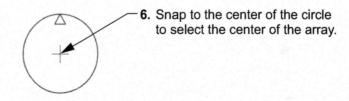

The **Array Creation** Tab appears and the array defaults to 6 items.

- 7. Enter Items: 12
- Enter Fill: 360
- Press **<Enter>** to display the selections.
- 10. Select Close Array if display is correct.

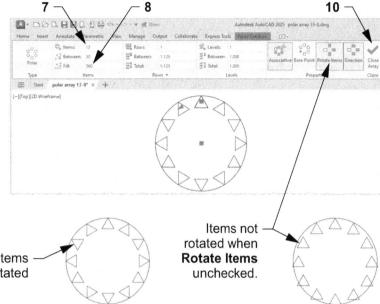

Note:

12 items were evenly distributed within 360 degrees.

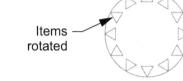

How to create a Polar Array

Using "Angle Between".

- 1. Draw a 3" [76.2mm] radius circle.
- 2. Add a 0.50" [12.7 mm] radius three-sided polygon and place as shown.
- 3. Select Polar Array.
- 4. Select the object to be arrayed (the polygon) and then press **<Enter>**.
- 5. Select the center point of the circle.

The Array Creation Tab appears and the array defaults to 6 items.

- 6. If not already correct, enter Items: 6
- 7. Enter Between: 45
- 8. Press < Enter> to display the selections.
- 9. Select Close Array if display is correct.

ONE?

Items not rotated when **Rotate Items**

unchecked.

Note:

6 items were copied at each 45 degree counter-clockwise.

To have the items copied in a clockwise direction, uncheck the "Direction" button.

How to create a Polar Array

Using "Fill Angle".

- 1. Draw a 3" [76.2mm] radius circle.
- 2. Add a 0.50" [12.7 mm] radius three-sided polygon and place as shown.
- 3. Select Polar Array.
- 4. Select the object to be arrayed (the polygon) and then press **<Enter>**.
- 5. Select the center point of the circle.

The Array Creation Tab appears and the array defaults to 6 items.

- 6. Enter items: 8
- 7. Enter Fill: 180
- 8. Press < Enter > to display the selections.
- 9. Select Close Array if display is correct.

Honse Inset Annoteis enseted eve Manage Output Colleborate Express Tools (Colleborate Express Tools (C

Note:

8 items were evenly distributed within 180 degree counter-clockwise.

To have the items copied in a clockwise direction, uncheck the "Direction" button.

How to create a Path Array

- 1. Draw a Line 6" [152.4 mm] long at 20 degrees.
- Add a 0.50" [12.7 mm] x 0.50" [12.7 m] rectangle and place as shown.
- 3. Select the Array command using one of the following:

4. Select Path Array.

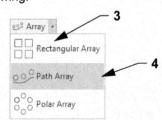

The following will appear on the Command Line:

5. Select the object to be arrayed (the small rectangle) and then press < Enter>.

The following will appear on the Command Line:

6. Select the path curve (the angled line).

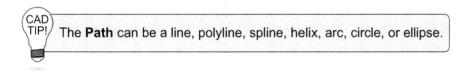

The **Array Creation** Tab appears and the array defaults to 9 items.

- 7. Make any alterations and press **<Enter>** to display.
- 8. If correct, select Close Array.

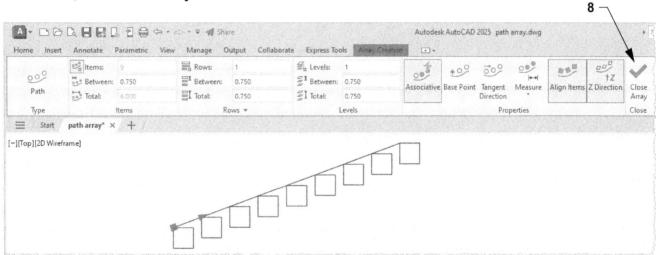

Note: If you want to change the number of items on the path, you will need to select the **Measure** drop-down arrow on the **Properties Panel**, then select **Divide**. You can then change the number of items in the **Items Panel**.

Exercise 13A

Exercise 13A

Instructions:

- 1. Start a New file using the Border A-Inch.dwt or the Border A-Metric.dwt
- 2. Draw the original 0.500" [12.7 mm] square on Layer Object Line.
- 3. Array the original square as shown.
- 4. Edit the Title and Ex-XX by double clicking on the text. Do not erase and replace.
- 5. Do not dimension.
- 6. Save as Ex-13A
- 7. Plot using Page Setup Class Model A

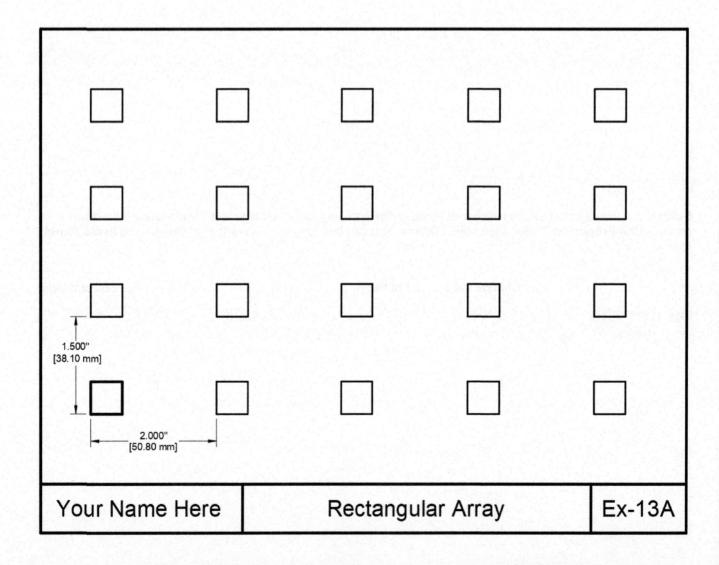

Exercise 13B

Instructions:

- 1. Start a New file using the Border A-Inch.dwt or the Border A-Metric.dwt
- 2. Draw the objects shown below using the most efficient methods.
- 3. Use Layer Object Line.
- 4. Edit the Title and Ex-XX by double clicking on the text. Do not erase and replace.
- 5. Do not dimension.
- 6. Save as Ex-13B
- 7. Plot using Page Setup Class Model A

Refer to the next page for helpful hints and more dimensions.

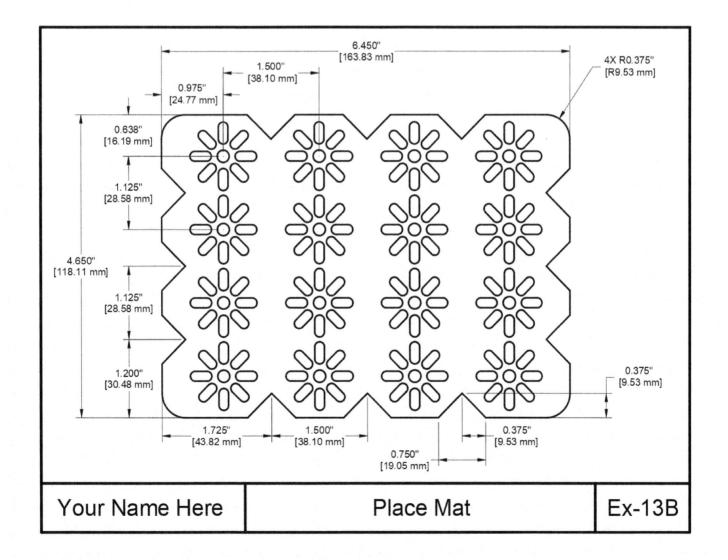

Exercise 13B-Helper

Exercise 13B-Helper

Notches

Step 1.

Draw the outside rectangle and then offset the location for the center of the notches.

Step 2.

Use Offset to frame the **0.375" [9.53 mm]** width and height.

Step 3.

Draw the diagonal lines by snapping to intersections.

Trim and Erase the lines.

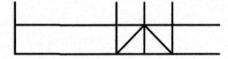

Flower

Step 1.

Offset.

Step 2.

Fillet.

Step 3. Array.

Exercise 13C

Instructions:

- 1. Start a New file using the Border A-Inch.dwt or the Border A-Metric.dwt
- 2. Draw the Centerlines and circles first.
- 3. Draw one polygon at the 12:00 location.
- 4. Array the original polygon as shown.
- 5. Edit the **Title** and **Ex-XX** by double clicking on the text. Do not erase and replace.
- 6. Do not dimension.
- 7. Save as Ex-13C
- 8. Plot using Page Setup Class Model A

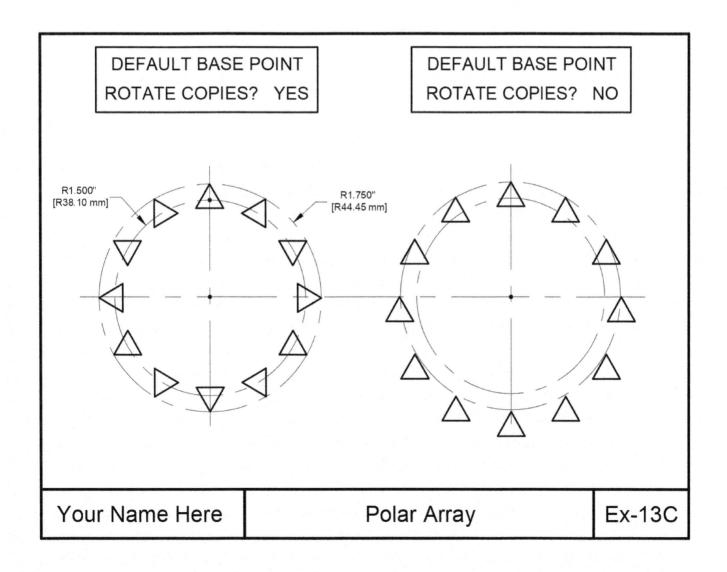

Exercise 13D

Exercise 13D

Instructions:

- 1. Start a New file using the Border A-Inch.dwt or the Border A-Metric.dwt
- 2. Draw the line first. 9.000" [228.6 mm] long and at an angle of 30 degrees.
- 3. Draw one circle with a radius of 0.500" [12.7 mm] at the lower left end.
- 4. Array 8 circles along the Path (Line), evenly divided.
- 5. Edit the Title and Ex-XX by double clicking on the text. Do not erase and replace.
- 6. Do not dimension.
- 7. Save as Ex-13D
- 8. Plot using Page Setup Class Model A

Note: When the Array Tab appears, you will need to click on the **Measure** drop-down arrow on the Properties Panel, and then click on **Divide**. This will enable you to change the number of items to **8**.

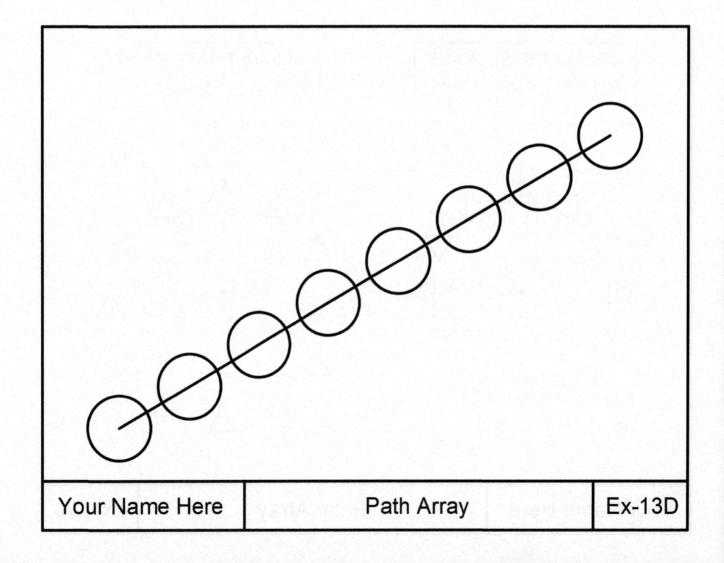

LESSON 14

LEARNING OBJECTIVES

After completing this lesson, you will be able to:

- 1. Make an existing object larger or smaller proportionately.
- 2. Stretch or Compress an existing object.
- 3. Rotate an existing object to a specific Angle.

14-2 Scale

Scale

The **Scale** command is used to make one or more objects larger or smaller **proportionately**. You may scale using a scale factor or a reference length. You must also specify a basepoint. The basepoint is a stationary point from which the objects scale.

1. Select the Scale command using one of the following:

Ribbon = Home Tab / Modify Panel / or Scale | Scale | Scale |

Scale Factor

The following will appear on the Command Line:

2. Select the objects and then press < Enter>.

The following will appear on the Command Line:

3. Select the stationary point on the objects (left click).

The following will appear on the Command Line:

4. Type the scale factor and then press < Enter>.

If the scale factor is greater than 1, the objects will increase in size. If the scale factor is less than 1, the objects will decrease in size.

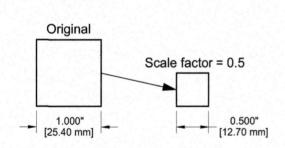

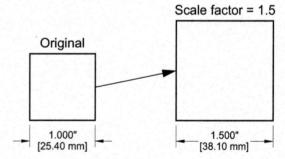

Reference Option

1. Select the Scale command.

The following will appear on the Command Line:

2. Select the objects and then press < Enter>.

The following will appear on the Command Line:

3. Select the stationary point on the objects (left click).

The following will appear on the Command Line:

4. Type **R** and then press **<Enter>**.

The following will appear on the Command Line:

```
|| × /3 □ ▼ SCALE Specify reference length <1.000>:
```

5. Specify a reference length and then press < Enter>.

The following will appear on the Command Line:

6. Specify the new length and then press < Enter>.

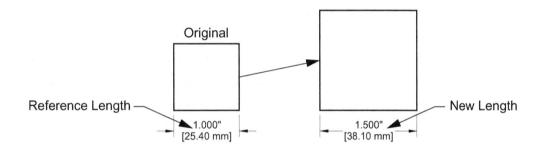

Copy Option

The **Copy Option** of the **Scale** command creates a duplicate of one or more selected objects. The duplicate is directly on top of the original. The duplicate will be scaled. The Original remains the same.

Stretch

The **Stretch** command allows you to stretch or compress one or more objects. Unlike the Scale command, you can alter an object's proportion with the Stretch command. In other words, you may increase the length without changing the width and vice versa.

Stretch is a very valuable tool. Take some time to really understand this command. It will save you hours when making corrections to drawings.

When selecting the objects, you must use a Crossing Window.

Objects that are crossed, will stretch.

Objects that are totally enclosed, will **move**.

14-4 Stretch

1. Select the Stretch command using one of the following:

The following will appear on the Command Line:

2. Select the first corner of the Crossing Window (left click).

The following will appear on the Command Line:

3. Specify the opposite corner of the Crossing Window (left click) and then press < Enter>.

The following will appear on the Command Line:

4. Select a basepoint (where it stretches from).

The following will appear on the Command Line:

5. Type coordinates or place the location with the cursor.

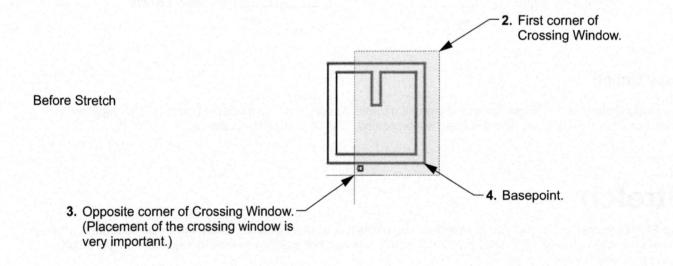

After Stretch

(Notice which objects stretched and which objects moved.)

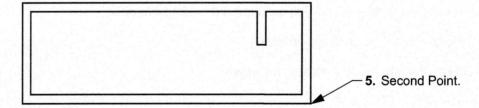

Rotate 14-5

Rotate

The Rotate command is used to rotate objects around a basepoint (pivot point).

After selecting the objects and the basepoint, you will enter the rotation angle from its **current** rotation angle or select a reference angle followed by the new angle.

A **Positive** rotation angle revolves the objects counter-clockwise. A **Negative** rotation angle revolves the objects clockwise.

1. Select the Rotate command using one of the following:

```
Ribbon = Home Tab / Modify Panel / or Rotate

Keyboard = RO <Enter>
```

Rotation Angle Option

The following will appear on the Command Line:

2. Select the objects to rotate and then press < Enter>.

The following will appear on the Command Line:

3. Select the basepoint (pivot point).

The following will appear on the Command Line:

4. Type the angle of rotation and then press **<Enter>**.

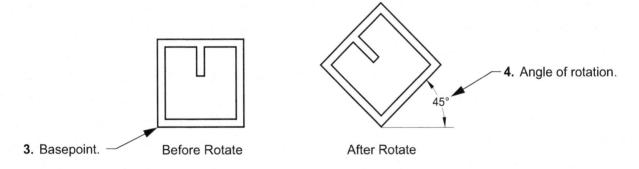

Reference Option

1. Select the Rotate command.

The following will appear on the Command Line:

2. Select the objects to rotate and then press **<***Enter***>**.

14-6 Rotate

The following will appear on the Command Line:

3. Select the basepoint (pivot point).

The following will appear on the Command Line:

|| × / > C ▼ ROTATE Specify rotation angle or [Copy Reference] <0>:

4. Type R and then press < Enter>.

The following will appear on the Command Line:

X B C ▼ ROTATE Specify the reference angle <0>:

5. Snap to the first reference point on the objects.

The following will appear on the Command Line:

6. Snap to the second reference point on the objects.

The following will appear on the Command Line:

7. Type P and then press < Enter>.

The following will appear on the Command Line:

|| × /³ C→ ROTATE Specify first point:

8. Select the first endpoint of the new angle.

The following will appear on the Command Line:

9. Select the second endpoint of the new angle.

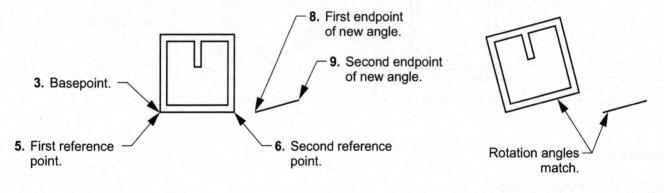

Before Rotate

After Rotate

Copy Option

The **Copy Option** of the **Rotate** command creates a duplicate of selected objects. The duplicate is rotated at the angle you enter. The Original remains in the same position.

Exercise 14A

Instructions:

- 1. Start a New file using the Border A-Inch.dwt or the Border A-Metric.dwt
- 2. Draw both 2" [50.8 mm] Squares shown below labelled "Original". Use Layer Object Line.
- 3. Scale the original on the left using "Scale Factor" method.
- 4. Scale the original on the right using "Scale Reference" method.
- 5. Edit the **Title** and **Ex-XX** by double clicking on the text. Do not erase and replace.
- 6. Do not dimension.
- 7. Save as Ex-14A
- 8. Plot using Page Setup Class Model A

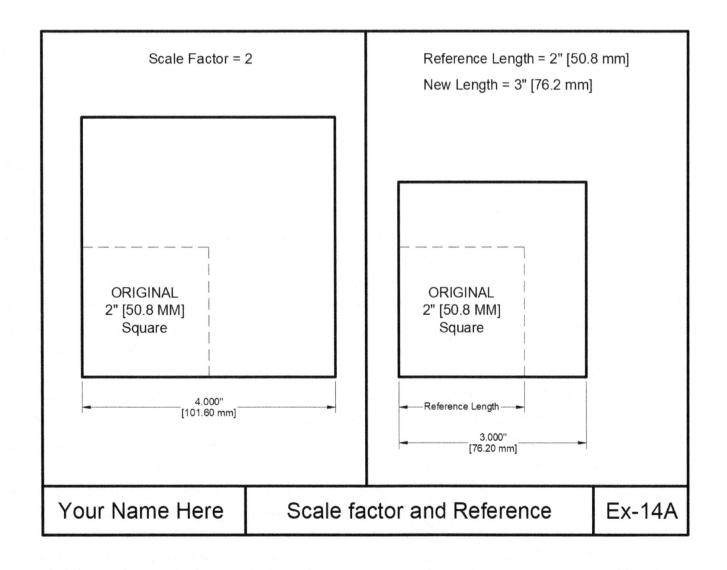

Exercise 14B

Instructions:

- Start a New file using the Border A-Inch.dwt or the Border A-Metric.dwt
- Draw the Original shape on the left side of the border. Use Layer Object Line.
- 3. Stretch the overall length to **8.5" [215.9 mm]** as shown. Notice the placement of the crossing window.

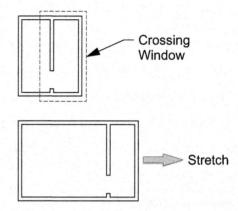

- 4. Edit the **Title** and **Ex-XX** by double clicking on the text. Do not erase and replace.
- 5. Do not dimension.
- 6. Save as Ex-14B
- 7. Plot using Page Setup Class Model A

Note: If this was an actual floor plan, consider how the Stretch command could be very helpful.

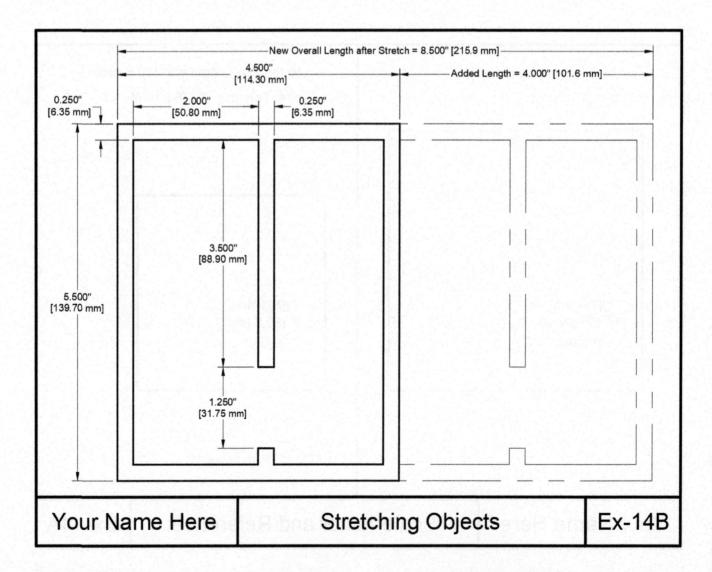

Exercise 14C

Exercise 14C

Instructions:

1. Open Ex-14B

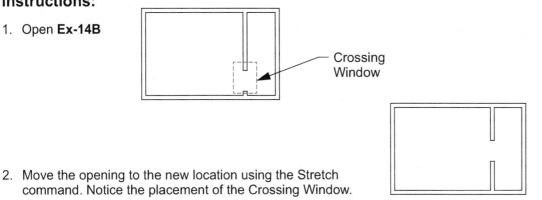

- 3. Edit the **Title** and **Ex-XX** by double clicking on the text. Do not erase and replace.
- 4. Do not dimension.
- 5. Save as Ex-14C
- 6. Plot using Page Setup Class Model A

Note: If this was an actual floor plan, consider how the Stretch command could be very helpful.

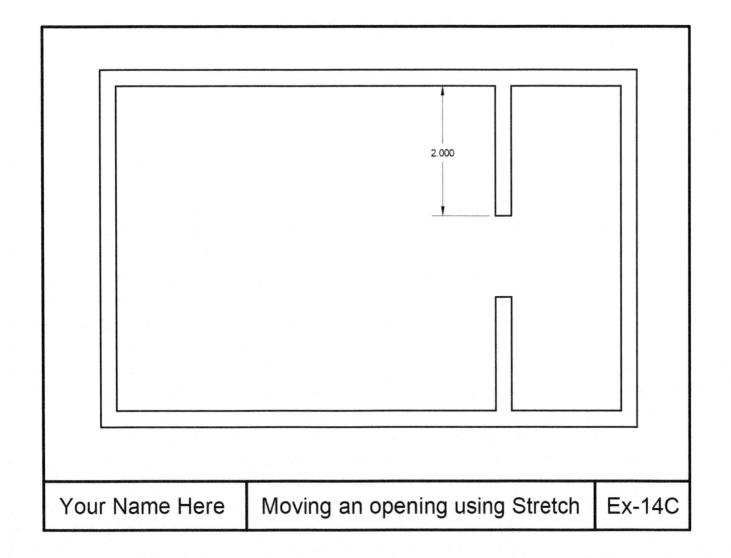

Exercise 14D

Instructions:

- 1. Start a New file using the Border A-Inch.dwt or the Border A-Metric.dwt
- 2. Draw the objects at position A. Use Layer Object Line.
- 3. Copy the objects to position **B** and **C**. (Shown as dashed lines.)
- 4. Rotate the copies as shown. Note: The basepoint is important.
- 5. Edit the Title and Ex-XX by double clicking on the text. Do not erase and replace.
- 6. Do not dimension.
- 7. Save as Ex-14D
- 8. Plot using Page Setup Class Model A

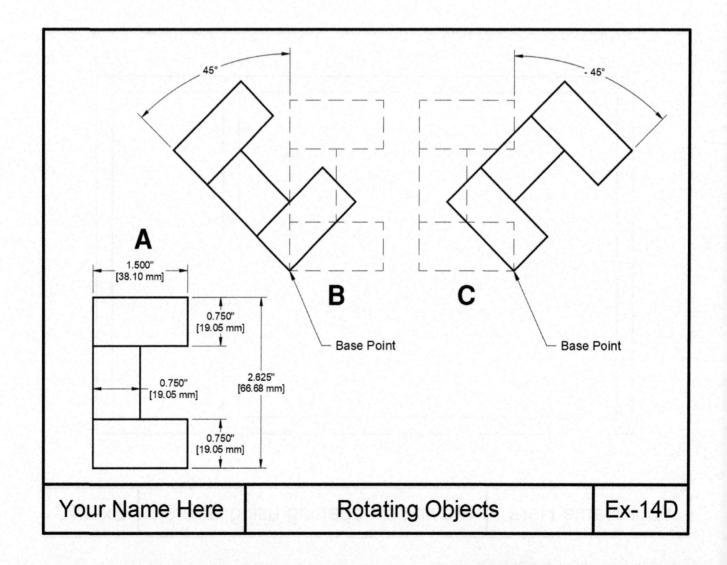

LESSON 15

LEARNING OBJECTIVES

After completing this lesson, you will be able to:

- 1. Place a Hatch pattern in a Boundary.
- 2. Fill an Area with solid fill.
- 3. Add Gradient fills.
- 4. Make changes to existing Hatch sets.
- 5. Place a Hatch pattern without a Boundary.

15-2 Hatch

Hatch

The Hatch command is used to create hatch lines for section views or filling areas with specific patterns. To draw hatch, you usually start with a closed boundary. A closed boundary is an area completely enclosed by objects. A rectangle would be a closed boundary. You simply place the cursor inside the closed boundary or select objects.

Although most hatches are created using a closed boundary, the **Hatch** command now also can be used to create a hatch without the need for a closed boundary. (Refer to page 15-11.)

Note: A Hatch set is one object. It is good drawing management to always place the Hatch on its own layer. Use Layer Hatch. You may also make the Hatch appear or disappear with the Fill command. (Refer to page 5-6.)

How to place Hatch

Draw a rectangle.

2. Select the **Hatch** command using one of the following:

Ribbon = Home Tab / Draw Panel / Keyboard = BH <Enter>

The **Hatch Creation** Ribbon Tab appears automatically.

A Hatch pattern preview will appear.

- 4. Press the left mouse button to accept the Hatch.
- Select Close Hatch Creation or press < Enter>.

Hatch Properties

When you select the Hatch command, the **Hatch Creation** Ribbon Tab appears automatically. The Panels on this Tab help set the properties of the Hatch. You should set the properties desired previous to placing the Hatch set, although you can easily edit an existing Hatch set.

Boundaries Panel

The Boundaries Panel allows you to choose what method you will use to select the Hatch boundary.

Remove the

circle.

Pick Point: Pick Point is the default selection. When you select the Hatch command, AutoCAD assumes that you want to use the Pick Points method. You merely place the cursor in the closed area to select the boundary. The Hatch set preview will appear. Press the left mouse button to accept.

Select and Remove: You may select or remove objects to a boundary. **Note: Remove** will not be available unless you click on **Select**.

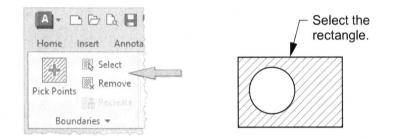

Pattern Panel

The Pattern Panel displays the Hatch swatches that relate to the Hatch Type that has been selected in the Properties Panel. Refer to Properties Panel below.

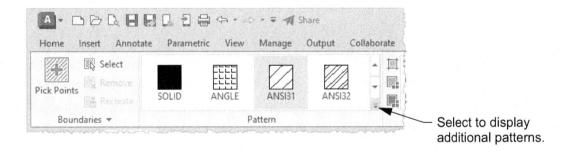

Properties Panel

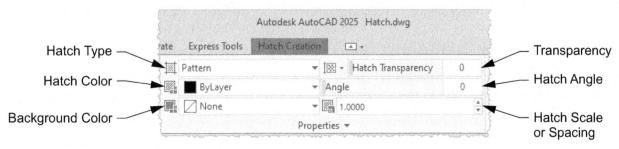

Hatch Type: When you select the drop-down arrow ▼, you may select one of the Hatch Types: Solid, Gradient, Pattern, or User Defined.

Note: Hatch Types will be explained in more detail on pages 15-7 through 15-9.

When you select a Hatch Type from the drop down list, the **Pattern Panel** displays the related hatch swatches from which to select.

Hatch Color: This color selection is specific to the Hatch and will not affect any other objects.

Hatch Transparency: Displays the selected transparency setting. You may select to use the current setting for the drawing or the current layer setting or to select a specific value.

Background Color: You may select a background color for the Hatch area.

Hatch Angle

Pattern: The default angle of a pattern is **0**. If you change this angle, the pattern will rotate relative to its original design.

User defined: Specify the actual angle of the hatch lines.

Hatch Scale or Spacing

If Hatch Type **Pattern** is selected, this value determines the scale of the Hatch pattern. A value greater than **1** will increase the scale. A value less than **1** will decrease the scale.

If Hatch Type **User Defined** is selected, this value determines the spacing between the hatch lines.

Origin Panel

You may specify where the Hatch will originate. Lower left, lower right, upper left, upper right, center, or even the at the UCS Origin.

The Origin locations shown on the right are displayed when Hatch Type, Pattern, Solid, or User Defined are selected.

The Origin location **Centered** is displayed only when Hatch Type Gradient is selected.

Options Panel

Hatch Properties

Associative: If the Associative option is selected, the Hatch set is associated to the boundary. This means if the boundary size is changed, the hatch will automatically change to fit the new boundary shape. (Refer to page 15-10 for an example.)

Annotative: AutoCAD will automatically adjust the scale to match the current Annotative scale. This option will be discussed in Lesson 27.

Match Properties

Match Properties allows you to set the properties of the new Hatch set by selecting an existing Hatch set. You may choose to "use the current origin" or "use the source hatch origin".

Use current origin: Sets all properties except the hatch origin.

Use source hatch origin: Sets all properties including the hatch origin.

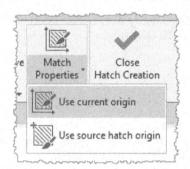

Gap Tolerance

If the area you selected to hatch is not completely closed (gaps), AutoCAD will bridge the gap depending on the Gap Tolerance. The Gap Tolerance can be set to a value from **0** to **5000**. Any gaps equal to or smaller than the value you specify are ignored and the boundary is treated as closed.

Create Separate Hatches

Controls whether Hatch creates a single hatch object or separate hatch objects when selecting several closed boundaries.

Outer Island Detection

These selections determine how Hatch recognizes internal objects.

Gap Tolerance 0.0000 Create Separate Hatches Outer Island Detection Normal Island Detection Ignore Island Detection No Island Detection

Send Behind Boundary

These selections determine the draw order of the Hatch set.

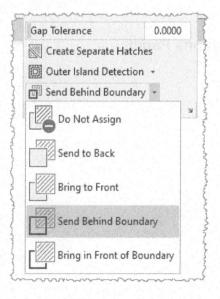

Hatch Types

Pattern

AutoCAD includes many previously designed Hatch patterns. **Note:** Using Hatch patterns will greatly increase the size of the drawing file. So use them conservatively. You may also purchase patterns from other software companies.

- 1. Select the Hatch Pattern.
- 2. Select a Pattern from the list of Hatch patterns displayed in the Pattern Panel.

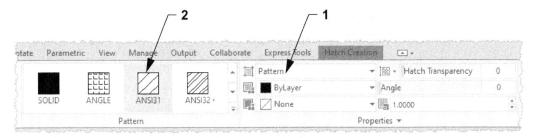

- 3. Select the Hatch Color, Boundary Background Color, and Hatch Transparency.
- 4. **Angle:** A previously designed pattern has a default angle of **0**. If you change this angle, the pattern will rotate relative to its original design. It is important that you understand how to control the angle.

Example: If **ANSI31** Hatch pattern is used and the angle is set to **45** degrees, the pattern will rotate relative to its original design and the pattern will appear to be **90** degrees.

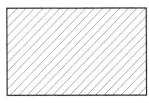

Original Pattern Design Angle = **0**

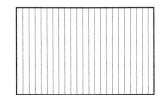

Pattern Design Rotated Angle = **45**

5. **Scale:** A value greater than 1 will increase the scale. A value less than 1 will decrease the scale. If the Hatch set is Annotative, the scale will automatically adjust to the Annotative scale. But you might have to tweak the scale additionally to make it display exactly as you desire. (*This will be discussed more in Lesson 27. Don't be too concerned about it right now.*)

User Defined

This Hatch Type allows you to simply draw continuous lines. No special pattern. You specify the **angle** of the lines and the **spacing** between the lines. **Note:** This Hatch Type does not significantly increase the size of the drawing file.

- 1. Select the Hatch Type User defined.
- 2. You also can select the User swatch on the Pattern Panel.

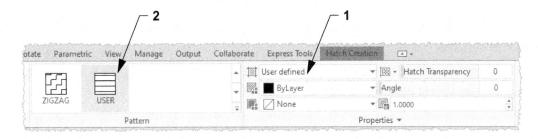

- 3. Select the Hatch Color, Boundary Background Color, Hatch Transparency.
- 4. Angle: Specify the actual angle that you desire from 0 to 180.

Example: If you want the lines to be on an angle of 45 degrees, you would enter 45. If you want the lines to be on an angle of 90 degrees, you would enter 90. (This is different from the angle for Patterns.)

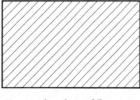

Angle = 45

Angle = 90

5. **Spacing:** Specify the actual distance between each of the hatch lines.

Solid

If you would like to fill an area with a solid fill, you should use Hatch Type Solid.

- 1. Select **Solid** by selecting the Hatch Type **Solid** on the Properties Panel
- 2. You also can select the **Solid** swatch on the Pattern Panel.

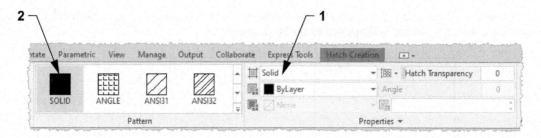

- 3. Select the Hatch Color. Note: The Boundary Background Color is not available when using Hatch Type Solid.
- 4. Select Hatch Transparency.

Transparency = 75

5. Angle and Scale: Not available when using Hatch Type Solid.

Gradient

Gradients are fills that gradually change from dark to light or from one color to another. Gradient fills can be used to enhance presentation drawings, giving the appearance of light reflecting on an object, or creating interesting backgrounds for illustrations.

Gradients are definitely fun to experiment with, but you will have to practice to achieve complete control. They will also greatly increase the size of the drawing file.

- 1. Select the Hatch Type **Gradient**.
- 2. Select a Gradient Pattern from the nine GR patterns displayed in the Pattern Panel.

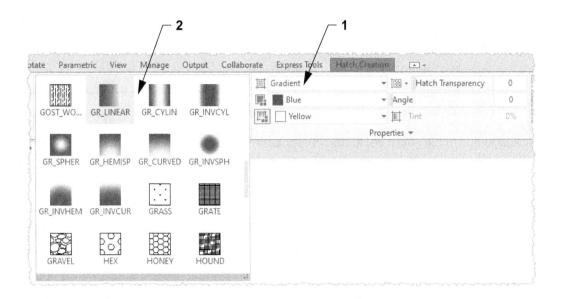

- 3. Select the Hatch **Color**. The Gradient can be in one color or two colors. If one color, you can select the Tint and Shade of that color. (See Step 6 below.)
- 4. Select the Hatch Transparency.
- 5. **Angle:** Specify the actual angle that you want from **0** to **180**. The pattern will rotate the pattern relative to its original design.

Angle = 0

Angle = **45**

6. **Tint and Shade:** Tint and Shade is used when you are using only one-color gradient fill. Specify the tint or shade of the color selected in Step 3 above.

Further examples of the Gradient Hatch using two colors, black and white.

Cylinder using pattern

GR_CYLIN

Angle = 0

Sphere using pattern
GR_SPHER
Angle = 0

Editing Hatch Set Properties

Editing a Hatch set properties is easy.

- 1. Simply select the Hatch set to edit.
- 2. The Hatch Editor Ribbon Tab will appear.
- 3. Make new selections. Any changes are applied immediately.

Changing the Boundary

If the Hatch set is **Associative** (see 15-5), you may change the shape of the boundary and the Hatch set will conform to the new shape. If the Hatch set is **Non-Associative**, the Hatch set will not change.

New Boundary with Associative Hatch

New Boundary with Non-Associative Hatch

Trimming Hatch

You may trim a Hatch set just like any other object.

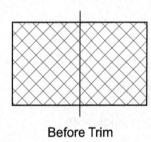

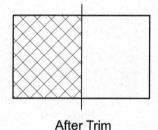

Mirror Hatch

An existing Hatch set can be **mirrored**. The boundary shape will automatically mirror. But you may control whether the Hatch pattern is mirrored or not.

To control the Hatch pattern mirror: (Note: Set prior to using the Mirror command.)

- 1. Type mirrhatch and then press <Enter>.
- 2. Enter 0 or 1 and the press **Enter**. 0 = Hatch not Mirrored. 1 = Hatch Mirrored.

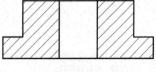

Mirrhatch = 0

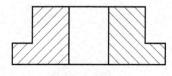

Mirrhatch = 1

Hatch without Boundaries

The **Hatch** command also has the ability to create a hatch without the need for a closed boundary. You can create a circle, rectangle, or polyline hatch. To create a circle or rectangle hatch to specific dimensions, follow the instructions for creating a circle or rectangle described in Lesson 3.

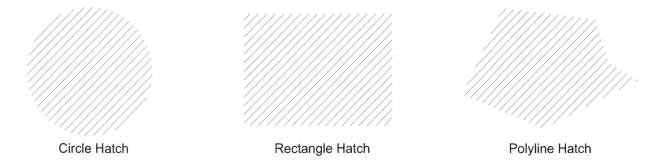

How to create a circle Hatch without boundaries

1. Select the Hatch command.

The following will appear on the Command Line:

```
X / MATCH Pick internal point or [Select objects Draw Undo seTtings]:
```

2. Type **D** and then press **<Enter>**.

The following will appear on the Command Line:

```
# × B Mode seTtings]:
```

3. Type C and then press < Enter>.

The following will appear on the Command Line:

4. Locate the center point for the circle Hatch by moving the cursor to the desired location in the drawing area (P1) and then press the left mouse button.

The following will appear on the Command Line:

- 5. Now move the cursor away from the center point. You should see a circle forming.
- 6. When the circle is the size desired (**P2**), press the left mouse button, or type in the radius and then press <**Enter>** <**Enter>**.

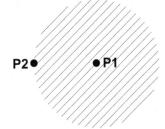

Note: Also see Lesson 3 for other methods of creating a circle for the Hatch.

How to create a rectangle Hatch without boundaries

1. Select the Hatch command.

The following will appear on the Command Line:

```
    ★ ★ HATCH Pick internal point or [Select objects Draw Undo seTtings]:
    ★
```

2. Type **D** and then press **<Enter>**.

The following will appear on the Command Line:

```
# × / Mode seTtings]:
```

3. Type R and then press < Enter>.

The following will appear on the Command Line:

4. Specify the location of the first corner by moving the cursor to a location (P1) and then press the left mouse button.

The following will appear on the Command Line:

5. Specify the location of the diagonal corner (P2) by moving the cursor diagonally away from the first corner (P1) and then pressing the left mouse button, followed by **<**Enter>.

Note: Also see Lesson 3 for other methods of creating a rectangle for the Hatch.

How to create a polyline Hatch without boundaries

1. Select the Hatch command.

The following will appear on the Command Line:

X / HATCH Pick internal point or [Select objects Draw Undo seTtings]:

2. Type **D** and then press **<Enter>**.

The following will appear on the Command Line:

* HATCH Specify start point or [picK internal point Select objects Rectangle Circle Mode seTtings]:

3. Specify the location of the first point by moving the cursor to a location (P1) and then press the left mouse button.

The following will appear on the Command Line:

4. Specify the location of the second point by moving the cursor to a location (**P2**) and then press the left mouse button.

The following will appear on the Command Line:

X / HATCH Specify the next point or [Arc Length Undo Exit] <Exit>:

5. Specify the location of the third point by moving the cursor to a location (P3) and then press the left mouse button.

The following will appear on the Command Line:

6. Continue to enter more points or press < Enter> < Enter> to stop entering points.

Note: The example below uses a four-point polyline Hatch.

Exercise 15A

- 1. Start a New file using the Border A-Inch.dwt or the Border A-Metric.dwt
- 2. Draw the rectangle, circle, and polygon as shown.
- 3. Use Layers Object Line and Hatch.
- 4. Hatch the boundaries shown using the Patterns shown.
- 5. Edit the Title and Ex-XX by double clicking on the text. Do not erase and replace.
- 6. Do not dimension.
- 7. Save as Ex-15A
- 8. Plot using Page Setup Class Model A

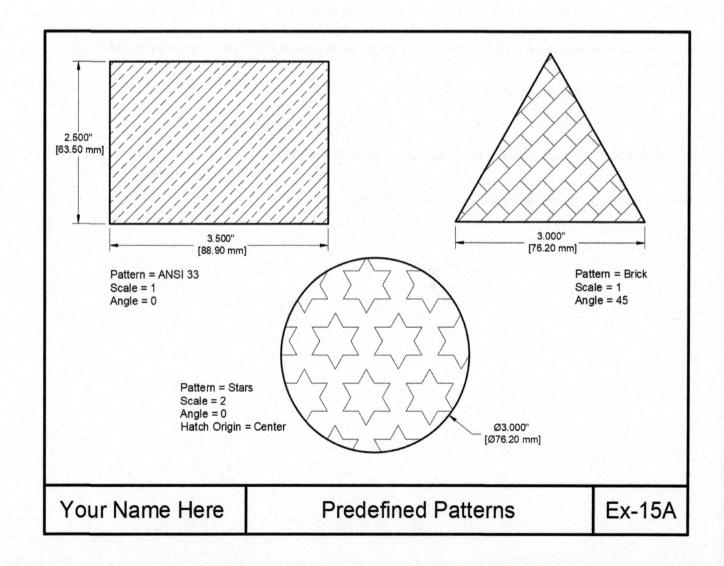

Exercise 15B

- 1. Start a New file using the Border A-Inch.dwt or the Border A-Metric.dwt
- 2. Draw the four rectangles as shown.
- 3. Use Layers Object Line and Hatch.
- 4. Hatch the boundaries shown using the Patterns shown.

 Notice the angles rotate the Hatch pattern from its original design. For example, angle 45 appears to be rotation 90 because the original design was drawn at a 45 degree...think about it.
- 5. Edit the **Title** and **Ex-XX** by double clicking on the text. Do not erase and replace.
- 6. Do not dimension.
- 7. Save as Ex-15B
- 8. Plot using Page Setup Class Model A

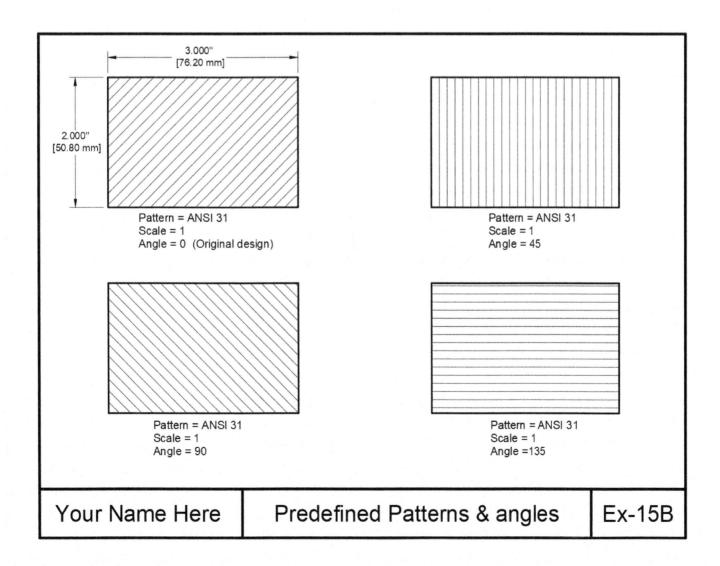

Exercise 15C

- 1. Start a New file using the Border A-Inch.dwt or the Border A-Metric.dwt
- 2. Draw the rectangle as shown using Layer Object Line.
- 3. Place the 1" [25.4 mm] high text in the middle of the rectangle. Use Layer Text.
- 4. Use Hatch Pattern ANSI 31. Use Layer Hatch.
- 5. Select the boundary using "Select Objects" this time
- 6. Edit the Title and Ex-XX by double clicking on the text. Do not erase and replace.
- 7. Do not dimension.
- 8. Save as Ex-15C
- 9. Plot using Page Setup Class Model A

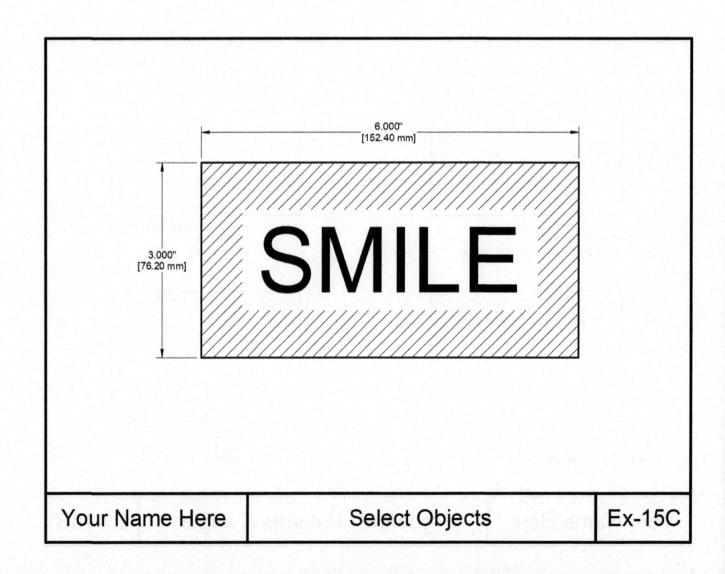

Exercise 15D

Exercise 15D

- 1. Start a New file using the Border A-Inch.dwt or the Border A-Metric.dwt
- 2. Draw the circle, rectangle, and polyline hatches approximately as shown using Layer Hatch.
- 3. Use Hatch pattern ANSI 31 Scale = 1 and Angle = 0.
- 4. Edit the **Title** and **Ex-XX** by double clicking on the text. Do not erase and replace.
- 5. Save as Ex-15D

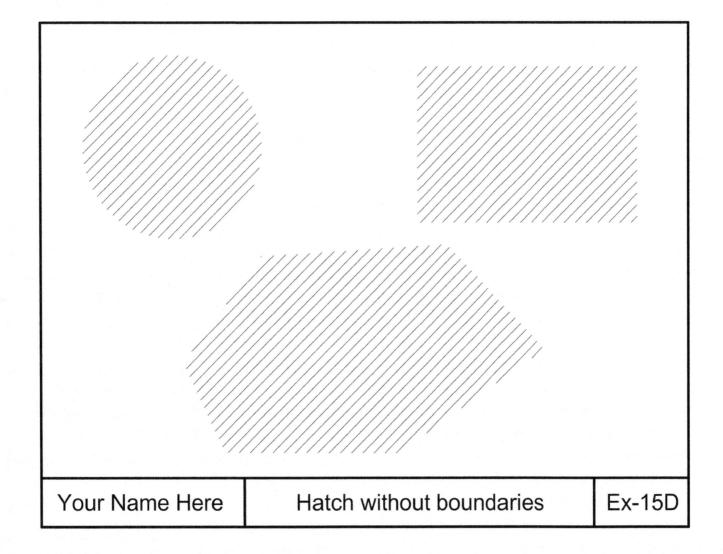

Exercise 15E

- 1. Start a New file using the Border A-Inch.dwt or the Border A-Metric.dwt
- 2. Draw the Hub as shown using Layer Object Line.
- 3. Use Hatch pattern ANSI 31 Scale = 1 and Angle = 0. Use Layer Hatch.
- 4. Draw the section arrowhead, approximately as shown. Fill with "Solid" hatch.
- 5. Edit the **Title** and **Ex-XX** by double clicking on the text. Do not erase and replace.
- 6. Do not dimension.
- 7. Save as Ex-15E
- 8. Plot using Page Setup Class Model A

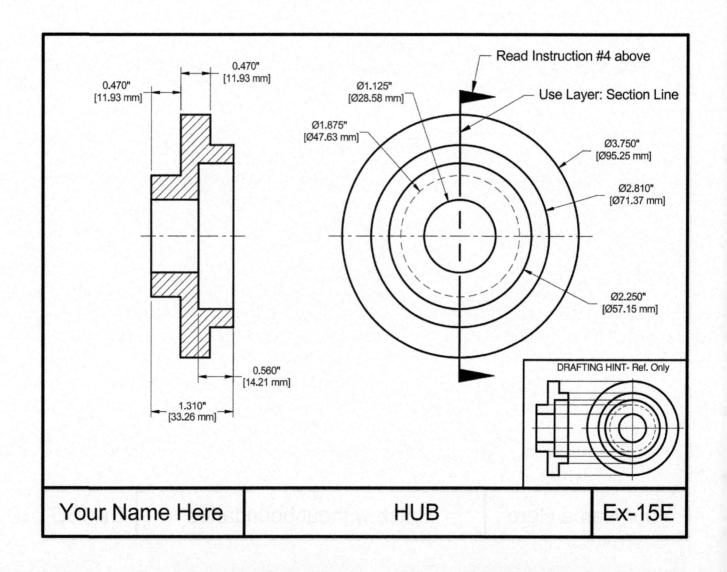

LESSON 16

LEARNING OBJECTIVES

After completing this lesson, you will be able to:

- 1. Understand the importance of True Associative dimensioning.
- 2. Create Linear, Continue, and Baseline dimensions.
- 3. Draw, Select, and Erase objects.
- 4. Use Grips to manipulate dimensions.
- 5. Create a new Dimension Style.
- 6. Ignore Hatch Lines when dimensioning.

Dimensioning

Dimensioning is basically easy, but as always, there are many options to learn. As a result, I have divided the dimensioning process into multiple lessons.

In addition, Annotative dimensioning will be discussed in Lesson 27. So relax and just take it one lesson at a time.

In this Lesson you will learn how to create a **dimension style** and how to create linear (horizontal and vertical) dimensions.

Dimensions can be **Associative**, **Non-Associative**, or **Exploded**. You need to understand what these are so you may decide which setting you want to use. Most of the time, you will use Associative, but you may have reasons to also use Non-Associative and Exploded.

Associative

Associative Dimensioning means that the dimension is actually associated to the objects that they dimension. If you move the object, the dimension will move with it. If you change the size of the object, the dimension text value will change also.

(**Note:** This is not parametric. In other words, you cannot change the dimension text value and expect the object to change. That would be parametric dimensioning.)

Non-Associative

Non-Associative means the dimension is not associated to the objects and will not change if the size of the object changes.

Exploded

Exploded means the dimension will be exploded into lines, text, and arrowheads and Non-Associative.

How to set dimensioning to Associative, Non-Associative or Exploded

- On the Command Line type dimassoc and then press < Enter>.
- 2. Enter the number 2, 1 or 0 and then press < Enter>.
 - 2 = Associative
 - 1 = Non-Associative
 - 0 = Exploded

How to Re-associate a dimension

If a dimension is **Non-Associative**, and you would like to make it **Associative**, you may use the **dimreassociate** command to change.

Select Reassociate using one of the following:

Ribbon = Annotate Tab / Dimension Panel / or Keyboard = dimreassociate <Enter>

The following will appear on the Command Line:

2. Select the dimensions to be re-associated and then press **<Enter>**.

The following will appear on the Command Line:

|| × / DIMREASSOCIATE Specify first extension line origin or [Select object] <next>: ♣

3. An "X" will appear to identify which is the first extension; use Object Snap to select the exact location, on the object, for the extension line point.

The following will appear on the Command Line:

|| × ⊅ | DIMREASSOCIATE Specify second extension line origin <next>:

- 4. An "X" will appear on the second extension; use Object Snap to select the exact location, on the object, for the extension line point.
- 5. Continue until all extension line points are selected.

Note: You must use Object Snap to specify the exact location for the extension lines.

Regenerating Associative dimensions

Sometimes after panning and zooming, the Associative dimensions seem to be floating or not following the object. The **dimregen** command will move the Associative dimensions back into their correct location.

1. Type dimregen and then press < Enter>.

Linear Dimensioning

Linear dimensioning allows you to create horizontal and vertical dimensions.

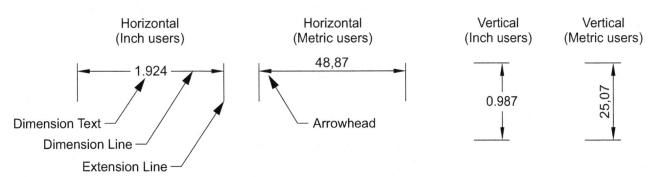

Note: A decimal point is used for inch dimensions and a comma is used for metric dimensions.

How to create a Linear Dimension

1. Select the Linear command using one of the following:

Ribbon = Annotate Tab / Dimension Panel / Linear or Keyboard = dimlinear <Enter>

The following will appear on the Command Line:

|| X /5 | → DIMLINEAR Specify first extension line origin or <select object>:

2. Snap to the first extension line origin (P1).

The following will appear on the Command Line:

3. Snap to the second extension line origin (P2).

The following will appear on the Command Line:

4. Select where you want the dimension line placed (P3).

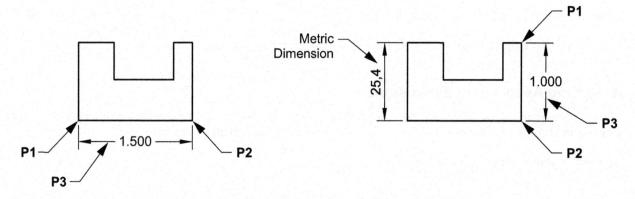

Continue Dimensioning

Continue Dimensioning creates a series of dimensions in-line with an existing dimension. If you use the continue dimensioning immediately after a Linear dimension, you do not have to specify the continue extension

How to create Continue Dimensions

- 1. Create a Linear dimension first (P1 and P2 shown on the next page).
- 2. Select the Continue command using one of the following:

Ribbon = Annotate Tab / Dimension Panel / or Keyboard = dimcontinue <Enter>

The following will appear on the Command Line:

| X B | Y | ▼ DIMCONTINUE Specify second extension line origin or [Select Undo] <Select>:

3. Snap to the second extension line origin (P3).

The following will appear on the Command Line:

× 🏂 📇 ▼ DIMCONTINUE Specify second extension line origin or [5elect Undo] <Select>:

4. Snap to the second extension line origin (P4).

The following will appear on the Command Line:

5. Press **<**Enter> (the second enter ends the command).

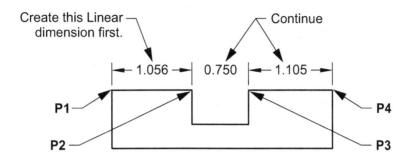

Baseline Dimensioning

Baseline Dimensioning allows you to establish a baseline for successive dimensions. The spacing between dimensions is automatic and should be set in the dimension style. (See the bottom figures on page 16-8, **Baseline spacing** setting.)

A Baseline dimension must be used with an existing dimension. If you use Baseline dimensioning immediately after a Linear dimension, you do not have to specify the baseline origin.

How to create Baseline Dimensions

- 1. Create a Linear dimension first (P1 and P2 shown on the next page).
- 2. Select the **Baseline** command using one of the following:

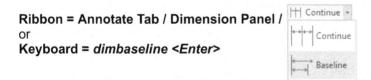

The following will appear on the Command Line:

3. Snap to the second extension line origin (P3).

The following will appear on the Command Line:

4. Snap to the second extension line origin (P4).

The following will appear on the Command Line:

5. Press < Enter> < Enter> (the second enter ends the command).

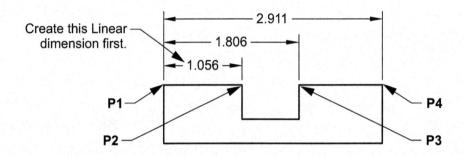

Dimension Styles

Using the **Dimension Style Manager** you can change the appearance of the dimension features, such as length of arrowheads, size of the dimension text, etc. There are over 70 different settings.

You can also Create New, Modify, and Override Dimension Styles. All of these are simple, by using the Dimension Style Manager described below.

1. Select the Dimension Style Manager using one of the following:

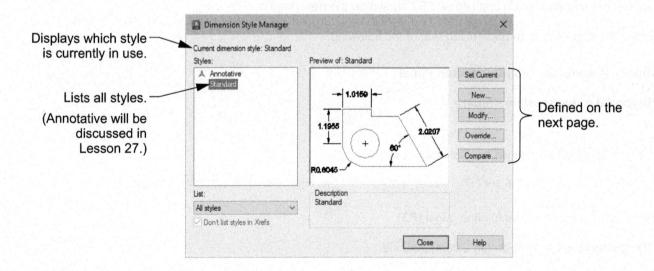

Set Current: Select a style from the list of styles and select the Set Current button.

New: Select this button to create a new style. When you select this button, the Create New Dimension

Style dialog box is displayed.

Modify: Selecting this button opens the Modify Dimension Style dialog box, which allows you to make

changes to the style selected from the "list of Styles".

Override: An override is a temporary change to the current style. Selecting this button opens the Override

Current Style dialog box.

Compare: Compares two dimension styles.

Creating a New Dimension Style

A dimension style is a group of settings that has been saved with a name you assign. When creating a new style, you must start with an existing style, such as **Standard**. Next, assign it a new name, make the desired changes, and when you select the **OK** button, the new style will have been successfully created.

How to create a new dimension style

- 1. Start a New file using the Border A-Inch.dwt or the Border A-Metric.dwt
- 2. Select the **Dimension Style Manager**. (Refer to the previous page.)
- 3. Select the New... button.

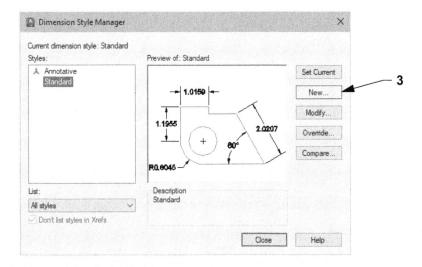

- Enter CLASS STYLE in the "New Style Name" box.
- 5. Select Standard in the "Start With:" box.
- 6. The "Use For:" box will be discussed later. For now, leave it set to "All dimensions".
- 7. Select the Continue button.

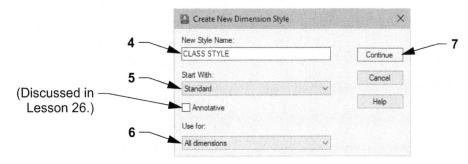

8. Select the Primary Units Tab and change your settings to match the settings shown below.

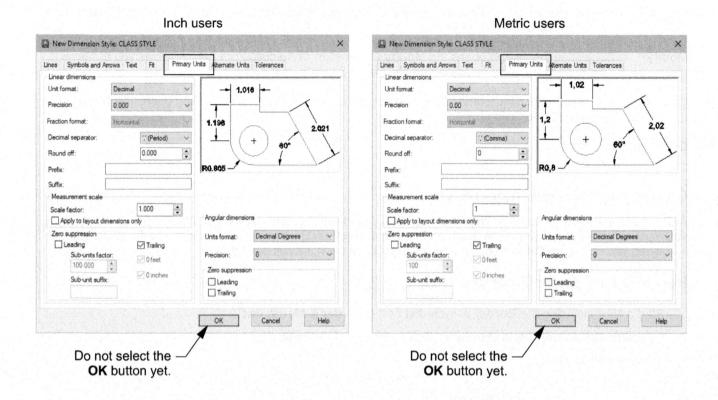

9. Select the Lines Tab and change your settings to match the settings shown below.

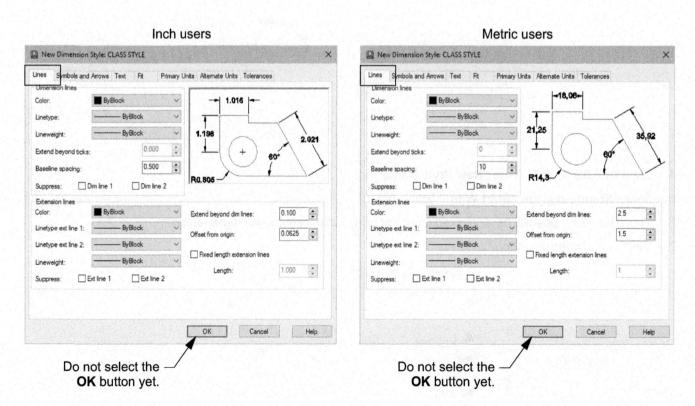

10. Select the Symbols and Arrows Tab and change your settings to match the settings shown below.

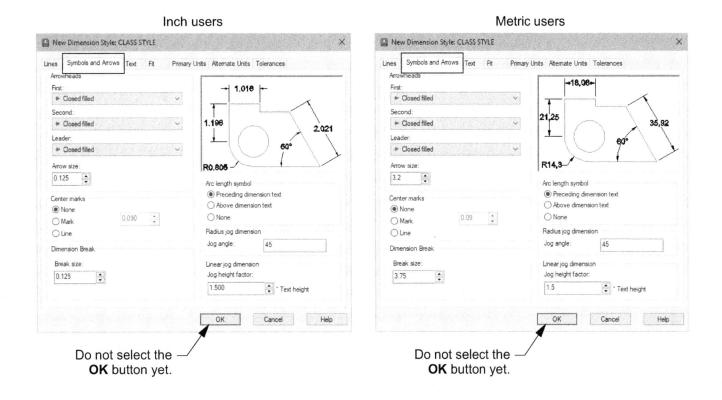

11. Select the **Text** Tab and change your settings to match the settings shown below.

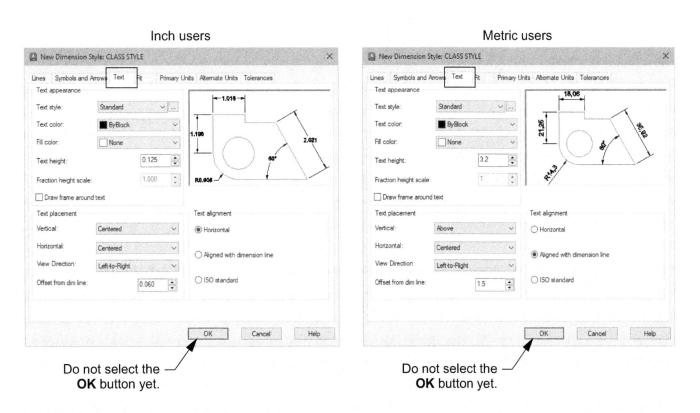

12. Select the Fit Tab and change your settings to match the settings shown below.

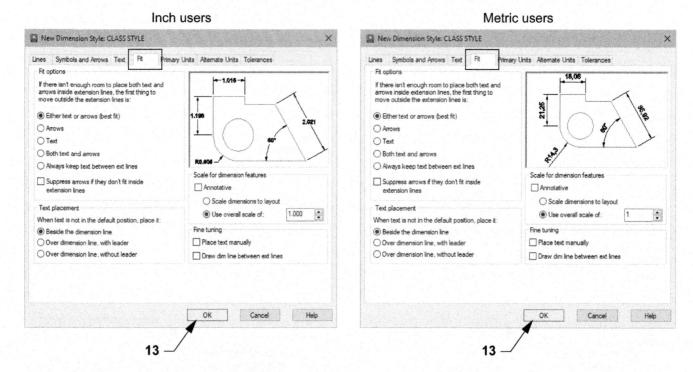

13. Now select the OK button.

Your new style "CLASS STYLE" should be listed.

14. Select the "Set Current" button to make your new style CLASS STYLE the style that will be used.

- 15. Select the Close button.
- Important: Re-Save this "template" as Border A-Inch.dwt for inch users, or Border A-Metric.dwt for metric users. (Refer to page 2-3.)

Note:

You have successfully created a new **Dimension Style** called **CLASS STYLE**. This style will be saved in your **Border A-Inch** and **Border A-Metric** template after you save the template. So every time you use this template, the dimension style will already be there and you will not have to create it again.

It is important that you understand that this dimension style resides **only** in the **Border A-Inch** and **Border A-Metric** templates. If you open another drawing, this dimension style will not be there.

Ignoring Hatch Objects

Occasionally, when you are dimensioning an object that has "Hatch Lines", your cursor will snap to the Hatch Line instead of the object that you want to dimension. To prevent this from occurring, select the option "Ignore hatch objects".

Example:

option **not selected**.

"Ignore hatch objects"

"Ignore hatch objects" option **selected**.

How to select the "Ignore hatch objects" option

- 1. Type *Options* and then press *<Enter>*.
- 2. Select the Drafting Tab.
- 3. Check the Ignore hatch objects box.
- 4. Select the **OK** button to close the **Options** dialog box.

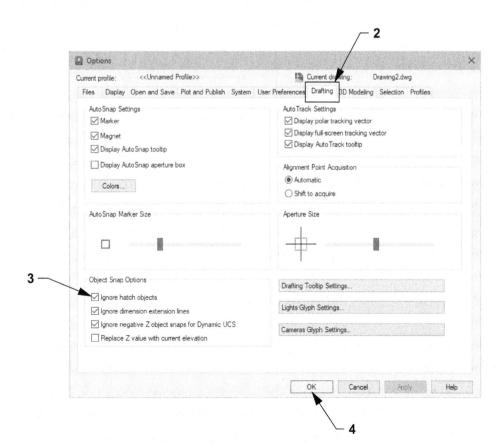

Exercise 16A-Inch

Exercise 16A-Inch

- 1. Start a New file using the Border A-Inch.dwt
- Create a dimension style in your Border A-Inch template by following the instructions on pages 16-7 through 16-10 if you haven't already completed the task. Re-save the template as Border A-Inch.dwt before starting this drawing.
- 3. Draw the objects as shown using Layer Object Line.
- 4. Dimension as shown using Dimension Style CLASS STYLE on Layer Dimension.
- 5. Use Linear, Continue, and Baseline.
- 6. Edit the Title and Ex-XX by double clicking on the text. Do not erase and replace.
- Save as Ex-16A-I
- 8. Plot using Page Setup Class Model A

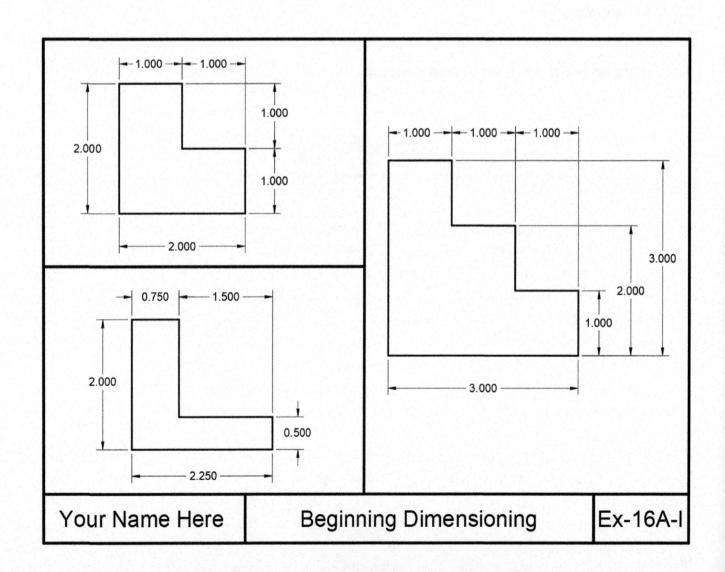

Exercise 16A-Metric

- 1. Start a New file using the Border A-Metric.dwt
- Create a dimension style in your Border A-Metric template by following the instructions on pages 16-7 through 16-10 if you haven't already completed the task. Re-save the template as Border A-Metric.dwt before starting this drawing.
- 3. Draw the objects as shown using Layer Object Line.
- 4. Dimension as shown using Dimension Style CLASS STYLE on Layer Dimension.
- 5. Use Linear, Continue, and Baseline.
- 6. Edit the **Title** and **Ex-XX** by double clicking on the text. Do not erase and replace.
- 7. Save as Ex-16A-M
- 8. Plot using Page Setup Class Model A

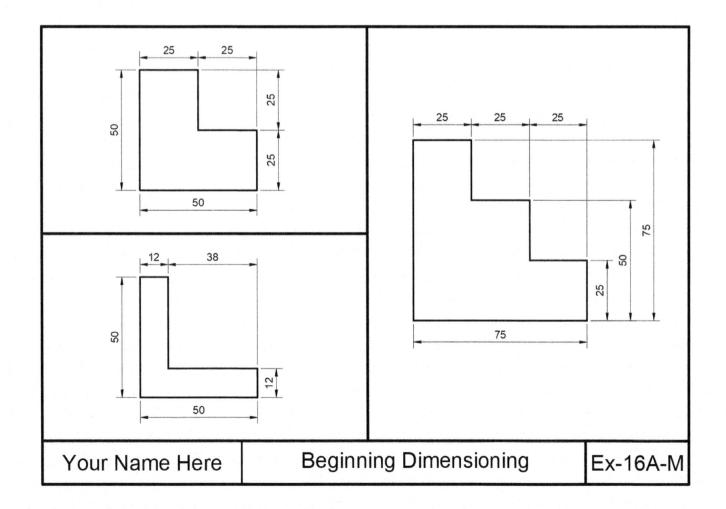

Exercise 16B-Inch

Exercise 16B-Inch

- 1. Start a New file using the Border A-Inch.dwt
- 2. Draw the objects as shown using Layer Object Line.
- 3. Dimension as shown using Dimension Style CLASS STYLE on Layer Dimension.
- 4. Use Linear, Continue, and Baseline.
- 5. Edit the **Title** and **Ex-XX** by double clicking on the text. Do not erase and replace.
- 6. Save as Ex-16B-I
- 7. Plot using Page Setup Class Model A

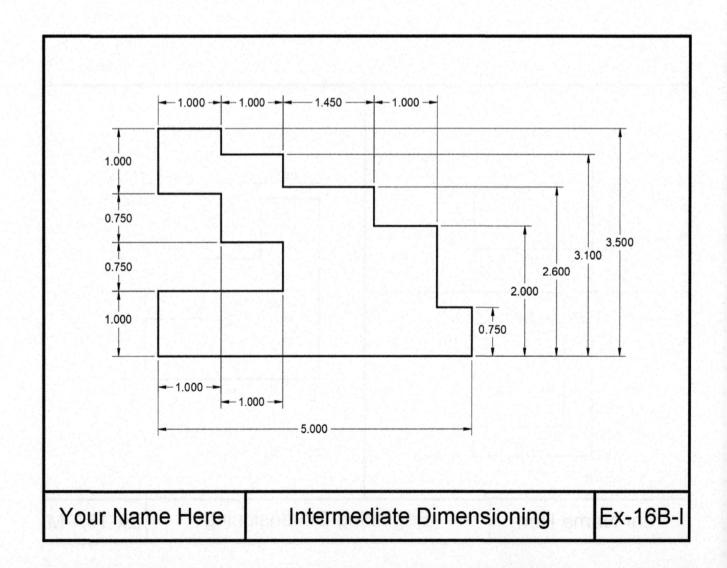

Exercise 16B-Metric

Exercise 16B-Metric

- 1. Start a New file using the Border A-Metric.dwt
- 2. Draw the objects as shown using Layer Object Line.
- 3. Dimension as shown using Dimension Style CLASS STYLE on Layer Dimension.
- 4. Use Linear, Continue, and Baseline.
- 5. Edit the **Title** and **Ex-XX** by double clicking on the text. Do not erase and replace.
- 6. Save as Ex-16B-M
- 7. Plot using Page Setup Class Model A

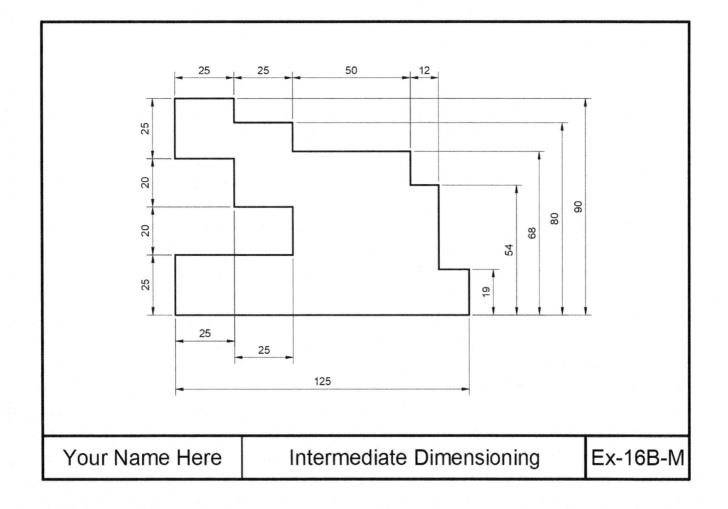

Exercise 16C-Inch

- 1. Start a New file using the Border A-Inch.dwt
- 2. Follow the instructions below.
- 3. Do not divide your drawing into four sections. Just draw one rectangle in the middle of your drawing area and follow the instructions.
- 4. Edit the **Title** and **Ex-XX** by double clicking on the text. Do not erase and replace.
- 5. Save as Ex-16C-I
- 6. Plot using Page Setup Class Model A

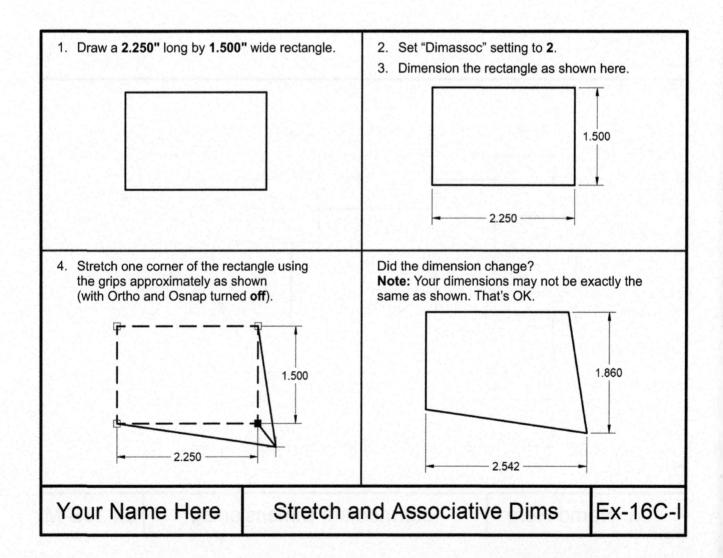

Exercise 16C-Metric

- 1. Start a New file using the Border A-Metric.dwt
- 2. Follow the instructions below.
- 3. Do not divide your drawing into four sections. Just draw one rectangle in the middle of your drawing area and follow the instructions.
- 4. Edit the **Title** and **Ex-XX** by double clicking on the text. Do not erase and replace.
- 5. Save as Ex-16C-M
- 6. Plot using Page Setup Class Model A

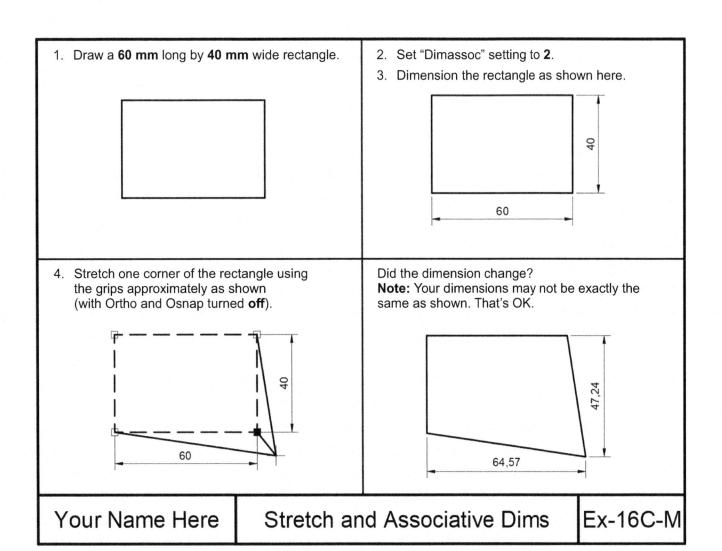

Exercise 16D-Inch

- 1. Start a New file using the Border A-Inch.dwt
- 2. Follow the instructions below.
- 3. Do not divide your drawing into four sections. Just draw one rectangle in the middle of your drawing area and follow the instructions.
- 4. Edit the **Title** and **Ex-XX** by double clicking on the text. Do not erase and replace.
- 5. Save as Ex-16D-I
- 6. Plot using Page Setup Class Model A

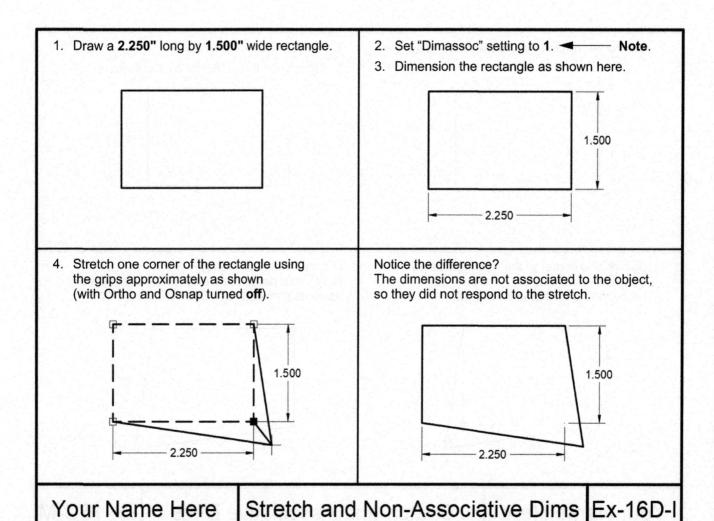

Exercise 16D-Metric

- 1. Start a New file using the Border A-Metric.dwt
- 2. Follow the instructions below.
- 3. Do not divide your drawing into four sections. Just draw one rectangle in the middle of your drawing area and follow the instructions.
- 4. Edit the **Title** and **Ex-XX** by double clicking on the text. Do not erase and replace.
- 5. Save as Ex-16D-M
- 6. Plot using Page Setup Class Model A

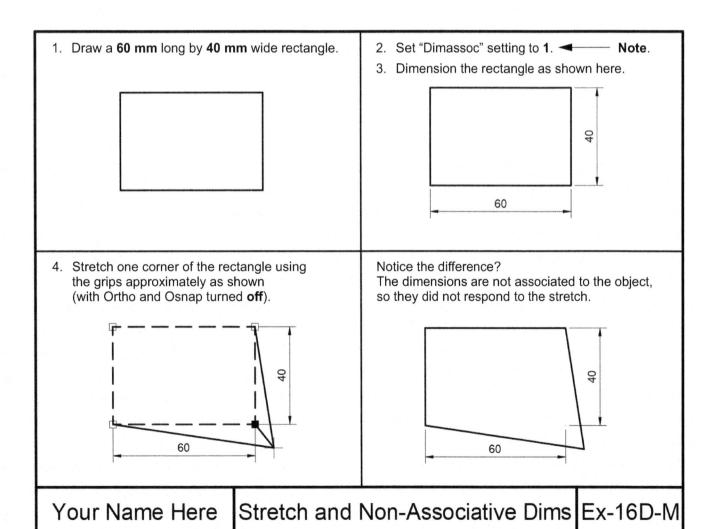

Notes:

LESSON 17

LEARNING OBJECTIVES

After completing this lesson, you will be able to:

- 1. Edit the dimension text without changing the value.
- 2. Move the dimension text within the dimension lines.
- 3. Modify an entire dimension style.
- 4. Override a dimension style.
- 5. Use the Properties Palette to change a dimension.
- 6. Break intersecting extension and dimension lines.
- 7. Add a Jog to a dimension line.
- 8. Adjust the distance between dimensions.

Editing Dimension Text Values

Sometimes you need to modify the dimension text value or text height. You may add a symbol, a note, or even change the text of an existing dimension.

Example: Add the word "MAX" to the existing dimension value text.

Editing Dimension Text

- 1. Double left click on the dimension text to be edited.
- The dimension text will be highlighted inside a text box area the same as Multiline Text.

3. The **Text Editor Ribbon** will appear where you may change things like text height or color, add a symbol, or change the text style.

Associative Dimension: If the dimension is Associative, the dimension text will appear highlighted.

You may add text in front or behind the dimension text and it will remain Associative. Be careful not to disturb the dimension value text.

Non-Associative or Exploded Dimension: If the dimension value has been changed or exploded, it will appear with a gray background and is not Associative.

- 4. Make any changes.
- 5. Select the Close Text Editor button or left click outside the dimension text box area.

Editing the Dimension Position

Grips are great tools for repositioning dimensions. Grips are small, solid-filled squares that are displayed at strategic points on objects. You can drag these grips to stretch, move, rotate, scale, or mirror objects quickly.

How to use Grips

- 1. Select the object (no command can be in use while using grips).
- Select one of the blue grips. It will turn to red. This indicates that grip is "hot". The "hot" grip is the basepoint.

- 3. Move the hot grip to the new location.
- 4. After editing you must press the **<Esc>** key to de-activate the grips.

The following is an example of how to use grips to guickly reposition dimensions.

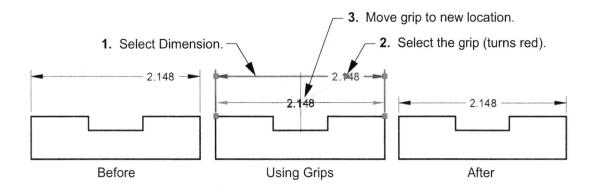

Additional editing options using the Shortcut Menu

- 1. Select the dimension that you want to change.
- 2. Place the cursor on one of the grips shown below. (Do not press the mouse button.)
- 3. Select an option from the Shortcut Menu that appears.

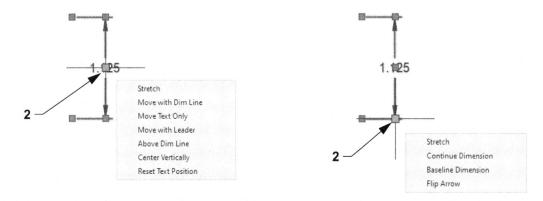

Modifying an Entire Dimension Style

After you have created a dimension style, you may find that you have changed your mind about some of the settings. You can easily change the entire style by using the **Modify...** button in the Dimension Style Manager dialog box. This will not only change the style for future use, but it will also update dimensions already in the drawing.

Note: If you do not want to update the dimensions already in the drawing but want to make a change to a new dimension, use **Override** (see the next page).

How to Modify a Dimension Style

- 1. Select the Dimension Style Manager. (Refer to page 16-7.)
- 2. Select the dimension style that you want to modify.

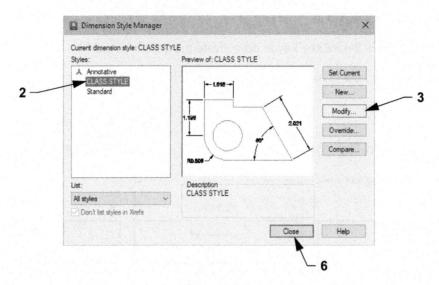

- 3. Select the Modify... button from the Dimension Style Manager dialog box.
- 4. Make the desired changes to the settings.
- 5. Select the OK button.
- 6. Select the Close button.

Now look at your drawing. Have your dimensions updated?

Note: The method above will not change dimensions that have previously been modified or exploded.

Note: If some of the dimensions have not changed:

- 1. Type: -dimstyle <Enter> (notice the (-) dash in front of "dimstyle").
- 2. Type: A <Enter>.
- 3. Select dimensions to update and then press < Enter>.

(Sometimes you have to give them a little nudge.)

Overriding a Dimension Style

A dimension Override is a temporary change to the dimension settings. An override **will not affect existing dimensions**. It will **only affect new dimensions**. Use this option when you want a **new** dimension just a little bit different but don't want to create a whole new dimension style and don't want the existing dimensions to change either.

Example: If you want the new dimension to have a text height of **0.500"** [12.7 mm] but you want the existing text to remain at **0.125"** [3.17 mm] height:

- 1. Select the Dimension Style Manager. (Refer to page 16-7.)
- 2. Select the "style" you want to override. (Such as: CLASS STYLE.)
- 3. Select the Override... button.
- 4. Make the desired changes to the settings. (Such as: Text height = 0.500" [12.7 mm].)
- 5. Select the OK button.

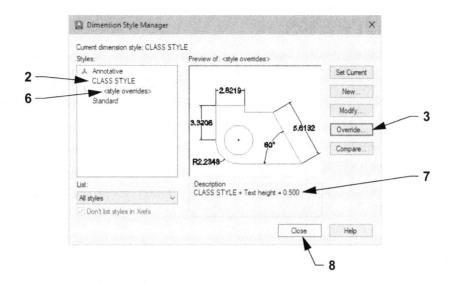

- Confirm the Override.
 Look at the list of styles. Under the style name, a sub heading of <style overrides> should be displayed.
- 7. The description box should display the style name and the override settings.
- 8. Select the Close button.

When you want to return to style CLASS STYLE, select CLASS STYLE from the styles list, then select the **Set Current** button. Each time you select a different style, you must select the **Set Current** button to activate it.

Editing an Individual Existing Dimension

Sometimes you would like to modify the settings of an individual existing dimension. This can be achieved using the Properties Palette.

- 1. Open the Properties Palette. (Refer to page 12-3.)
- 2. Select the dimension to change.
- 3. Select and change the desired settings.

Example: Change the dimension text height to 0.500" [12.7 mm]

Dim scale overall

1.000

- 4. Press *Enter*. (The dimension should have changed.)
- 5. Close the **Properties Palette**.
- 6. Press the **<**Esc> key to de-activate the grips.

Note: The dimension will remain Associative.

Dimension Breaks

Occasionally extension lines overlap other extension lines or even objects. If you do not like this, you may use the **Dimbreak** command to break the intersecting lines. Either the **Automatic** (described below) or **Manual** (described on the next page) method may be used. You may use the **Remove** (described on page 17-8) option to remove the break.

Automatic Dimension Breaks

To create an automatically placed dimension break, you select a dimension and then use the **Auto** option of the **Dimbreak** command.

Automatic dimension breaks are updated any time the dimension or intersecting objects are modified.

You control the size of automatically placed dimension breaks on the **Symbols and Arrows** Tab of the **Dimension Style Manager** dialog box.

The specified size is affected by the dimension break size, dimension scale, and current annotation scale for the current viewport. (Annotation is discussed in Lesson 27.)

1. Select the Dimbreak command using one of the following:

The following will appear on the Command Line:

2. Type M and then press < Enter>.

The following will appear on the Command Line:

```
|| × ₺ - + DIMBREAK Select dimensions:
```

3. Select the dimension(s) you want to break and then press < Enter>. (You may select more than one.)

The following will appear on the Command Line:

```
| × 🏂 - → DIMBREAK Select object to break dimensions or [Auto Remove] <Auto>:
```

4. Press < Enter>.

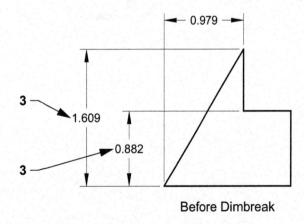

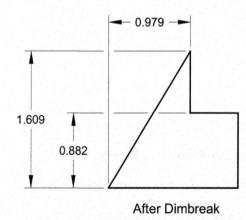

Manual Dimension Break

You can place a dimension break by **picking two points** on the dimension, extension, or leader line to determine the size and placement of the break.

Dimension breaks that are added manually by picking two points are not automatically updated if the dimension or intersecting object is modified. So if a dimension with a manually added dimension break is moved or the intersecting object is modified, you might have to restore the dimension and then add the dimension break again.

The size of a dimension break that is created by picking two points is not affected by the current dimension scale or annotation scale value for the current viewport. (You will learn Annotation in Lesson 27.)

1. Select the **Dimbreak** command using one of the following:

The following will appear on the Command Line:

2. Select the dimension you want to break.

The following will appear on the Command Line:

3. Type *M* and then press <*Enter*>.

The following will appear on the Command Line:

```
|| X /3 - + → DIMBREAK Specify first break point:
```

4. Select the first break point location (Object Snap Nearest is ideal for this operation).

The following will appear on the Command Line:

5. Select the second break point location (Object Snap **Nearest** is ideal for this operation).

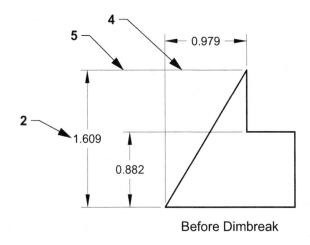

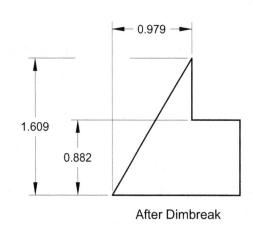

Note: The following objects can be used as cutting edges when adding a dimension break: dimension, leader, line, circle, arc, spline, ellipse, polyline, text, and multiline text.

Remove a Dimension Break

Removing the break is easy using the Remove option.

1. Select the Dimbreak command.

Ribbon = Annotate Tab / Dimension Panel / or Keyboard = dimbreak <Enter>

- 140명 : 140명 : 140명 : 150명 : 150 - 150명 : 150

The following will appear on the Command Line:

|| × /³ - + DIMBREAK Select dimension to add/remove break or [Multiple]:
▲

2. Type M and then press < Enter>.

The following will appear on the Command Line:

|| × ⊅ -±++ DIMBREAK Select dimensions:

3. Select the dimension breaks(s) you want to remove and then press < Enter>. (You may select more than one.)

The following will appear on the Command Line:

| × ⊅ - + DIMBREAK Select object to break dimensions or [Auto Remove] <Auto>:

4. Type R and then press < Enter>.

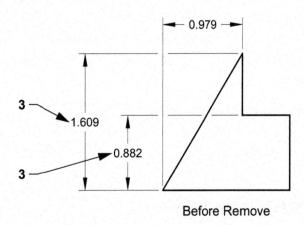

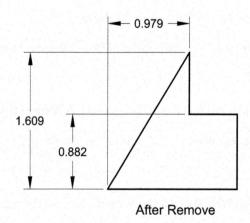

Jogging a Dimension Line

Jog lines can be added to Linear dimensions. Jog lines are used to represent a dimension value that does not display the actual measurement. Before you add a jog, the jog angle and the height factor of the jog should be set in the **Symbols and Arrows** Tab within the dimension style.

The height is calculated as a factor of the text height.

Example:

If the text height was 0.250" [6.35 mm] and the jog height factor was 1.500, the jog would be 0.375" [9.52 mm]

Formula: (0.250" height. X 1.500 jog height. factor = 0.375") (6.35 mm height. X 1.500 jog height. factor = 9.52 mm)

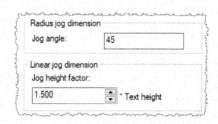

How to Jog a Dimension Line

1. Select the **Jogged Linear** command using one of the following:

Ribbon = Annotate Tab / Dimension Panel / or Keyboard = dimjogline <Enter>

The following will appear on the Command Line:

| × / → DIMJOGLINE Select dimension to add jog or [Remove]:

2. Select a dimension to jog.

The following will appear on the Command Line:

- 3. Press < Enter>.
- 4. After you have added the jog, you can re-position it by using **grips** and adjust the height of the jog symbol using the **Properties Palette**.

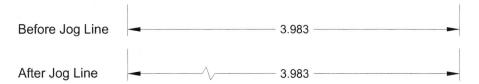

How to Remove a Jog Line

1. Select the **Jogged Linear** command.

The following will appear on the Command Line:

| × / → DIMJOGLINE Select dimension to add jog or [Remove]:

2. Type R and then press < Enter>.

The following will appear on the Command Line:

|| × /3 →√ ▼ DIMJOGLINE Select jog to remove:

3. Select the Jogged dimension.

Adjusting the Distance Between Dimensions

The **Adjust Space** command allows you to adjust the distance between existing parallel linear and angular dimensions, so they are equally spaced. You may also align the dimensions to create a string.

1. Select the **Dimension Space** command using one of the following:

Ribbon = Annotate Tab / Dimension Panel / or Keyboard = dimspace <Enter>

The following will appear on the Command Line:

2. Select the dimension that you want to use as the base dimension when equally spacing dimensions (P1).

The following will appear on the Command Line:

3. Select the next dimension to be spaced (P2).

The following will appear on the Command Line:

|| × /> ፲ ▼ DIMSPACE Select dimensions to space:

4. Select the next dimension to be spaced (P3).

The following will appear on the Command Line:

|| ×
| → DIMSPACE Select dimensions to space:

5. Continue to select more dimensions or press < Enter> to stop selecting dimensions.

The following will appear on the Command Line:

6. Enter a value or press < Enter > for Auto.

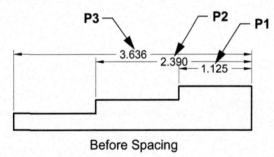

Example:

If the dimension text is 1/8" [3.17 mm], the spacing will be 1/4" [6.35 mm].

Aligning dimensions

Follow the steps shown above, but when asked for the value, enter 0 and then press < Enter>.

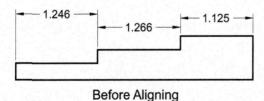

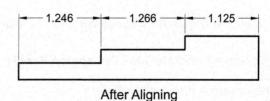

3.636

After Spacing

2.390

- 1.125

Exercise 17A-Inch

- 1. Start a New file using the Border A-Inch.dwt
- 2. Draw the 6" x 4" rectangle shown below. Use Layer Object Line.
- 3. Upper and right dimension: Use Dimension Style CLASS STYLE. Use Layer Dimension.
- 4. **Lower** and **left dimension**: Use **Override**. Change the text height setting to **0.500**". If the upper and right dimension also changed, you did not use "Override". Try again.
- 5. Edit the **Title** and **Ex-XX** by double clicking on the text. Do not erase and replace.
- 6. Save as Ex-17A-I
- 7. Plot using Page Setup Class Model A

Exercise 17A-Metric

- 1. Start a New file using the Border A-Metric.dwt
- 2. Draw the 150 mm x 100 mm rectangle shown below. Use Layer Object Line.
- 3. Upper and right dimension: Use Dimension Style CLASS STYLE. Use Layer Dimension.
- 4. Lower and left dimension: Use Override. Change the text height setting to 12 mm. If the upper and right dimension also changed, you did not use "Override". Try again.
- 5. Edit the **Title** and **Ex-XX** by double clicking on the text. Do not erase and replace.
- 6. Save as Ex-17A-M
- 7. Plot using Page Setup Class Model A

Exercise 17B-Inch

- 1. Open Ex-16B-I
- 2. Re-space the Baseline dimensions on the right side. Use Auto for spacing.
- 3. Align the two 1.000" dimensions.
- 4. Edit the **Title** and **Ex-XX** by double clicking on the text. Do not erase and replace.
- 5. Save as Ex-17B-I
- 6. Plot using Page Setup Class Model A

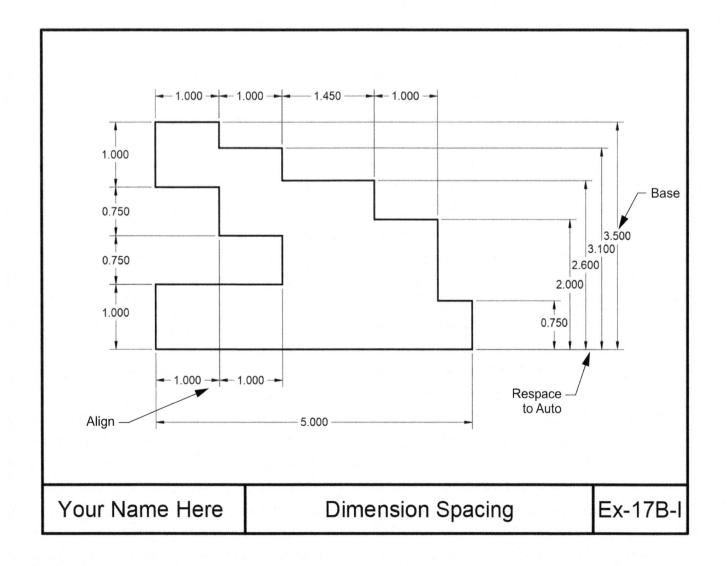

Exercise 17B-Metric

Exercise 17B-Metric

- 1. Open Ex-16B-M
- 2. Re-space the Baseline dimensions on the right side. Use Auto for spacing.
- 3. Align the two 25 mm dimensions.
- 4. Edit the Title and Ex-XX by double clicking on the text. Do not erase and replace.
- 5. Save as Ex-17B-M
- 6. Plot using Page Setup Class Model A

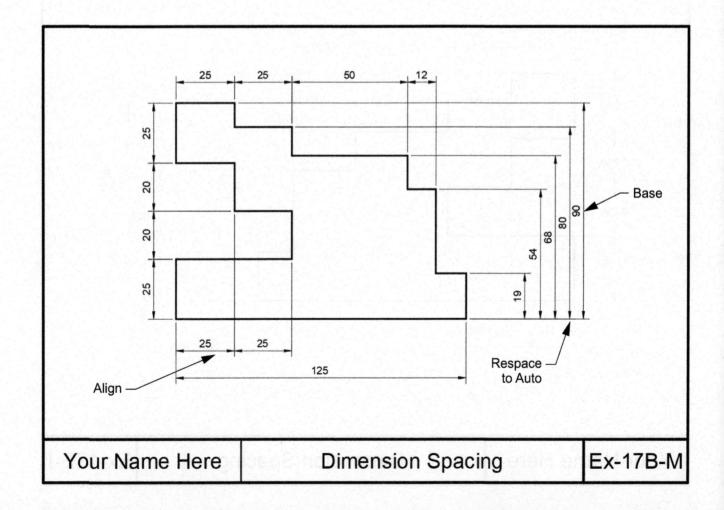

Exercise 17C-Inch

- 1. Open Ex-17B-I
- 2. Make the changes shown below. Use the grips and the Properties Palette.
- 3. Notice: Not all dimensions change, so you can't make changes to the dimension style.
- 4. Edit the **Title** and **Ex-XX** by double clicking on the text. Do not erase and replace.
- 5. Save as Ex-17C-I
- 6. Plot using Page Setup Class Model A

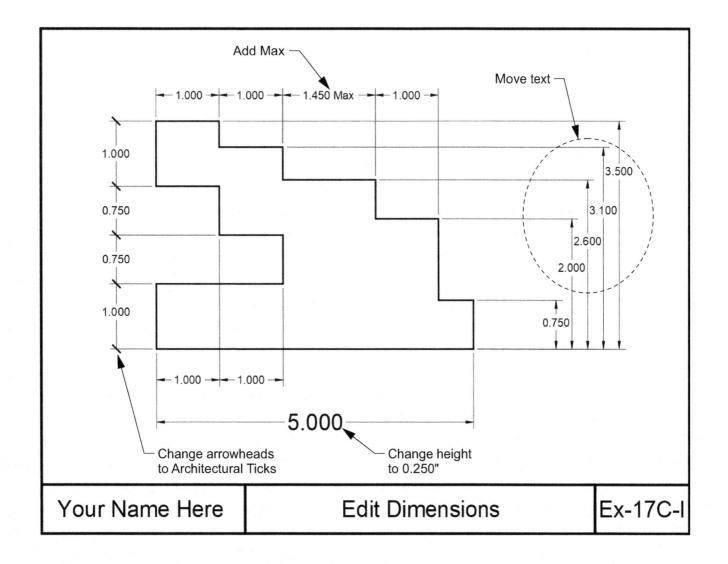

Exercise 17C-Metric

Exercise 17C-Metric

- 1. Open Ex-17B-M
- 2. Make the changes shown below. Use the grips and the Properties Palette.
- 3. Notice: Not all dimensions change, so you can't make changes to the dimension style.
- 4. Edit the **Title** and **Ex-XX** by double clicking on the text. Do not erase and replace.
- 5. Save as Ex-17C-M
- 6. Plot using Page Setup Class Model A

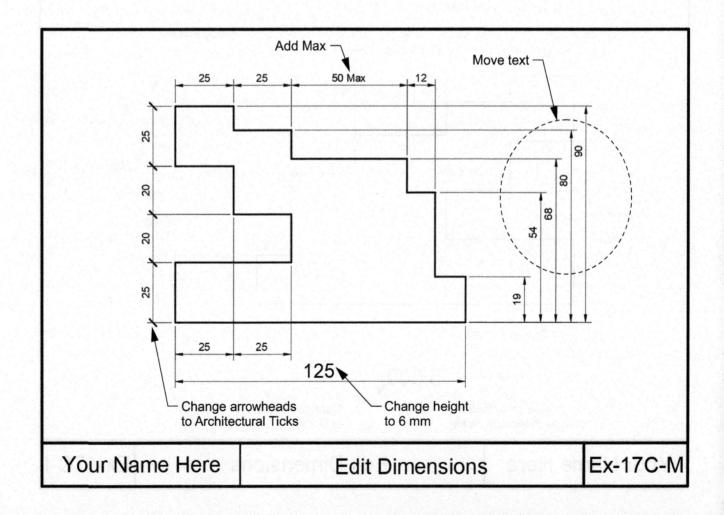

Exercise 17D-Inch

Exercise 17D-Inch

- 1. Start a New file using Border A-Inch.dwt
- 2. Draw the objects shown below.
- 3. Dimension as shown. Be very careful because there is just enough drawing area.
- 4. Use Dimension Break to break the extension lines as shown.
- 5. Use Dimension Jog to create a jog in the lower dimension.
- 6. Edit the Title and Ex-XX by double clicking on the text. Do not erase and replace.
- 7. Save as Ex-17D-I
- 8. Plot using Page Setup Class Model A

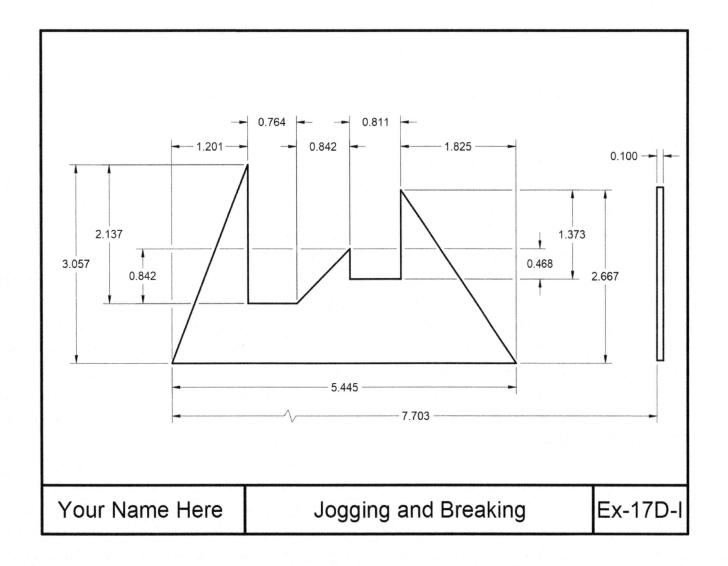

Exercise 17D-Metric

Exercise 17D-Metric

- 1. Start a New file using Border A-Metric.dwt
- 2. Draw the objects shown below.
- 3. Dimension as shown. Be very careful because there is just enough drawing area.
- 4. Use Dimension Break to break the extension lines as shown.
- 5. Use Dimension Jog to create a jog in the lower dimension.
- 6. Edit the Title and Ex-XX by double clicking on the text. Do not erase and replace.
- 7. Save as Ex-17D-M
- 8. Plot using Page Setup Class Model A

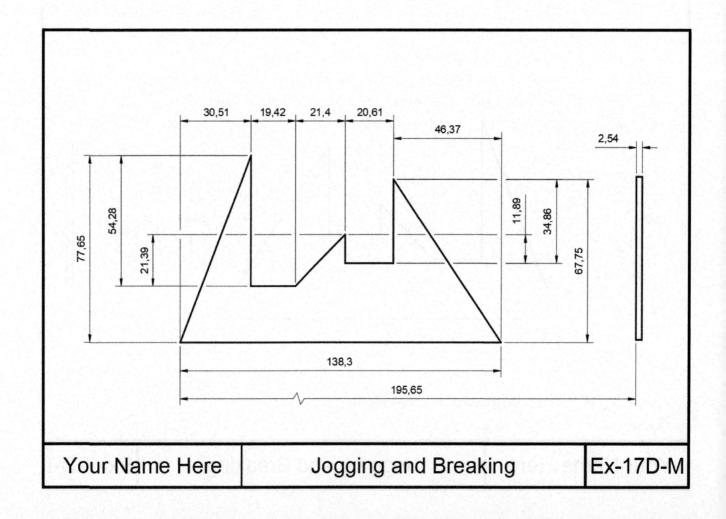

LESSON 18

LEARNING OBJECTIVES

After completing this lesson, you will be able to:

- 1. Add Diameter, Radius and Angular dimensions to a drawing.
- 2. Draw and control Center Marks.
- 3. Manually place Center Marks and Centerlines.
- 4. Flip the direction of an arrowhead.
- 5. Understand the need for sub-styles.
- 6. Create a sub-style.

Dimensioning Diameters

The **Diameter** dimensioning command should be used when dimensioning circles and arcs of **more than 180 degrees**. AutoCAD measures the selected circle or arc and displays the dimension text with the diameter symbol (**Ø**) in front of it.

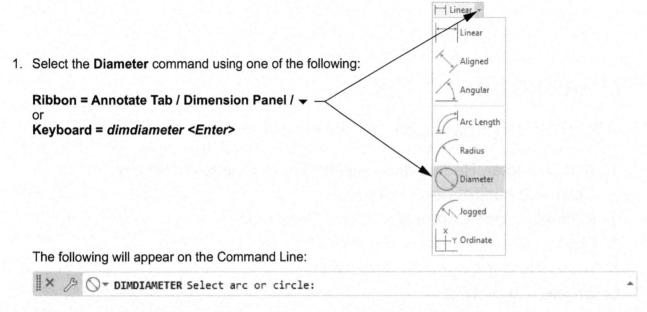

2. Select the arc or circle (P1).

The following will appear on the Command Line:

3. Place the dimension text location (P2).

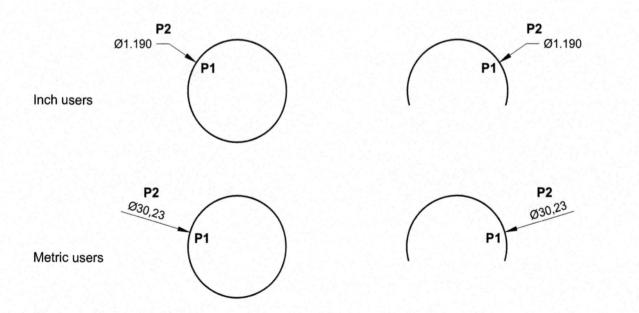

Note: Refer to page 18-6 if you require Center Marks to be included automatically with a diameter dimension, or if you want to manually place a Center Mark on a circle.

Controlling the Diameter dimension appearance

If you would like your diameter dimensions to appear as shown in the two examples below, you must change some settings in the Dimension Style Manager **Fit** Tab.

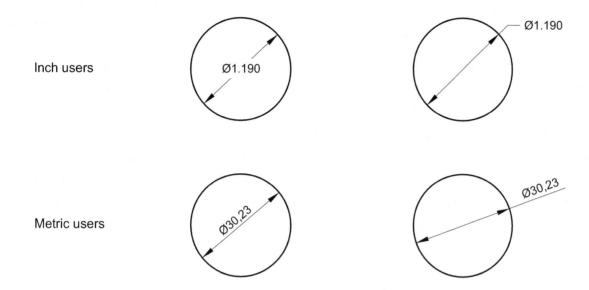

How to change the Diameter dimension appearance

- 1. Open the **Dimension Style Manager** dialog box.
- 2. Select the Fit Tab.
- 3. Fit options: Select Text.
- 4. Fine tuning: Check Place text manually.

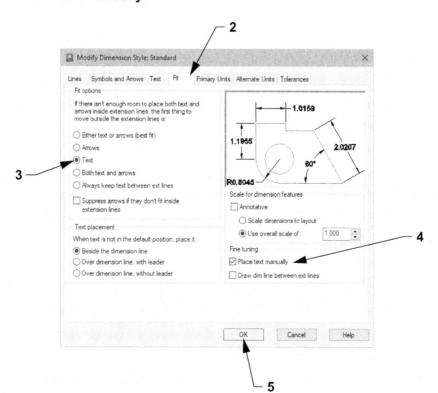

5. Select the **OK** button.

Dimensioning Radii

The **Radius** dimensioning command should be used when dimensioning arcs of **less than 180 degrees**. AutoCAD measures the selected arc and displays the dimension text with the radius symbol (**R**) in front of it.

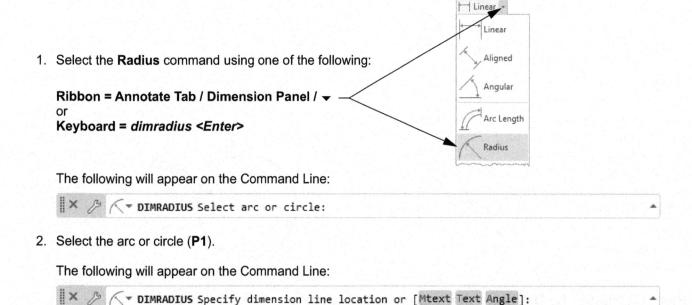

3. Place the dimension text location (P2).

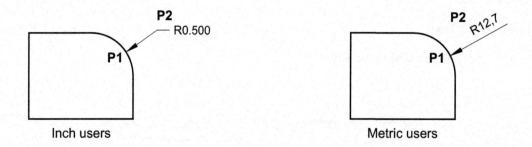

Note: Refer to page 18-6 if you require Center Marks to be included automatically with a radius dimension, or if you want to manually place a Center Mark on a circle.

Controlling the Radius dimension appearance

If you would like your radius dimensions to appear as shown in the two examples below, you must change some settings in the Dimension Style Manager **Fit** Tab. Change the settings to be the same as those shown for diameter dimensions on page 18-3

Angular Dimensioning

The **Angular** dimension command is used to create an angular dimension between two lines that form an angle. AutoCAD determines the angle between the selected lines and displays the dimension text followed by a degree (°) symbol.

1. Select the **Angular** command using one of the following:

Ribbon = Annotate Tab / Dimension Panel / ▼ —

Keyboard = dimangular <Enter>

The following will appear on the Command Line:

|| × /³ / ▼ DIMANGULAR Select arc, circle, line, or <specify vertex>:

2. Select the first line that forms the angle (P1). Location is not important, do not use Object Snap.

The following will appear on the Command Line:

|| × / △ ▼ DIMANGULAR Select second line:

3. Select the first line that forms the angle (P2).

The following will appear on the Command Line:

4. Place the dimension text location (P3).

Any of the four angular dimensions shown below can be displayed by moving the cursor in the direction of the dimension after selecting the two lines (**P1** and **P2**) that form the angle.

Center Mark – Automatic

Center Marks can automatically be drawn when you dimension circular objects like circles and arcs. You set the size and type.

The Center Mark has three types, None, Mark, and Line as shown below.

What does "size" mean?

The **size** setting determines both, (A) the length of half of the intersection line and (B) the length extending beyond the circle. (See above right.)

Where do you set the Center Mark "type" and "size"?

- 1. Open the Dimension Style Manager dialog box.
- 2. Select Modify or Override.
- 3. Select the Symbols and Arrows Tab.
- 4. Select the Center marks type.
- 5. Set the size.

Center Mark - Manual

Center Marks can be manually placed on circles and arcs.

1. Select the Centermark command using one of the following:

The following will appear on the Command Line:

- 2. Select a circle or arc.
- 3. Continue to select more circles or arcs, or press < Enter> to end the command.

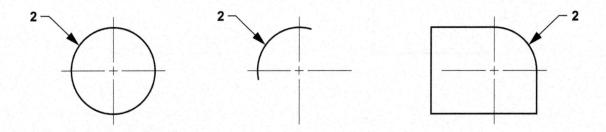

Modifying Center Marks

You can modify Center Marks by using the grips after first selecting a Center Mark. You can choose to lengthen each extension line individually by selecting an **arrow grip**, or you can lengthen all four extension lines equally at the same time by selecting the **square center grip** then selecting "**Change Extension Length**" from the menu.

Selecting an arrow grip to extend an individual line

Selecting the square grip to change the extension length of all four lines equally

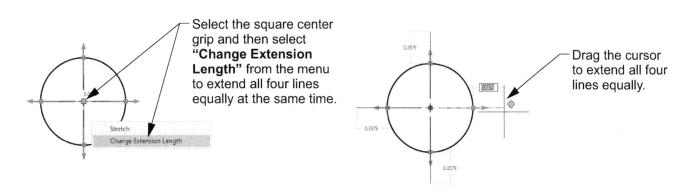

Note: Center Marks are **Associative**, so if you choose to move or change the size of a circle or arc, the Center Mark will automatically move or resize with it.

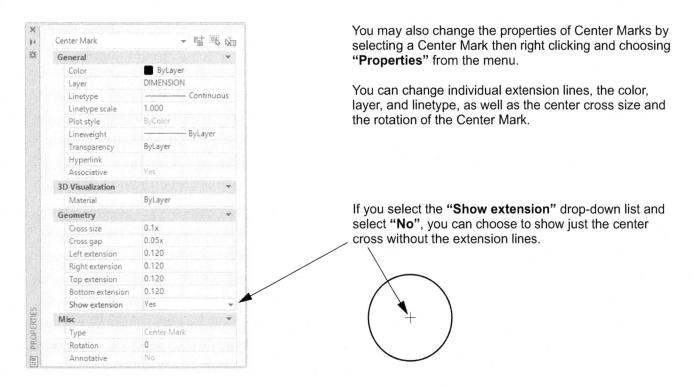

18-8 Centerline

Centerline

Centerlines are created by selecting two lines or polylines.

1. Select the Centerline command using one of the following:

Ribbon = Annotate Tab / Centerlines Panel / or Keyboard = centerline <Enter>

The following will appear on the Command Line:

2. Select the first line.

The following will appear on the Command Line:

```
|| × /³ = ▼ CENTERLINE Select second line:
```

- 3. Select the second line.
- 4. The Centerline will be created and the command will end automatically.

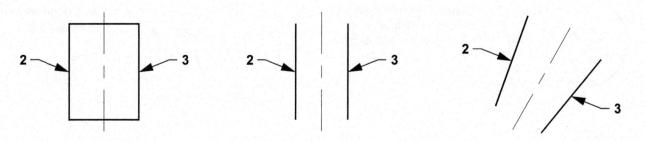

Modifying Centerlines

You can modify Centerlines by using the grips after first selecting a Centerline. You can choose to lengthen either end of the Centerline by dragging an arrow grip, or you may choose to extend the Centerline to another object as shown in the example below.

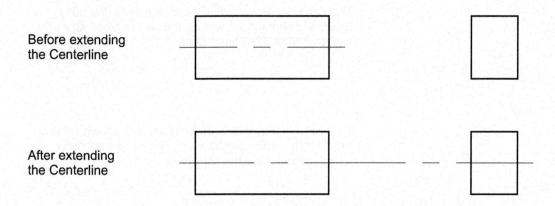

Note: Centerlines are **Associative**, so if you choose to move an object or one of the lines, the Centerline will automatically adjust to the new center position. You may also change the properties of Centerlines by selecting a Centerline and then right clicking and choosing "**Properties**" from the menu.

Flip Arrow

You can easily **flip** the direction of the arrowhead using the **Flip Arrow** option.

How to Flip an arrowhead

- 1. Select the dimension that you want to flip.
- 2. Rest your cursor on the arrow grip. (Do not press the button, just rest the cursor.)
- 3. Select Flip Arrow from the Shortcut Menu.
- 4. The arrowhead flips.
- 5. Press **<**Esc> and the grips will disappear. (Do not press **<**Enter>.)

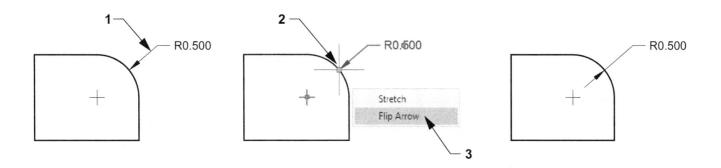

Creating a Dimension Sub-Style

In Lesson 16, you learned how to create a dimension style named CLASS STYLE. All of the dimensions created with that style appear identical because they have the same settings. Now you are going to learn how to create a "sub-style" of the CLASS STYLE.

Example:

If you want all of the **diameter** dimensions to have a **Center Mark** automatically displayed but do not want a **Center Mark** displayed when using the **Radius** dimension command, you must create a "**sub-style**" for all **diameter** dimensions.

Sub-styles have also been called "children" of the "parent" dimension styles. As a result, they form a family.

A sub-style is permanent, unlike the Override command, which is temporary.

Note: This sounds much more complicated than it is. Just follow the steps below. It is very easy.

How to create a sub-style for Diameter dimensions

You will set the Center Mark to **Line** for the Diameter command only. The Radius command Center Mark will not change.

- 1. Start a New file using either the Border A-Inch.dwt or the Border A-Metric.dwt
- 2. Select the **Dimension Style Manager**. (Refer to page 16-7.)

- 3. Select CLASS STYLE from the Styles list.
- 4. Select the New... button.

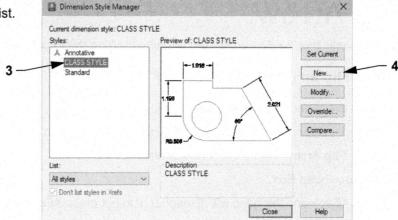

Create New Dimension Style

New Style Name: Copy of CLASS STYLE

Start With:

CLASS STYLE

Annotative

Use for:

5

10

This will turn gray. That's OK.

Continue

- 5. Change the "Use for" to: Diameter dimensions.
- 6. Select Continue.

- Select the Symbols and Arrows Tab.
- Change the "Center marks" to Line.
- 9. Select the OK button.

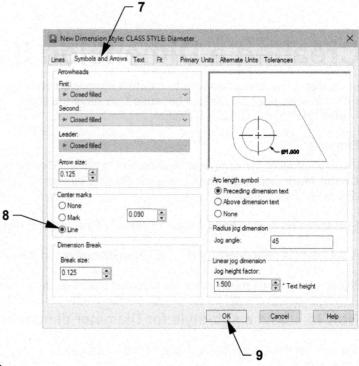

 You now have a sub-style that will automatically override the basic CLASS STYLE whenever you use a Diameter command. Diameter dimensions will have Center Marks and radius dimensions will not.

If you would like to keep this sub-style, re-save the template.

Exercise 18A-Inch

- 1. Start a New file using the Border A-Inch.dwt
- 2. Draw the objects below using Layer Object Line.
- 3. Dimension as shown using Linear, Diameter, and Radius. Use Layer Dimension.
- 4. Edit the **Title** and **Ex-XX** by double clicking on the text. Do not erase and replace.
- 5. Save as Ex-18A-I
- 6. Plot using Page Setup Class Model A

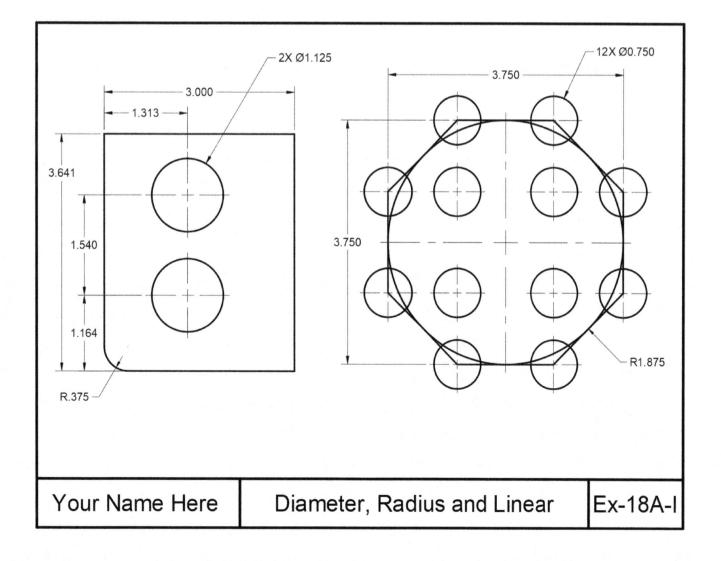

Exercise 18A-Metric

Exercise 18A-Metric

- 1. Start a New file using the Border A-Metric.dwt
- 2. Draw the objects below using Layer Object Line.
- 3. Dimension as shown using Linear, Diameter, and Radius. Use Layer Dimension.
- 4. Edit the **Title** and **Ex-XX** by double clicking on the text. Do not erase and replace.
- 5. Save as Ex-18A-M
- 6. Plot using Page Setup Class Model A

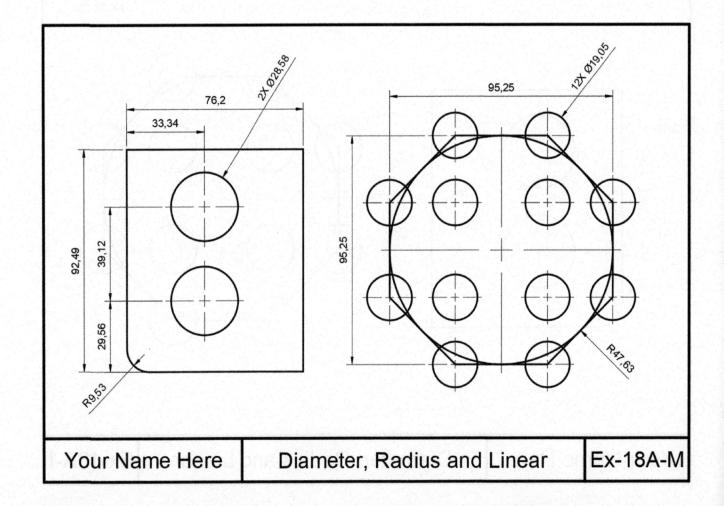

Exercise 18B-Inch

Instructions:

- 1. Start a New file using the Border A-Inch.dwt
- 2. Draw the objects below using Layer Object Line.
- 3. Dimension as shown using Linear, Diameter, and Angular. Use Layer Dimension.
- 4. Edit the **Title** and **Ex-XX** by double clicking on the text. Do not erase and replace.
- 5. Save as Ex-18B-I
- 6. Plot using Page Setup Class Model A

Note: Refer to the next page for drawing hints.

Exercise 18B-Inch Helper

Follow the step-by-step instructions to complete the exercise.

Step 1. Draw horizontal and vertical lines.

Step 2. Offset some lines.

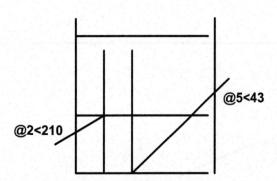

Step 3. Use Polar coordinate input to draw the two angled lines.

Step 4. Trim the lines so it doesn't get confusing.

Step 5. Offset some more lines. Use Polar coordinate input again.

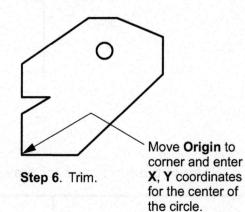

Exercise 18B-Metric

Exercise 18B-Metric

Instructions:

- 1. Start a New file using the Border A-Metric.dwt
- 2. Draw the objects below using Layer Object Line.
- 3. Dimension as shown using Linear, Diameter, and Angular. Use Layer Dimension.
- 4. Edit the **Title** and **Ex-XX** by double clicking on the text. Do not erase and replace.
- 5. Save as Ex-18B-M
- 6. Plot using Page Setup Class Model A

Note: Refer to the next page for drawing hints.

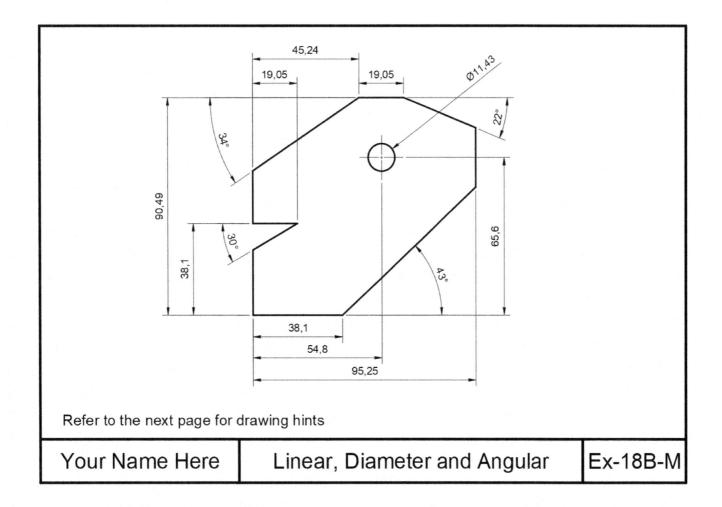

Exercise 18B-Metric Helper

Follow the step-by-step instructions to complete the exercise.

Step 1. Draw horizontal and vertical lines.

Step 2. Offset some lines.

Step 3. Use Polar coordinate input to draw the two angled lines.

Step 4. Trim the lines so it doesn't get confusing.

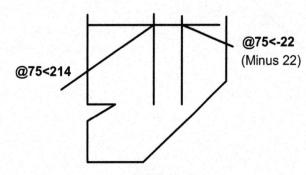

Step 5. Offset some more lines. Use Polar coordinate input again.

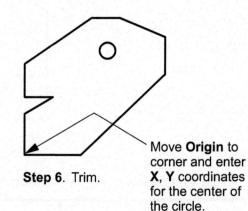

Exercise 18C-Inch

- 1. Start a New file using the Border A-Inch.dwt
- 2. Draw the objects below using Layer Object Line.
- 3. Manually place the Center Marks and Centerlines. Use Layer Centerline and change the line color to black.
- 4. Dimension as shown using Linear and Diameter. Use Layer Dimension.
- 5. Edit the **Title** and **Ex-XX** by double clicking on the text. Do not erase and replace.
- 6. Save as Ex-18C-I
- 7. Plot using Page Setup Class Model A

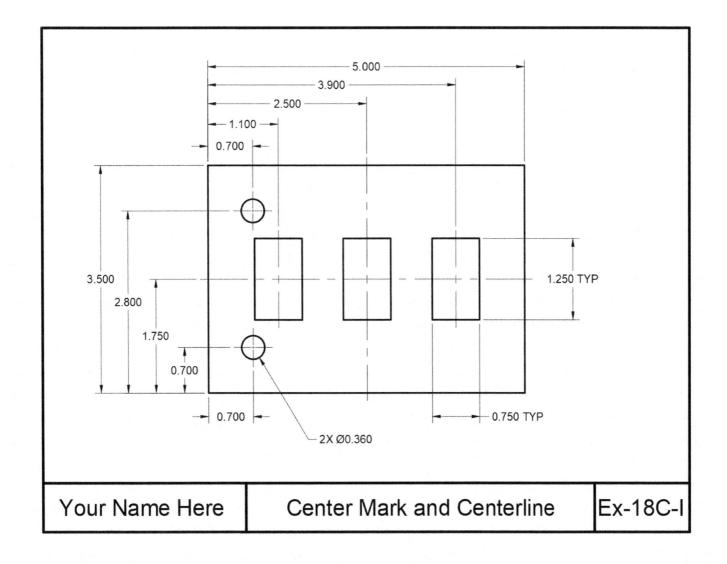

Exercise 18C-Metric

- 1. Start a New file using the Border A-Metric.dwt
- 2. Draw the objects below using Layer Object Line.
- 3. Manually place the Center Marks and Centerlines. Use Layer Centerline and change the line color to black.
- 4. Dimension as shown using Linear and Diameter. Use Layer Dimension.
- 5. Edit the Title and Ex-XX by double clicking on the text. Do not erase and replace.
- 6. Save as Ex-18C-M
- 7. Plot using Page Setup Class Model A

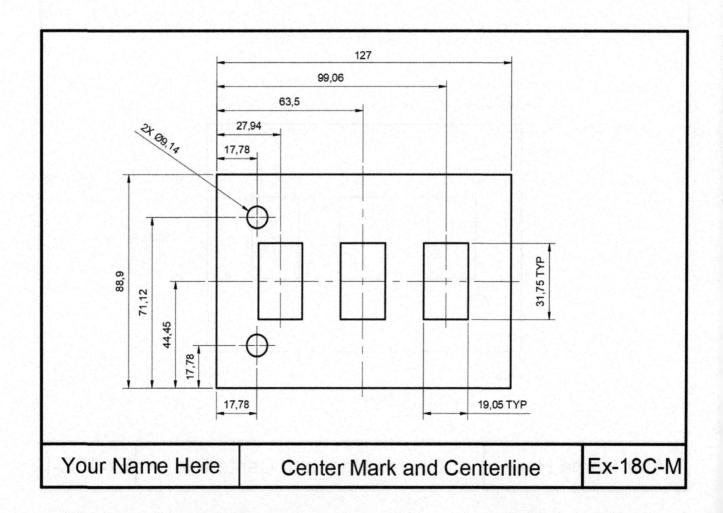

LESSON 19

LEARNING OBJECTIVES

After completing this lesson, you will be able to:

- 1. Create Multileaders.
- 2. Modify Multileader lines.
- 3. Create a new Multileader style.
- 4. Dimension angular surfaces.
- 5. Add Special Characters.
- 6. Pre-assign a Prefix or Suffix to a dimension.

Multileader

A **multileader** is a single object consisting of a pointer, line, landing, and content. You may draw a multileader, pointer first, tail first, or content first.

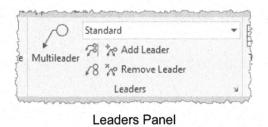

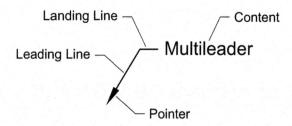

How to create a single Multileader

1. To select the Multileader command use one of the following:

The following will appear on the Command Line:

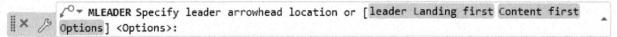

2. Specify the arrowhead location (P1).

The following will appear on the Command Line:

- 3. Specify the leader landing location (P2).
- The Multiline Text Editor Ribbon will appear: Enter the text for the leader and then select Close Text Editor.

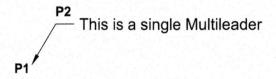

Add leader lines to an existing Multileader

1. Select the **Add Leader** tool. Add Leader

The following will appear on the Command Line:

2. Select an existing multileader (P1).

The following will appear on the Command Line:

3. Specify the arrowhead location (P2).

The following will appear on the Command Line:

🛮 🗶 🏂 🖛 AIMLEADEREDITADD Specify leader arrowhead location or [Remove leaders]:

4. Specify the arrowhead location (P3).

The following will appear on the Command Line:

- 5. Specify the arrowhead location (P4).
- 6. Press **<Enter>** to stop.

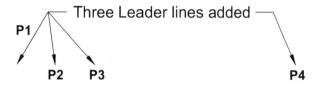

Remove a leader line from an existing Multileader

1. Select the Remove Leader tool. Remove Leader

The following will appear on the Command Line:

2. Select an existing multileader (P1). (You can click anywhere on the multileader.)

The following will appear on the Command Line:

🛮 🗴 🥕 🗔 🕶 AIMLEADEREDITREMOVE Specify leaders to remove or [Add leaders]:

- 3. Select the leader line to remove (P2).
- 4. You can select more leader lines to remove or press **<Enter>** to end the command.

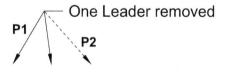

Align Multileaders

1. Select the Align Multileader tool.

The following will appear on the Command Line:

2. Select the leaders to align (Note 1 and Note 3 as shown on the next page) and then press < Enter> to stop selecting.

The following will appear on the Command Line:

■ X B T MLEADERALIGN Select multileader to align to or [Options]:

19-4 Multileader

3. Select the leader to align to (Note 2).

The following will appear on the Command Line:

4. Move the cursor in the direction you want the leaders aligned, and then press the left mouse button.

Note: If you want the leaders perfectly aligned vertically or horizontally, make sure Ortho Mode <F8> is on.

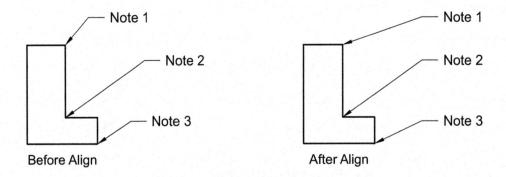

Note: Collect Multileader 8 works best with Blocks and will be discussed in another lesson.

Creating a Multileader Style

You may create multileader styles to control its appearance. This will be similar to creating a dimension style.

- 1. Start a New file using either the Border A-Inch.dwt or the Border A-Metric.dwt
- 2. Select the Multileader Style Manager by selecting the diagonal arrow > on the Leaders Panel.

- 3. Select the New... button.
- 4. Enter the New Style name: Class ML Style
- 5. Select the Continue button.

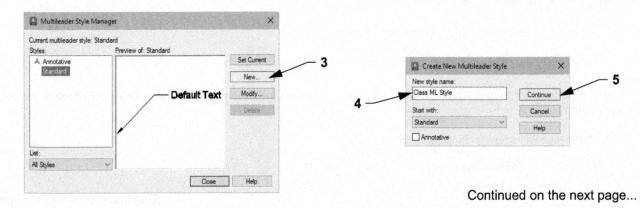

6. Select the **Leader Format** Tab and change the settings as shown.

Metric users: Arrowhead Size = 3.2 Break Size = 3.2

General: You may set the leader line to straight or spline (curved). You may change the color, linetype, and lineweight.

Arrowhead: Select the symbol for the pointer and size of pointer.

Leader break: Specify the size of the gap in the leader line if Dimension break is used. (Refer to page 17-6 for Dimension break reminder.)

7. Select the **Leader Structure** Tab and change the settings as shown.

Metric users: Set landing distance = 3.2

Constraints: Specify how many line segments to allow and on what angle.

Landing settings: Specify the length of the landing (the horizontal line next to the note) or turn it off by unchecking the "Automatically include landing" box.

Scale: "Annotative" will be discussed in Lesson 27

8. Select the **Content** Tab and change the settings as shown.

Metric users: Text height = 3.2 Landing gap = 1.5

Multileader type: Select what to attach to the landing.

Text options: Specify the leader note appearance.

Leader connection: Specify how the note attaches to the landing.

9. Select the OK button.

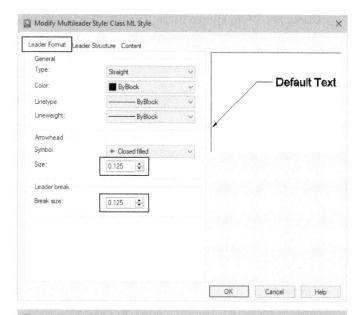

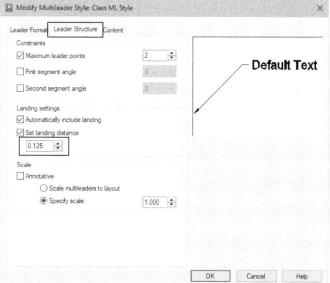

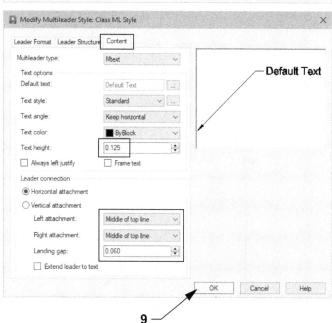

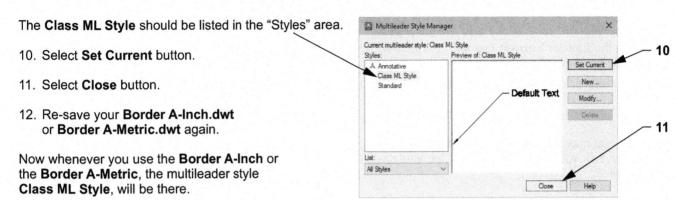

Aligned Dimensioning

The **Aligned** dimension command aligns the dimension with the angle of the object that you are dimensioning. The process is the same as Linear dimensioning. It requires two extension line origins and the placement of the dimension text location. (See the example below.)

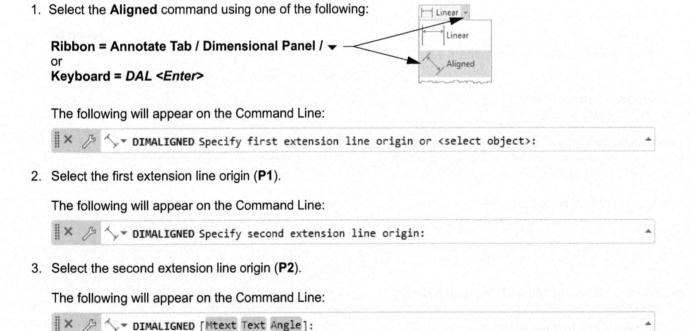

4. Place the dimension text (P3).

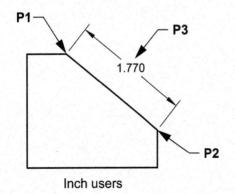

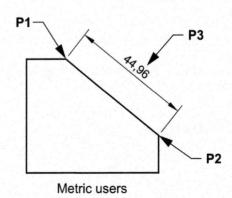

Special Text Characters

Characters such as the **Degrees symbol** ($^{\circ}$), **Plus/Minus symbols** ($^{\pm}$), and the **Diameter symbol** ($^{\varnothing}$), are created by typing %% and then the appropriate "**code**" letter.

Symbol		Code
0	Degrees	%%d
±	Plus/Minus	%%p
Ø	Diameter	%%c

Single Line Text

When using Single Line Text, type the code in the sentence. After you enter the code, the symbol will appear.

Example:

Entering: 350%%d will create: 350°. The "d" is the "code" letter for degree.

Multiline Text

When using **Multiline Text**, you may enter the code in the sentence or you may select a symbol using the **Symbol** tool located on the **Insert Panel** of the **Text Editor** Ribbon.

Prefix and Suffix

The prefix (before) and the suffix (after) allows you to preset text to be inserted automatically as you dimension.

Note: You would use this if you had multiple dimensions that included a prefix or a suffix. If you had only one or two, you would merely edit the dimension text as shown on page 17-2.

- 1. Select the **Dimension Style Manager**.
- 2. Select Dimension Style CLASS STYLE.
- 3. Select the Primary Units Tab.
- 4. Enter the Prefix or Suffix content.

Example:

Note: Make sure you add a space **after "2X"** in the **Prefix** box, and a space **before "Ref"** in the **Suffix** box. If you didn't add those spaces, the dimension text would look like the example below.

Note: If you enter text in the **Prefix** box and you create **radius** or **diameter** dimensions, the "**R**" for radius or the "**Ø**" for the diameter symbol, will not be automatically drawn. You must create a **dimension sub-style** for both radius and diameter dimensions, and add the examples shown below to the **Prefix** box for each sub-style. (Refer to page 18-9 for creating dimension sub-styles.)

2XR

Prefix for a Radius Dimension Sub-Style 2X %%C

Prefix for a Diameter Dimension Sub-Style

Exercise 19A-Inch

Exercise 19A-Inch

- 1. Start a New file using the Border A-Inch.dwt
- 2. Draw the lines as shown using Polar coordinates or Dynamic Input. (Refer to Lessons 9 and 11.)
- 3. Use Layer Object Line.
- 4. Dimension using Linear, Aligned, and Angular.
- 5. Use Dimension Style CLASS STYLE and Layer Dimension.
- 6. Edit the **Title** and **Ex-XX** by double clicking on the text. Do not erase and replace.
- 7. Save as Ex-19A-I
- 8. Plot using Page Setup Class Model A

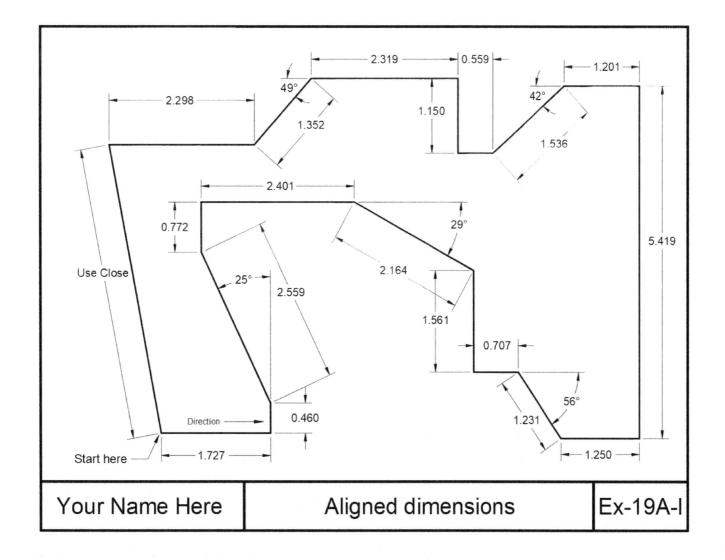

Exercise 19A-Metric

Exercise 19A-Metric

- 1. Start a New file using the Border A-Metric.dwt
- 2. Draw the lines as shown using Polar coordinates or Dynamic Input. (Refer to Lessons 9 and 11.)
- 3. Use Layer Object Line.
- 4. Dimension using Linear, Aligned, and Angular.
- 5. Use Dimension Style CLASS STYLE and Layer Dimension.
- 6. Edit the Title and Ex-XX by double clicking on the text. Do not erase and replace.
- 7. Save as Ex-19A-M
- 8. Plot using Page Setup Class Model A

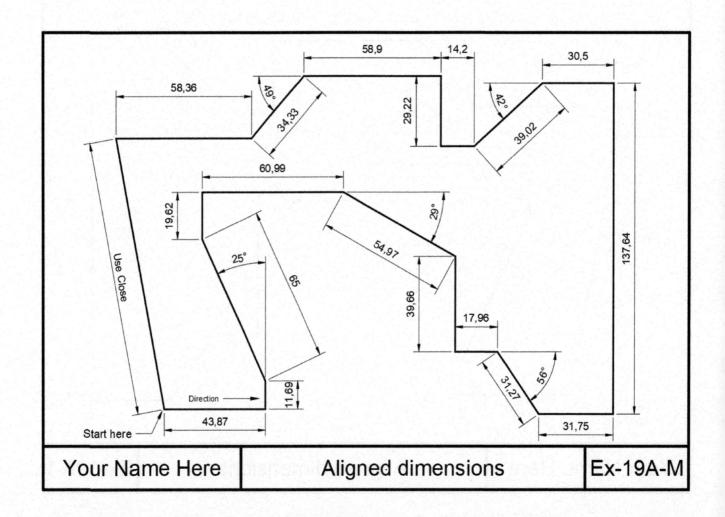

Exercise 19B-Inch

- 1. Start a New file using the Border A-Inch.dwt
- 2. Draw the object shown below.
- 3. Use Layer Object Line.
- 4. Dimension as shown.
- 5. Use Dimension Style CLASS STYLE and Layer Dimension.
- 6. For the note "Special Instructions to Baker" use Text Height = 0.125 Layer = Text.
- 7. Edit the **Title** and **Ex-XX** by double clicking on the text. Do not erase and replace.
- 8. Save as Ex-19B-I
- 9. Plot using Page Setup Class Model A

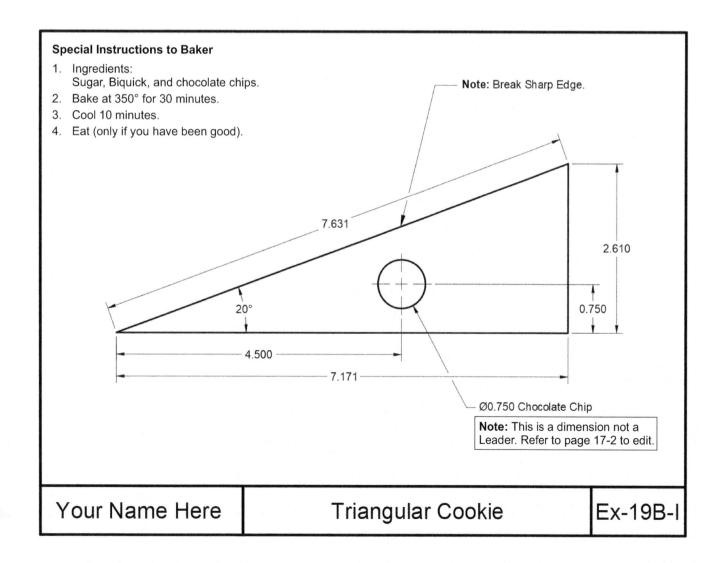

Exercise 19B-Metric

Exercise 19B-Metric

- 1. Start a New file using the Border A-Metric.dwt
- 2. Draw the object shown below.
- 3. Use Layer Object Line.
- 4. Dimension as shown.
- 5. Use Dimension Style CLASS STYLE and Layer Dimension.
- 6. For the note "Special Instructions to Baker" use Text Height = 3.2 Layer = Text.
- 7. Edit the Title and Ex-XX by double clicking on the text. Do not erase and replace.
- 8. Save as Ex-19B-M
- 9. Plot using Page Setup Class Model A

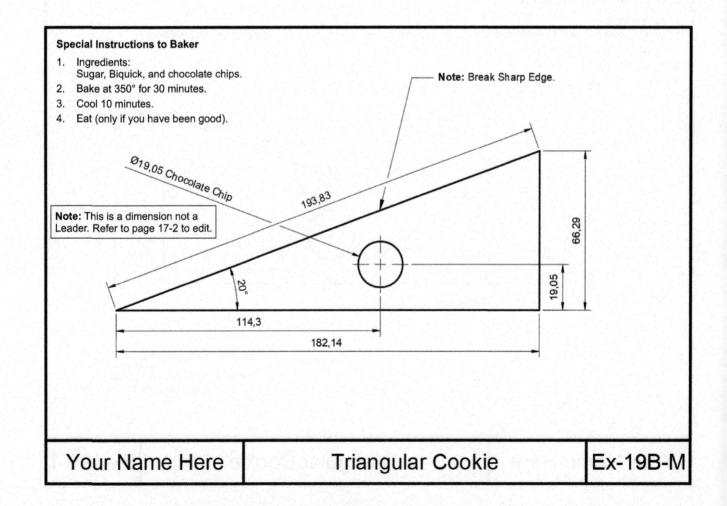

Exercise 19C-Inch

- 1. Start a New file using the Border A-Inch.dwt
- 2. Create the multileader style shown on page 19-4 if you haven't already.
- 3. Draw the object shown below.
- 4. Use Layer Object Line.
- 5. Dimension as shown.
- 6. Use Dimension Style CLASS STYLE and Class ML Style and Layer Dimension.
- 7. Edit the **Title** and **Ex-XX** by double clicking on the text. Do not erase and replace.
- 8. Save as Ex-19C-I
- 9. Plot using Page Setup Class Model A

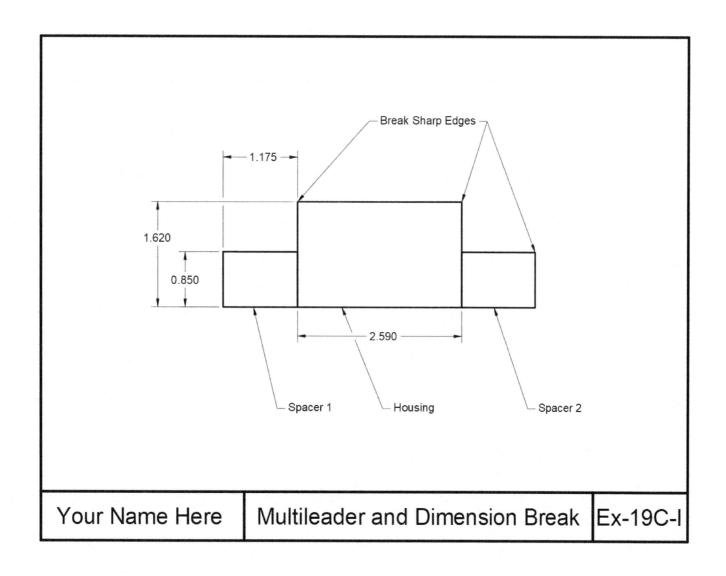

Exercise 19C-Metric

Exercise 19C-Metric

- 1. Start a New file using the Border A-Metric.dwt
- 2. Create the multileader style shown on page 19-4 if you haven't already.
- 3. Draw the object shown below.
- 4. Use Layer Object Line.
- 5. Dimension as shown.
- 6. Use Dimension Style CLASS STYLE and Class ML Style and Layer Dimension.
- 7. Edit the Title and Ex-XX by double clicking on the text. Do not erase and replace.
- 8. Save as Ex-19C-M
- 9. Plot using Page Setup Class Model A

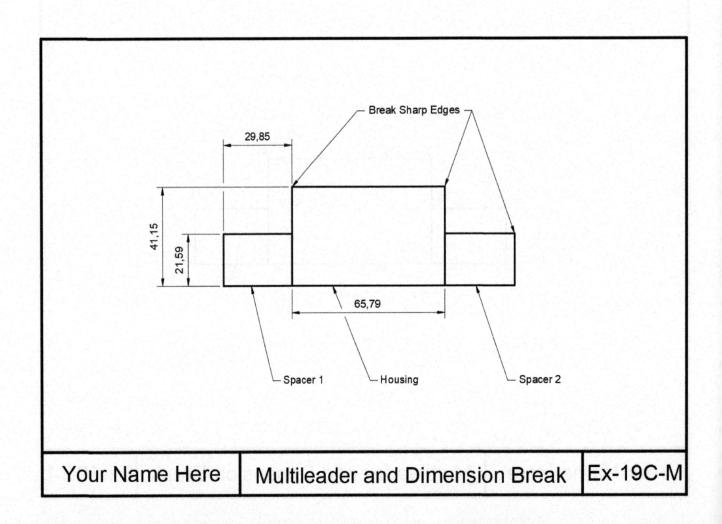

LESSON 20

LEARNING OBJECTIVES

After completing this lesson, you will be able to:

1. Use the Dim command to create multiple dimensions all within a single command.

Dim Command

Dim command allows you to automatically create dimensions based on the object you select. After selecting the Dim command, you simply hover the cursor over an object to see a preview of the dimension before you create it.

Dim command allows you to create multiple dimensions all within the one command by selecting an object or by using the appropriate prompts on the Command Line. In previous lessons, you had to select a command for each dimension you wanted to create.

1. Select the Dim command using one of the following:

The following examples show you the previews when creating dimensions for Linear objects. **Note:** Metric users will see the dimension text aligned with the dimension line.

2. If you are satisfied with the preview of the dimension required, you simply left click to select the object and then drag the cursor to place the dimension in the position you require. Then left click again to accept the position.

Note: It is best to turn off Ortho Mode <F8>, especially for Aligned dimensions.

Some examples showing the previews when selecting arcs and circles:

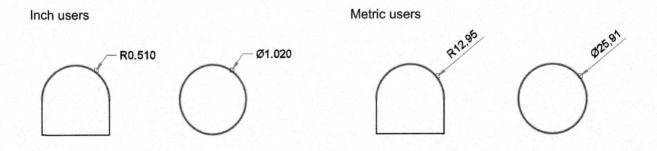

Baseline Dimensioning

The following is an example of how to use the **Baseline** option of the **Dim** command.

- 1. Select the **Dim** command.
- 2. Left click on the line (**P1**), drag the cursor down to the position you require for the first dimension, and then left click again to place the dimension (**P2**).

The following will appear on the Command Line:

3. Select **Baseline** on the Command Line or type **B <Enter>**.

The following will appear on the Command Line:

4. Left click on the first extension line (P3).

The following will appear on the Command Line:

```
X & DIM Specify second extension line origin or [Select Offset Undo] <Select>:
```

5. Left click on the endpoints at **P4** and **P5** (make sure **Object Snap** is turned on).

6. Press **<Enter> <Enter> to end the Dim** command.

Continuous Dimensioning

The following is an example of how to use the **Continue** option of the **Dim** command.

- 1. Select the **Dim** command.
- 2. Place the first dimension P1 and P2 the same as shown for the Baseline option of the Dim command.

The following will appear on the Command Line:

To DIM Select objects or specify first extension line origin or [Angular Baseline Continue Ordinate aliGn Distribute Layer Undo]:

3. Select Continue on the Command Line or type C < Enter>.

The following will appear on the Command Line:

|| × / DIM Specify first extension line origin to continue:

4. Left click on the first extension line (P3).

The following will appear on the Command Line:

5. Left click on the endpoints at P4 and P5 (make sure Object Snap is turned on).

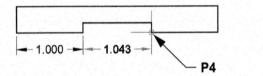

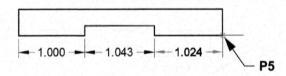

6. Press < Enter> < Enter> to end the Dim command.

Angular Dimensioning

The following is an example of how to dimension **angles** with the **Dim** command. **Note:** Metric users will see the dimension text aligned with the dimension line.

- 1. Select the Dim command.
- 2. Left click on the first line (P1) and then on the second line (P2).
- 3. Drag the cursor to the position you require for the dimension and then left click (P3).

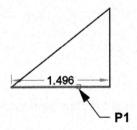

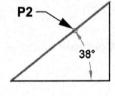

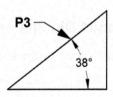

4. Press < Enter> to end the Dim command.

Note: You can place the Angular dimension in various positions as shown in the examples below.

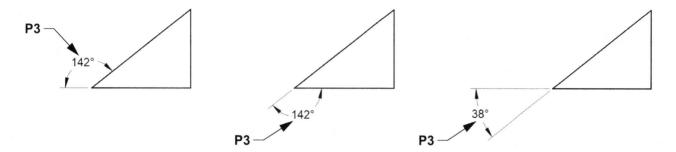

Linear Dimensioning

You also may wish to dimension the horizontal and vertical distances of an angled line as shown in the inch and metric examples below.

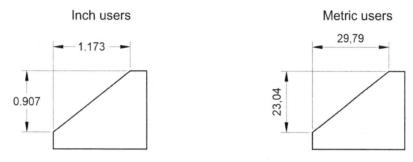

- 1. Select the Dim command.
- 2. Left click on the angled line (P1) and then drag the cursor down and to the left (P2). Left click again to place the dimension.

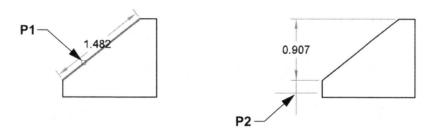

3. Left click on the angled line (P3) and then drag the cursor up and to the right (P4). Left click again to place the dimension.

4. Press **<Enter>** to end the **Dim** command.

Note: Quick Dimension is still an option, but the new **Dim** command is a better choice as it is more effective and has eliminated some of the challenges users had with Quick Dimension.

Exercise 20A-Inch

Exercise 20A-Inch

- 1. Start a New file using the Border A-Inch.dwt
- 2. Draw the object shown below.
- 3. Dimension as shown using a mixture of **Baseline** and **Linear** dimensions with the **Dim** command.
- 4. Use Dimension Style CLASS STYLE and Layer Dimension.
- 5. Edit the **Title** and **Ex-XX** by double clicking on the text. Do not erase and replace.
- 6. Save as Ex-20A-I
- 7. Plot using Page Setup Class Model A

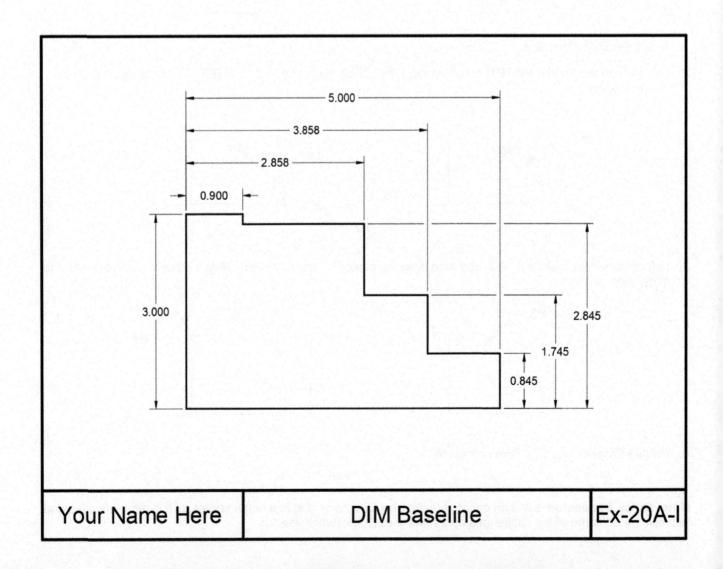

Exercise 20A-Metric

- 1. Start a New file using the Border A-Metric.dwt
- 2. Draw the object shown below.
- 3. Dimension as shown using a mixture of Baseline and Linear dimensions with the Dim command.
- 4. Use Dimension Style CLASS STYLE and Layer Dimension.
- 5. Edit the **Title** and **Ex-XX** by double clicking on the text. Do not erase and replace.
- 6. Save as Ex-20A-M
- 7. Plot using Page Setup Class Model A

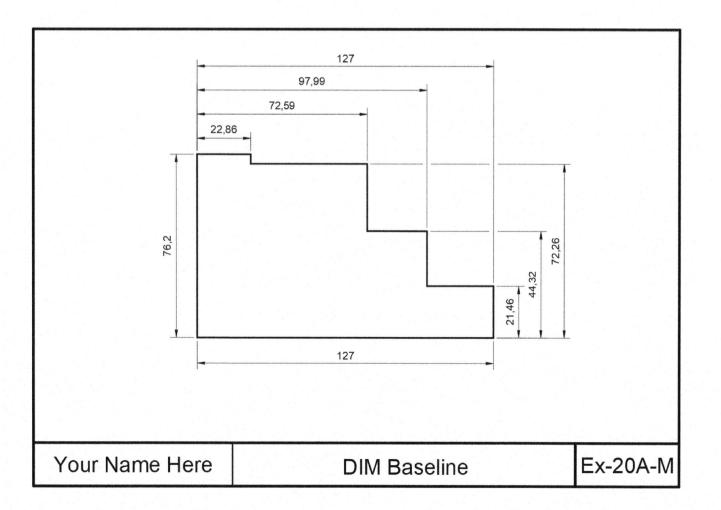

Exercise 20B-Inch

Exercise 20B-Inch

- 1. Open Ex-20A-I
- 2. Erase the original dimensions.
- 3. Dimension as shown using a mixture of Continuous and Linear dimensions with the Dim command.
- 4. Use Dimension Style CLASS STYLE and Layer Dimension.
- 5. Edit the Title and Ex-XX by double clicking on the text. Do not erase and replace.
- 6. Save as Ex-20B-I
- 7. Plot using Page Setup Class Model A

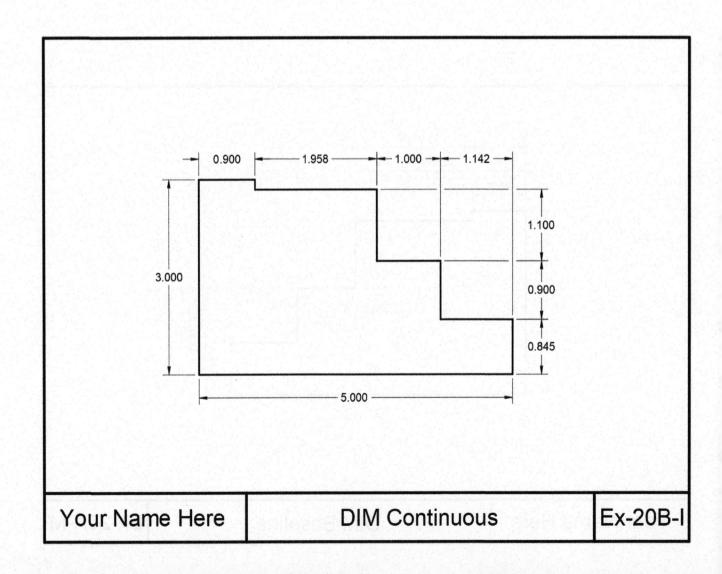

Exercise 20B-Metric

- 1. Open Ex-20A-M
- 2. Erase the original dimensions.
- 3. Dimension as shown using a mixture of **Continuous** and **Linear** dimensions with the **Dim** command.
- 4. Use Dimension Style CLASS STYLE and Layer Dimension.
- 5. Edit the **Title** and **Ex-XX** by double clicking on the text. Do not erase and replace.
- 6. Save as Ex-20B-M
- 7. Plot using Page Setup Class Model A

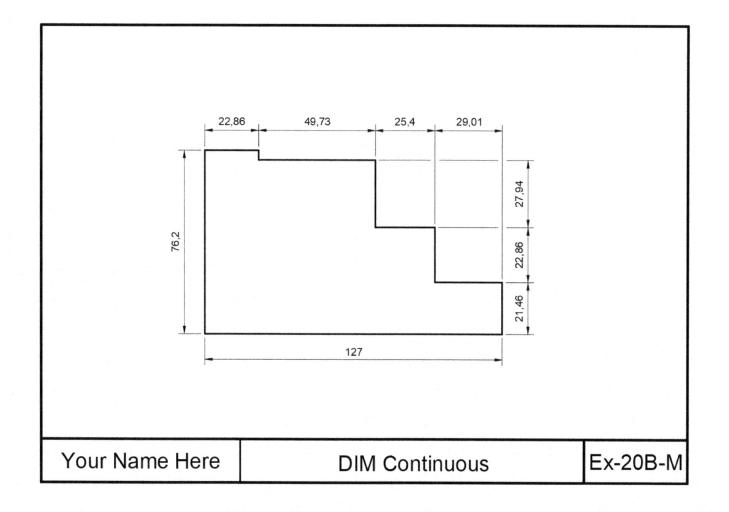

Exercise 20C-Inch

Exercise 20C-Inch

- 1. Start a New file using the Border A-Inch.dwt
- 2. Draw the object shown below.
- 3. Dimension as shown using a mixture of **Linear**, **Diameter**, **Radius**, and **Angular** dimensions with the **Dim** command.
- 4. Use Dimension Style CLASS STYLE and Layer Dimension.
- 5. Edit the **Title** and **Ex-XX** by double clicking on the text. Do not erase and replace.
- 6. Save as Ex-20C-I
- 7. Plot using Page Setup Class Model A

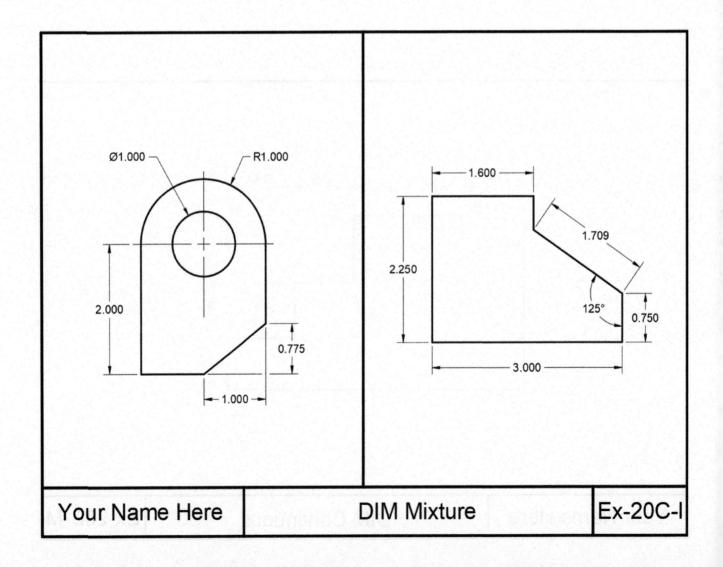

Exercise 20C-Metric

Exercise 20C-Metric

- 1. Start a New file using the Border A-Metric.dwt
- 2. Draw the object shown below.
- 3. Dimension as shown using a mixture of Linear, Diameter, Radius, and Angular dimensions with the Dim command.
- 4. Use Dimension Style CLASS STYLE and Layer Dimension.
- 5. Edit the **Title** and **Ex-XX** by double clicking on the text. Do not erase and replace.
- 6. Save as Ex-20C-M
- 7. Plot using Page Setup Class Model A

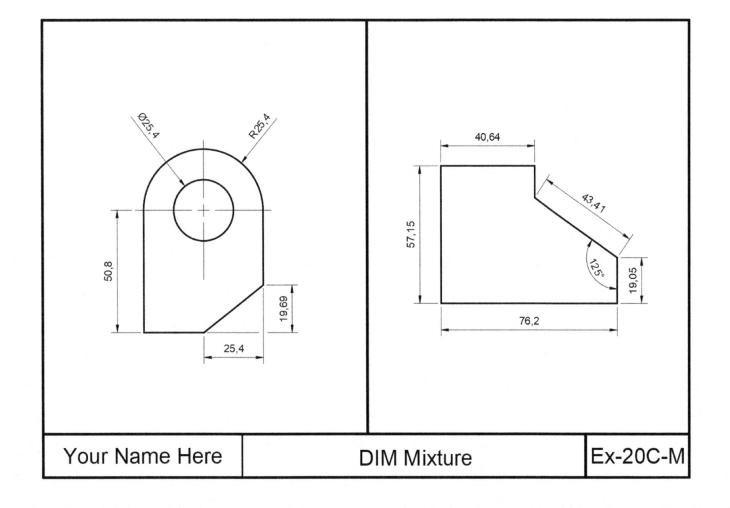

Notes:

LESSON 21

LEARNING OBJECTIVES

After completing this lesson, you will be able to:

- 1. Match an object's properties with another object.
- 2. Create a Revision Cloud.
- 3. Select a Revision Cloud style.
- 4. "Wipe Out" an area of an object.

Match Properties

Match Properties is used to "paint" the properties of one object to another. This is a simple and useful command. You first select the object that has the desired properties (the source object) and then select the object you want to "paint" the properties to (destination object).

Only one "source object" can be selected. But its properties can be painted to any number of "destination objects".

1. Select the Match Properties command using one of the following:

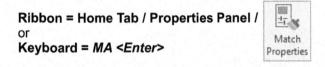

The following will appear on the Command Line:

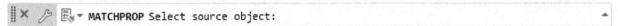

2. Select the object with the desired properties to match...

The following will appear on the Command Line:

3. Select the object(s) you want to receive the matching properties and then press < Enter>.

Note: If you do not want to match all of the properties, after you have selected the source object, right click and select "**Settings**" from the Shortcut Menu, before selecting the destination object.

In the **Property Settings** dialog box, uncheck all the properties you do not want to match and then select the **OK** button. Then select the destination object(s).

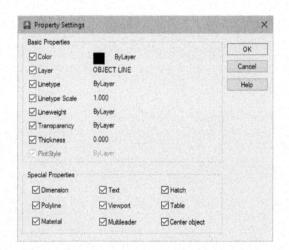

Match Layer

If you draw an object on the wrong layer, you can easily change it to the desired layer using the Layer Match command. You first select the object that needs to be changed and then select an object that is on the correct layer (object on destination layer).

Select the Layer Match command using one of the following:

The following will appear on the Command Line:

The following will appear on the Command Line:

3. Select the object that is on the layer that you want to change.

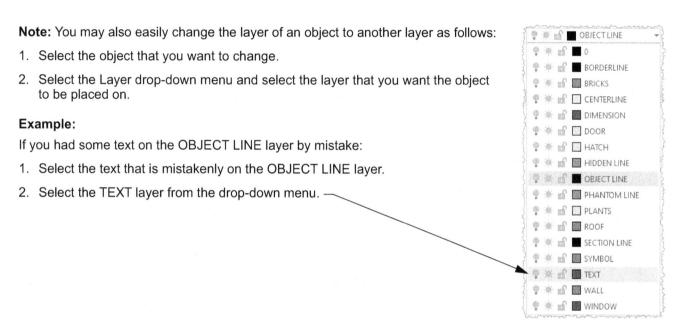

Creating a Revision Cloud

When you make a revision to a drawing, it is sometimes helpful to highlight the revision for someone viewing the drawing. A common method to highlight the area is to draw a "Revision Cloud" around the revised area. This can be accomplished easily with the Revision Cloud command.

The Revision Cloud command creates a series of sequential arcs to form a cloud shaped object. The size of the arcs are measured by an approximate chord length which is the distance between the endpoints of each arc segment. You can set the arc chord lengths when you first start the Revision Cloud command, or you can change the arc chord lengths in the Properties Palette.

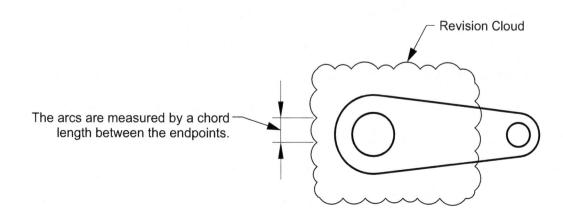

Freehand Revision Cloud

To draw a **Freehand Revision Cloud**, specify the start point with a left click and then drag the cursor to form the outline. AutoCAD automatically draws the arcs. When the cursor gets very close to the start point, AutoCAD snaps the last arc to the first arc and closes the shape.

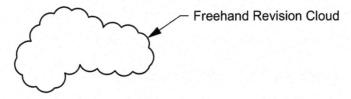

1. Select the Freehand Revision Cloud command using one of the following:

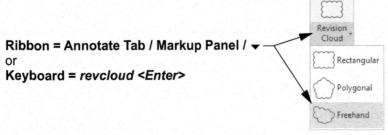

The following will appear on the Command Line:

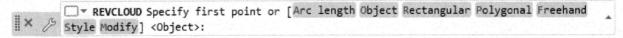

2. Type A and then press < Enter>.

The following will appear on the Command Line:

- 3. Enter the arc chord length you require and then press < Enter>.
- 4. Place the cursor at the start location and then left click.

The following will appear on the Command Line:

- 5. Move the cursor to create the cloud outline.
- 6. When the cursor approaches the start point, the cloud closes automatically and the command ends.

Rectangular Revision Cloud

To draw a **Rectangular Revision Cloud**, specify the start point with a left click and then drag the cursor to form the rectangular outline. AutoCAD automatically draws the arcs. When you are satisfied with the size of the rectangular shape, left click again to finish the command.

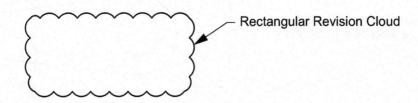

1. Select the Rectangular Revision Cloud command using one of the following:

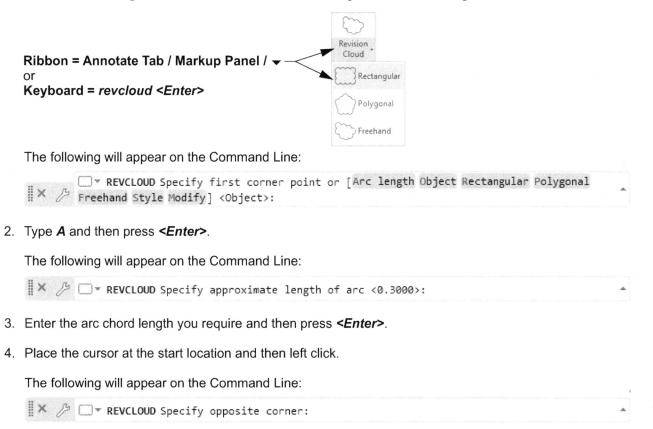

- 5. Move the cursor to the opposite corner to create the cloud outline.
- 6. When you are satisfied with the size of the shape, left click to finish the command.

Polygonal Revision Cloud

To draw a **Polygonal Revision Cloud**, specify the start point with a left click and then drag the cursor to form the polygonal outline, using a left click to specify each point of the shape. AutoCAD automatically draws the arcs. When you are satisfied with the size of the polygonal shape, press *Enter* to finish the command.

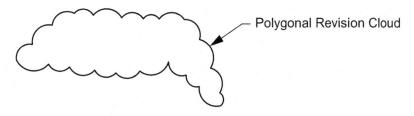

1. Select the Polygonal Revision Cloud command using one of the following:

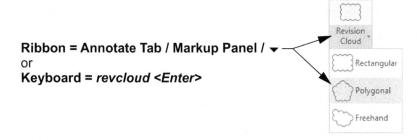

The following will appear on the Command Line:

× /3	□▼ REVCLOUD	Specify	start	point	or	[Arc	length	Object	Rectangular	Polygonal	Freehand	
	☐ ▼ REVCLOUD Specify start point or [Arc length Object Rectangular Polygonal Style Modify] <object>:</object>								_			

2. Type A and then press < Enter>.

The following will appear on the Command Line:

× /> □ ▼ REVCLOUD Specify	approximate length o	of arc <0.3000>:	

- 3. Enter the arc chord length you require and then press < Enter>.
- 4. Place the cursor at the start location and then left click.

The following will appear on the Command Line:

5. Move the cursor to the next point and left click.

The following will appear on the Command Line:

- 6. Continue to left click for the next points until you are satisfied with the shape.
- 7. When you are satisfied with the size of the shape, press **<Enter>** to finish the command.

Converting an Object to a Revision Cloud

You can convert a closed object, such as a circle, ellipse, rectangle, or closed polyline to a Revision Cloud. The original object is deleted when it is converted.

If you want the original object to remain, in addition to the new Revision Cloud, set the variable "delobj" to "0". The default setting is "3".

- 1. Draw a closed object such as a circle.
- 2. Select the Revision Cloud command using one of the following:

The following will appear on the Command Line:

3. Type A and then press < Enter>.

The following will appear on the Command Line:

The state of the s					
	approximate	length of	arc	<0.3000>:	A.
		0			

4. Enter the arc chord length you require and then press < Enter>.

The following will appear on the Command Line:

```
REVCLOUD Specify first corner point or [Arc length Object Rectangular Polygonal Freehand Style Modify] <Object>:
```

5. Type the letter **O** and then press **<Enter>**, or select **Object** on the Command Line.

The following will appear on the Command Line:

6. Select the object to convert.

The following will appear on the Command Line:

7. Select Yes or No.

Note: The Match Properties command will not match the arc length from the source cloud to the destination cloud.

Selecting the Revision Cloud Style

You may select one of two styles for the Revision Cloud: Normal or Calligraphy.

Normal will draw the cloud with one line width.

Calligraphy will draw the cloud with variable line widths to appear as though you used a chiseled calligraphy pen.

1. Select the Revision Cloud command using one of the following:

The following will appear on the Command Line:

2. Type **S** and then press **<Enter>**, or select **Style** on the Command Line.

The following will appear on the Command Line:

- 3. Type N (for Normal) or C (for Calligraphy) and then press < Enter>, or select from the Command Line.
- 4. Continue to create the Revision Cloud as shown in previous examples.

Wipeout

The **Wipeout** command creates a blank area that covers existing objects. The area has a background that matches the background of the drawing area. This area is bounded by the wipeout frame, which you can turn on or off.

1. Select the Wipeout command using one of the following:

The following will appear on the Command Line:

2. Specify the first point of the shape (P1).

The following will appear on the Command Line:

3. Specify the next point (P2).

The following will appear on the Command Line:

4. Specify the next point (P3).

The following will appear on the Command Line:

5. Specify the next point or press **<**Enter> to end the command.

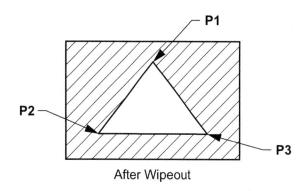

Turning Frames On or Off

1. Select the Wipeout command.

The following will appear on the Command Line:

```
X / WIPEOUT _wipeout Specify first point or [Frames Polyline] <Polyline>:
```

2. Type *F* and then press *<Enter>*, or select *Frames* on the Command Line.

The following will appear on the Command Line:

3. Type **on** or **off** and then press **<Enter>**, or select from the Command Line.

Frames on

Frames off

Note: If you want to move the objects and the wipeout area, you must select both and move them at the same time. Do not move them separately.

Exercise 21A

Exercise 21A

- 1. Open Ex-5F.dwg
- 2. Using Match Properties, change the properties of the polygon to the same properties as the donut.
- 3. Use Wipeout, block out the bottom donut approximately as shown.
- 4. Save as Ex-21A

Exercise 21B

- 1. Start a New file using the Border A-Inch.dwt or the Border A-Metric.dwt
- 2. Draw the Revision Clouds shown below:
 - #1: Set the arc chord length to 0.500" [12.7 mm].
 - #2: Set the arc chord length to 0.500" [12.7 mm].
 - #3: Set the arc chord length to 0.750" [19.05 mm] and change the Style to Calligraphy.
- 3. Draw (2) ${\bf 2.500}$ " [63.5 mm] diameter circles and ${\bf Convert}$ to Revision Clouds.
 - Set the arc chord length to 0.300" [7.62 mm]
 - #4: Reverse = No. #5: Reverse = Yes.
- 4. Use Layer Object Line.
- 5. Edit the **Title** and **Ex-XX** by double clicking on the text. Do not erase and replace.
- 6. Save as Ex-21B
- 7. Plot using Page Setup Class Model A

Exercise 21C-Inch

Exercise 21C-Inch

- 1. Start a New file using the Border A-Inch.dwt
- 2. The drawing below is designed to give you more practice drawing objects and dimensioning. Use any method that you have learned in the previous lessons.
- 3. Edit the Title and Ex-XX by double clicking on the text. Do not erase and replace.
- 4. Save as Ex-21C-I
- 5. Plot using Page Setup Class Model A

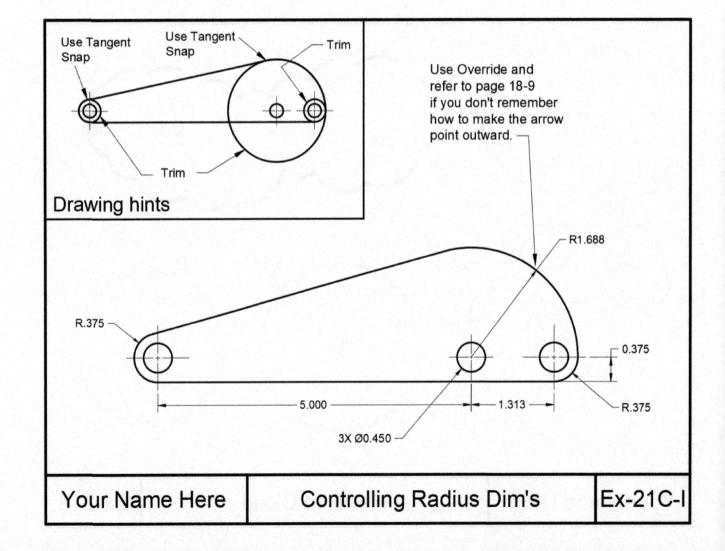

Exercise 21C-Metric

- 1. Start a New file using the Border A-Metric.dwt
- 2. The drawing below is designed to give you more practice drawing objects and dimensioning. Use any method that you have learned in the previous lessons.
- 3. Edit the **Title** and **Ex-XX** by double clicking on the text. Do not erase and replace.
- 4. Save as Ex-21C-M
- 5. Plot using Page Setup Class Model A

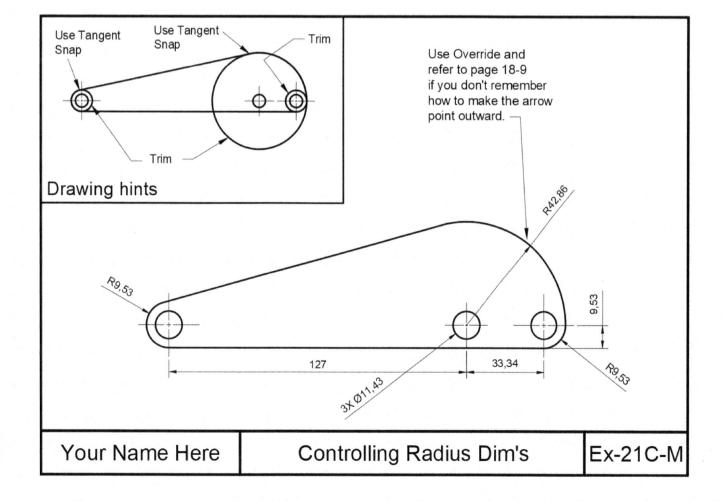

Exercise 21D-Inch

Exercise 21D-Inch

- 1. Start a New file using the Border A-Inch.dwt
- 2. The drawing below is designed to give you more practice drawing objects and dimensioning. Use any method that you have learned in the previous lessons.
- 3. Edit the **Title** and **Ex-XX** by double clicking on the text. Do not erase and replace.
- 4. Save as Ex-21D-I
- 5. Plot using Page Setup Class Model A

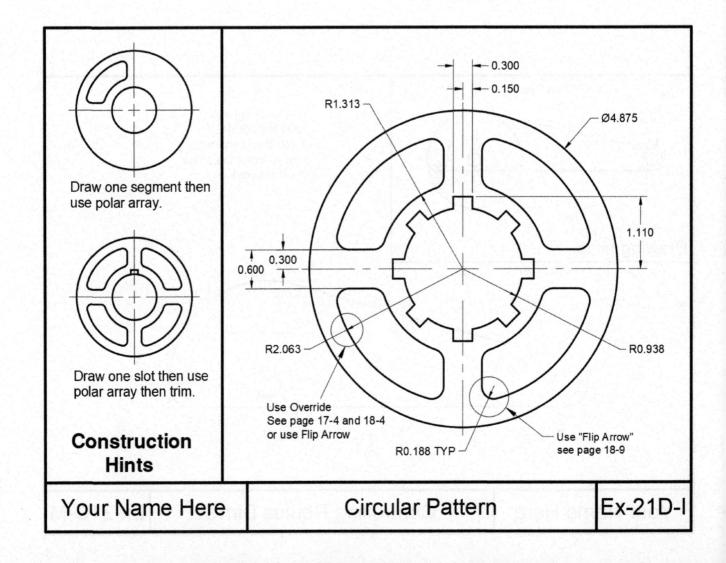

Exercise 21D-Metric

Instructions:

- 1. Start a New file using the Border A-Metric.dwt
- 2. The drawing below is designed to give you more practice drawing objects and dimensioning. Use any method that you have learned in the previous lessons.
- 3. Edit the **Title** and **Ex-XX** by double clicking on the text. Do not erase and replace.
- 4. Save as Ex-21D-M
- 5. Plot using Page Setup Class Model A

Note: You will notice that the **diameter** and **radius** dimension text is horizontal in the drawing below. By default the diameter and radius text is aligned with the dimension arrow for metric dimensions. If you prefer to have your diameter and radius dimensions horizontal, you must set up a **Dimension Sub-Style** for both the diameter and radius dimensions (see page 18-9). Select the **Text** Tab, then in the **Text Alignment Panel**, change it to **"Horizontal"**.

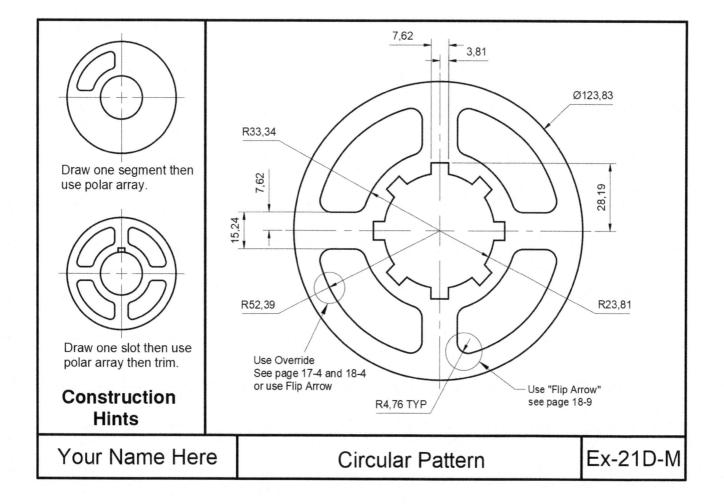

Notes:

LESSON 22

LEARNING OBJECTIVES

After completing this lesson, you will be able to:

- 1. Draw an Arc using 10 different methods.
- 2. Dimension Arc segments.

Drawing an Arc

There are 10 ways to draw an **arc** in AutoCAD. Not all of the arcs options are easy to create, so you may find it is often easier to **trim a circle** or use the **Fillet** command.

On the job, you will probably only use two of these methods. Which of these you choose to use will depend on the application.

An arc is a segment of a circle and must be less than 360 degrees.

By default, arcs are drawn counter-clockwise. You can change the direction by holding down the **<Ctrl>** key to draw in a clockwise direction. Or in some cases, you can enter a negative input to draw in a clockwise direction.

1. Select the Arc command using one of the following:

Ribbon = Home Tab / Draw Panel / → or Keyboard = A <Enter>

2. Refer to Exercises 22A and 22B for examples of two of the most commonly used methods of creating an arc.

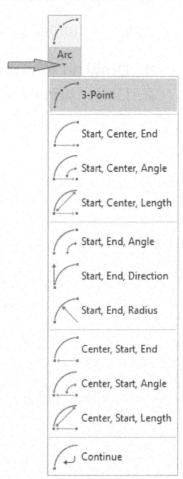

Dimensioning Arc Lengths

You may dimension the distance along an arc. This is known as the **arc length**. Arc length is an **Associative** dimension.

Example:

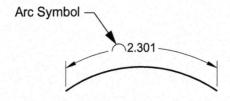

1. Select the Arc Length dimension command using one of the following:

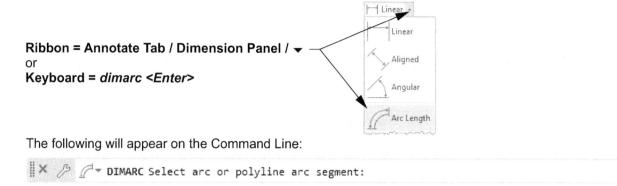

2. Select the arc.

The following will appear on the Command Line:

3. Place the dimension line and text location.

To differentiate the arc length dimensions from linear or angular dimensions, arc length dimensions display an arc (\frown) symbol by default. (Also called a "hat" or "cap".)

The arc symbol may be displayed either **above** or **preceding** the dimension text. You may also choose **not** to display the arc symbol.

Example:

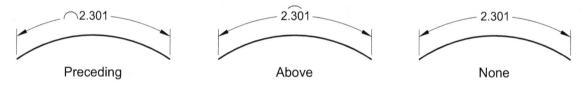

Specify the placement of the arc length symbol in the **Dimension Style Manager / Symbols and Arrows** Tab, or you may edit its position using the **Properties Palette**.

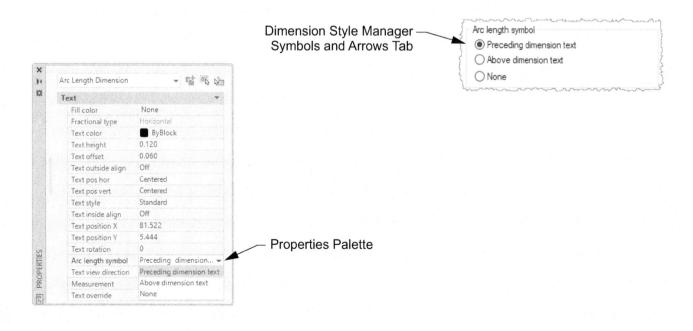

The extension lines of an arc length dimension are displayed as **radial** if the included angle is **greater than 90** degrees.

The extension lines of an arc length dimension are displayed as **orthogonal** if the included angle is **less than 90 degrees**.

Example:

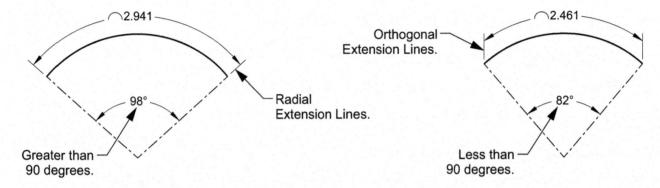

Dimensioning a Large Curve

When dimensioning an arc, the dimension line should pass through the center of the arc. However, for large curves, the true center of the arc could be very far away, even off the sheet.

When the true center location cannot be displayed, you can create a "Jogged" radius dimension.

Example:

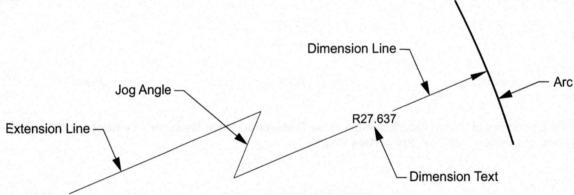

Controlling the Jog

You can specify the **Jog angle** and **Jog height factor** in the **Dimension Style Manager / Symbols and Arrows** Tab.

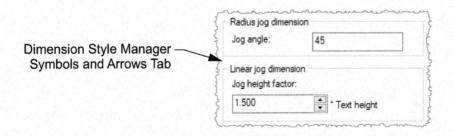

1. Select the **Jogged** radius dimension command using one of the following:

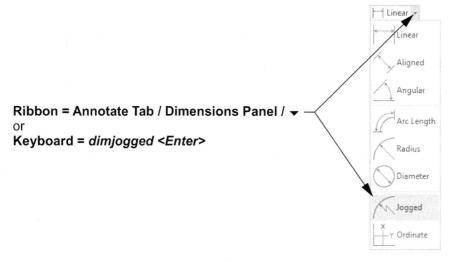

The following will appear on the Command Line:

2. Select the large arc or circle (P1), anywhere on the arc or circle.

The following will appear on the Command Line:

3. Move the cursor and left click to specify the "fake" center location (P2).

The following will appear on the Command Line:

4. Move the cursor and left click to specify the location for the dimension text (P3).

The following will appear on the Command Line:

5. Move the cursor and left click to specify the location for the jog (P4).

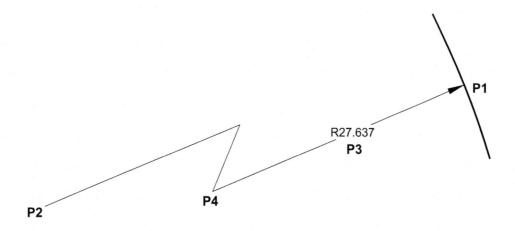

Exercise 22A

Instructions:

- 1. Start a New file using either the Border A-Inch.dwt or the Border A-Metric.dwt
- 2. Draw the Centerlines first on Layer Centerline.
- 3. Draw the **3-Point** arcs using Layer Object Line. Place the **first point** at location **1**, **second point** at location **2**, and **third point** at location **3**.
- 4. Dimension as shown using Dimension Style CLASS STYLE and Layer Dimension. (See note below.)
- 5. Edit the **Title** and **Ex-XX** by double clicking on the text. Do not erase and replace.
- 6. Save as Ex-22A
- 7. Plot using Page Setup Class Model A

Note: You will notice that I have used both inch and metric dimensions for Exercises **22A** through **22D**. Each of the exercises will be suitable for both inch and metric users. Your dimensions will either show inch or metric, depending on which template you use.

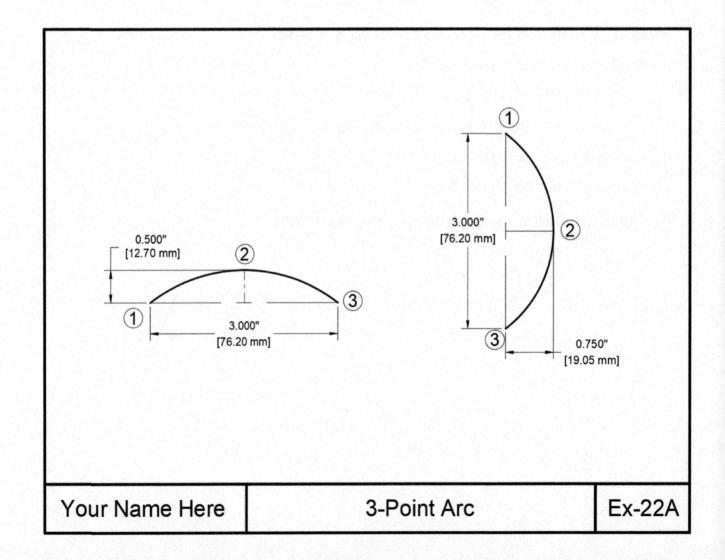

Exercise 22B

Exercise 22B

Instructions:

- 1. Start a New file using either the Border A-Inch.dwt or the Border A-Metric.dwt
- 2. Draw the Centerlines first on Layer Centerline.
- 3. Draw the two arcs using method **Start**, **End**, **Radius** on Layer Object Line. Place the **Start** at location **1**, **End** at location **2** and enter the **Radius** of **3**.
- 4. Dimension as shown using Dimension Style CLASS STYLE and Layer Dimension.
- 5. Edit the **Title** and **Ex-XX** by double clicking on the text. Do not erase and replace.
- 6. Save as Ex-22B
- 7. Plot using Page Setup Class Model A

Note: Positive radius draws the small segment and negative radius draws the large segment. To reverse the directions hold down the **<**Ctrl> key.

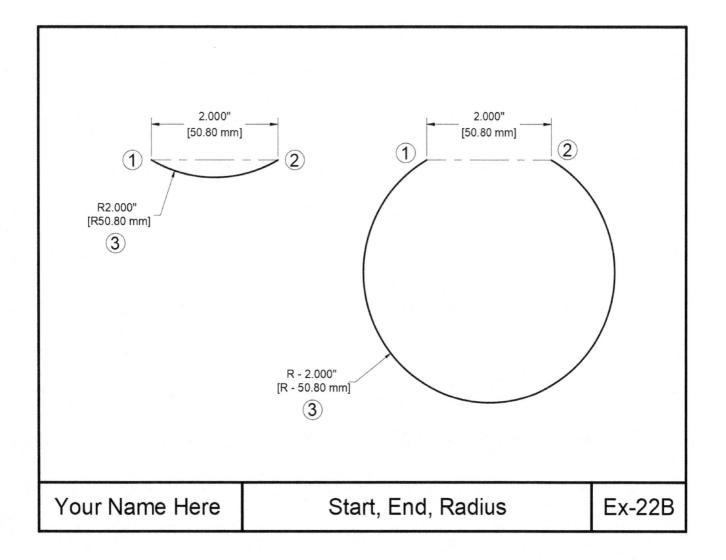

Exercise 22C

Instructions:

- 1. Start a New file using either the Border A-Inch.dwt or the Border A-Metric.dwt
- 2. Draw the Centerlines first on Layer Centerline.
- 3. Draw the arc using Layer Object Line. Refer to the previous pages to select method.
- 4. Dimension as shown using Dimension Style CLASS STYLE and Layer Dimension.
- 5. Edit the Title and Ex-XX by double clicking on the text. Do not erase and replace.
- 6. Save as Ex-22C
- 7. Plot using Page Setup Class Model A

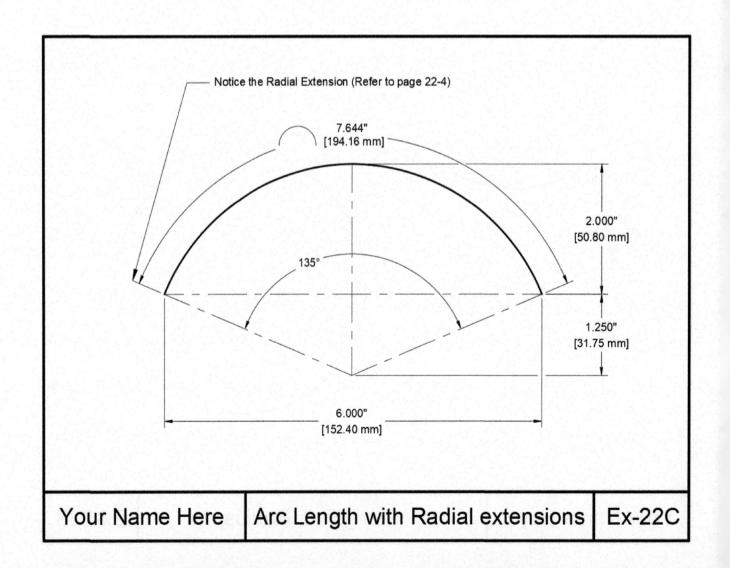

Exercise 22D

Instructions:

- 1. Start a New file using either the Border A-Inch.dwt or the Border A-Metric.dwt
- 2. Draw the Centerlines first on Layer Centerline.
- 3. Draw the arc using Layer Object Line. Refer to the previous pages to select method.
- 4. Dimension as shown using Dimension Style CLASS STYLE and Layer Dimension.
- 5. Edit the **Title** and **Ex-XX** by double clicking on the text. Do not erase and replace.
- 6. Save as Ex-22D
- 7. Plot using Page Setup Class Model A

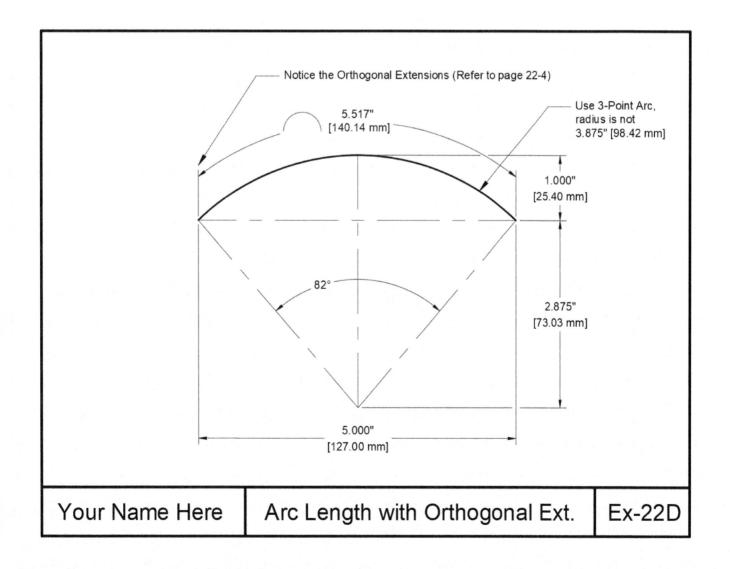

Exercise 22E-Inch

Exercise 22E-Inch

Instructions:

- 1. Start a New file using the Border A-Inch.dwt
- 2. Draw the objects below using circles, arcs, lines, and fillets on Layer Object Line.
- 3. Dimension as shown using Dimension Style CLASS STYLE and Layer Dimension. (Refer to pages 18-3 and 18-4 for diameter and radius dimension settings.)
- 4. Edit the Title and Ex-XX by double clicking on the text. Do not erase and replace.
- 5. Save as Ex-22E-I
- 6. Plot using Page Setup Class Model A

See the next page for drawing assistance.

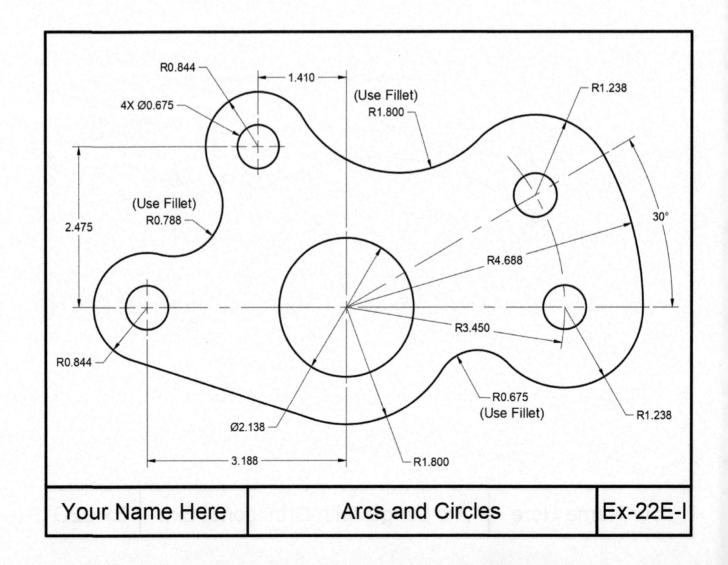

Exercise 22E-Inch Helper

Instructions:

Step 1.

Draw the horizontal and vertical lines, then offset to create intersections for circles. Draw the 30 degree line.

Step 2.

Draw the circles.

Step 3.

Draw the arcs and draw the circles.

Step 4.

Fillet, draw the tangent line, and dimension.

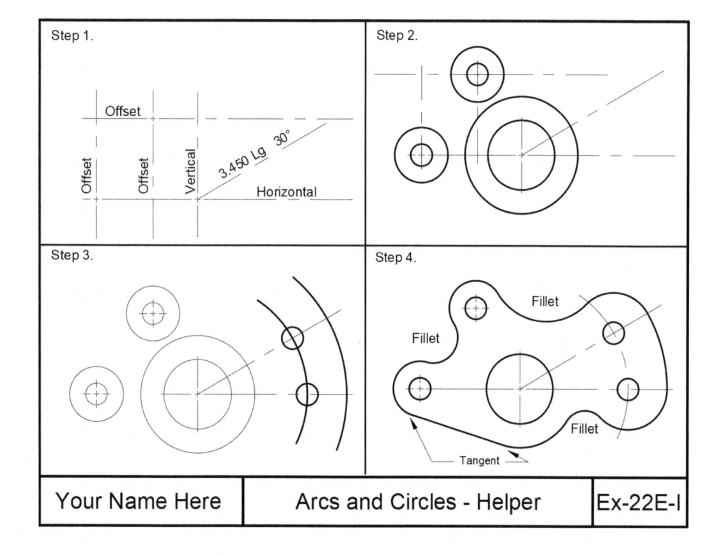

Exercise 22E-Metric

Exercise 22E-Metric

Instructions:

- 1. Start a New file using the Border A-Metric.dwt
- 2. Draw the objects below using circles, arcs, lines, and fillets on Layer Object Line.
- 3. Dimension as shown using Dimension Style CLASS STYLE and Layer Dimension. (Refer to pages 18-3 and 18-4 for diameter and radius dimension settings.)
- 4. Edit the Title and Ex-XX by double clicking on the text. Do not erase and replace.
- 5. Save as Ex-22E-M
- 6. Plot using Page Setup Class Model A

See the next page for drawing assistance.

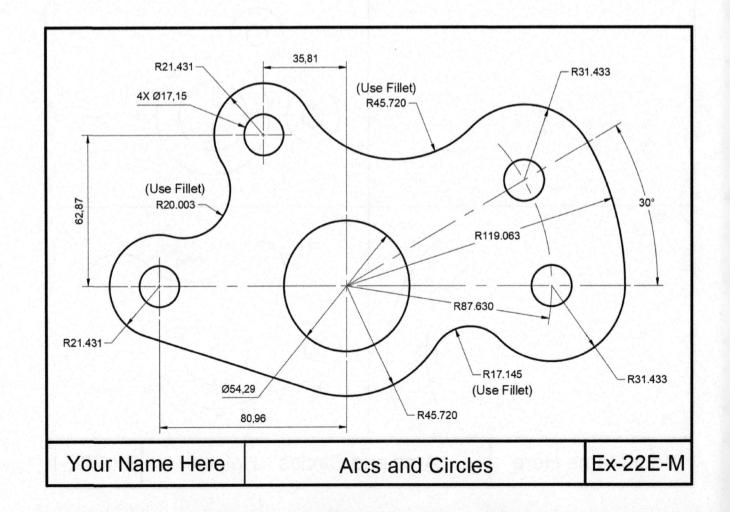

Exercise 22E-Metric Helper

Exercise 22E-Metric Helper

Instructions:

Step 1.

Draw the horizontal and vertical lines, then offset to create intersections for circles. Draw the 30 degree line.

Step 2.

Draw the circles.

Step 3.

Draw the arcs and draw the circles.

Step 4.

Fillet, draw the tangent line, and dimension.

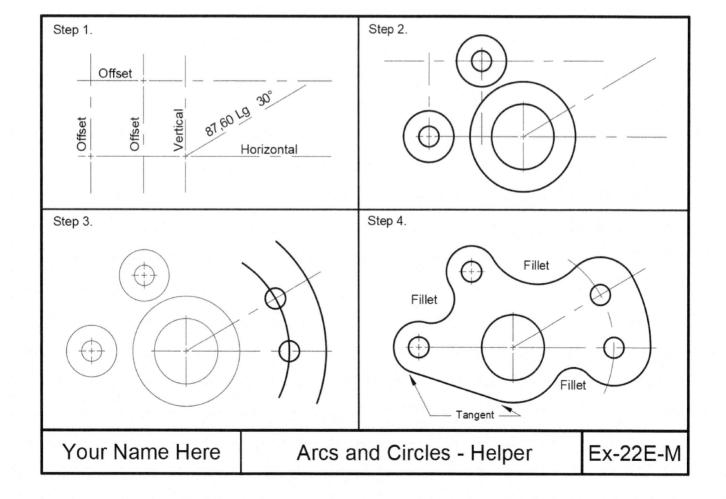

Exercise 22F

Exercise 22F

Instructions:

- 1. Start a New file using either the Border A-Inch.dwt or the Border A-Metric.dwt
- 2. Draw 9.000" [228.60 mm] radius circle on Layer Object Line, as shown below.
- 3. Dimension as shown using Dimension Style CLASS STYLE and Layer Dimension. (Refer to page 22-4.)
- 4. Edit the Title and Ex-XX by double clicking on the text. Do not erase and replace.
- 5. Save as Ex-22F
- Plot using Page Setup Class Model A

Note: You will notice that I again have used dual dimensions for this exercise. Your dimension will either show inch or metric, depending on which template you use.

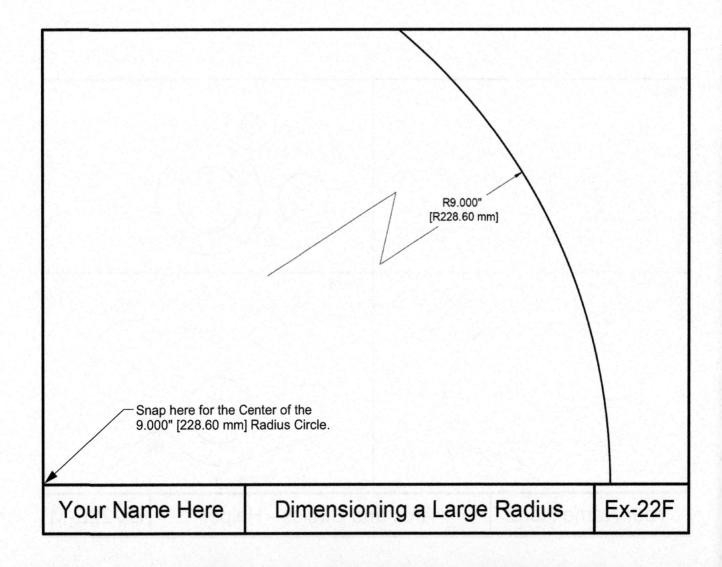

LESSON 23

LEARNING OBJECTIVES

After completing this lesson, you will be able to:

- 1. Understand the Polyline command.
- 2. Draw a Polyline and a Polyarc.
- 3. Assign widths to Polylines.
- 4. Set the Fill mode to On or Off.
- 5. Explode a Polyline.

Understanding and Creating Polylines

A **polyline** is very similar to a line. It is created in the same way a line is drawn. It requires first and second endpoints. But a polyline has additional features, as follows:

- A. A polyline is one object, even though it may have many segments.
- B. You may specify a specific width to each segment.
- C. You may specify a different width to the start and end of a polyline segment.
- 1. Select the **Polyline** command using one of the following:

The following are examples of polylines with widths assigned.

Options

Width: Specify the start and end width.

You can create a tapered polyline by specifying different starting and ending widths.

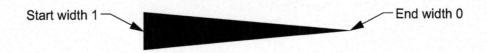

Halfwidth: The same as width except the starting and ending halfwidth specifies half the width rather than the entire width.

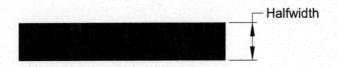

Arc: This option allows you to create a circular polyline less than 360 degrees. You may use two 180 degree arcs to form a full circular shape.

Close: The close option is the same as in the Line command. Close attaches the last segment to the first segment.

Length: This option allows you to draw a polyline at the same angle as the last polyline drawn. This option is very similar to the **Offset** command. You specify the first endpoint and the length. The new polyline will automatically be drawn at the same angle as the previous polyline.

Controlling the Fill Mode

If you turn the **Fill Mode off**, the polylines will appear as shown below.

How to turn Fill Mode on or off

1. Type *fill* and then press *<Enter>*.

The following will appear on the Command Line:

- 2. Type on or off and then press <Enter>.
- 3. Type *regen* and then press *<Enter>*.

Exploding a Polyline

Note: If you explode a polyline, it loses its width and turns into a regular line as shown below.

The following is an example of how to draw a polyline using Width.

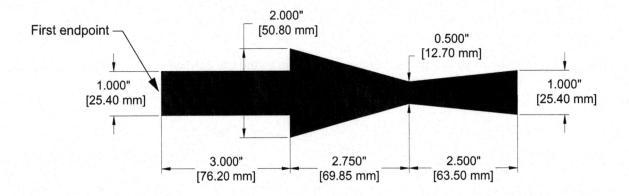

Note: Metric users, type in the sizes inside the brackets [....]

1. Select the Polyline command.

The following will appear on the Command Line:

|| × / > ...> ▼ PLINE Specify start point:

2. Place the first endpoint of the polyline.

The following will appear on the Command Line:

X > PLINE Specify next point or [Arc Halfwidth Length Undo Width]:

3. Type in W and then press < Enter>, or select Width on the Command Line.

The following will appear on the Command Line:

4. Type in 1 [25.4] and then press < Enter>.

The following will appear on the Command Line:

5. Type in 1 [25.4] and then press < Enter>.

The following will appear on the Command Line:

X > PLINE Specify next point or [Arc Halfwidth Length Undo Width]:

6. Type in L and then press < Enter>, or select Length on the Command Line.

The following will appear on the Command Line:

|| × / PLINE Specify length of line:

7. Type in 3 [76.2] and then press < Enter>.

The following will appear on the Command Line:

Type in **W** and then press **<Enter>**, or select **Width** on the Command Line. The following will appear on the Command Line: X A ... → PLINE Specify starting width <1.000>: Type in 2 [50.8] and then press < Enter>. The following will appear on the Command Line: 10. Type in **0.5 [12.7]** and then press **<Enter>**. The following will appear on the Command Line: X >> PLINE Specify next point or [Arc Halfwidth Length Undo Width]: 11. Type in *L* and then press **<***Enter***>**, or select **Length** on the Command Line. The following will appear on the Command Line: 12. Type in 2.75 [69.85] and then press < Enter>. The following will appear on the Command Line: 13. Type in **W** and then press **<Enter>**, or select **Width** on the Command Line. The following will appear on the Command Line: X > PLINE Specify starting width <0.500>: 14. Type in **0.5** [12.7] and then press **<**Enter>. The following will appear on the Command Line: # X B ...>▼ PLINE Specify ending width <0.500>: 15. Type in 1 [25.4] and then press < Enter>. The following will appear on the Command Line: | X /> ...>▼ PLINE Specify next point or [Arc Halfwidth Length Undo Width]: 16. Type in *L* and then press *Enter*, or select **Length** on the Command Line. The following will appear on the Command Line: X B ...>▼ PLINE Specify length of line: 17. Type in **2.5** [63.5] and then press **<**Enter>. The following will appear on the Command Line: ■× 🎤 ._> PLINE Specify next point or [Arc Halfwidth Length Undo Width]: 18. Press **<Enter>** to stop the Polyline command.

Exercise 23A

Instructions:

- 1. Start a New file using either the Border A-Inch.dwt or the Border A-Metric.dwt
- 2. Draw the polylines as shown using Layer Object Line.
- 3. Do not dimension.
- 4. Edit the Title and Ex-XX by double clicking on the text. Do not erase and replace.
- 5. Save as Ex-23A
- 6. Plot using Page Setup Class Model A

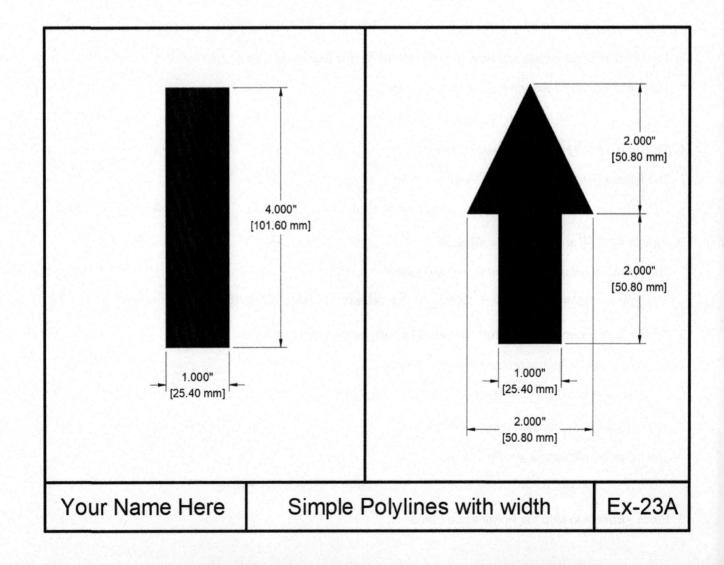

Exercise 23B

Instructions:

- 1. Open Ex-23A
- 2. Turn off the **Fill Mode**. (Refer to page 23-3.)
- 3. Do not dimension.
- 4. Edit the **Title** and **Ex-XX** by double clicking on the text. Do not erase and replace.
- 5. Save as Ex-23B
- 6. Plot using Page Setup Class Model A

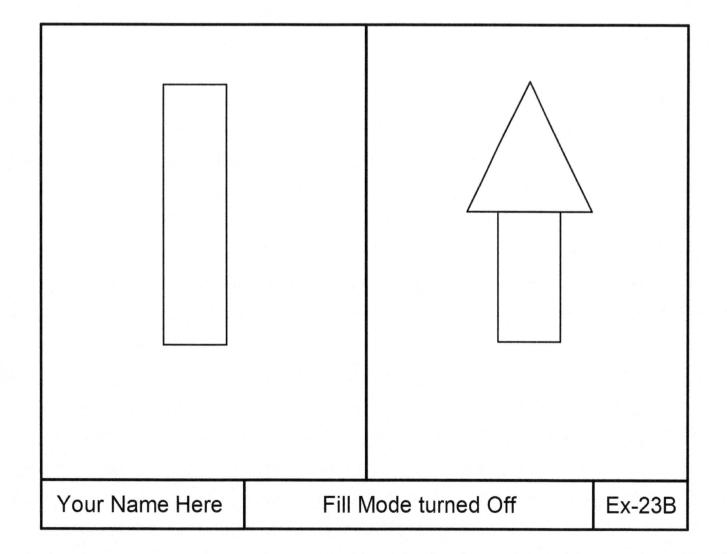

Exercise 23C

Instructions:

- 1. Open Ex-23B
- 2. Explode each of the polylines.

Note: Architectural students may be thinking that the Polyline command would be good to use when creating floor plan walls. But notice what happens if you explode the polylines. Consider instead using the Multiline or Double line (LT) commands for floor plan walls. You can find these commands by referring to the Autodesk Assistant or AutoCAD Help Menu.

- 3. Edit the **Title** and **Ex-XX** by double clicking on the text. Do not erase and replace.
- 4. Save as Ex-23C
- 5. Plot using Page Setup Class Model A

Your Name Here	Explode the Polylines	Ex-23C

Exercise 23D

Exercise 23D

Instructions:

- 1. Start a New file using either the Border A-Inch.dwt or the Border A-Metric.dwt
- 2. Draw the polyline as shown using Layer Object Line.
- 3. Do not dimension.
- 4. Edit the **Title** and **Ex-XX** by double clicking on the text. Do not erase and replace.
- 5. Save as Ex-23D
- 6. Plot using Page Setup Class Model A

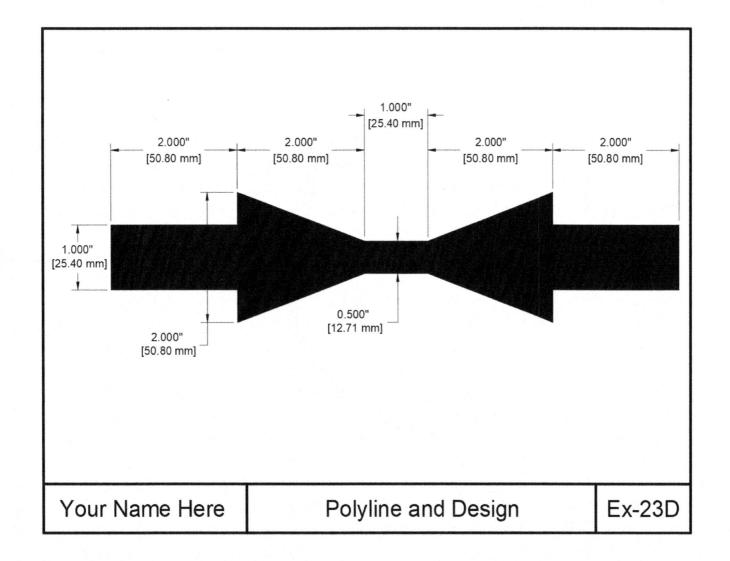

Exercise 23E

Exercise 23E

Instructions:

- Start a New file using either the Border A-Inch.dwt or the Border A-Metric.dwt
- 2. Select the Polyline command.
- 3. Place the start point approximately as shown.
- 4. Set the Widths: Starting width = 0.100 [2.54] Ending width = 0.500 [12.7].
- 5. Select option Arc.
- 6. Select option Radius and enter 2.50 [63.5].
- 7. Select option Angle and enter 180.
- 8. Enter 90 for the Direction of the Chord.
- 9. Press < Enter > to end the command.
- 10. Do not dimension.
- 11. Edit the **Title** and **Ex-XX** by double clicking on the text. Do not erase and replace.
- 12. Save as Ex-23E
- 13. Plot using Page Setup Class Model A

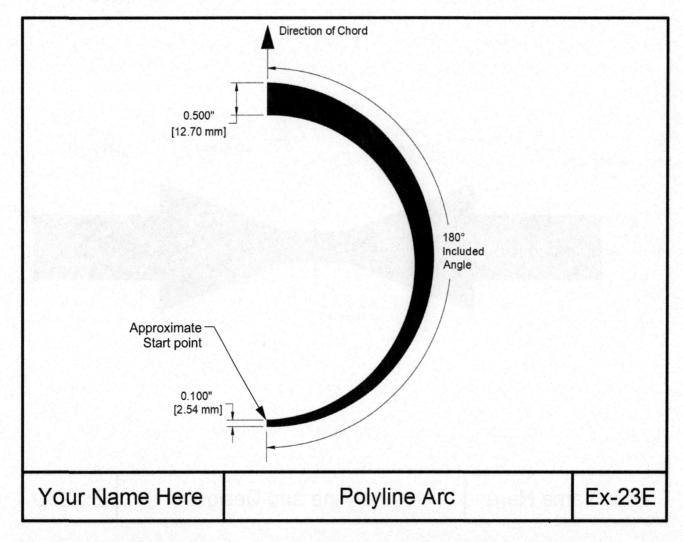

LESSON 24

LEARNING OBJECTIVES

After completing this lesson, you will be able to:

- 1. Edit the width of Polylines.
- 2. Join Polylines.
- 3. Convert Polylines to Curves.
- 4. Convert a basic Line to a Polyline.
- 5. Join Lines, Polylines, Arcs, and Splines.

Editing Polylines

The **Edit Polyline** command allows you to make changes to a polyline's option, such as the width. You can also change a regular line into a polyline and **Join** the segments.

Note: If you select a line that is not a polyline, the prompt will ask if you would like to turn it into a polyline.

1. Select the Edit Polyline command using one of the following:

Note: You may modify "Multiple" polylines simultaneously.

The following will appear on the Command Line:

2. Select the polyline to be edited or type M (for multiple polylines).

The following will appear on the Command Line:

3. Select an option (descriptions of each option are listed below).

Options

Close: This option connects the last segment with the first segment of an **Open** polyline. AutoCAD considers a polyline open unless you use the **Close** option to connect the segments originally.

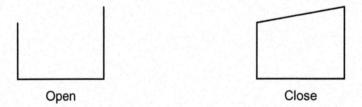

Open: This option removes the closing segment, but only if the **Close** option was used to close the polyline originally.

Join: The **Join** option allows you to join individual polyline segments into one polyline. The segments must have matching endpoints.

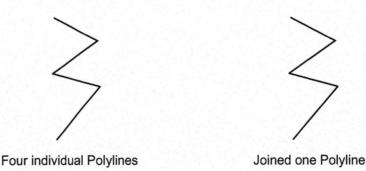

Width: The Width option allows you to change the width of the polyline. But the entire polyline will have the same width.

Edit Vertex: This option allows you to change the starting and ending width of each segment individually.

Spline: This option allows you to change straight polylines to curves.

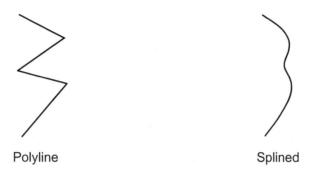

Decurve: This option removes the spline curves and returns the polyline to its original straight line segments.

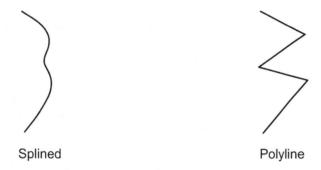

Reverse: This option reverses the direction. The start point becomes the endpoint and vice versa.

Join Command

This might seem confusing, but this **Join** command is not the same as the Join "option" within the Polyedit tool. The Polyedit option can only be used to join individual polyline segments. This Join command joins similar objects to form a single unbroken object.

1. Select the **Join** command using one of the following:

The following will appear on the Command Line:

Select the source object.

The following will appear on the Command Line:

3. Select the object(s) to join to the source object and then press < Enter>.

Seems easy, and it is, but there are a few rules regarding each type of object that you must understand.

Lines

The lines must be collinear (on the same plane) but can have gaps between them.

Polylines

Same rules as lines except no gaps allowed between them.

Arc

The arcs must lie on the same imaginary circle but can have gaps.

Note: The Close option in Polyedit can be used to turn it into a circle.

Spline

The spline must lie in the same plane and be contiguous (end to end). (You haven't learned this command yet.)

Exercise 24A

Instructions:

1. Start a New file using either the Border A-Inch.dwt or the Border A-Metric.dwt

Step 1.

2. Draw the polyline 4" [101.6 mm] Long and 0 width using Layer Object Line.

Step 2.

- 3. Change the width of the polyline to 0.500 [12.7].
- 4. Do not dimension.
- 5. Edit the **Title** and **Ex-XX** by double clicking on the text. Do not erase and replace.
- 6. Save as Ex-24A
- 7. Plot using Page Setup Class Model A

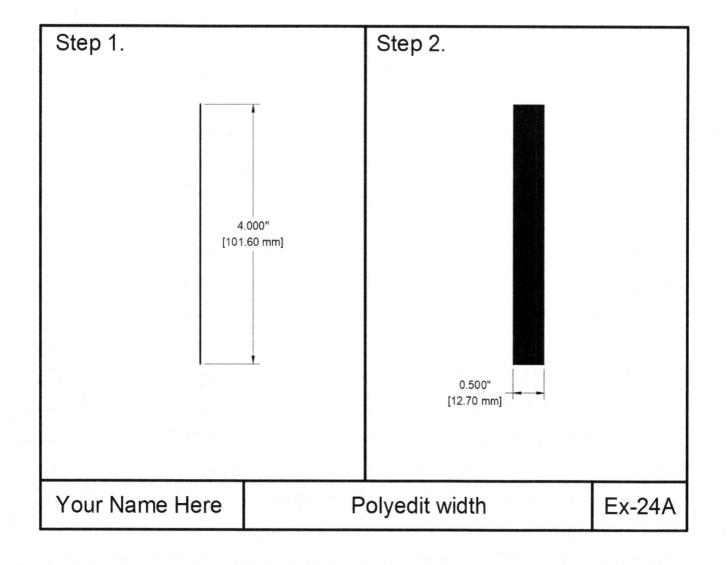

Exercise 24B

Instructions:

1. Start a New file using either the Border A-Inch.dwt or the Border A-Metric.dwt

Step 1.

2. Draw one continuous polyline with (3) 2" [50.8 mm] Long segments.

Step 2.

- 3. Select the Polyedit command and select the first segment.
- 4. Select the Edit Vertex option. (Notice the "X" marking the starting point.
- 5. Select the Width option and set Start to 1 [25.4] and Ending to 0.5 [12.7].
- 6. Select Next option. (The "X" should have moved to the next segment.)
- 7. Select the Width option and set Start to 0.5 [12.7] and Ending to 0.5 [12.7].
- 8. Select the Next option (The "X" should have moved to the next segment).
- 9. Select the Width option and set Start to 2 [50.8] and Ending to 0.
- 10. Select the Exit option and press **<Enter>** to stop.
- 11. Edit the Title and Ex-XX. Save as Ex-24B. Plot using Page Setup Class Model A

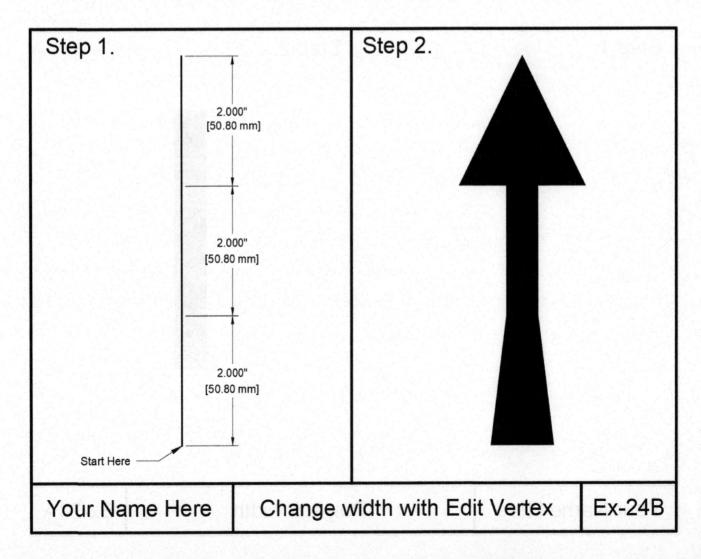

Exercise 24C

Instructions:

1. Start a New file using either the Border A-Inch.dwt or the Border A-Metric.dwt

Step 1.

2. Draw the objects below using the Line command not Polyline.

Step 2.

- 3. Select the Polyedit command and select the first segment drawn. (Answer **Yes** to "Not a polyline, do you want to turn it into one?")
- 4. Select the Width option and set the width to **0.1 [2.54]**. (Notice only one segment changed.)
- 5. Select the Join option.
- 6. Select the remaining lines using a crossing window. (Now the width should be constant for all lines.)
- 7. Edit the **Title** and **Ex-XX** by double clicking on the text. Do not erase and replace.
- 8. Save as Ex-24C
- 9. Plot using Page Setup Class Model A

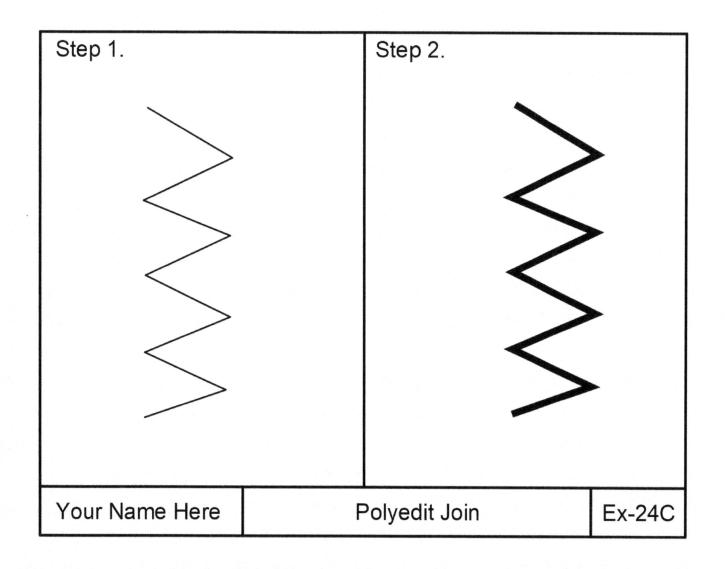

Exercise 24D

Instructions:

- 1. Open Ex-24C
- 2. Select the Polyedit command.
- 3. Select the polyline.
- 4. Select the Spline option
- 5. Edit the **Title** and **Ex-XX** by double clicking on the text. Do not erase and replace.
- 6. Save as Ex-24D
- 7. Plot using Page Setup Class Model A

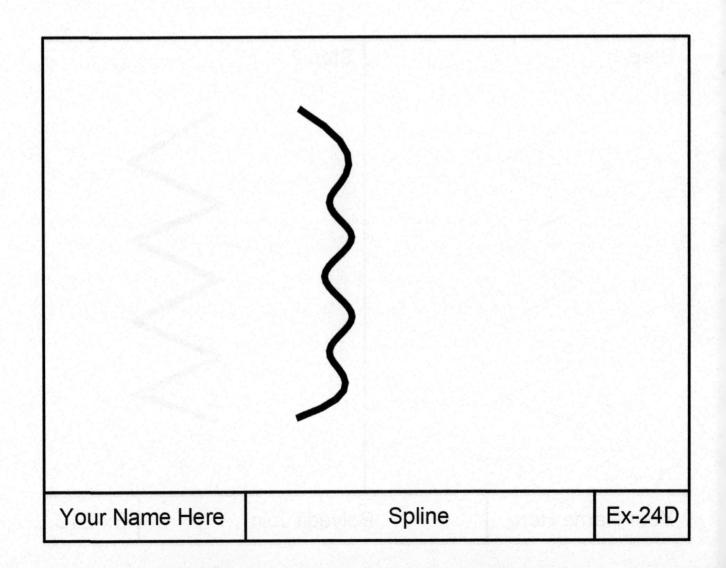

LESSON 25

LEARNING OBJECTIVES

After completing this lesson, you will be able to:

- 1. Create a new Text style.
- 2. Change an existing Text style.
- 3. Delete a Text style.
- 4. Select a Point style.
- 5. Divide an object into a specified number of segments.
- 6. Divide an object into segments based on a specified measurement.

Creating New Text Styles

AutoCAD provides you with two preset text styles named "Standard" and "Annotative". (Annotative will be discussed in Lesson 27.) You may want to create a new text style with a different font and effects. The following illustrates how to create a new text style.

1. Select the **Text Style** command using one of the following:

Ribbon = Annotate Tab / Text Panel / >
or
Keyboard = ST <Enter>

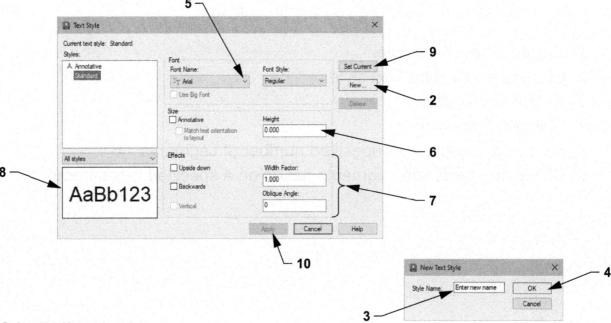

- 2. Select the New... button.
- Type the new style name in Style Name box. Styles names can have a maximum of 31 characters.
- 4. Select the OK button.
- 5. Select the Font.
- 6. Enter the value of the Height.

Note: If the value is **0**, AutoCAD will always prompt you for a height. If you enter a number, the new text style will have a fixed height and AutoCAD will not prompt you for the height.

Assign Effects.

Upside down: Each letter will be created upside-down in the order in which it was typed. (**Note:** This is different from rotating text 180 degrees.)

Backwards: The letters will be created backwards as typed.

Vertical: Each letter will be inserted directly under the other. Only ".shx" fonts can be used. Vertical text will not display in the Preview box.

Width Factor: This effect compresses or extends the width of each character. A value less than 1 compresses each character. A value greater than 1 extends each character.

Oblique Angle: Creates letter with a slant, like italic. An angle of **0** creates a vertical letter. A positive angle will slant the letter forward. A negative angle will slant the letter backward.

8. The **Preview** box displays the text with the selected settings. In the example below, it shows what the text will look like if you select **Upside down** text.

- 9. Select the Set Current button.
- 10. Select the Apply or Close button.

Selecting a Text Style

After you have created text styles, you will want to use them. You must select the text style before you use it.

Below are the methods when using Single Line or Multiline text.

Single Line Text

Select the style before selecting **Single Line Text** command.

- 1. Select the Annotate Tab.
- 2. Using the **Text Panel**, select the style down arrow **▼**
- Select the text style.

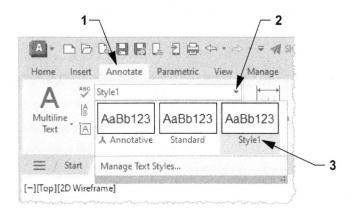

Multiline Text

- Select Multiline Text and place the first corner and opposite corner.
- 2. Find the Style Panel and scroll through the text styles available using the up and down arrows.

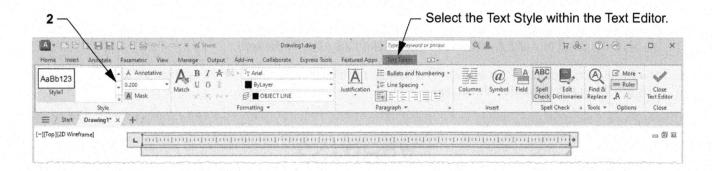

Deleting a Text Style

1. Select the **Text Style** command using one of the following:

Ribbon = Annotate Tab / Text Panel / >
or
Keyboard = ST <Enter>

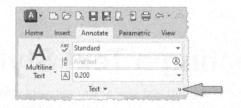

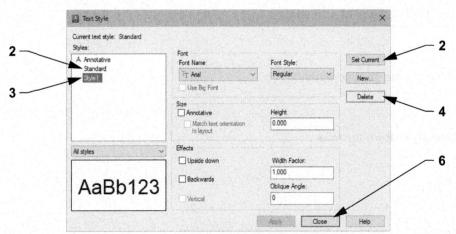

- 2. First, select a **text style** that you **do not want to Delete** and select **Set Current** button. (You can't Delete a Text Style that is in use.)
- 3. Select the **text style** that you want to Delete.
- 4. Select the Delete button.
- 5. A warning appears, select **OK** or **Cancel**.
- 6. Select the Close button.

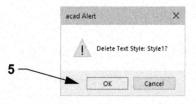

Note: Also refer to page 29-12 for the **Purge** command. The Purge command will remove any unused text styles, dimension styles, layers, and linetypes.

Changing the Effects of a Text Style

1. Select the **Text Style** command using one of the following:

Ribbon = Annotate Tab / Text Panel / >
or
Keyboard = ST <Enter>

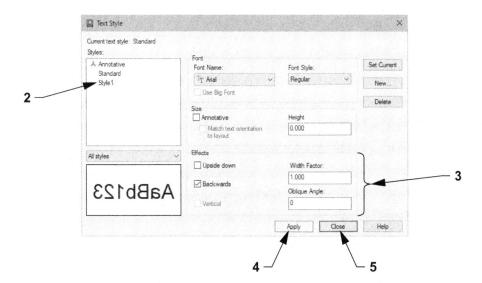

- 2. Select the **text style** you want to change.
- 3. Make the changes in the Effects boxes.

Note about Vertical text: Only .shx fonts can be vertical. Vertical text will not display in the Preview box.

- 4. Select the Apply button. (Apply will stay gray if you did not change a setting.)
- 5. Select the Close button.

Divide Command

The **Divide** command divides an object mathematically by the **number** of segments you specify. A **Point** (object) is placed at each interval on the object.

Note: The object selected is not broken into segments. The Points are simply drawn on the object.

Example:

This **Line** has been divided into four **equal** lengths. But remember, the line is not broken into segments. The Points are simply drawn on the object.

1. First open the **Point Style** dialog box and select the **Point Style** to be placed on the object, using one of the following:

Ribbon = Home Tab / Utilities Panel → / Point Style or

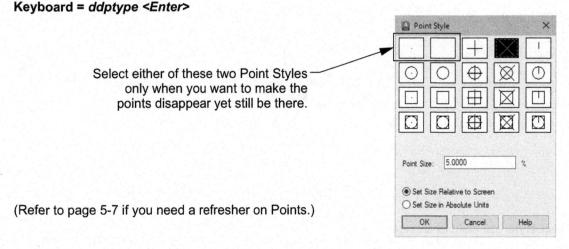

2. Next select the **Divide** command using one of the following:

The following will appear on the Command Line:

3. Select the object to divide.

The following will appear on the Command Line:

4. Type the number of segments and then press **<Enter>**.

Measure Command

The **Measure** command is very similar to the **Divide** command because point objects are drawn at intervals on an object. However, the **Measure** command allows you to specify the **length** of the segments rather than the number of segments.

Note: The object selected is not broken into segments. The Points are simply drawn on the object.

Example:

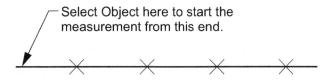

The **Measurement** was started at the left endpoint, and ended just short of the right end of the line. The remainder is less than the measurement length specified. You designate which end you want the measurement to start at by selecting the end when prompted to select the object.

 First open the Point Style dialog box and select the Point Style to be placed on the object, using one of the following:

Ribbon = Home Tab / Utilities Panel → / Point Style or Keyboard = ddptype <Enter>

(Refer to page 5-7 if you need a refresher on Points.)

2. Next select the **Measure** command using one of the following:

Ribbon = Home Tab / Draw Panel ▼ / or Keyboard = me <Enter>

The following will appear on the Command Line:

3. Select the object to measure.

The following will appear on the Command Line:

4. Type the length of one segment and then press **<Enter>**.

Exercise 25A

Exercise 25A

Instructions:

- 1. Start a New file using the Border A-Inch.dwt or the Border A-Metric.dwt
- 2. Create the three text styles shown below. (Style 1, Style 2 and Style 3.)
- 3. Select all of the options shown.
- 4. Save as Ex-25A

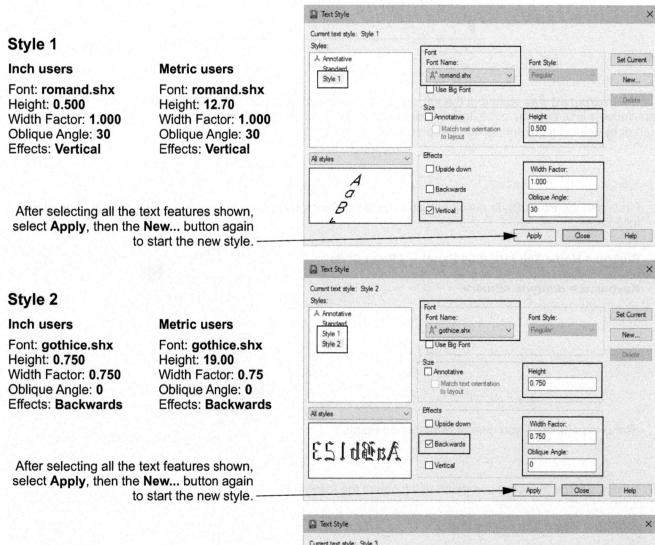

Style 3

Metric users

Select Apply and then Close.

Font: italic.shx Height: 38.10 Width Factor: 0.75 Oblique Angle: 0 Effects: Upside down

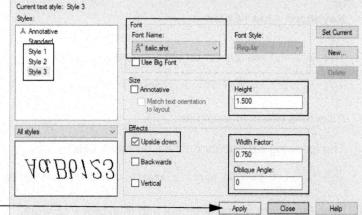

Exercise 25B

Instructions:

- 1. Open Ex-25A (if not already open).
- 2. Before entering text, move the **Origin** to the lower left corner as shown.
- Draw the three text styles using "Single Line Text".
 Remember to select the text style before selecting the Single Line Text command.
- 4. Place the start point exactly as shown. (Enter coordinates and the Rotation angle.)
- 5. Use Layer Text.
- 6. Edit the **Title** and **Ex-XX** by double clicking on the text. Do not erase and replace.
- 7. Save as Ex-25B
- 8. Plot using Page Setup Class Model A

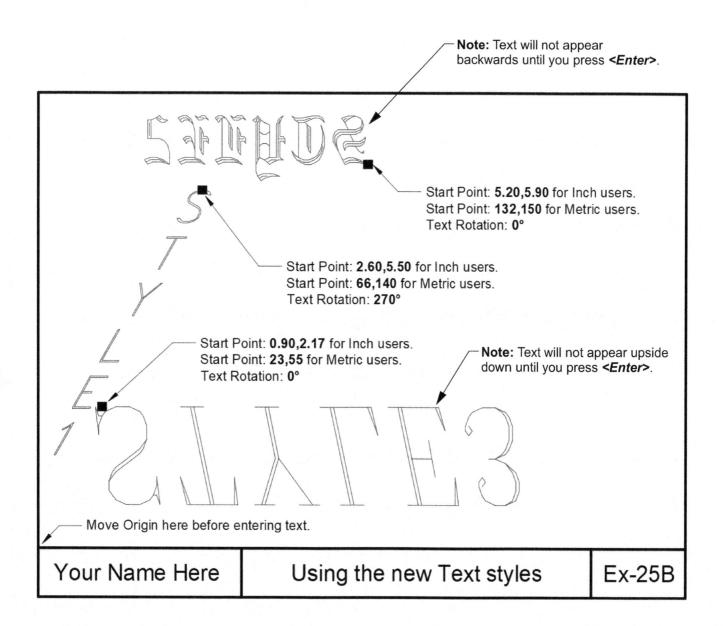

Exercise 25C

Instructions:

- 1. Open Ex-25B (if not already open).
- 2. Change the text to Text Style Standard.
 - A. Select all the text.
 - B. Right click and choose "Quick Properties" from the menu.
 - C. Change text "VARIES" to Standard.
- 3. Edit the Title and Ex-XX by double clicking on the text. Do not erase and replace.
- 4. Save as Ex-25C
- 5. Plot using Page Setup Class Model A

STYLE1 STYLE2

STYLE3

Your Name Here

Changing the Text styles

Ex-25C

Exercise 25D

Instructions:

- 1. Open Ex-25C (if not already open).
- 2. Delete Text Styles 1, 2, and 3 as follows.
 - A. Select the Text Style dialog box.
 - B. Select the Standard text style.
 - C. Select the Set Current button. (This makes Standard the current text style.)

AutoCAD will not allow you to delete an active or current text style. That is why you must make the Standard text style current before you can delete a text style.

- D. Select the text style you want to **delete**.
- E. Click on the Delete button.

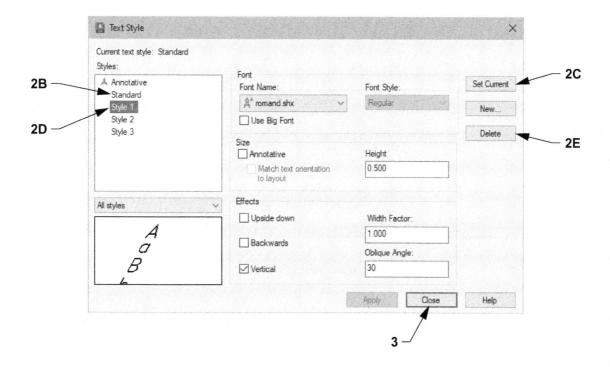

- 3. Select the Close button.
- 4. Save as Ex-25D

Exercise 25E

Exercise 25E

Instructions:

- 1. Start a New file using the Border A-Inch.dwt or the Border A-Metric.dwt
- 2. Draw the two 8" [203.2 mm] long lines shown below on Layer Object Line.
- 3. Divide the upper line into 10 equal segments.
- 4. Using Measure create five 1.500" [38.1 mm] long segments on the lower line as shown.
- 5. Dimension as shown. (Remember "Node" is the Object Snap to use for Points.)
- 6. Edit the Title and Ex-XX by double clicking on the text. Do not erase and replace.
- 7. Save as Ex-25E
- 8. Plot using Page Setup Class Model A

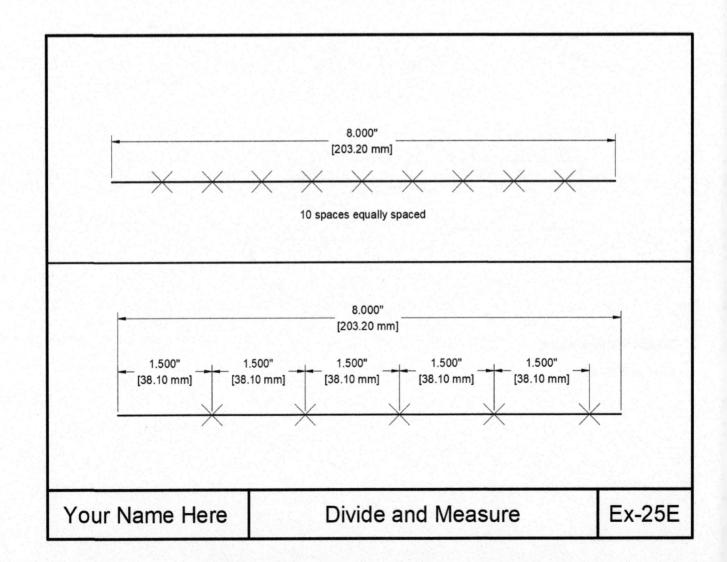

Exercise 25F

Instructions:

- 1. Start a New file using the Border A-Inch.dwt or the Border A-Metric.dwt
- 2. Draw the "pretend" house roof plan with the fence line shown below.
- 3. Refer to the next page for instructions and helpful hints.
- 4. Dimension using Dimension Style CLASS STYLE and Layer Dimension.
- 5. Edit the **Title** and **Ex-XX** by double clicking on the text. Do not erase and replace.
- 6. Save as Ex-25F
- 7. Plot using Page Setup Class Model A

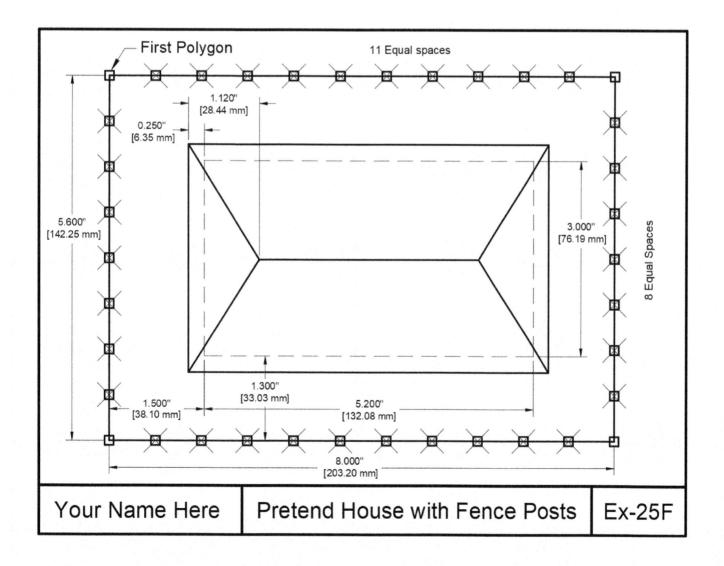

Exercise 25F Helper

Exercise 25F Helper

Step 1.

Draw the "pretend" house roof plan with the fence line.

Use Layers Roof, Walls, and Hidden Lines.

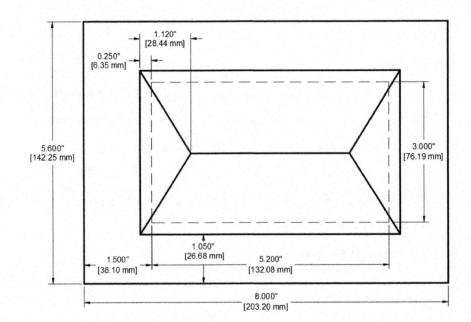

Step 2.

Divide the fence lines: 11 equal spaces horizontally, 8 equal spaces vertically.

Step 3.

Draw a fence post at upper-left corner using an inscribed, four-sided polygon, **0.100"** [2.54 mm] radius.

Step 4.

Copy the fence post to the "Points" and corner. Use Object Snap "Node" to snap to the "Points".

Step 5.

Change the Point style so the Points will not be displayed.

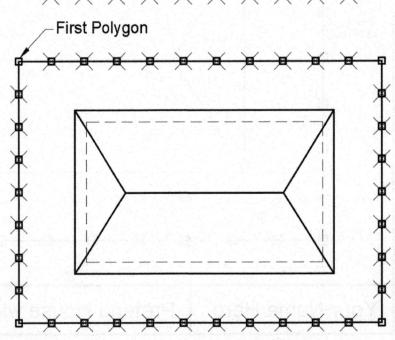

LESSON 26

LEARNING OBJECTIVES

After completing this lesson, you will be able to:

- 1. Understand the difference between Model and Layout Tabs.
- 2. Create Viewports.
- 3. Create a Page Setup.
- 4. Create a Plot Page Setup.
- 5. Create a Master Decimal Setup template.
- 6. Create a new Border.
- 7. Experiment with multiple Viewports.

Serious Business

In the previous lessons, you have been having fun learning most of the basic commands that AutoCAD offers and you have been using a template that included preset layers and drawing settings, etc. But now it is time to get down to the "serious business" of setting up your own drawing from scratch.

Starting from scratch means you will need to set or create the following:

Items 1 through 5 you have learned in previous lessons.

- 1. Drawing Units (Lesson 4).
- 2. Snap and Grid (Lesson 2).
- 3. Create text styles (Lesson 25).
- 4. Create dimension styles (Lesson 16).
- 5. Create new layers and load linetypes.

Items 6 through 9 will be learned in this lesson.

- 6. Create a "Layout" for plotting.
- 7. Create a "Floating Viewport" in the Layout.
- 8. Create a "Page Setup" to save plot settings.
- 9. Plot the drawing from Paper space.

After reading pages 26-3 through 26-17, start Exercise 26A and work your way through 26D. When you have completed Exercise 26E, you will have created a master template named, "My Decimal Setup". This master template will have everything set, created, and prepared, ready to use each time you want to create a drawing using decimal units and to be plotted on an 11" X 8-1/2" or 297 mm X 210 mm sheet.

This means, for future drawings, you merely select **File / New** and **"My Decimal Setup.dwt"** and start drawing. No time consuming setups. It is all ready to go.

In Lesson 27, you will create a master template for "feet and inches". Although metric users no longer use feet and inches, it is good practice and you can print your results out on an A4 size sheet of paper.

So take it one page at a time and really concentrate on understanding the process.

Note: I am using sheet sizes of 11" X 8-1/2" and 297 mm X 210 mm so you may print the exercises on your printer. After you understand the Page Setup concept, you will be able to assign a larger sheet size to conform to any large format printer that you may use in the future.

Model and Layout Options

Very important: Before I discuss Model and Layout, I need you to confirm the Model and Layout Tabs are displayed.

This will just take a minute.
1. Type options and then press <Enter>.
or
Right click and select Options.
2. Select the Display Tab.

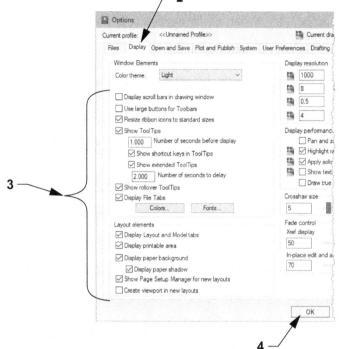

- 3. Check and un-check boxes as shown.
- 4. Select the **OK** button.
- 5. The lower left corner of the drawing area should display the three Tabs: Model, Layout1, and Layout2. And a few tools should be displayed in the lower right corner on the Status Bar.

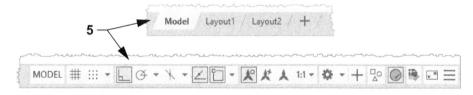

Model and Layout Tabs

Read this information carefully. It is very important that you understand this concept and the information on the following pages.

AutoCAD provides two drawing spaces, Model and Layout. You move into one or the other by selecting either the Model or Layout Tabs, located at the bottom left of the drawing area. (If you do not have these displayed, follow the instructions above.)

Model

Model Tab (also called Model Space).

When you select the **Model** Tab, you enter **Model Space**. (This is where you have been drawing and plotting from for the last 25 lessons.) Model Space is where you **create** and **modify** your drawings.

Layout Tabs (also called Paper Space).

When you select a Layout Tab, you enter **Paper Space**. The primary function of Paper Space is to **prepare the drawing for plotting or printing**.

When you select the Layout Tab for the first time, the "Page Setup Manager" dialog box will appear. The Page Setup Manager allows you to specify the printing device and paper size to use. (More information on this is in "Creating a Page Setup" on page 26-9.)

When you select a Layout Tab, Model Space will seem to have disappeared, and a **blank sheet of paper** is displayed on the screen. This sheet of paper is basically **in front of the Model Space**. (Refer to the illustration below.)

To see the drawing in Model Space, while still in Paper Space, you must cut a hole in this sheet. This hole is called a "viewport". (Refer to "Viewports" on page 26-5.)

Try to think of this as a picture frame (Paper Space) in front of a photograph (Model Space).

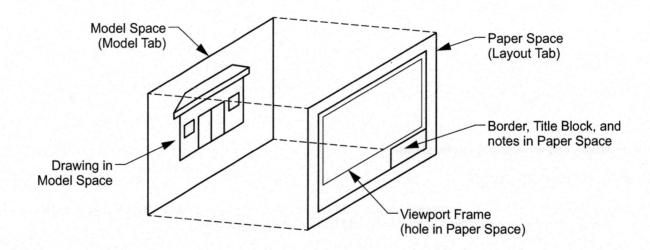

This is what you see when you select the Model Tab.

You see Model Space.

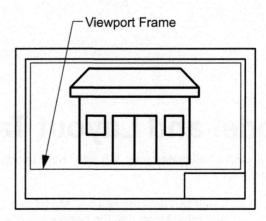

This is what you see when you select the Layout1 Tab.

You see through the viewport to Model Space.

Viewports

Note: This is just the concept to get you thinking. The actual step-by-step instructions will follow in the exercises.

Viewports are only used in Paper Space (Layout Tab). Viewports are holes cut into the sheet of paper displayed on the screen in Paper Space. **Viewport frames** are objects. They can be moved, stretched, scaled, copied, and erased. You can have multiple viewports, and their size and shape can vary.

Note: It is considered good drawing management to create a layer for the viewport "frames" to reside on. This will allow you to control them separately: such as setting the Viewport layer to "**No plot**" so it will not be plotted out.

How to create a Viewport

- 1. First, create a drawing in **Model Space** (**Model** Tab Model) and save it.
- 2. Select the **Layout1** Tab. Layout1

When the "Page Setup Manager" dialog box appears, select the New... button. Then you will select the printing device and paper size to plot on. (Refer to "Creating a Page Setup" on page 26-9.)

3. You are now in **Paper Space**. Model Space appears to have disappeared, because a blank paper is now in front of Model Space, preventing you from seeing your drawing. You designated the size of this sheet in the "Page Setup" mentioned in Step 2 above. (The border, Title Block, and notes will be drawn on this paper.)

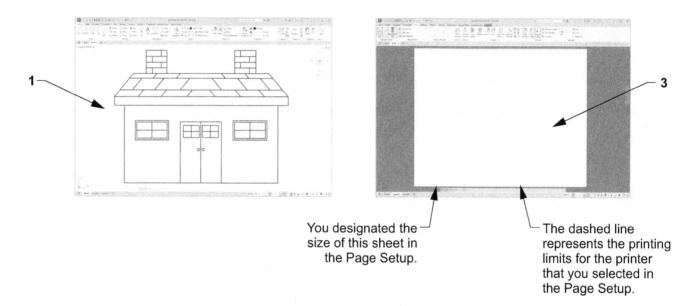

4. Draw a border, Title Block, and notes in Paper Space (Layout).

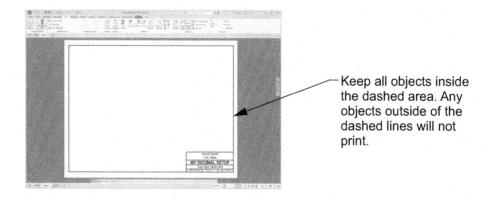

26-6 Viewports

Now you will want to see the drawing that is in Model Space.

- 5. Select the "Viewport" layer (you want the viewport frame to be on this layer).
- 6. Select the Viewport command using one of the following:

 Ribbon = Layout Tab / Layout Viewports Panel / ▼ / Polygonal Keyboard = MV <Enter>

 Rectangular → Polygonal Object
- 7. Draw a rectangular shaped viewport "frame" by placing the location for the "first corner" and then the "opposite corner" using the cursor. (Similar to drawing a rectangle, but **do not** use the Rectangle command. You must remain in the **MV** command.)

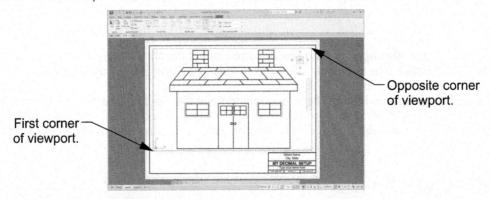

You should now be able to look through the Paper Space sheet to Model Space and see your drawing because you just cut a rectangular shaped hole in the sheet.

Note: Now you may go back to Model Space or return to Paper Space, simply by selecting the Tabs, Model or Layout.

Why Layouts are Useful

You are probably wondering why you should bother with Layouts. A Layout (Paper Space) is a great method to manipulate your drawing for plotting or printing.

Notice the drawing below with **multiple viewports**. Each viewport is a hole in the paper. You can see through each viewport (hole) to Model Space. Using Zoom and Pan, you can manipulate the display of model space in each viewport. To manipulate the display, you must be inside the viewport.

Refer to the next page for instructions on how to achieve this.

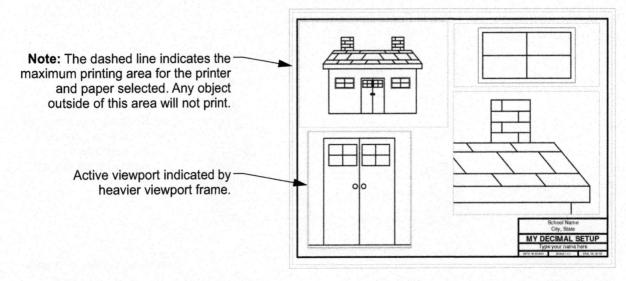

How to Reach Into a Viewport

Here are the rules:

- 1. You have to be in Paper Space (Layout Tab) and at least one viewport must have been created.
- 2. You have to be **inside a viewport** to manipulate the scale or position of the drawing that you see in that Viewport.

How to reach into a viewport to manipulate the display

First, select a Layout Tab and cut a viewport.

At the bottom right of the screen on the Status Bar, there is a button that either says Model or Paper. This button displays which space you are in currently.

When the button is **Paper**, you are working on the Paper sheet that is in front of Model Space. (Refer to the illustration on page 26-4.) You may cut a viewport, draw a border, add a Title Block, and place notes.

If you want to reach into a viewport to manipulate the display, double click inside of the viewport frame. Only one viewport can be activated at one time. The active viewport is indicated by a heavier viewport frame. (Refer to the illustration on the previous page. The viewport displaying the doors is active.) Also, the Paper button changed to Model.

While you are inside a viewport, you may manipulate the scale and position of the drawing displayed. To return to the Paper surface, click on the word Model and it will change to Paper paper surface.

Note: Do not confuse the Model / Layout Tabs with the MODEL / PAPER button.

Here is the difference.

The **Model / Layout** Tabs shuffle you from the actual drawing area (Model Space) to the Layout area (Paper Space). It is sort of like having two stacked pieces of paper and when you select the Model Tab, the drawing would come to the front and you could not see the layout. When you select the Layout Tab, a blank sheet would come to the front and you would not see Model Space, unless you have a viewport cut.

The **MODEL / PAPER** button allows you to work in Model Space or paper space without leaving the Layout Tab. No flipping of sheets. You are either on the paper surface or in the viewport reaching through to Model Space.

Don't worry it will get easier. This is the concept...but it will become clearer when you have completed the exercises in this lesson.

Pan

After you zoom in and out or adjust the scale of a viewport, the drawing within the viewport frame may not be positioned as you would like it. This is where **Pan** comes in handy. **Pan** will allow you to move the drawing around, within the viewport, without affecting the size or scale.

Note: Do not use the **Move** command. You do not want to actually move the original drawing. You only want to slide the viewport image, of the original drawing, around within the viewport.

How to use the Pan command

- 1. Select a Layout Tab (Paper Space).
- 2. Unlock the viewport if it is locked. (Refer to page 26-9.)
- 3. Click inside a viewport.
- 4. Select the Pan command using one of the following:

Ribbon = View Tab / Navigate Panel / Pan (Refer to pages 1-9 and 4-7.) or Keyboard = P < Enter > or Navigation Bar = (Turned off on page 1-19.)

(Consider adding the Pan tool to the Quick Access Toolbar. See page 1-8.)

5. Place the cursor inside the viewport and hold the left mouse button down while moving the cursor. (Click and drag.) When the drawing is in the desired location, release the mouse button.

Pan

- 6. Press the < Esc > key or press < Enter > to end the Pan command.
- 7. Lock the viewport. (Refer to page 26-9.)

Refer to the example below.

If you have a wheel mouse, you may also use the **Pan** command by holding down the center wheel while moving the cursor.

Before Pan.

Double click in the viewport to active it. Use Pan (Click, Drag, Release).

After Pan.

Locking a Viewport

After you have manipulated the drawing within each viewport to suit your display needs, you will want to **Lock** the viewport so the display can't be changed accidentally. Then you may zoom in and out, knowing that you will not disturb the display.

Note: Accurately adjusting the scale of a viewport will be discussed in detail in Lesson 27.

1. Make sure you are in Paper Space.

2. Click once on a viewport frame.

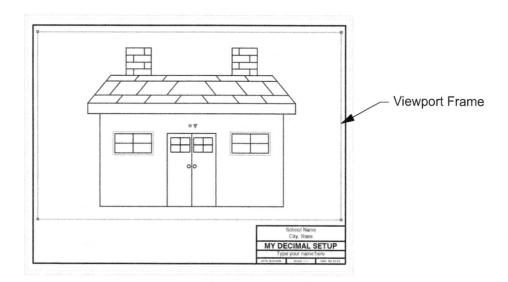

3. Click on the **Open Lock** tool located in the lower right corner of drawing area.

The icon will change to a Closed Lock tool.

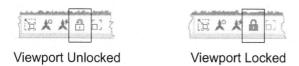

4. Press the **<**Esc> key to deactivate the grips on the viewport frame.

Now, any time you want to know if a viewport is locked or unlocked, just glance down to the **Lock** tool shown above.

Creating a Page Setup

When you select a Layout Tab for the first time, the Page Setup Manager will appear. The Page Setup Manager allows you to select the **printer** / **plotter** and **paper size**. These specifications are called the "**Page Setup**". This Page Setup will be saved to that Layout Tab so it will be available whenever you use that Layout Tab.

Note: The following is for concept only. The actual exercise starts with 26A.

- 1. Open the drawing you want to plot. (The drawing must be displayed on the screen.)
- 2. Select a Layout Tab. (Refer to page 26-3 if you do not have a Layout Tab.)

Note: If the "Page Setup Manager" dialog box shown below does not appear automatically, right click on the Layout Tab and select "Page Setup Manager".

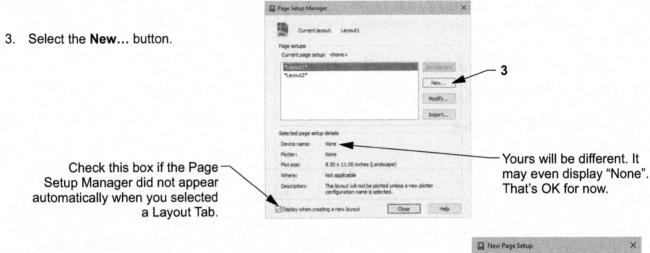

- 4. Select < Default output device> in the Start with: list.
- Enter the New Page Setup name: Setup A
- 6. Select the OK button.

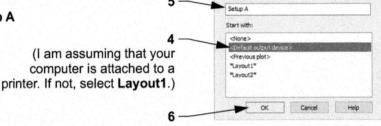

This is where you will select the printer / plotter, paper size, and the plot offset.

7. Select the Printer / Plotter

Note: Your current system printer should already be displayed here. If you prefer another, select the down arrow and select from the list. If the preferred printer is not in the list, you must configure the printer. (Refer to **Appendix-A** for instructions.)

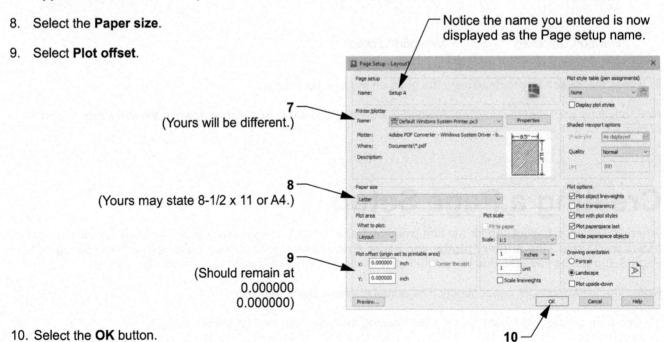

- 11. Select the Page Setup.
- 12. Select the Set Current button.
- 13. Select the Close button.

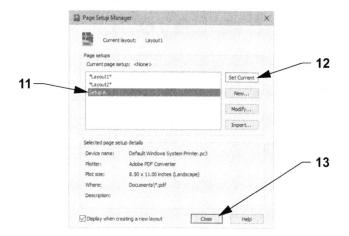

You should now have a sheet of paper displayed on the screen.

This sheet is the size you specified in the "Page Setup".

This sheet is in front of Model Space.

Rename the Layout Tab

- 14. Right click on the active Layout Tab and select Rename from the list.
- 15. Enter the new Layout name A Size and then press < Enter >.

This was just the concept of Page Setup. You will actually create one in Exercise 26B.

Using the Layout

Now that you have the correct paper size on the screen, you need to do a little bit more to make it useful.

The next step is to:

- 1. Add a border, Title Block, and notes in Paper Space.
- 2. Cut a viewport to see through to Model Space. (Refer to page 26-6.)

- 3. Adjust the scale of the viewport as follows:
 - A. You must be in Paper Space.
 - B. Click on the viewport frame.
 - C. Unlock the viewport if it is locked.
 - D. Select the viewport scale down arrow .
 - E. Select a scale.

4. Lock the viewport.

Now you may zoom as much as you want and it will not affect the adjusted scale.

Note: Adjusting the scale of the viewport will be discussed more in Lesson 27.

Plotting from a Layout Tab

Note: You must create a **Page Setup** before Plotting from a Layout Tab. If you have not created a Page Setup, refer to page 26-9 before proceeding.

The previous Page Setup instructions were to select the printer and paper size. Now you need to specify how you want to plot the drawing. You will find the **Plot** dialog box almost identical to the Page Setup dialog box.

- 1. Open the drawing you want to plot.
- 2. Select the Layout Tab you want to plot.
- 3. Select the **Plot** command using one of the following:

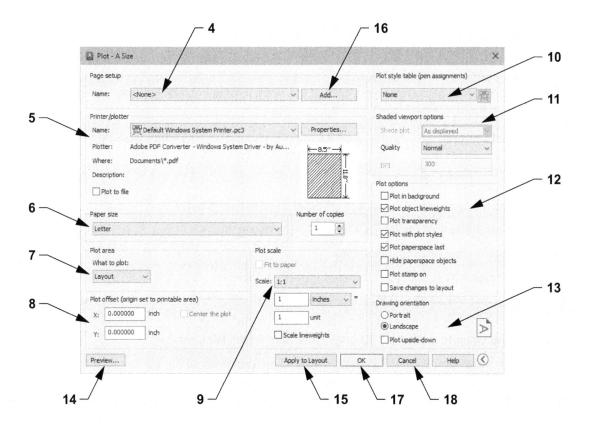

- 4. **Page Setup Name:** After you have selected the desired settings, you will save the new Page Setup and it will appear here. If you have previously created a Page Setup, you may select it from the drop-down list and all of the settings will change to reflect the previously saved Page Setup settings.
- 5. **Printer / Plotter:** Select the Printer that you want to use. All previously configured devices will be listed here. (If your printer / plotter is not listed, refer to "Add a Printer / Plotter" Appendix A.)

- 6. Paper size: Select the paper size. The paper sizes shown in the drop-down list are the available sizes for the printer that you selected. If the size you require is not listed, the printer you selected may not be able to handle that size. For example, a letter size printer cannot handle a 24" X 18" size sheet. You must select a large format printer.
- 7. Plot area: Select the area to plot. Layout is the default.

Limits plots the area inside the drawing limits.

(This option is only available when plotting from Model Space.)

Layout plots the paper size.

(Select this option when plotting from a Layout.)

Extents plots all objects in the drawing file even if out of view. (This option is only available if you have a viewport.)

Display plots the drawing exactly as displayed on the screen.

Window plots objects inside a Window. To specify the Window, choose Window and specify the first and opposite (diagonal) corner of the area you choose to plot. (Similar to the Zoom / Window command.)

- 8. **Plot offset:** The plot can be moved away from the lower left plot limit corner by changing the X and / or Y offset. If you have selected Plot area "Display" or "Extents", select "Center the plot".
- 9. Scale: Select a scale from the drop-down list or enter a custom scale.

Note: This scale is the Paper Space scale. The Model Space scale will be adjusted within the viewport. If you are plotting from a **Layout** Tab, normally you will use **plot scale 1:1**. (This may seem a little confusing right now. Scaling will be discussed more in Lesson 27.)

- 10. **Plot style table:** Select the Plot style table from the list. The Plot Styles determine if the plot is in color, black ink, or screened. You may also create your own. If you want to print in black lnk only, select Monochrome.ctb. If you want to print in color, select Acad.ctb
- 11. **Shaded viewport options:** This area is used for printing shaded objects when working in the 3D environment.
- 12. Plot options:

Plot background = specifies that the plot is processed in the background.

Plot Object Lineweights = plots objects with assigned lineweights.

Plot transparency = plots any transparencies.

Plot with Plot Styles = plots using the selected Plot Style Table.

Plot paperspace last = plots Model Space objects before plotting Paper Space objects. Not available when plotting from Model Space.

Hide Paperspace Objects = used for 3D only. Plots with hidden lines removed.

Plot Stamp on = allows you to print information around the perimeter of the border such as: drawing name, layout name, date/time, login name, device name, paper size, and plot scale.

Save Changes to Layout = is what you check if you want to save all settings to the current Layout Tab.

13. Drawing orientation:

Portrait = the short edge of the paper represents the top of the page.

Landscape = the long edge of the paper represents the top of the page

Plot Upside-down = plots the drawing upside down.

14. Select the Preview... button. Preview displays the drawing as it will plot on the sheet of paper.

(Note: If you cannot see through to Model Space, you have not cut your viewport yet.)

If the drawing appears as you would like it, press the **<**Esc> key and continue.

If the drawing does not look correct, press the **<Esc>** key and re-check your settings, then preview again.

Note: If you have any of the layers set to "no plot", they will not appear in the preview display. The Preview Display only displays what will be printed.

- 15. **Apply to Layout** button: This applies all of the settings to the Layout Tab. Whenever you select this Layout Tab, the settings will already be set.
- 16. Save the Page Setup: At this point, you have the option of saving these settings as another Page Setup for future use on other Layout Tabs. If you want to save this setup, select the Add... button, type a name, and select OK.
- 17. If your computer **is** connected to the plotter / printer selected, select the **OK** button to plot, then proceed to **Step 19**.
- 18. If your computer is **not** connected to the plotter / printer selected, select the **Cancel** button to close the Plot dialog box and proceed to **Step 19**.

Note: Selecting **Cancel** will cancel your selected setting if you did not save the Page Setup as specified in **Step 16** above.

Save the drawing: This will guarantee that the Page Setup you just created will be saved to this file for future use.

Note: This is the concept only. The step-by-step instructions are shown in Exercise 26E on page 26-27.

Annotative Property

In Lesson 16, you learned to create a dimension style. In Lesson 25, you learned to create a text style.

In this Lesson, you will create a new dimension style and text style, but this time you will include the **Annotative Property** in both.

The Annotative property automates the process of scaling text, dimensions, hatch, tolerances, leaders, and symbols. The height of these objects will automatically be determined by the annotation scale setting. This will be discussed more in Lesson 27.

For now, I just want you to know how to select it when creating your new styles.

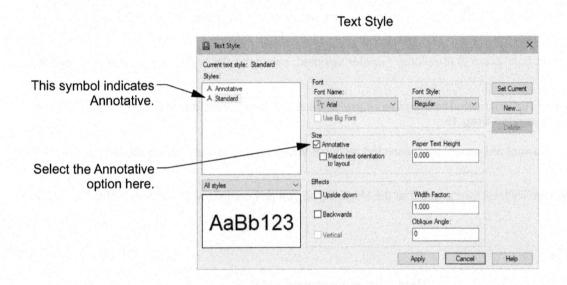

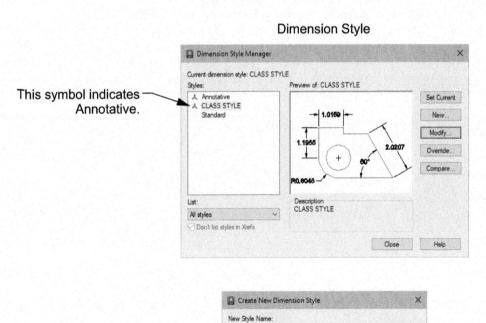

Copy of CLASS STYLE

Start With

Select the Annotative

option here.

CLASS STYLE

Annotative

Use for: All dimensions Continue

Cancel

Help

Exercise 26A

Exercise 26A: Create a Master Decimal Setup Template

The following instructions will guide you through creating a "master" decimal setup template. The "inch-helper" and "Border A-Metric" are examples of a master setup template. Once you have created this "master" template, you just open it and draw. No more repetitive inputting of settings.

New Settings

- 1. Begin your drawing with a different template as follows:
 - A. Select the New command.
 - B. Select template file **acad.dwt** from the list of templates for inch users. or

Select template file **acadiso.dwt** from the list of templates for metric users.

(Note: Do not select "acad3D.dwt" or "acadiso3D.dwt" by mistake.)

- 2. Set the Drawing Units as follows:
 - A. Type *units* and then press *<Enter>*.
 - B. Change the Length Type: Decimal and Precision: 0.000 or 0.00 as shown below.
 - C. Select the **OK** button.

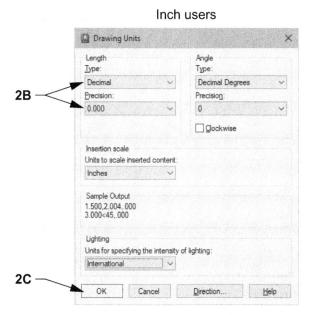

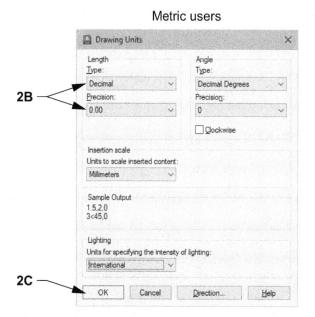

3. Set the **Drawing Limits**:

- A. Type Limits and then press <Enter>.
- B. Enter lower left corner = 0,0
- C. Enter upper right corner = 11,8.5 inch users. or 297,210 for metric users.
- D. Use "Zoom / All" to view the new limits.
- E. Set your Grids to on to display the limits.

- 4. Set the Grids and Snap as follows:
 - A. Type DS and then press <Enter>.
 - B. Select the Snap and Grid Tab.
 - C. Change the settings as shown below.
 - D. Select the OK button.

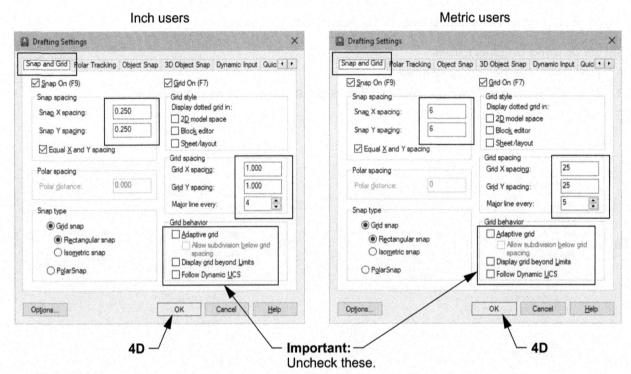

- 5. Change the Lineweight Settings as follows:
 - A. Right click on Lineweight button located on the Status Bar.
 - B. Select Lineweight Settings. (Refer to page 3-10 for instructions.)
 - C. Change to Inches or Millimeters and Adjust Display Scale as shown below.
 - D. Select the OK button.

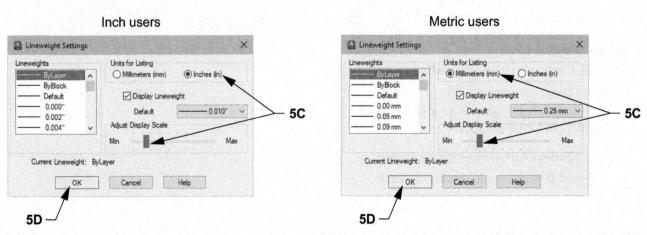

6. Create new layers as follows:

Current layer: OBJECT LINE

Invert filter

All: 16 layers displayed of 16 total layers

Not Plot

- A. Load the linetypes listed below. (Refer to page 3-13 for instructions.) CENTER2, HIDDEN, and PHANTOM2.
- B. Assign names, colors, linetypes, lineweights, and plotability as shown below. (Refer to page 3-12 for instructions.)

Note: Make the Object Line layer current and change the Viewport layer to Not Plot by clicking on the printer icon.

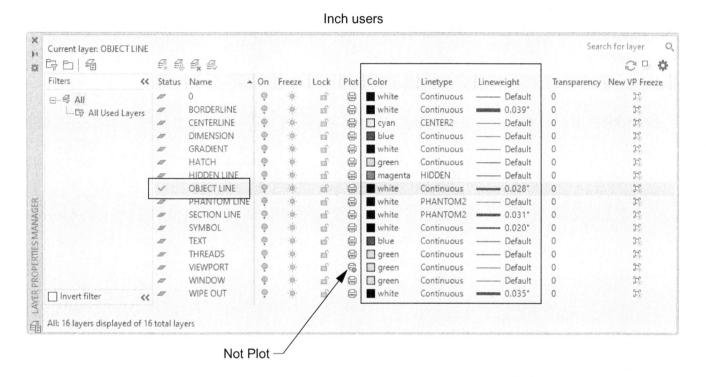

岛口角 9 9 9 9 0 0 0 Filters Lock << Status Name ▲ On Plot Color Linetype Lineweight Transparency New VP Freeze Freeze 1 white 0 RE Continuous - Default Ð-- € All BORDERLINE 10 mi 8 white Continuous 1.00 mm 0 H - ER All Used Layers 0 · (6) and H CENTERI INF cyan cyan CENTER2 - Default 0 T DIMENSION 1 먑 **blue** Default 0 Continuous GRADIENT 0 昭 **w**hite Continuous Default 0 I 0 T HATCH 88 green Continuous - Default 0 HIDDEN LINE 0 stf. HIDDEN 0 T magenta magenta Default **OBJECT LINE** 0 H ES 品 white Continuous • 0.70 mm 0 PHANTOM LINE 0 ES white PHANTOM2 Default T SECTION LINE EÉ. T white PHANTOM2 - 0.80 mm 0 SYMBOL T mf white - 0.50 mm 0 Continuous H TEXT 略 **blue** Continuous Default THREADS 0 10 ECE. 自 green Continuous Default 0 T ٥ 10 EOF. green 0 H VIEWPORT Default Continuous WINDOW 0 20 green Default 0 Continuous WIPE OUT white = 0.90 mm Continuous

Search for layer

- 7. Create a new Text Style as follows:
 - A. Select Text Style. (Refer to page 25-2.)
 - B. Create the text style TEXT-CLASSIC using the settings shown below.
 - C. When complete, select Set Current.
 - D. Select Close.

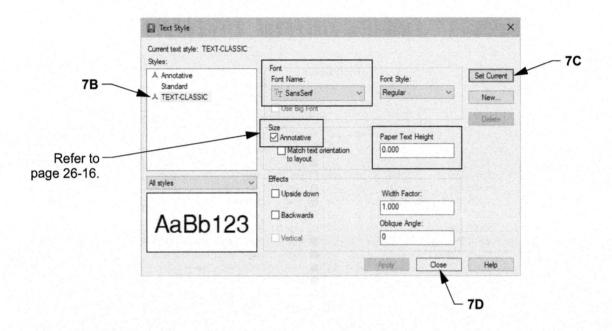

- 8. Create a new **Dimension Style** as follows:
 - A. Important: Follow the directions on pages 16-7 through 16-10.
 - B. All settings will be the same as pages 16-7 through 16-10 except the following:

Name = DIM-DECIMAL

Annotative = This new dimension style will be Annotative. (Refer to page 26-16.)

Text Style = Select the newly created TEXT-CLASSIC.

- 9. Create a new **Dimension Sub-Style** as follows:
 - A. Follow the directions on page 18-9 and 18-10.
 - All settings will be the same as pages 16-7 through 16-10 except the following:
 Annotative = This new sub-style will be Annotative. (Refer to page 26-16.)

Your Dimension Style Manager should now appear as shown below:

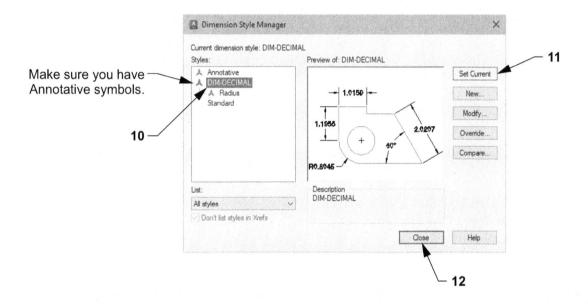

- 10. Select DIM-DECIMAL.
- 11. Select Set Current.
- 12. Select the Close button.

This next step is very important.

Save all the settings you just created as follows:
 Save as / AutoCAD Drawing Template / My Decimal Setup

Now continue on to Exercise 26B...you are not done yet.

Exercise 26B

Exercise 26B: Page Setup

Now you will select the printer and the paper size to use for printing. You will use the Layout1 Tab (Paper Space).

- 1. Open My Decimal Setup (if not already open).
- 2. Select the Layout1 Tab.

(Refer to page 26-3 if you do not have these Tabs.)

Note: If the "Page Setup Manager" dialog box shown below does not appear automatically, right click on the Layout Tab and select Page Setup Manager.

Select the New... button.

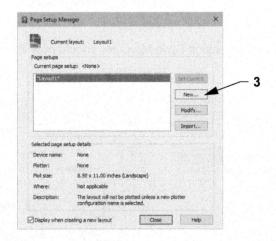

- 4. Select < Default output device> in the Start with: list.
- Enter the New Page Setup name: Setup A
- 6. Select the OK button.

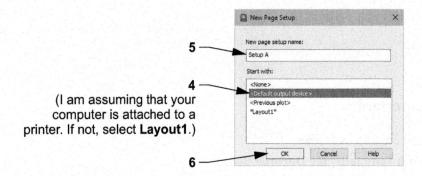

This is where you will select the printer / plotter, paper size, and the plot offset.

7. Select the Printer / Plotter

Note: Your current system printer should already be displayed here. If you prefer another, select the down arrow and select from the list. If the preferred printer is not in the list, you must configure the printer. (Refer to **Appendix-A** for instructions.)

- 8. Select the Paper size.
- 9. Select Plot offset.
- 10. Set to Inches for inch users, or Millimeters for metric users.

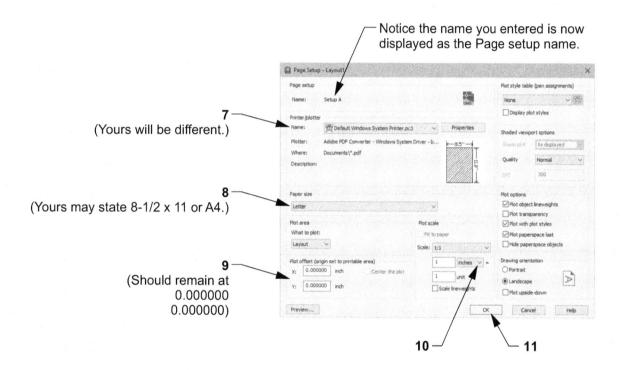

- 11. Select the **OK** button.
- 12. Select Setup A.
- 13. Select the Set Current button.
- 14. Select the Close button.

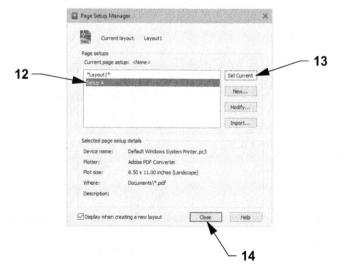

You should now have a sheet of paper displayed on the screen.

This sheet is the size you specified in the "Page Setup".

This sheet is in front of Model Space.

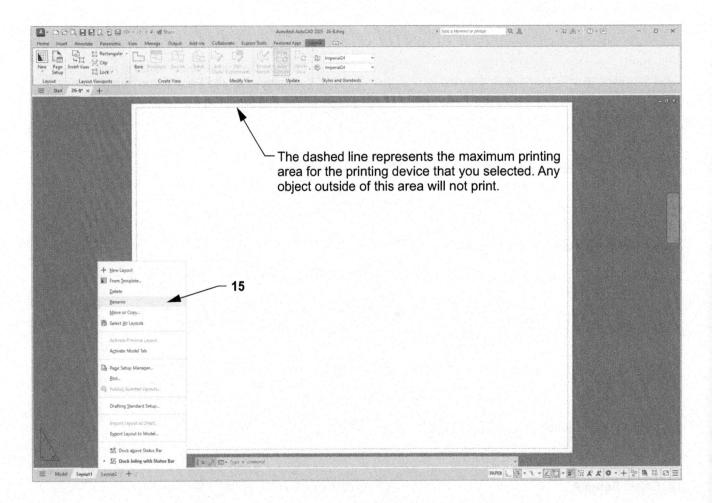

Rename the Layout Tab

- 15. Right click on the active Layout Tab and select Rename from the list.
- 16. Enter the new Layout name A Size and then press < Enter>.

17. Very important: Save as / AutoCAD Drawing Template / My Decimal Setup again.

Now continue on to Exercise 26C...you are not done yet.

Exercise 26C

Exercise 26C: Create a Border and Title Block

1. Draw the border rectangle as large as you can within the dashed lines approximately as shown below using Layer Borderline.

- 2. Draw the Title Block as shown using:
 - A. Layers Borderline and Text.
 - B. Multiline Text: Justify Middle Center in each rectangular area.
 - C. Text Style = TEXT CLASSIC. Text Height: Varies.

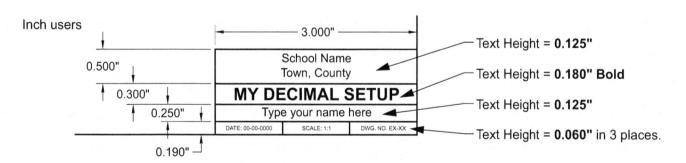

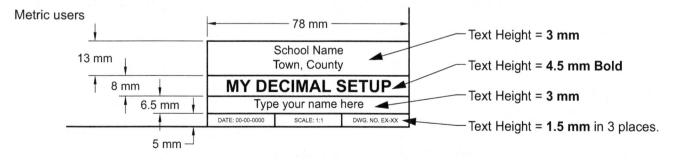

3. Very important: Save as / AutoCAD Drawing Template / My Decimal Setup again.

Now continue on to Exercise 26D...you are not done yet.

Exercise 26D: Create a Viewport

The following instructions will guide you through creating a **viewport** in the Border Layout sheet. Creating a viewport has the same effect as cutting a hole in the sheet of paper. You will be able to see through the viewport frame (hole) to Model Space.

- 1. Open My Decimal Setup (if not already open).
- 2. Select the A Size Layout Tab.
- 3. Select Layer Viewport.
- 4. Type MV and then press < Enter>. (Refer to page 26-6.)
- Before

ore After

5. Draw a single viewport approximately as shown. (Turn off Osnap.)

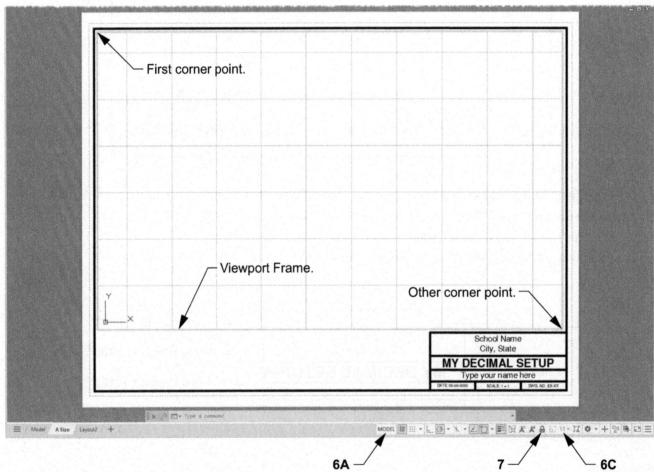

- 6. Adjust the viewport scale as follows:
 - A. Confirm the "MODEL" button is showing.
 - B. Select "Zoom / All".
 - C. Select the viewport scale of 1:1 (Refer to page 26-12).
- 7. Lock the viewport. (Refer to page 26-9.)
- 8. Very important: Save as / AutoCAD Drawing Template / My Decimal Setup again.

Now continue on to Exercise 26E...you are not done yet.

Exercise 26E: Plotting from the Layout

The following instructions will guide you through the final steps for setting up the master template for plotting. These settings will stay with **My Decimal Setup** and you will be able to use it over and over again.

- 1. Open My Decimal Setup (if not already open).
- 2. Select the A Size Layout Tab.
- 3. Select the Plot command.

Note: Make sure your settings match the settings shown below.

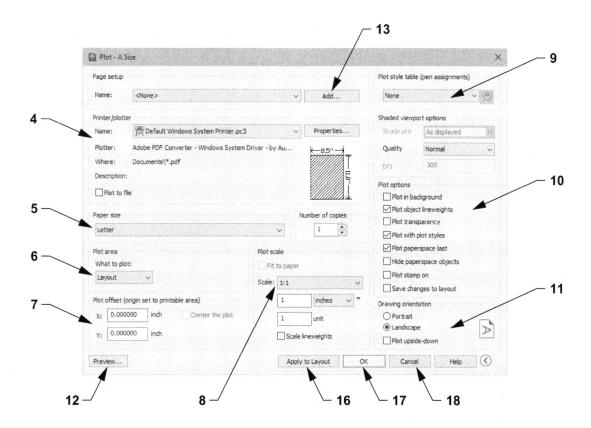

- Select your printer.
- Select the Paper Size.
- Select the Plot Area.
- 7. Plot offset should be 0.000000 for X and Y.
- 8. Select scale 1:1 (Note: Make sure you select Inches for inch users, or Millimeters for metric users.
- 9. Select the Plot Style Table Monochrome.ctb
- 10. Select the Plot options shown.
- 11. Select Drawing Orientation: Landscape.
- 12. Select the Preview... button.

Note: The viewport frame and the grids will not appear in the **preview** because the Viewport layer is set to **No Plot** and grids never plot.

If the drawing appears as you would like it, press the < Esc> key and continue on to Step 13.

If the drawing does not look correct, press the < Esc> key and re-check all the settings, then preview again.

- 13. Select the Add... button.
- 14. Type the new Page Setup name: Plot Setup A
- 15. Select the OK button.

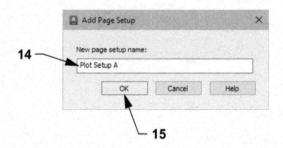

- 16. Select the "Apply to Layout" button.

 The settings are now saved to the Layout Tab for future use.
- 17. If your computer <u>is</u> connected to the plotter / printer selected, select the **OK** button to plot, then proceed to **Step 20**.
- 18. If your computer is <u>not</u> connected to the plotter / printer selected, select the **Cancel** button to close the Plot dialog box and proceed to **Step 20**. **Note:** Selecting **Cancel** will cancel your selected setting if you did not **Add** the Page Setup as specified in **Step 13**.

You are almost done.

- 19. Select Layer Object Line. (You don't want Layer Viewport to be the current layer.)
- 20. Now Save all of this work as a Template one last time: Application Menu / Save as / AutoCAD Drawing Template / My Decimal Setup.

That probably seemed like a lot of work, but you have now completed the **Plotting Page Setup** for the **My Decimal Setup.dwt**.

Now you are ready to use this master template to create and plot many drawings in the future. In fact, you have one on the very next page.

Exercise 26F

Exercise 26F: Model Space and Paper Space

This exercise is in two parts. First you will draw the drawing in the **Model** Tab. Then you will create a layout to display parts of the drawing in three viewports. *Hopefully this will help you understand the differences between Model Space and Paper Space*.

Part 1.

- 1. Select New and select My Decimal Setup template (if not already open).
- 2. Select the Model Tab.

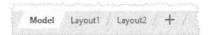

3. Draw the object shown below.

Use Layer Object Line, do not use Layer Viewport and do not dimension.

4. Save the drawing as: Ex-26F

(Make sure that you save it as a **drawing** (.dwg) and not as a template.)

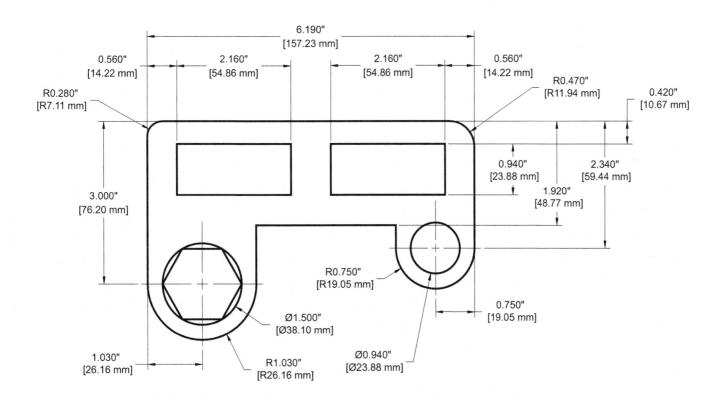

Part 2.

1. Select the A Size Tab.

Confirm the MODEL / PAPER button says PAPER.

- 3. Erase the one existing viewport frame. (Click on the frame and select Erase.)
- 4. Select the Viewport layer and create three new viewports approximately as shown below.
- 5. Using Zoom and Pan, inside each viewport, try to display each viewport content as shown below. (**Note:** Scale is not critical at this time, but it will be in Lesson 27.)
- 6. Lock the viewport.
- 7. This time, I would like you to **print the viewport frames**, so you need to make the Viewport layer **plottable**. (Remove the **No Plot** sign an the printer symbol in the **Layer Properties Manager**.)
- 8. Change the Title block: Title: VIEWPORTS Scale: NONE Dwg no: Ex-26F
- 9. Save the drawing again as: EX-26F
- 10. Plot using Plot Page Setup name: Plot Setup A. (Remember to view the preview.)

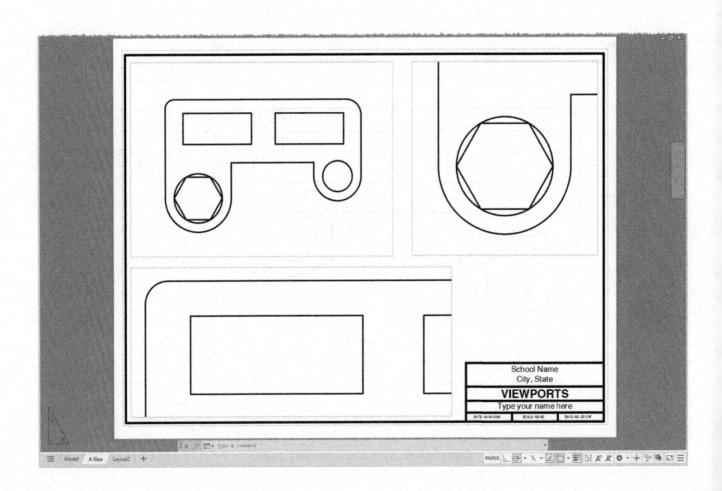

LESSON 27

LEARNING OBJECTIVES

After completing this lesson, you will be able to:

- 1. Understand Scaled Drawings.
- 2. Adjust the Scale within a Viewport.
- 3. Understand Annotative Objects.
- 4. Understand Paper Space versus Model Space dimensioning.
- 5. Create a Master Feet-Inches Setup Template.

Creating Scaled Drawings

In the lessons previous to Lesson 26, you worked only in Model Space. Then in Lesson 26, you learned that AutoCAD actually has another environment called Paper Space, or Layout. In this lesson, we need to learn more about why we need two environments and how they make it easier to display and plot your drawings.

A very important rule in CAD you must understand: "All objects are drawn full size".

In other words, if you want to draw a line 20 feet long, you actually draw it 20 feet long. If the line is 1/8" long, you actually draw it 1/8" long.

Drawing and Plotting objects that are very large or very small

In the previous lessons, you created medium-sized drawings. Not too big, not too small. But what if you wanted to draw a house? Could you print it to scale on an 11" X 8-1/2" or 297 mm X 210 mm piece of paper? How about a small paper clip? Could you make it big enough to dimension? Let's start with the house.

How to print an entire house on an 11" X 8-1/2" or 297 mm X 210 mm sheet of paper

Remember the photo and picture frame example I suggested in Lesson 26? (Refer to 26-4.) This time, try to picture yourself standing at the front door of your house with an empty picture frame in your hands. Look at your house through the picture frame. Of course the house is way too big to fit in the frame. Or is it because you are standing too close to the house?

Now walk across the street and look through the picture frame in your hands again. Does the house appear smaller? Can you see all of it in the frame? If you could walk far enough away from the house, it would eventually appear small enough to fit in the picture frame in your hands. But the house did not actually change size, did it? It only appears smaller because you and the picture frame are farther away from it.

Adjusting the Viewport scale

When using AutoCAD, walking across the street with the frame in your hands is called **adjusting the viewport scale**. You are increasing the distance between Model Space (your drawing) and Paper Space (Layout) and that makes the drawing appear smaller.

Example: A viewport scale of 1/4" = 1' would make Model Space appear 48 times smaller. But when you dimension the house, the dimension values will be the actual measurement of the house. In other words, a 30 foot line will have a dimension of 30'-0".

When plotting something smaller, like a paperclip, you have to move the picture frame closer to Model Space to make it appear larger. For example, you might use a viewport scale of 8 = 1.

Adjusting the Viewport Scale

The following will take you through the process of adjusting the scale within a viewport.

- 1. Open a drawing.
- 2. Select a Layout Tab. (Paper Space.)
- 3. Create a new Page Setup.
- 4. Cut a new viewport or unlock an existing viewport.
- 5. Adjust the scale:
 - A. You must be in Paper Space. (See below.)
 - B. Select the viewport frame.
 - C. Unlock the viewport, if locked.
 - D. Select the viewport scale down arrow.
 - E. Select the scale from the list of scales.

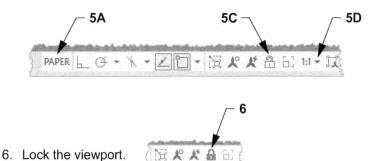

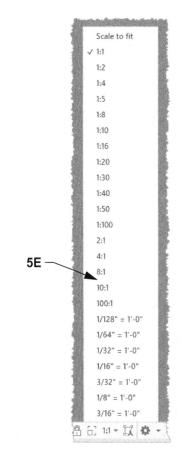

Note: If you would like to add a scale that is not on the list:

- 1. Type *scalelistedit* and then press *<Enter>*.
- 2. Select the Add... button.
- 3. Enter the **Scale name** to display in Scale List.
- 4. Enter Paper and Drawing units.
- 5. Select the **OK** button.

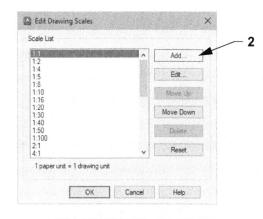

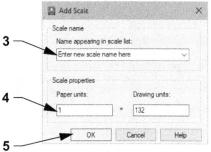

Annotative Objects

In Lesson 26, you created a new text style and dimension style. You also added the "Annotative" property to both simply by placing a check mark in the Annotative box.

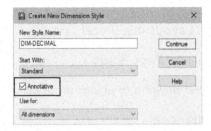

The Text Style and Dimension Style shown above are now Annotative. Notice the Annotative symbol 🧘 beside the style name. (No symbol by "Standard".)

"Annotative objects" are scaled automatically to match the scale of the viewport. For example, if you want the text, inside the viewport, to print 0.200" or 5 mm in height and the viewport scale is 1:2, AutoCAD will automatically scale the text height to 0.400" or 10 mm. The text height needs to be scaled by a factor of 2 to compensate for the Model Space contents appearing smaller.

The easiest way to understand how Annotative property works is to do it. So try this example. (When complete, you will save this file for use in Lesson 28.)

- 1. Start a New file using My Decimal Setup.dwt
- 2. Select the Model Tab (Model Space).
- 3. Draw a rectangle 3" [76.2 mm] Long X 1.5" [38.1 mm] Wide. Use Layer Object Line. Do not dimension.

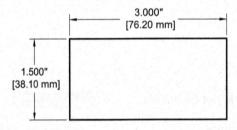

- 4. Select the A Size Tab (Paper Space).
- 5. Erase the existing single viewport frame.

- Change current layer to Viewport and cut two new viewports as shown below. (See 26-6.)
- 7. Activate the left viewport (double click inside the viewport frame) and do the following:
 - A. Adjust the scale of the viewport to 1:1. (Refer to page 27-3.)
 - B. **Pan** to place the rectangle in the center of the viewport. (Refer to page 26-8.)
 - C. Lock the viewport. (Refer to page 27-3.)
- 8. Activate the right viewport (click inside the viewport frame) and do the following:
 - A. Adjust the scale of the viewport to 1:4.
 - B. Pan to place the rectangle in the center of the viewport.
 - C. Lock the viewport.

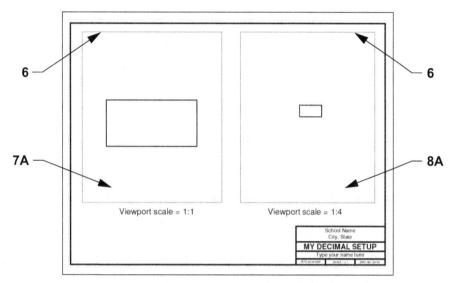

Your screen should appear approximately like this.

Note: My grids are off.

- 9. Activate the **left-hand** viewport. (Double click inside left-hand viewport.)
- 10. Change current layer to Text and add **0.200"** [5 mm] height text, Scale **1:1** as shown using text style TEXT-CLASSIC. (**Note:** Text style TEXT-CLASSIC is annotative.)
- 11. Change current layer to Dimension and add the dimension shown using dimension style DIM-DECIMAL. (**Note:** Dimension style DIM-DECIMAL is annotative. The dimension shown is in inches, metric users dimensions will appear differently.)

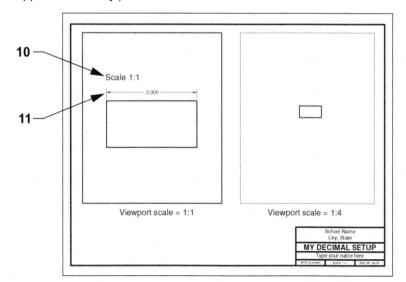

- 12. Activate the right-hand viewport. (Click inside right-hand viewport.)
- 13. Change current layer to Text and add **0.200" [5 mm]** height text, Scale **1:4** as shown using text style TEXT-CLASSIC. (**Note:** Text style TEXT-CLASSIC is annotative.)
- 14. Change current layer to Dimension and add the dimension shown using dimension style DIM-DECIMAL. (**Note:** Dimension style DIM-DECIMAL is annotative. The dimension shown is in inches, metric users dimensions will appear differently.)

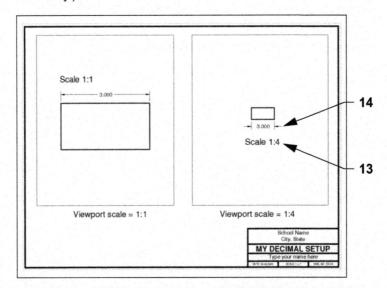

Notice that the text and dimensions appear the same size in both viewports.

15. Now select the Model Tab. (Model Space.)

Notice there are two sets of text and dimensions.

One set has the annotative scale of 1:1 and will be visible only in a 1:1 viewport. One set has the annotative scale of 1:4 and will be visible only in a 1:4 viewport. But you see both sets when you select the Model Tab.

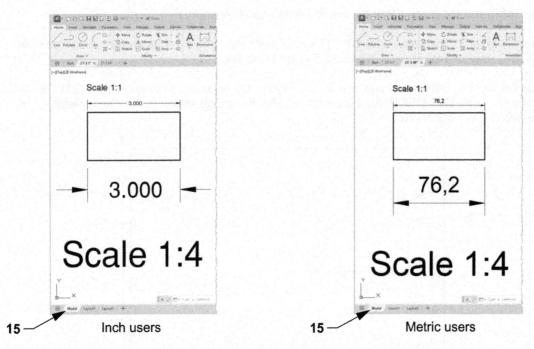

(In Lesson 28, you will learn how to assign multiple annotative scales to one set of text or dimensions so you will not have duplicate sets in the Model Tab.)

16. Place your cursor on any of the text or dimensions. An "Annotative symbol" & will appear. This indicates this object is annotative and it has only one annotative scale. (In Lesson 28, you will learn how to assign multiple annotative scales to a single annotative object so it will be visible in multiple viewports.

17. Click once on the **Scale: 1:4** text. The Quick Properties box should appear. (**Quick Properties** button on the Status Bar must be **on**.) *Notice the text height is listed twice*.

Paper text height (inch users) = .200 This is the height that you selected when placing the text. When the drawing is printed, the text will print at 0.200".

Model text height (inch users) = .800 This is the desired height of the text (.200) factored by the viewport scale (1:4). The viewport scale is a factor of 4. (4 X .200 = .800)

Paper text height (metric users) = 5 This is the height that you selected when placing the text. When the drawing is printed, the text will print at 5 mm.

Model text height (metric users) = 20 This is the desired height of the text (5) factored by the viewport scale (1:4). The viewport scale is a factor of 4. (4 X 5 = 20)

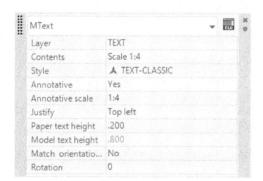

Quick Properties Inch users

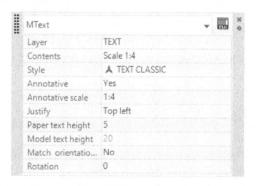

Quick Properties Metric users

18. Important: Save this drawing as: Annotative objects. (You will need it for Lesson 28.)

Summary: If an object is annotative, AutoCAD automatically adjusts the scale of the object to the viewport scale. The most commonly used Annotative objects are: Dimensions, Text, Hatch, and Multileaders. Refer to the Autodesk Assistant or AutoCAD Help Menu for more information. (In Lesson 28, you will learn how to assign multiple annotative scales to a single annotative object.)

Paper Space Dimensioning

Some people prefer to dimension in Paper Space. Paper Space dimensions are Trans-spatial. Trans-spatial means that you may place the dimension in Paper Space while the object you are dimensioning is in Model Space. Even though the dimension is in Paper Space, it is actually attached to the object in Model Space.

Example:

- 1. You draw a house in Model Space.
- Now select the Layout Tab.
- 3. Cut a viewport so you can see the drawing of the house.
- 4. Go to Model Space, adjust the scale of the viewport (Model Space), and lock it.
- 5. Now go to Paper Space and dimension the house.

Should you dimension in Paper Space or Model Space?

This is your choice. Personally, I dimension in either space depending on the situation. Here are some things to consider.

Paper Space dimensioning

Pros

- 1. You never have to worry about the viewport scale.
- 2. All dimensions will have the same appearance in all viewports.
- 3. If you Xref the drawing, the dimensions do not come with it. (Xref is not discussed in this Workbook.)

Cons

- 1. If you move the objects in Model Space, or adjust the viewport scale, sometimes the dimensions do not move with them. (If this happens, type: **dimregen** and then press **<Enter>**.)
- 2. Dimensions will not appear in the Model Tab. They appear only in the Layout Tab in which they were placed. If you go to another Layout Tab, they will not appear.

Annotative dimensioning in Model Space

Pros

- 1. Dimensions always appear and move with the objects.
- 2. Dimensions will appear in all Layout Tabs within viewports.

Cons

1. If you External Reference (Xref the drawing), the dimensions also are included.

Exercise 27A

Exercise 27A: Create a Master Feet-Inches Setup Template

The following instructions will guide you through creating a "master" Feet-Inches Setup Template. The "inchhelper" is an example of a master setup template. Once you have created this "master" template, you just open it and draw. No more repetitive inputting of settings.

Note to Metric users: This template is for "**Architectural Inch**" units of measurement, which are no longer used in countries where "**Metric**" units of measurement are used. It is still good practice for metric users, so have a go and see how you do. There may be occasions when you have to use architectural drawings that use the inch system.

New Settings

- 1. Begin your drawing with a different template as follows:
 - A. Select the New command.
 - B. Select template file **acad.dwt** from the list of templates. (**Not** acad3D.dwt.)
 - C. Save the drawing as: **My Feet-Inches Setup** but keep the drawing open.
- 2. Set the Drawing Units as follows:
 - A. Type *units* and then press <*Enter>*.
 - B. Change the **Type** and **Precision** as shown.
 - C. Select the OK button.

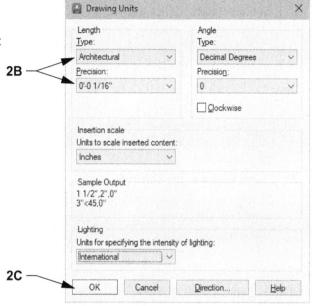

- 3. Set the Grids and Snap as follows:
 - A. Type **DS** and then press **<Enter>**.
 - B. Select the Snap and Grid Tab.
 - C. Change the settings as shown below.
 - D. Select the **OK** button.

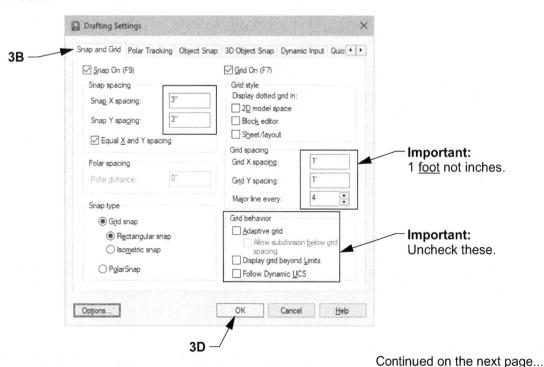

Exercise 27A...continued

- 4. Set the Drawing Limits (size of the drawing area) as follows:
 - A. Type Limits and then press <Enter>.
 - B. Enter lower left corner = 0'-0".0'-0"
 - C. Enter upper right corner = 44',34' (Notice this is feet, not inches.)
 - D. Use "Zoom / All" to view the new limits.
 - E. Set your Grids to on to display the limits.

If your screen does not appear as shown here, check these:

- Did you use, Zoom / All (Step 4D)?
- Is your Grid spacing feet or inches?
- Is the Grid on?

- 5. Change the **Lineweight Settings** as follows:
 - Right click on **Lineweight** button located on the Status Bar.
 - B. Select Lineweight Settings.
 - C. Change to Inches and Adjust Display Scale as shown. (See note.)
 - D. Select the OK button.

Note: Metric users will be showing metric lineweights. Change to inches, then **re-save** the drawing. Close down AutoCAD, then re-open **My Feet-Inches Setup**.

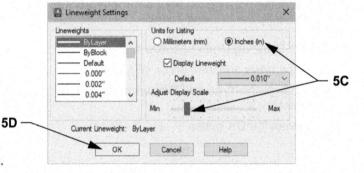

- 6. Create new layers as follows:
 - A. Load the linetype DASHED. (Refer to page 3-13 for instructions.)
 - B. Assign names, colors, linetypes, lineweights, and plotability as shown below.
 Make the Viewport layer Not Plot and the Walls layer current. (Refer to page 3-12 for instructions.)

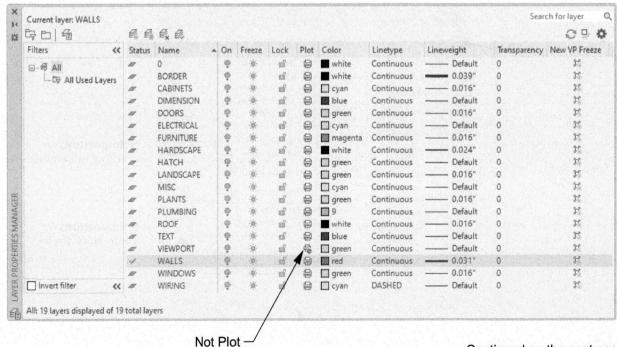

Exercise 27A...continued

- 7. Create two new **Text Styles** as follows:
 - A. Select Text Style. (Refer to page 25-2.)
 - B. Create the text style TEXT-CLASSIC and TEXT-ARCH using the settings shown below.

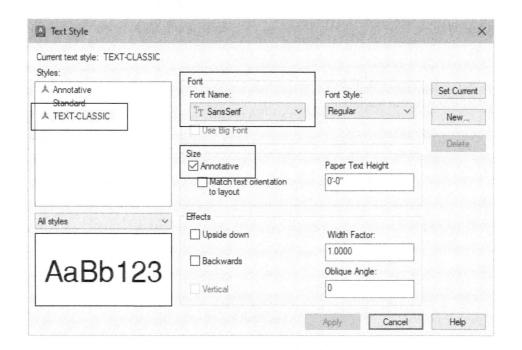

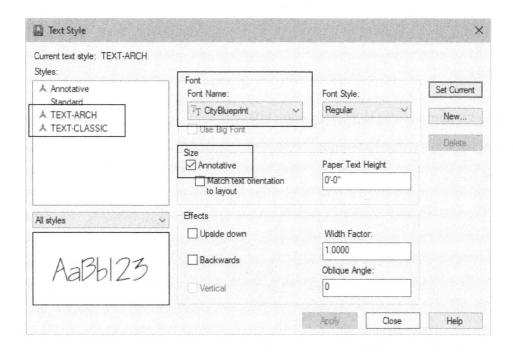

This next step is very important.

8. Save all the settings you just created as follows: Save your drawing again as: My Feet-Inches Setup

Now continue on to Exercise 27B...you are not done yet.

Exercise 27B

Exercise 27B: Page Setup

Now you will select the printer and the paper size to use for printing. You will use the Layout1 Tab (Paper Space).

- 1. Open My Feet-Inches Setup (if not already open).
- 2. Select the Layout1 Tab.

(Refer to page 26-3 if you do not have these Tabs.)

Note: If the "Page Setup Manager" dialog box shown below does not appear automatically, right click on the Layout Tab and select Page Setup Manager.

3. Select the New... button.

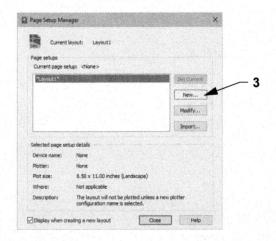

- 4. Select < Default output device > in the Start with: list.
- Enter the New Page Setup name: Setup B
- Select the OK button.

Exercise 27B...continued

This is where you will select the printer / plotter, paper size, and the plot offset.

7. Select the Printer / Plotter

Note: Your current system printer should already be displayed here. If you prefer another, select the down arrow and select from the list. If the preferred printer is not in the list, you must configure the printer. (Refer to **Appendix-A** for instructions.)

- 8. Select the Paper size.
- Select Plot offset.

- 10. Select the OK button.
- 11. Select Setup B.
- 12. Select the Set Current button.
- 13. Select the Close button.

Exercise 27B...continued

You should now have a sheet of paper displayed on the screen.

This sheet is the size you specified in the "Page Setup".

This sheet is in front of Model Space.

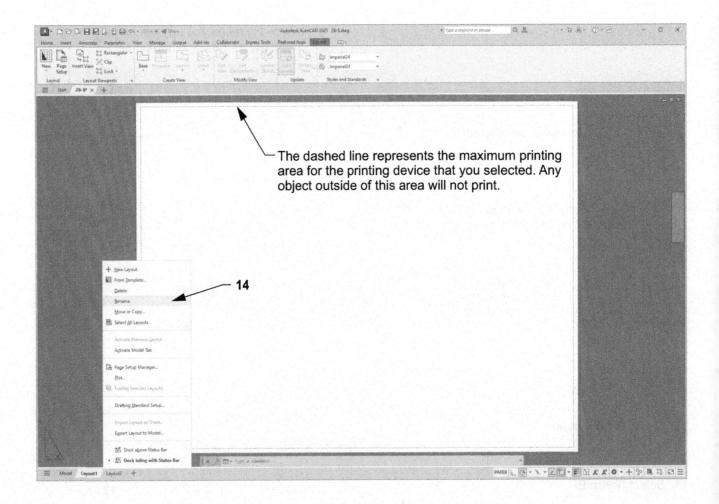

Rename the Layout Tab

- 14. Right click on the active Layout Tab and select Rename from the list.
- 15. Enter the new Layout name A Size and then press < Enter>.

16. Very important: Save as / AutoCAD Drawing Template / My Feet-Inches Setup again.

Now continue on to Exercise 27C...you are not done yet.

Exercise 27C: Create a Border and Title Block

1. Draw the border rectangle as large as you can within the dashed lines approximately as shown below using Layer Border.

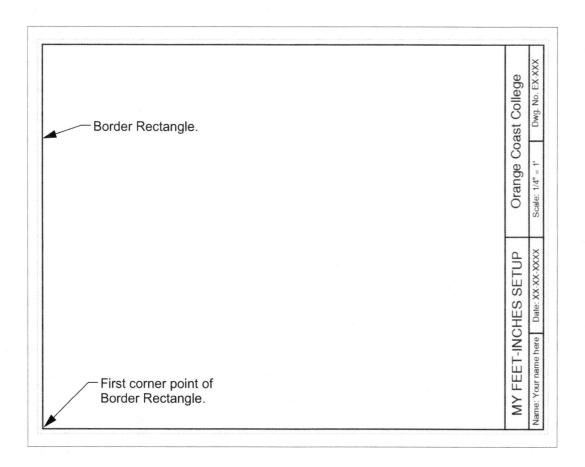

- 2. Draw the Title Block as shown using:
 - A. Layers Border and Text.
 - B. Single Line Text: Justify **Middle** in each rectangular area. (**Note**: The diagonal lines are an aid to find the center of each rectangle and can be erased after the text has been placed into position.)
 - C. Text Style = **TEXT CLASSIC**. Text Height: Varies.

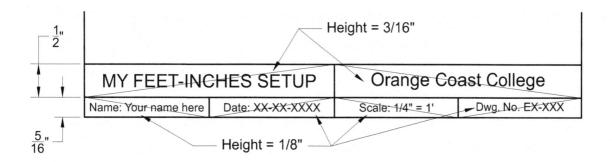

3. Very important: Save as / AutoCAD Drawing Template / My Feet-Inches Setup again.

Now continue on to Exercise 27D...you are not done yet.

Exercise 27D: Create a Viewport

The following instructions will guide you through creating a **viewport** in the Border Layout sheet. Creating a viewport has the same effect as cutting a hole in the sheet of paper. You will be able to see through the viewport Frame (hole) to Model Space.

- 1. Open My Feet-Inches Setup (if not already open).
- 2. Select the A Size Layout Tab.
- 3. Select Layer Viewport.
- 4. Type MV and then press < Enter>. (Refer to page 26-6.)
- 5. Draw a Single viewport approximately as shown. (Turn off Osnap temporarily.)

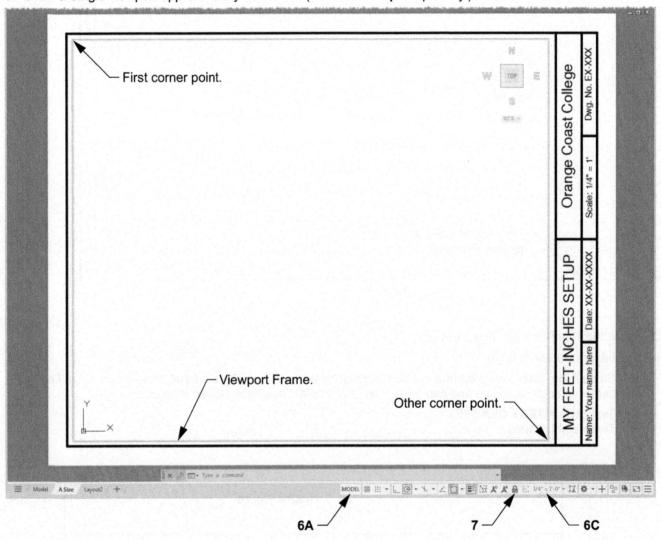

- 6. Adjust the viewport scale as follows:
 - A. Confirm the "MODEL" button is showing.
 - B. Select "Zoom / All".
 - C. Select the viewport scale of 1:4" = 1'-0" (Note: inches =feet.)
- 7. **Lock** the viewport. (Refer to page 27-3.)
- 8. Very important: Save as / AutoCAD Drawing Template / My Decimal Setup again.

Now continue on to Exercise 27E...you are not done yet.

Exercise 27E: Plotting from the Layout

The following instructions will guide you through the final steps for setting up the master template for plotting. These settings will stay with **My Feet-Inches Setup** and you will be able to use it over and over again.

In this exercise, you will take a short cut by importing the **Plot Setup A** from **My Decimal Setup**. (**Note:** If the **Printer**, **Paper size**, and **Plot Scale** is the same, you can use the same Page Setup.)

Note: If you prefer not to use Import, you may go to page 26-27 and follow the instructions for creating the **Plot- Page Setup**.

- 1. Open My Feet-Inches Setup (if not already open).
- Select the A Size Layout Tab.
 You should be seeing your border and Title Block now.
- 3. Select the Plot command.
- 4. Select Import... from the Page setup drop-down menu

- 5. Find My Decimal Setup.dwt as follows:
 - A. Select Files of type: Template [.dwt]
 - B. Select My Decimal Setup.dwt
 - C. Select the **Open** button.

Exercise 27E...continued

- 6. Select **Plot Setup A** from the Page Setups list. (**Note:** If you do not have a "**Plot Setup A**" in My Decimal Setup, refer to page 26-27.)
- 7. Select the **OK** button.

8. Select **Plot Setup A** from the Page list. (**Note:** It was not there before. You just imported it in from My Decimal Setup.)

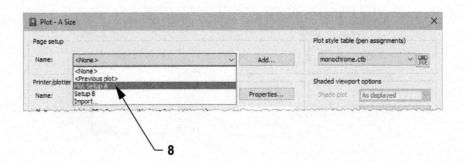

9. Check all settings.

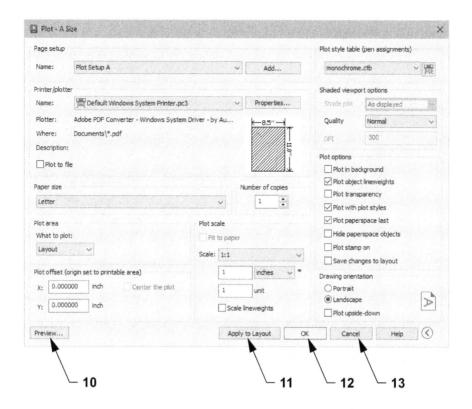

10. Select the Preview... button.

If the drawing appears as you would like it, press the <Esc> key and continue.

If the drawing does not look correct, press the < Esc> key and check all your settings, then preview again.

Note: The viewport frame and the grids will not appear in the preview because the viewport is on a **no plot** layer and grids never plot.

- 11. Select the Apply to Layout button.
 - (The settings are now saved to the Layout Tab for future use.)
- 12. If your computer <u>is</u> connected to the plotter/printer selected, select the **OK** button to plot, then proceed to **Step 14**.
- 13. If your computer is <u>not</u> connected to the plotter/ printer selected, select the **Cancel** button to close the Plot dialog box and proceed to **Step 14**.
- 14. Very important... Save as My Feet-Inches Setup again.

Now continue on to Exercise 27F....you are not done yet.

Exercise 27F

Exercise 27F: Create a Dimension Style

- 1. Open My Feet-Inches Setup (if not already open).
- 2. Select the Dimension Style Manager command. (Refer to page 16-6.)
- 3. Select the New... button.

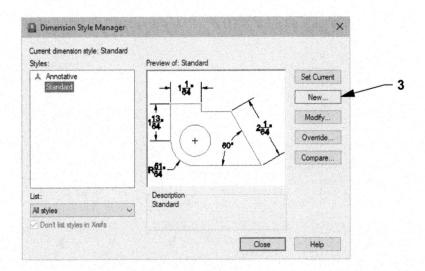

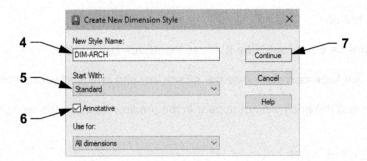

- 4. Enter DIM-ARCH in the "New Style Name:" box.
- 5. Select Standard in the "Start With:" box.
- 6. Select the Annotative box.
- 7. Select the Continue button.

Exercise 27F...continued

8. Select the **Primary Units** Tab and change your settings to match the settings shown below.

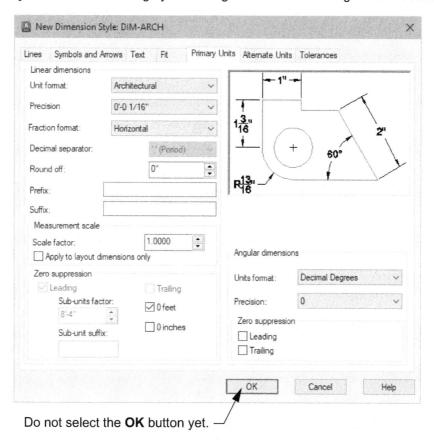

9. Select the Lines Tab and change your settings to match the settings shown below.

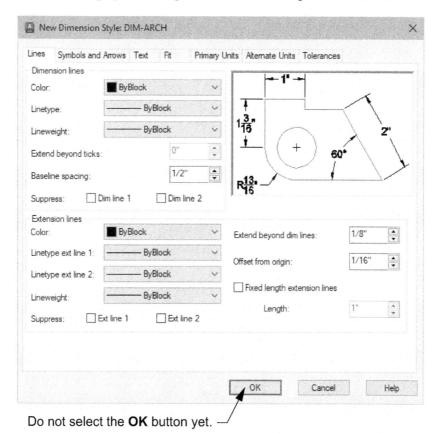

Exercise 27F...continued

10. Select the Symbols and Arrows Tab and change your settings to match the settings shown below.

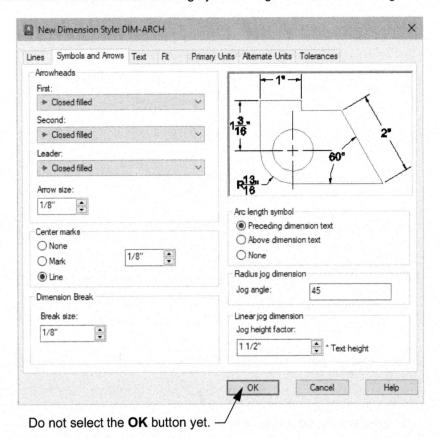

11. Select the Text Tab and change your settings to match the settings shown below.

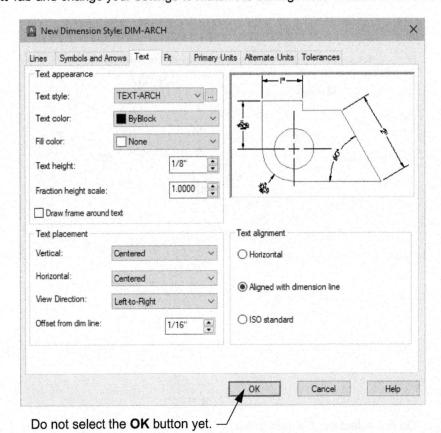

Continued on the next page...

Exercise 27F...continued

12. Select the Fit Tab and change your settings to match the settings shown below.

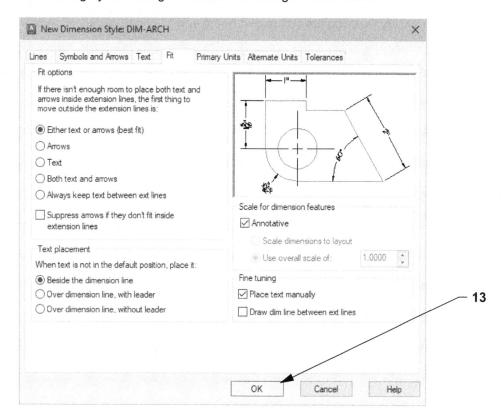

13. Now select the **OK** button.

Your new **DIM-ARCH** dimension style should now be in the list.

14. Select the Set Current button to make your new style DIM-ARCH the style that will be used.

- 15. Select the Close button.
- 16. Important: Save your drawing as My Feet-Inches Setup again.
- 17. Change the current layer to Walls. (So Layer Walls will always be the current layer when you start a New file.)
- 18. Now Save all of this work as a **Template**: **Application Menu / Save As / AutoCAD Drawing Template / My Feet-Inches Setup**. (Refer to page 2-3.)

Again, that probably seemed like a lot of work, but you are now ready to use this master setup template to create and plot many drawings in the future.

Exercise 27G

Exercise 27G: Instructions:

- 1. Select New and select My Feet-Inches Setup.dwt (template).
- 2. Draw the classroom shown below.
- 3. Use Layers Walls, Furniture, Doors, and Windows.
- 4. Dimension as shown inside the viewport.
- 5. Use Dimension Style DIM-ARCH and Layer Dimension.
- 6. Edit the Title and Ex-XX by double clicking on the text. Do not erase and replace.
- 7. Save as Ex-27G
- 8. Plot using Page Setup Plot Setup A. (Refer to page 27-19.)

Drawing hints:

- 1. Consider using Array (Lesson 13) and Offset (Lesson 12).
- 2. Remember you have to Unlock the viewport to use Pan inside the viewport.
- 3. If you change the scale of the viewport, change the viewport scale back to 1/4"=1' and lock the viewport.
- 4. If your dimensions are gigantic, you are not inside the viewport.

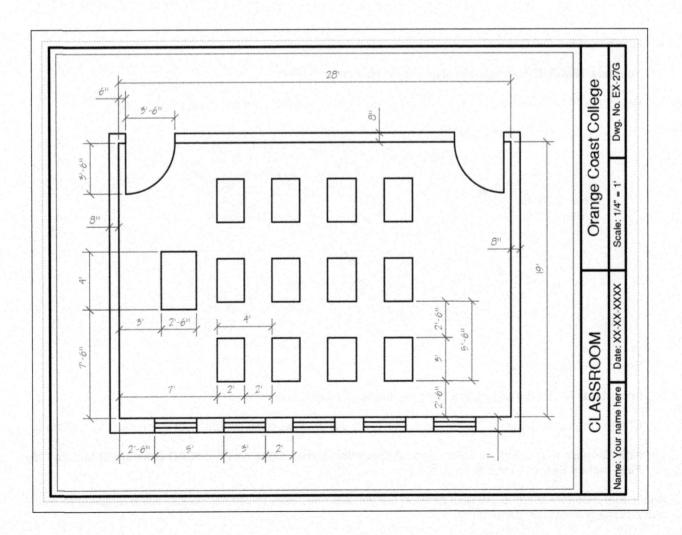

Exercise 27H-Inch

Exercise 27H-Inch: Instructions:

Step 1.

- 1. Select New and select My Decimal Setup.dwt (template).
- 2. Unlock the viewport.
- 3. Change the viewport scale to **8:1** (important: not 1:8).
- 4. Lock the viewport.
- 5. Turn **Snap** and **Grids** off or change them relative to the new viewport scale.
- 6. Draw the Paperclip on Layer Object Line.
- 7. Dimension as shown using Dimension Style DIM-DECIMAL. (Dimensions should be inside the viewport, in Model Space. Confirm the "MODEL" button is displayed.) MODEL # :::

Drawing hints:

1. The entire Paper clip can easily be drawn using Offset (Lesson 12) and Fillet (Lesson 7) or Circles and trim.

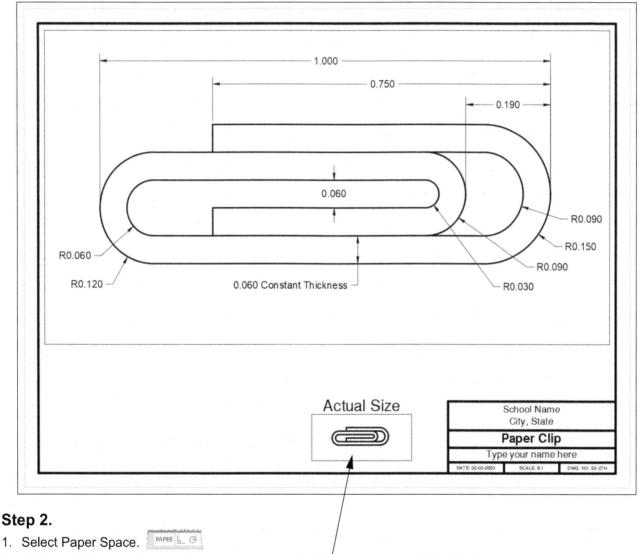

- 1. Select Paper Space.
- 2. Select the Viewport layer and cut a second small viewport next to the Title Block.
- 3. Double click inside the small viewport to make it active. Use Zoom / All (You should now see the paper clip.)
- 4. Change the viewport scale of the **small** viewport to **1:1** and Lock the viewport.
- 5. Add "Actual Size" text 0.200" height in Paper Space. Use: Layer Text.
- 6. Edit the **Title** and **Ex-XX** by double clicking on the text. Do not erase and replace.
- 7. Save as Ex-27H-I
- 8. Plot using Page Setup Plot Setup A. (Refer to page 26-27.)

Exercise 27H-Metric

Exercise 27H-Metric: Instructions:

Step 1.

- 1. Select New and select My Decimal Setup.dwt (template).
- 2. Unlock the viewport.
- 3. Change the viewport scale to 8:1 (important: not 1:8).
- 4. Lock the viewport.
- 5. Turn **Snap** and **Grids** off or change them relative to the new viewport scale.
- 6. Draw the Paperclip on Layer Object Line.
- 7. Dimension as shown using Dimension Style DIM-DECIMAL. (Dimensions should be inside the viewport, in Model Space. Confirm the "MODEL" button is displayed.) MODEL # :::

Drawing hints:

1. The entire Paper clip can easily be drawn using Offset (Lesson 12) and Fillet (Lesson 7) or Circles and trim.

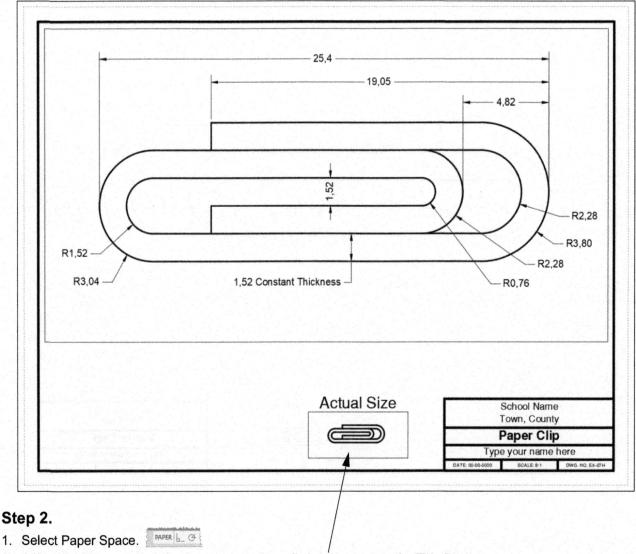

- Select the Viewport layer and cut a second small viewport next to the Title Block.
- 3. Double click inside the small viewport to make it active. Use **Zoom / All** (You should now see the paper clip.)
- Change the viewport scale of the small viewport to 1:1 and Lock the viewport.
- Add "Actual Size" text 5 mm height in Paper Space. Use: Layer Text.
- Edit the Title and Ex-XX by double clicking on the text. Do not erase and replace.
- 7. Save as Ex-27H-M
- 8. Plot using Page Setup Plot Setup A. (Refer to page 26-27.)

LESSON 28

LEARNING OBJECTIVES

After completing this lesson, you will be able to:

- 1. Assign multiple annotative scales to a single annotative object.
- 2. Remove an Annotative Scale from a Viewport.
- 3. Assign annotative scales to Hatch sets.

Assigning Multiple Annotative Scales

In the previous lesson, you learned how annotative text and dimensions are automatically scaled to the viewport scale. But in order to have an annotative object appear in both viewports, you placed two sets of text and dimensions. In this lesson, you will learn how to easily assign multiple annotative scales to a single text string or dimension so that you will not need to duplicate them each time you create a new viewport. You will just assign an additional annotative scale to the annotative object.

Again, the easiest way to understand this process is to do it. The following is a step-by-step example.

- 1. Open **Annotative Objects.dwg** from the previous lesson and select the **A size** Layout Tab. If you did not complete the example from the previous lesson, go back and do it now. (Refer to page 27-4.)
- 2. Make the right-hand viewport active. (Double click inside the viewport.)

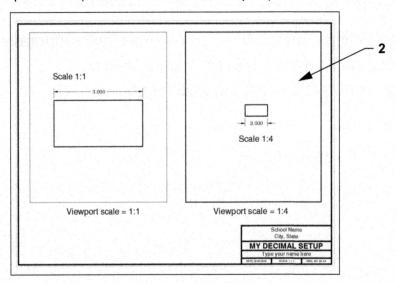

Erase the text and the dimension in the right-hand viewport only.

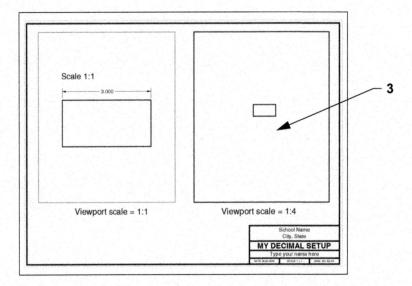

- 4. Display all annotative objects in all viewports as follows:
 - A. Select the Annotation Visibility button located in the lower right corner of the Drawing Status Bar.

On (Blue icon) Displays all Annotative objects in all viewports (example below).

Off (Gray icon) Displays **only** Annotative objects that have an annotative scale that matches the viewport scale.

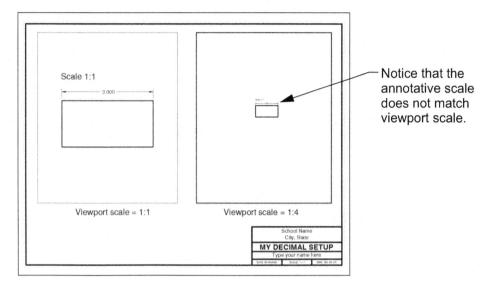

The dimensions and text are now displayed in both viewports. But the annotative scale of the dimensions and text in the right-hand viewport do not match the scale of the viewport. (Notice they are smaller.) **The scale of the annotative objects must match the scale of the viewport**. Follow the next steps to assign multiple annotative scales to an annotative object.

Place your cursor near the dimension in the right-hand viewport. Notice the single annotative symbol. This single symbol indicates the annotative dimension has only one annotative scale assigned to it.

6. Select the Annotate Tab.

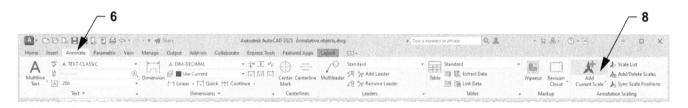

7. Select only the dimension in the right-hand viewport.

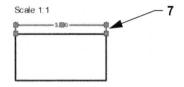

8. Select the Add Current Scale tool on the Annotation Scaling Panel.

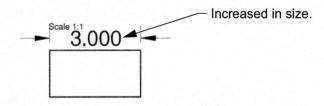

The annotative dimension should have increased in size as shown above.

9. Turn off the Annotation Visibility. (Click on button. The icon should turn Gray.)

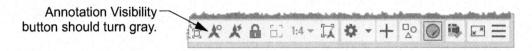

Notice the text in the right-hand viewport is no longer visible. When the **Annotation Visibility** is **off**, only the annotative objects that match the viewport scale will remain visible. The dimension is the only annotative object that has the 1:4 annotative scale assigned to it.

10. Place your cursor near the dimension. Notice two annotative symbols appear now. This indicates two annotative scales have been assigned to the annotative object.

11. Click on the dimension to display the grips and drag the dimension away from the rectangle approximately as shown below. (The dimension was too close to the rectangle.) Notice the dimension in the left-hand viewport did not move. They can be moved individually.

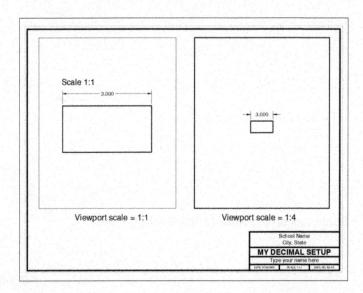

Removing an Annotative Scale

If you have an annotative object such as a dimension that you would like to remove from a viewport, you must remove the annotative scale that matches the viewport scale. **Do not delete** the dimension because it will also be deleted from all of the other viewports. This sounds complicated but is very easy to accomplish.

Problem: I would like to remove **dimension A** from the right-hand viewport. But I do not want **dimension B** in the left-hand viewport to disappear.

Solution: I must remove the 1:4 Annotative scale from dimension A.

(Refer to the step-by-step instructions below.)

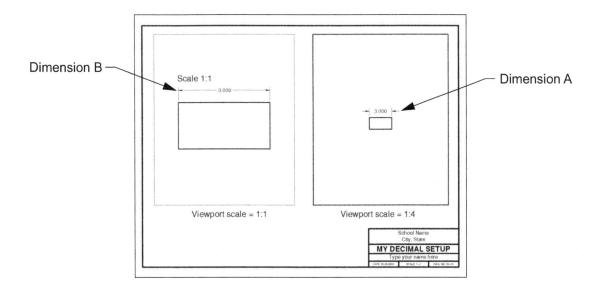

- 1. Select the **Annotate** Tab on the Ribbon.
- 2. Select dimension A shown above. (You must be inside the viewport.)
- 3. Select the Add / Delete Scales tool located on the Annotation Scaling Panel.

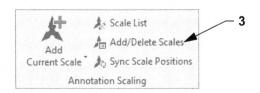

- 4. Select the Annotative scale to remove. 1:4
- 5. Select the **Delete** button. (Remember, you are deleting the annotative scale from the dimension. You are not deleting the dimension. The dimension still exists, but it will not have an annotative scale of 1:4 assigned to it. As a result, it will not be visible within any viewport that has been scaled to 1:4.)
- 6. Select the OK button.

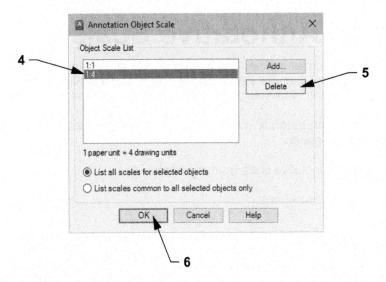

Note: Dimension A has been removed and dimension B remains.

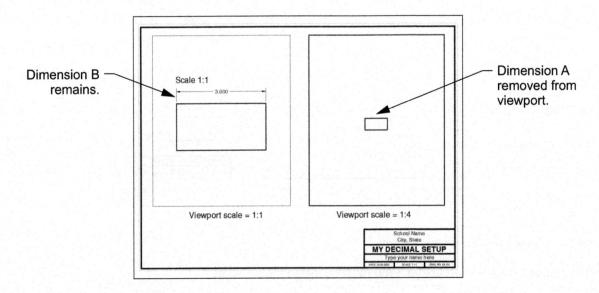

Annotative Hatch

A Hatch may be Annotative also. You may select the Annotative setting as you create the Hatch set or you may add the annotative setting to an existing Hatch set.

How to select the Annotative setting as you create the Hatch set

1. Select the **Hatch** command (refer to Lesson 15) and select the desired settings including **Annotative**. The Hatch set created will be **Annotative**. (Blue is **on**.)

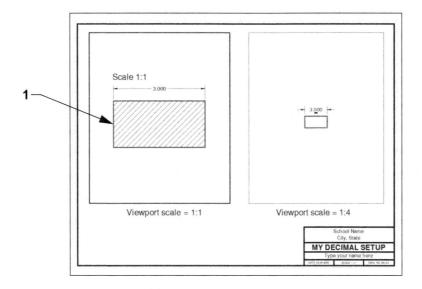

How to change an existing Non-Annotative Hatch set to Annotative

1. Click on the existing Hatch set.

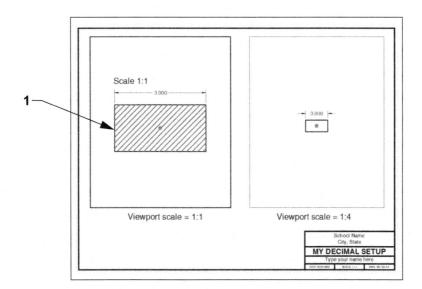

The Hatch Editor will appear.

- 2. Select the Annotative option.
- 3. Select Close Hatch Editor.

The Non-Annotative Hatch is now **Annotative**.

How to assign multiple Annotative scales to a Hatch set

1. Create the hatch in one of the viewports using **Annotative Hatch**. (Refer to page 28-6.)

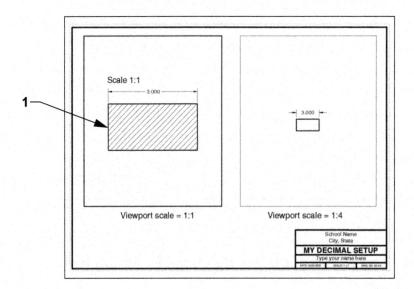

- 2. Turn on Annotation Visibility.

(Blue.) (Refer to page 28-2.)

3. Select the Hatch set to change.

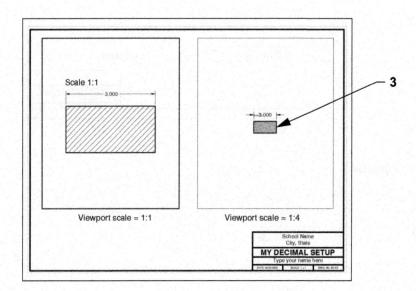

4. Select the Annotate Tab.

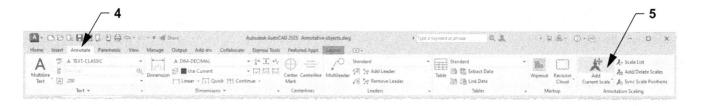

- 5. Select the Add Current Scale tool.
- 6. Turn **off** Annotation Visibility. (Gray.)

Now the appearance of the Hatch sets should be identical in both viewports.

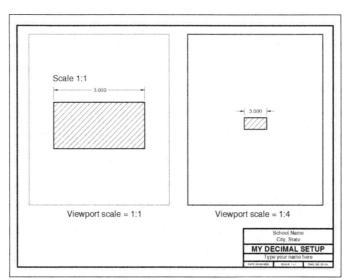

Exercise 28A

Exercise 28A

The following exercise will give you practice adding annotative scales to existing dimensions in order to display them within viewports with different scales. Follow the instructions below as you manipulate the drawing to appear as shown on page 28-12.

Step 1.

- 1. Open Ex-27G
- 2. Select the A Size Tab.
- Erase the one existing viewport (click on it and select delete).
 (The classroom will disappear from Paper Space because the hole is gone.)
- 4. Select the Viewport layer and create four new viewports approximately as shown below.

Notice each viewport is a hole in Paper Space and you are looking through to Model Space.

Also notice the dimensions do not appear.

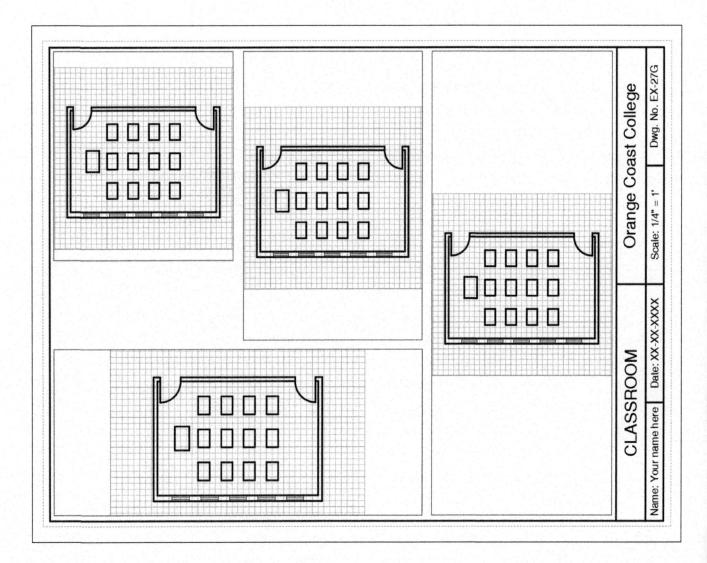

Step 2.

- 1. Adjust the scale of each viewport as indicated below.
- 2. Use **Pan** to move the image within the viewport without changing the scale.
- 3. Add the VP SCALE labels.

Place them in **Paper Space**. Text style: TEXT-CLASSIC

Text Height: 1/8"

4. Lock each viewport.

Notice the annotative dimensions appear only in the 1/4" = 1' viewport.

The dimensions currently have only 1/4" = 1' annotation scale.

Note: I have turned the grids off for clarity.

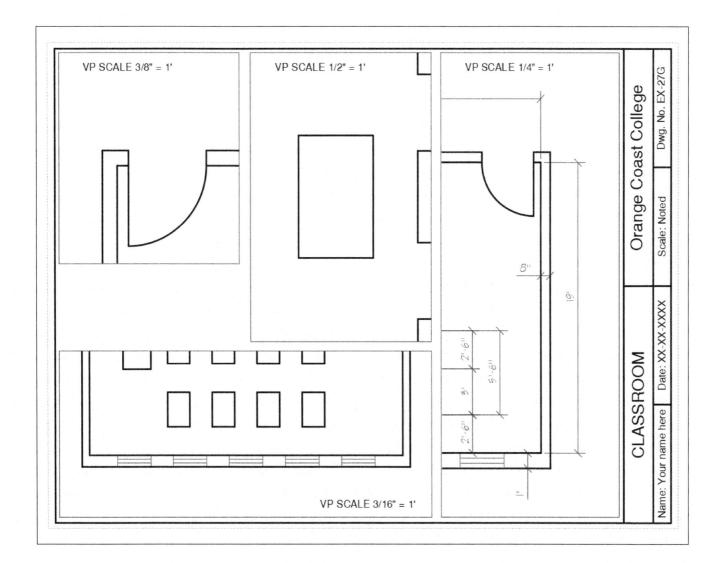

Exercise 28A...continued

Step 3.

1. Turn on Annotation Visibility.

(Blue.) (Refer to page 28-2.)

You should see dimensions in all viewports now. And they are all different sizes.

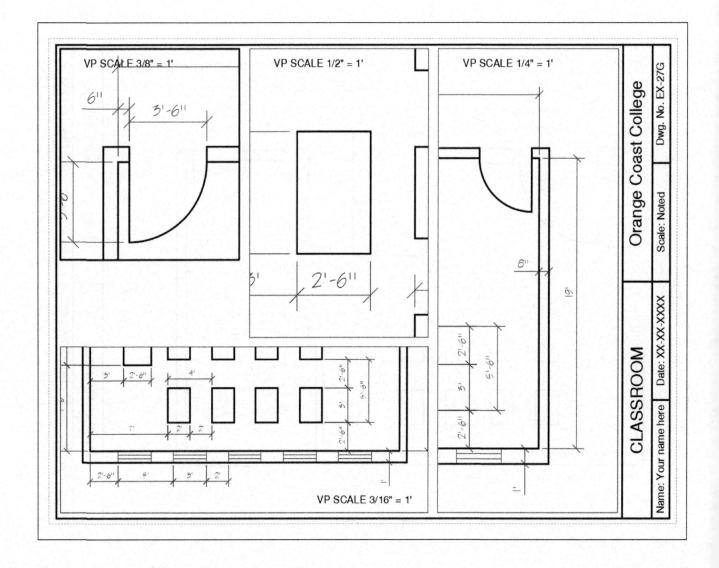

Step 4.

- 1. Add annotative scales to the dimensions shown in the viewports below:
 - A. Select a viewport (double click inside viewport).
 - B. Select the dimensions that you want to stay visible in that viewport.
 - C. Select the Annotate Tab. (Refer to page 28-3.)
 - D. Select Add Current Scale button. This will automatically add the current viewport scale to the selected objects.
 - E. Go on to the next viewport and repeat **A** through **D** above until they are all done.

Step 5.

1. Turn off Annotation Visibility.

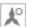

(Gray.) The unwanted dimensions should have disappeared.

2. Save as Ex-28A

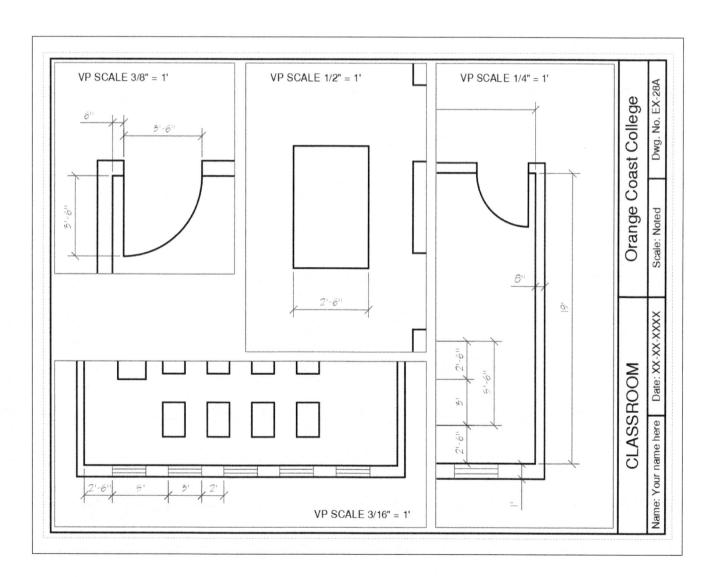

Exercise 28B

Exercise 28B

The following exercise will give you practice with Hatch within scaled viewports using the **annotative scale** option. Follow the instructions below while you manipulate the drawing to appear as shown.

Step 1.

- 1. Start a New file using My Decimal Setup.dwt
- 2. Select the A size Layout Tab.
- 3. Erase the one existing viewport.
- 4. Select the Viewport layer and create three new viewports approximately as shown.
- Adjust the scale of each viewport as indicated.
- 6. Lock each viewport.
- 7. Activate the 1:1 viewport. (Double click inside the viewport.)
- 8. Draw a 2" X 2" [50.8 mm X 50.8 mm] rectangle inside the 1:1 viewport as shown using Layer Object Line. (The rectangle will appear in the other two viewports because all viewports display Model Space.)

Step 2.

- 1. Select the Layer Hatch.
- 2. Hatch the 1:1 rectangle using:
 - A. Pattern: ANSI31
 - B. Angle: 0
 - C. Scale: 1.000
 - D. Select the Annotative option.

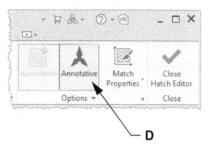

3. Place the Hatch inside the rectangle as shown and press **<Enter>**.

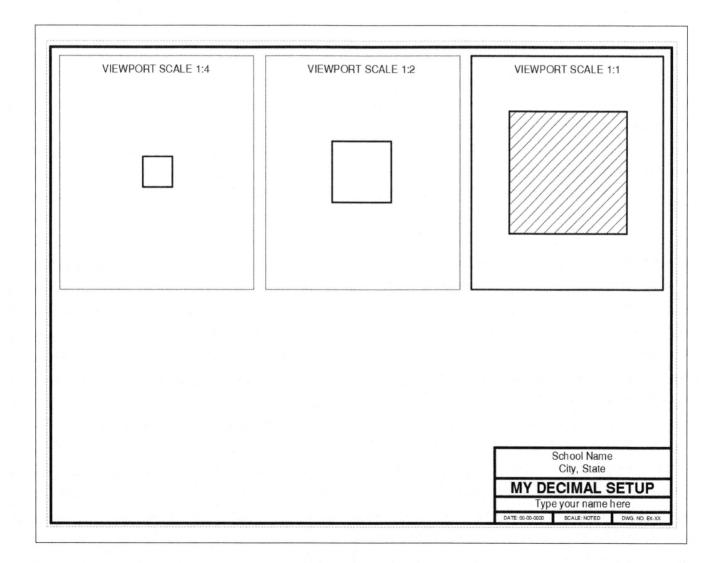

Note: If a Hatch set appears in all rectangles, you probably forgot to select the **Annotative box** or you have **Annotation Visibility on**.

Exercise 28B...continued

Step 3.

1. Turn on Annotation Visibility.

(Blue.) (Refer to page 28-2.)

The Hatch set appears in all of the viewports. But the sizes are all different.

2. Assign the correct Annotative scale to the Hatch sets in viewport 1:4 and 1:2.

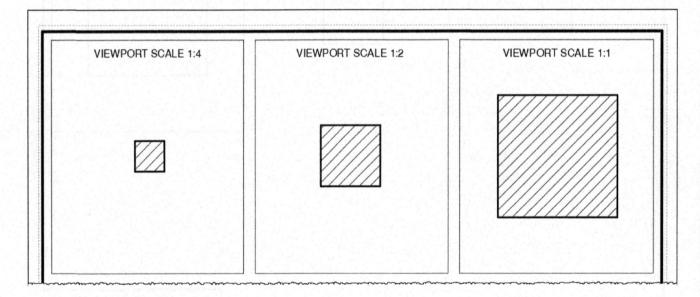

3. Turn off Annotation Visibility.

(Gray.) (Refer to page 28-2.)

4. Save as Ex-28B

LESSON 29

LEARNING OBJECTIVES

After completing this lesson, you will be able to:

- 1. Understand Blocks.
- 2. Create a Block.
- 3. Insert a Block.
- 4. Insert a Block using Automatic Block Placement.
- 5. Re-define a Block.
- 6. Count the number of Blocks in a Drawing.
- 7. Purge unused Blocks.
- 8. Create Multileaders with Blocks attached.
- 9. Use the Collect Multileader tool.

29-2 Blocks

Blocks

A **Block** is a group of objects that have been converted into **one** object. A Symbol, such as a transistor, bathroom fixture, window, screw or tree, is a typical application for the block command. First a Block must be **created**. Then it can be inserted into the drawing. An inserted Block uses less file space than a set of objects copied.

Creating a Block

1. First draw the objects that will be converted into a Block.

For this example, a circle and two lines are drawn.

2. Select the Create Block command using one of the following:

3. In the Block Definition dialog box, enter the new block name in the Name box.

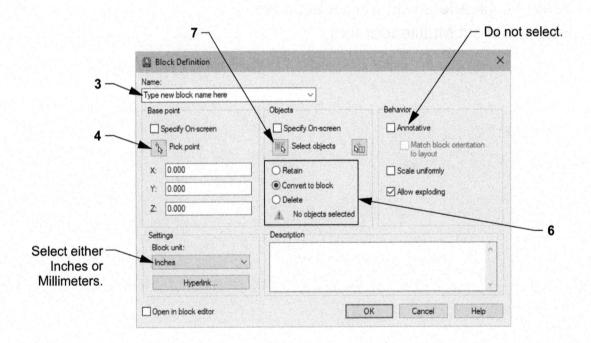

- 4. Select the **Pick point** button. (Or you may type the X, Y, and Z coordinates.) The **Block Definition** box will disappear and you will return temporarily to the drawing.
- 5. Select the location where you would like the insertion point for the Block. Later when you insert this block, the block will appear on the screen attached to the cursor at this insertion point. Usually this point is the **Center**, **Midpoint**, or **Endpoint** of an object.

6. Select one of the options described below. It is important that you select one and understand the options below.

Retain: If this option is selected, the original objects will stay visible on the screen after the block has been created.

Convert to block: If this option is selected, the original objects will disappear after the block has been created, but will immediately reappear as a block. It happens so fast you won't even notice the original objects disappeared.

Delete: If this option is selected, the original objects will disappear from the screen after the block has been created. (This is the one I use most of the time.)

7. Select the **Select objects** button.

The Block Definition box will disappear and you will return temporarily to the drawing.

8. Select the objects you want in the block, and then press < Enter>.

The Block Definition box will reappear and the objects you selected should be displayed in the Preview icon area.

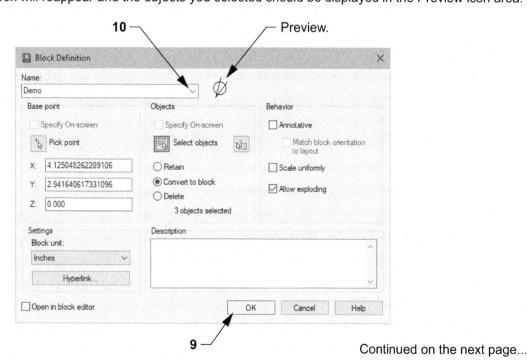

29-4 Blocks

- 9. Select the **OK** button. The new block is now stored in the drawing's block definition table.
- 10. To verify the creation of this Block, select **Create Block** again, and select the Name (**∨**). A list of all the blocks in this drawing will appear. (Refer to page 29-5 for inserting instructions.)

Additional definitions of Options

Block unit: You may define the units of measurement for the block. This option is used with the "Design Center" to drag and drop with Autoscaling. The Design Center is an advanced option and is not discussed in this book.

Hyperlink: Opens the Insert Hyperlink dialog box, which you can use to associate a hyperlink with the block.

Description: You may enter a text description of the block.

Scale uniformly: Specifies whether or not the block is prevented from being scaled non-uniformly during insertion.

Allow exploding: Specifies whether or not the block can be exploded after insertion.

How Layers affect Blocks

If a block is created on Layer 0:

- 1. When the block is inserted, it will take on the properties of the current layer.
- 2. The inserted block will reside on the layer that was current at the time of insertion.
- 3. If you Freeze or turn off the layer, the block was inserted onto, the block will disappear.
- 4. If the Block is Exploded, the objects included in the block will revert to their original properties of Layer 0.

If a block is created on Specific layers:

- 1. When the block is inserted, it will retain its own properties. It will not take on the properties of the current layer.
- 2. The inserted block will reside on the current layer at the time of insertion.
- 3. If you Freeze the layer that was current at the time of insertion, the block will disappear.
- 4. If you turn off the layer that was current at the time of insertion, the block will not disappear.
- 5. If you Freeze or turn off the block's original layers, the block will disappear.
- 6. If the Block is Exploded, the objects included in the block will go back to their original layer.

Inserting Blocks

A Block can be inserted at any location within the drawing. When inserting a Block, you can Scale, Rotate or Explode it.

1. Select the **Insert** command using one of the following:

Ribbon = Insert Tab / Block Panel / or Keyboard = insert <Enter>

- 2. Select the **Block** you want to insert, from the Insert Window.
- 3. Select the insertion location for the Block by moving the cursor and pressing the left mouse button.

If you create a new drawing file with no recent or current Blocks, the **Insert** drop-down window will be blank. Select **Recent Blocks...** to access the **Blocks Palette**. You may also type **insert** and then press **<Enter>** to access the Blocks Palette, which is discussed below.

Note: If you want to change the **Basepoint** or **Scale** or to **Rotate** the Block before you actually place the Block, press the right-hand mouse button and you may select an option from the menu, or select an option from the Command Line, shown above.

You may also "preset" the insertion point, scale, rotation, or insert recent Blocks or Blocks from Libraries. This is discussed next.

Presetting the Insertion Point, Scale, or Rotation

You may preset the **insertion point**, **scale**, or **rotation**, using the **Blocks Palette** instead of at the Command Line.

- 1. Select the Insert command.
- 2. Select **Recent Blocks...** from the drop-down menu.

3. The **Blocks Palette** will open. Any recent Blocks used in the current drawing or previously opened drawings, will appear in the **Recent Blocks** Window.

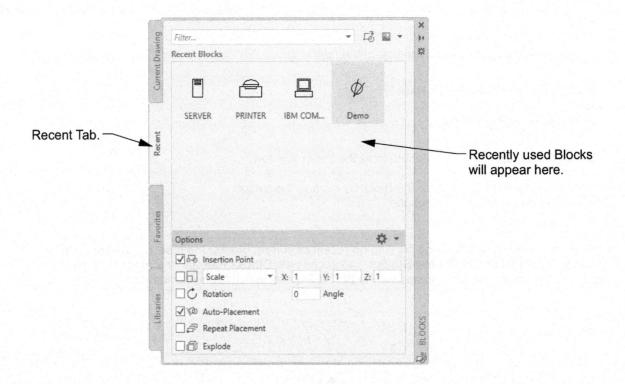

4. If there are no recent Blocks used, select the Current Drawing Tab.

- 5. If you want to insert the Block at a specific location, uncheck the Insertion Point box.
- 6. Enter the location coordinates required in the "X" and "Y" fields. (Note: The "Z" field is used for 3D, so leave it as it is for 2D drawing.)

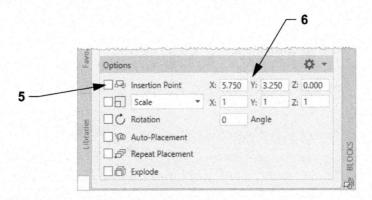

- 7. If you want to insert the Block at a specific scale, uncheck the **Scale** box.
- 8. Enter the scale factors in the "X" and "Y" fields. You can set the "X" and "Y" fields at different scale factors if you require the Block to be scaled non-uniformly.

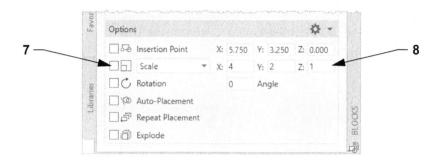

- 9. If you want to insert the Block at a specific angle, uncheck the **Rotation** box.
- 10. Enter the rotation angle you require for the Block, in the **Angle** field.

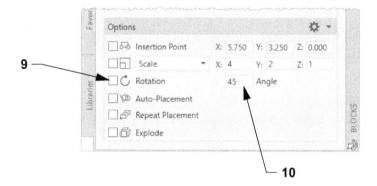

- 11. If you want to insert more than one instance of the Block, check the **Repeat Placement** box.
- 12. If you want the Block to be exploded into its constituent parts, check the Explode box.

Note: If you check the **Explode** box, the non-uniformed scale factor will not work. Instead it will just scale to the "X" factor that you have set, and in a uniformed scale. So in the example above, the Block will scale at four times its original size.

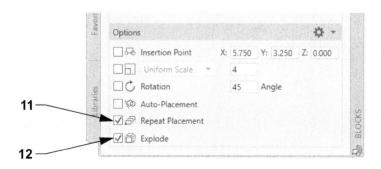

13. Once you have completed selecting any of the options in the **Insertion Options** fields, click on the Block you want to insert. Then left click in the drawing area for the Block to be placed.

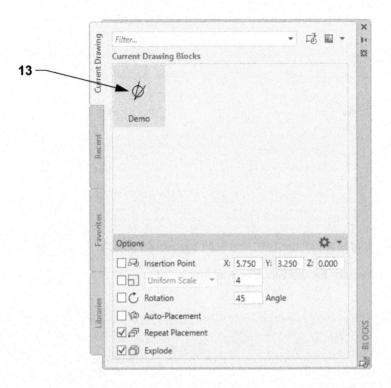

If you want to insert a Block from a drawing stored on your system that is not currently available in the **Blocks Palette**, select the **Libraries** Tab, then select the **Browse** button to search for a Block on your system.

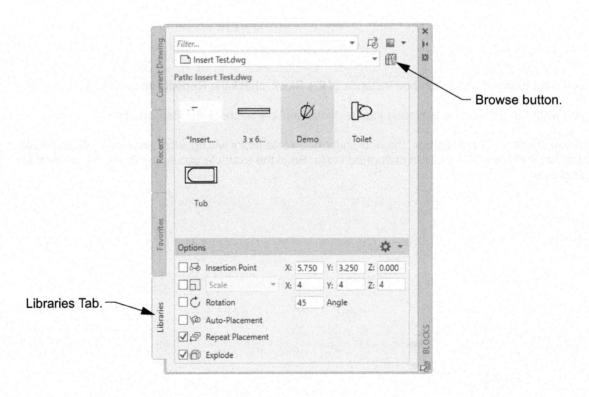

Automatic Block Placement

Automatic Block Placement allows you to quickly position and insert a new block into a drawing by providing placement suggestions, based on existing blocks of the same type that have already been inserted into the drawing. For example, if you have placed a block of an office chair by a desk in a room, and want to place the same chair in an adjacent room with the same type of desk, this command makes similar positioning easier.

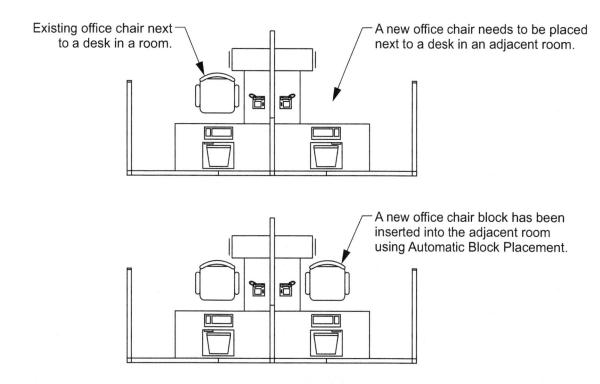

How to insert a block using Automatic Block Placement

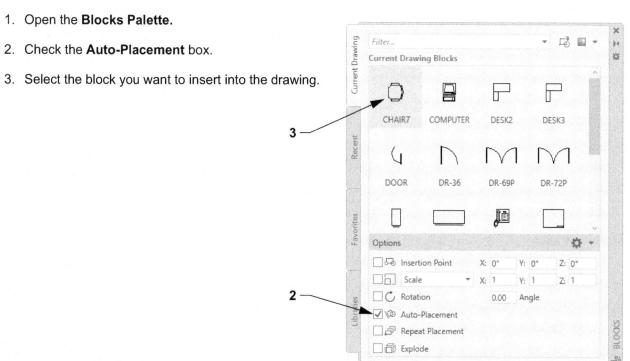

- 4. Move the cursor to approximately the position where you want to place the block.
- 5. As you move the block to the position, the desk edges will highlight in orange.
- 6. Left click to place the block in the suggested position.

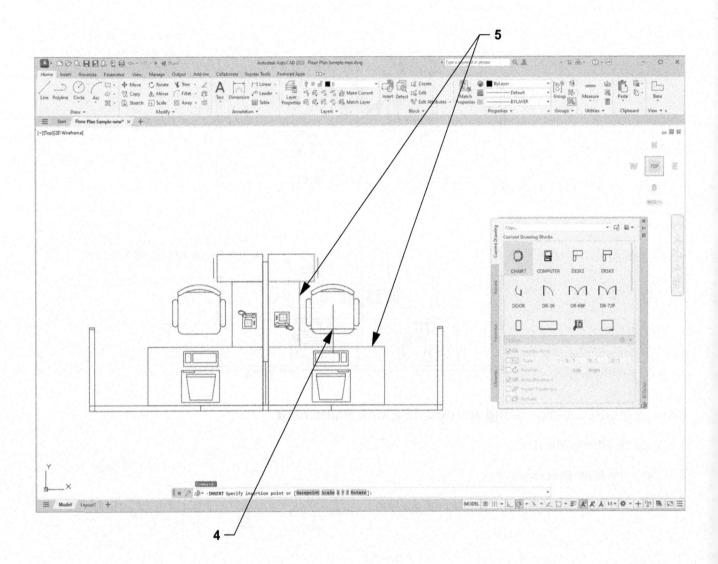

Note: If you do not want to place the block in the suggested position, press the **<7ab>** key for alternative placement suggestions. If you want to temporarily hide the suggestions for the block placement, hold down the **<Shift>** + **W** keys.

Re-Defining a Block

How to change the design of a block previously inserted

Select the Block Editor command using one of the following:

The Edit Block Definition dialog box will appear.

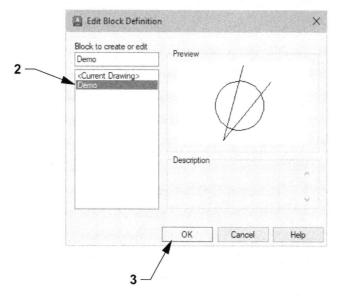

- 2. Select the name of the Block that you want to change.
- 3. Select the **OK** button.
- 4. The Block that you selected should appear large on the screen. You may now make any additions or changes to the block. You can change Tabs and use other Panels such as Draw and Modify. But you must return to the **Block Editor** Tab to complete the process.
- 5. Return to the **Block Editor** button if you selected any other Tab while editing.
- 6. Select the Save Block tool from the Open/Save Panel.
- 7. Select the Close Block Editor tool.

You will be returned to the drawing, and **all previously inserted** blocks with the **same name** will be updated with the changes that you made.

Count the Number of Blocks in a Drawing

You can quickly count the number of blocks in a drawing by using the **Count** command. After selecting the Count command, the **Count Palette** will open, showing you how many blocks there are in your drawing, along with the names of those blocks.

You can also create a table with the blocks you select, and then insert the table into your drawing. The table will display the name of the blocks, as well as how many blocks there are of each type.

The example below shows a network diagram with various types of blocks, along with the Count Palette that shows the name of and total count for each type of block.

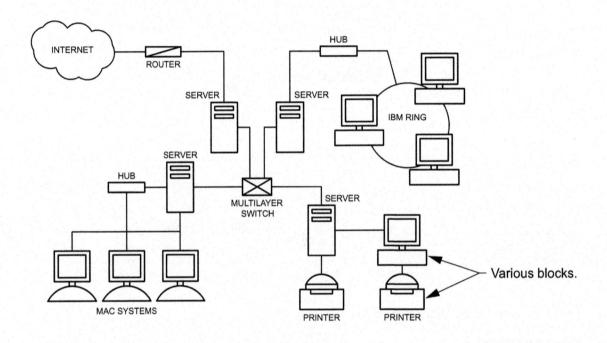

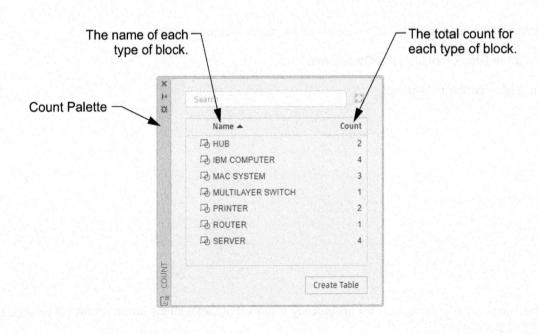

How to count the number of blocks in a drawing

1. Select the **Count** command using one of the following:

Ribbon = View Tab / Palettes Panel / or Keyboard = countlist <Enter>

2. The Count Palette will open.

How to create and insert a table into the drawing

- 1. Open the Count Palette.
- 2. Select the Create Table button.
- 3. Place a checkmark in the top field if you want the table to show all the blocks, or select fields individually.
- 4. Select Insert.

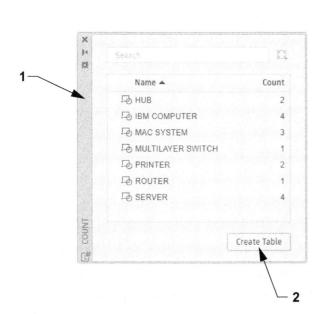

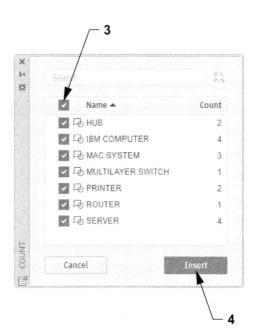

- 5. Move the table to the location where you want it to appear in the drawing.
- 6. Left click to place the table in the drawing.

Item	Count
HUB	2
IBM COMPUTER	4
MAC SYSTEM	3
MULTILAYER SWITCH	1
PRINTER	2
ROUTER	1
SERVER	4

Note: The style and height of the text in the table is determined by your current Text Style. If you want a different text style and/or height, you must change it before selecting the table insert button.

Purge Unwanted and Unused Blocks

You can remove a block reference from your drawing by erasing it; however, the block definition remains in the drawing's block definition table. To remove any **unused** blocks, dimension styles, text styles, layers, and linetypes, you may use the **Purge** command.

How to delete unwanted and unused blocks from the current drawing

Select the **Purge** command using one of the following:

- 2. Select the + sign beside Blocks. (It will change to a sign.)
- 3. Select the block that you want to purge by clicking in the box to insert a check mark.

Note: Only unused blocks will be listed.

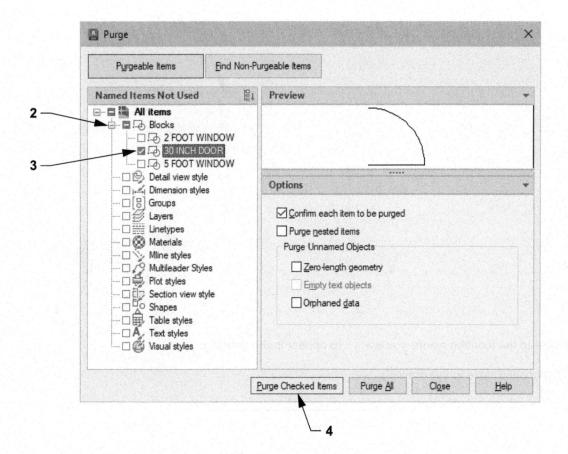

4. Select the Purge Checked Items button.

5. Select Purge this item in the Purge - Confirm Purge dialog box.

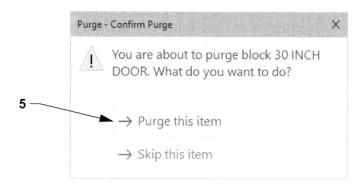

6. The block has now been removed from the drawing and no longer shows in the Named Items Not Used list.

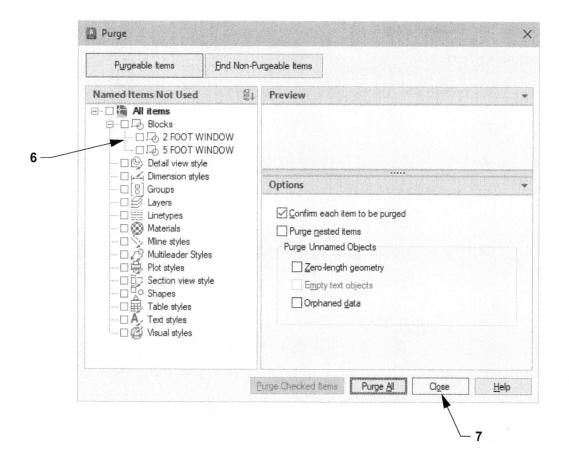

7. Select Close.

Where are Blocks saved?

When you create a block, it is saved within the drawing you created it in.

(If you open another drawing, you will not find that block.)

Multileader and Blocks

In Lesson 19, you learned about multileaders and how easy and helpful they are to use. (*I saved this command for this lesson because it works best with Blocks attached to the leader.*) In this lesson, you will learn another user option within the Multileader Style Manager that allows you to **attach a pre-designed block** to the landing end of the leader. To accomplish this, you must first create the style and then you may use it.

Here are a few examples of multileaders with pre-designed blocks attached:

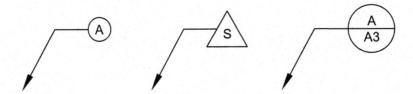

Step 1. Create a new Multileader Style

1. Select the Multileader Style Manager command using one of the following:

Ribbon = Annotate Tab / Leaders Panel / Standard

or

Keyboard = mleaderstyle <Enter>

Standard

Multileader

No Add Leader

Remove Leader

Leaders

2. Select the New... button.

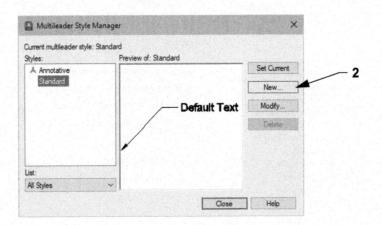

- 3. Enter New style name
- 4. Select a style to Start with:
- 5. Select the Annotative box.
- 6. Select the Continue button.

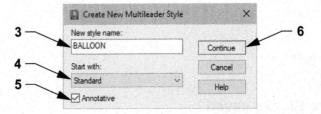

- 7. Select the Content Tab.
- 8. Multileader type: Select Block from drop-down menu.
- Source block: Select Circle from the drop-down menu.
 Note: You have many choices here. These are AutoCAD pre-designed blocks with attributes.
- 10. Attachment: Select Center Extents.

Note: This selection works best with Circle, but you will be given different choices depending on which source block you select.

- Color: Select ByLayer.
 ByLayer works best as it acquires the color of the current layer setting.
- 12. Scale: Select 1.000
- 13. Select OK button.

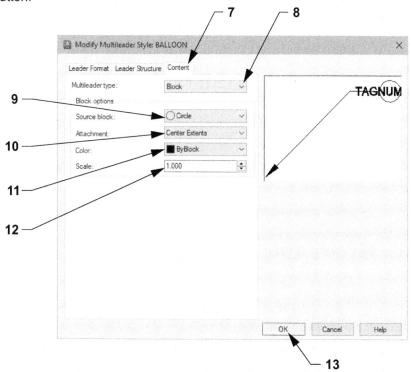

Your new multileader style should be displayed in the Styles list.

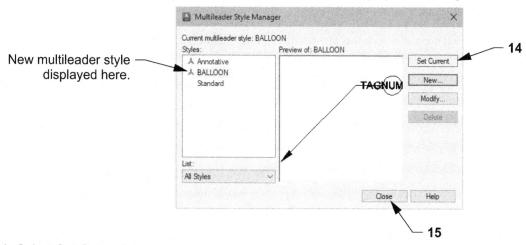

- 14. Select Set Current.
- 15. Select the Close button.

Step 2. Using the Multileader with a Block Style

- 1. Select the Annotate Tab / Leaders Panel.
- 2. Select the Style from the Multileader drop-down list.

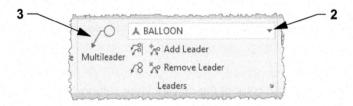

- 3. Select the Multileader tool.
- 4. The Select Annotation Scale box may appear. Select OK for now.

The following will appear on the Command Line:

5. Place the desired location of the arrowhead (left click).

The following will appear on the Command Line:

6. Place the desired location of the landing (left click).

The next step is where the pre-assigned **Attributes** activate. Refer to the *Advanced AutoCAD*® *Exercise Workbook* for Attributes.

7. The Edit Attributes dialog box will appear. Type the number or letter of the multileader tag and then select OK.

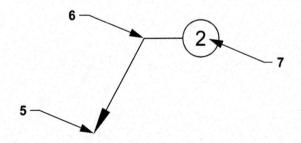

Collect Multileader

In Lesson 19, you learned how to **Add**, **Remove**, and **Align** multileaders. Now you will learn how to use the **Collect Multileader** tool.

If you have multiple leaders pointing to the same location or object, you may wish to **Collect** them into one Leader.

Example:

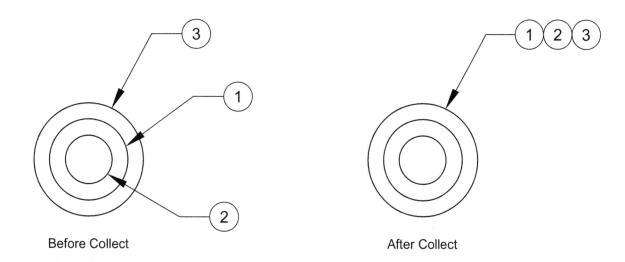

How to use Collect Multileader

1. Select the Collect Mutileader tool.

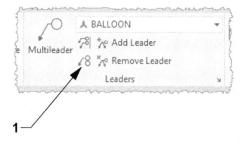

2. Select the multileaders that you want to combine and then press < Enter>.

Note: Select them one at a time in the order you want them to display:

1, 2, 3, A, B, C, etc.

3. Place the combined leader location. (Ortho Mode should be off.)

Exercise 29A

Exercise 29A

Step 1.

- 1. Start a New file using My Decimal Setup.dwt.
- 2. Select the Model Tab.
- 3. Draw the objects shown below approximately as shown. Use Layer Symbol.
- 4. Do not dimension.
- 5. Create a block of each.
 - A. Important: Don't forget to select a basepoint on each object.
 - B. Select "Delete" so they disappear as they are made.
 - C. Do not include the name when selecting the objects for each block.

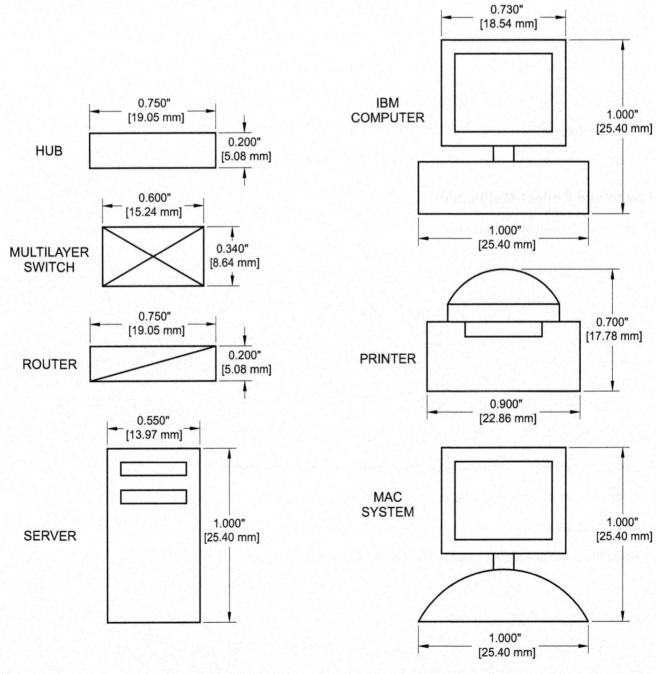

29-21

Exercise 29A...continued

Step 2.

- 1. Open Ex-29A (if not already open).
- 2. Select the A Size Tab and confirm the Model Tab is displayed.
- 3. Draw the Network Diagram approximately as shown within Model Space.
- 4. Insert the blocks you previously created in Step 1.
- 5. Add the labels. Use Text Style TEXT-CLASSIC. Text height 0.125" [3.2 mm].
- 6. Edit the Title Block: SCALE: NONE
- 7. Save the drawing as Ex-29A again.
- 8. Plot using plot page setup Plot Setup A

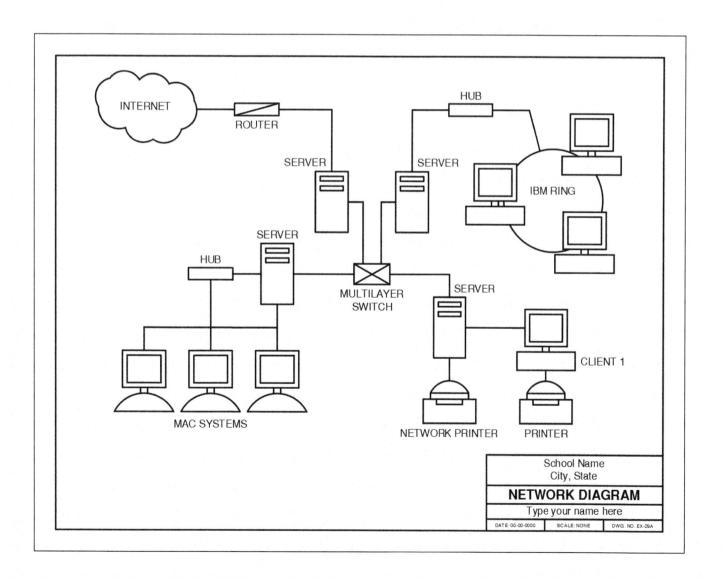

Exercise 29B

Exercise 29B

Step 1.

- 1. Start a New file using My Feet-Inches Setup.dwt.
- 2. Select the Model Tab.
- 3. Draw the objects shown below approximately as shown. Use layers specified.
- 4. Do not dimension.
- 5. Create a block of each.
 - A. Important: Don't forget to select a basepoint on each object.
 - B. Select "Delete" so they disappear as they are made.
 - C. Use the numbers for name. Do not include the number when selecting the objects for the block.

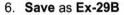

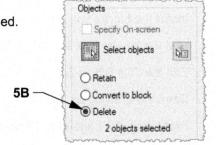

Note: Your blocks will appear much smaller and thinner than the blocks shown below. These have been enlarged for clarity.

Step 2.

- 1. Open Ex-29B (if not already open).
- 2. Select the A Size Tab.
- 3. Draw the floor plan approximately as shown below inside the viewport.

(Note: The viewport scale should already be adjusted to 1/4" = 1'.)

- A. The walls are 6" wide.
- B. The space behind the door is 4" and counter depth is 24".
- 4. Insert the (8) DOOR Blocks on Layer Doors.
- 5. Insert the (9) WINDOW Blocks on Layer Windows.
- 6. Dimension as shown using Dimension Style DIM-ARCH. (Your dimension text will appear different. I used text style TEXT-CLASSIC because it is easier for you to read.)
- 7. Save the drawing as Ex-29B again.

Exercise 29B...continued

Step 3.

- 1. Open Ex-29B (if not already open).
- 2. Add the Electrical Blocks (1, 2, 3, 4 and 5) on Layer Electrical.
- 3. Add the Plumbing Blocks (6 and 7) on Layer Plumbing.
- 4. Save the drawing as Ex-29B again.

Note: The Dimension layer has been temporarily turned off so you can see the electrical and plumbing blocks easier.

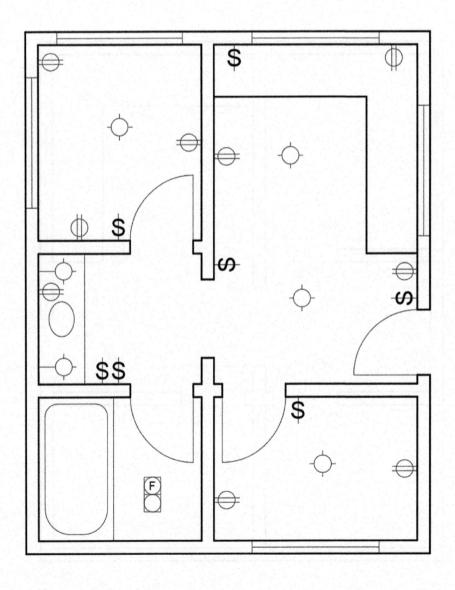

Step 4.

- 1. Open Ex-29B (if not already open).
- 2. Add the Wiring.
 - A. Use Layer Wiring.
 - B. Use Arc, (Start, End, Direction).
- 3. Notice that your dashed lines do not appear like the example below.
 - A. Type *LTS* and then press *<Enter>*. (This is the **Linetype Scale** setting.)
 - B. Type 0.25 and then press < Enter>. (This scales all linetypes).
- 4. Save the drawing as Ex-29B again.

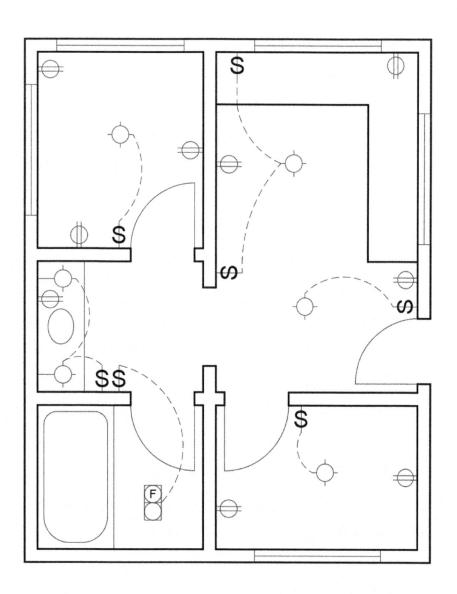

Exercise 29B...continued

Step 5.

- 1. Open Ex-29B (if not already open).
- 2. Erase the existing viewport Frame. (The floor plan will disappear.)
- 3. Select Viewport as the current layer and create three new viewports approximately as shown.
- 4. Adjust the scale of each viewport.
- 5. Use Pan to find the area to view as shown below.
- 6. Lock each viewport.
- 7. Add the dimensions in the two viewports on the right by adding the current object scale. (Refer to pages 28-3 and 28-4.)
- 8. Add the viewport scale labels (3/16" height) in Paper Space (not Model Space).
- 9. Make viewport Frames plottable. (Refer to page 3-8.)
- 10. Edit the Title Block.
- 11. Plot using plot page setup Plot Setup A
- 12. Save as Ex-29B

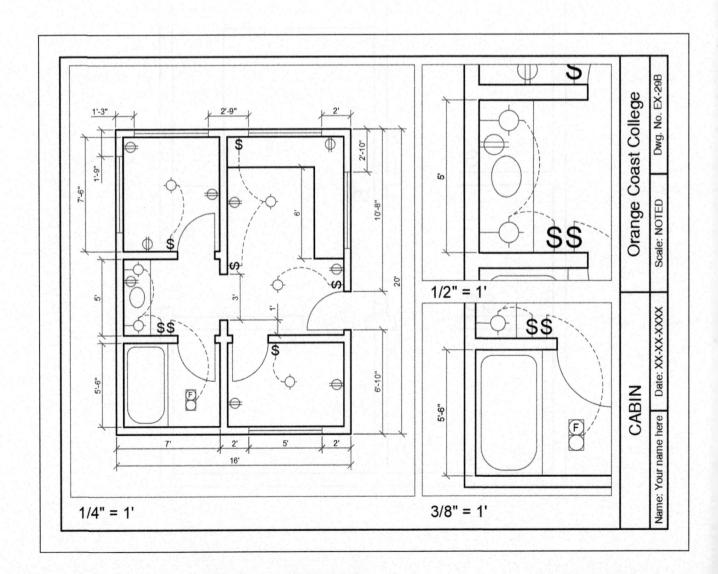

Exercise 29C-Inch

Exercise 29C-Inch

Step 1.

- 1. Start a New file using My Decimal Setup.dwt.
- 2. The viewport should already be scaled to 1:1 and locked.
- 3. Draw the objects shown below.
- 4. Draw the Break line using the Polyline command with the Spline option. (Refer to page 24-3.)
- 5. Draw the Hatch using Pattern ANSI31 and Layer Hatch.
- 6. Draw the Threads.
 - A. Use Layer Threads.
 - B. Thread lines are 0.0625" distance apart.
- 7. Dimension as shown using Layer Dimension and dimension style = DIM-DECIMAL.
- 8. Save the drawing as Ex-29C-I STEP 1.

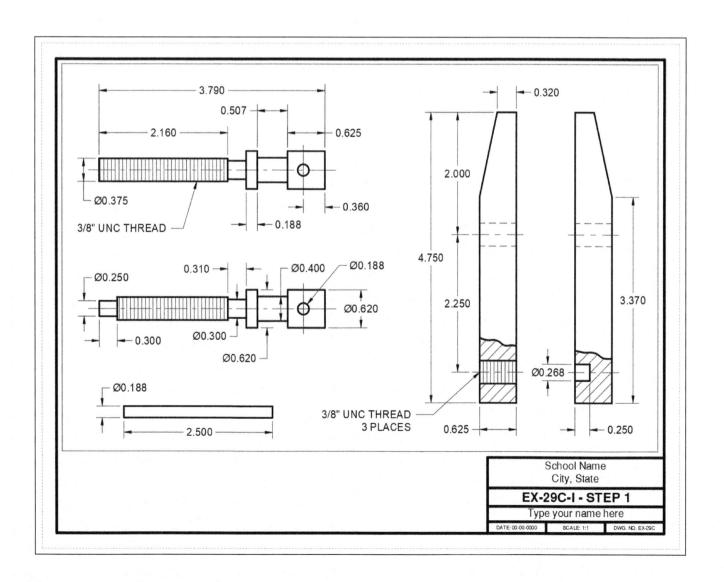

Exercise 29C-Inch...continued

Step 2.

- 1. Open Ex-29C-I STEP 1 (if not already open).
- 2. Freeze the Dimension layer.
- 3. Assemble the parts as shown below.
- 4. Use Move, Mirror, Rotate, Trim, Erase, and any other command that you need.
- 5. The distance between the Jaws should be 1.000".
- 7. Save the drawing as Ex-29C-I STEP 2.

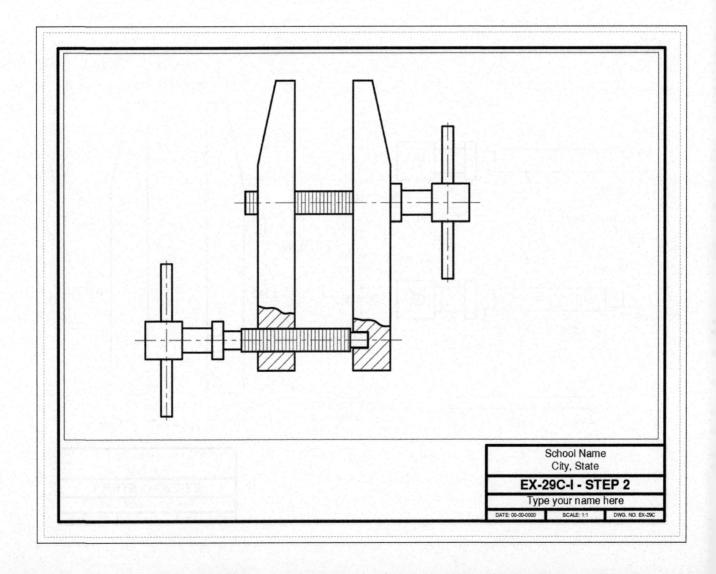

29-29

Exercise 29C-Inch...continued

Step 3.

- 1. Open Ex-29C-I STEP 2 (if not already open).
- 2. Draw the list of parts in Paper Space above the Title Block as shown.
- 3. Use Multiline Text to enter text. Justify = Middle Center. Text height = 0.125" and 0.062".
- 4. Add Ballooned Leaders as shown in Model Space. Scale 1.5. Use Collect and Align.
- 5. Save as CLAMP ASSEMBLY and plot using plot Page Setup Plot Setup A

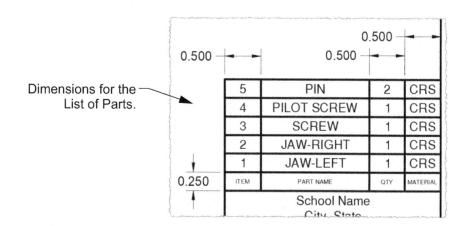

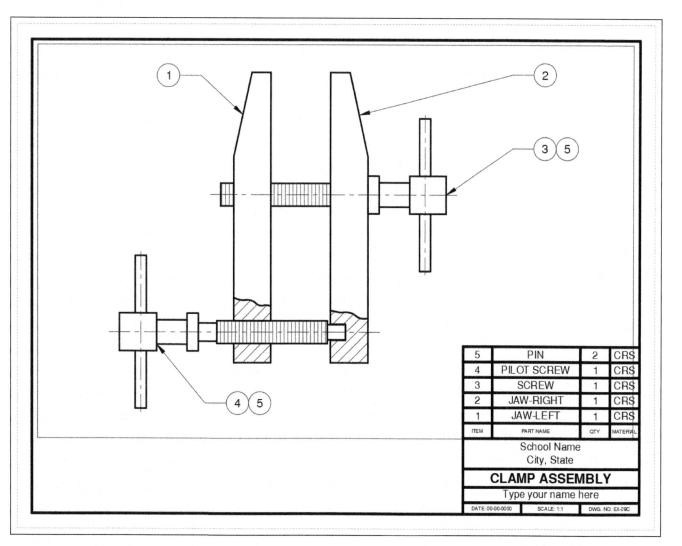

Exercise 29C-Metric

Exercise 29C-Metric

Step 1.

- 1. Start a New file using My Decimal Setup.dwt.
- 2. The viewport should already be scaled to 1:1 and locked.
- 3. Draw the objects shown below.
- 4. Draw the Break line using the Polyline command with the Spline option. (Refer to page 24-3.)
- 5. Draw the Hatch using Pattern ANSI31 and Layer Hatch.
- 6. Draw the Threads.
 - A. Use Layer Threads.
 - B. Thread lines are 1.5 mm distance apart.
- 7. Dimension as shown using Layer Dimension and dimension style = DIM-DECIMAL.
- 8. Save the drawing as Ex-29C-M STEP 1.

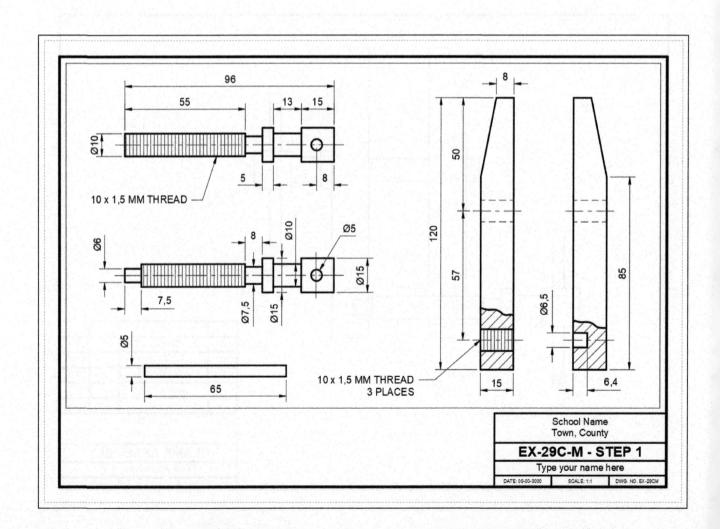

Step 2.

- 1. Open Ex-29C-M STEP 1 (if not already open).
- 2. Freeze the Dimension layer.
- 3. Assemble the parts as shown below.
- 4. Use Move, Mirror, Rotate, Trim, Erase, and any other command that you need.
- 5. The distance between the Jaws should be 25 mm.
- 7. Save the drawing as Ex-29C-M STEP 2.

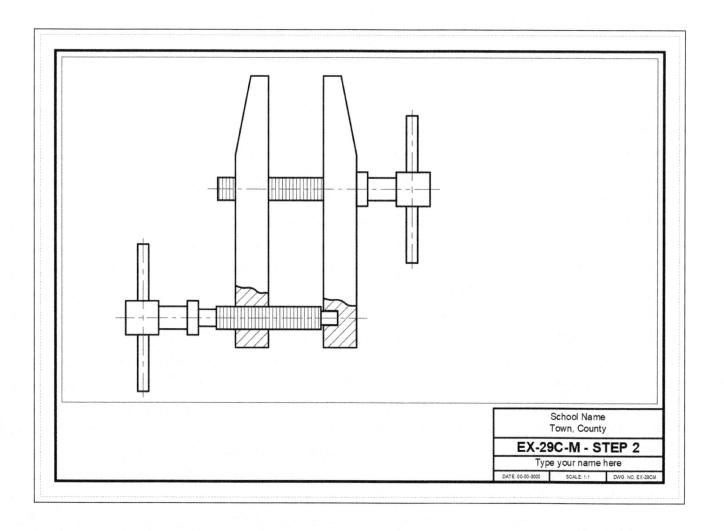

Exercise 29C-Metric...continued

Step 3.

- 1. Open Ex-29C-M STEP 2 (if not already open).
- 2. Draw the list of parts in Paper Space above the Title Block as shown.
- 3. Use Multiline Text to enter text. Justify = Middle Center. Text height = 3.2 mm and 1.5 mm.
- 4. Add Ballooned Leaders as shown in Model Space. Scale 1.5. Use Collect and Align.
- 5. Save as CLAMP ASSEMBLY and plot using plot Page Setup Plot Setup A

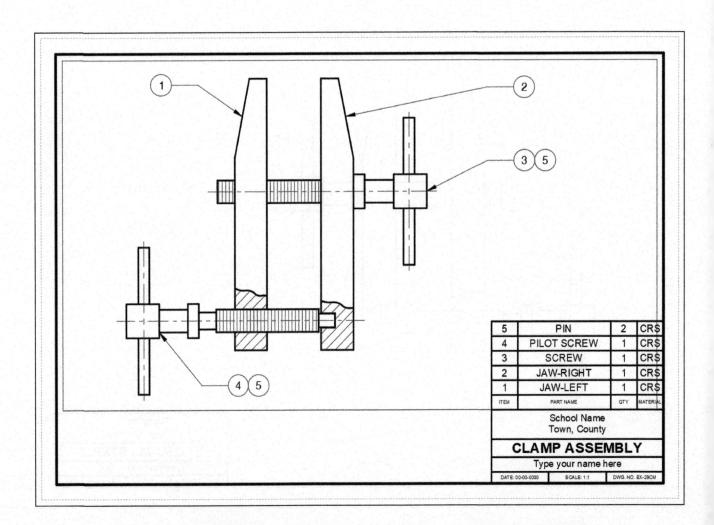

LESSON 30

LEARNING OBJECTIVES

After completing this lesson, you will be able to:

- 1. Use six useful "Express Tools".
- 2. Import a PDF file into AutoCAD as usable geometry.
- 3. Import a PDF file with SHX fonts.
- 4. Compare the differences between two versions of any drawing.
- 5. Store your designs in the Cloud for other users to view.

Text - Arc Aligned

ArcText allows you to place text along the arc's curve. You may control the appearance of the text easily using the ArcAlignedText Workshop Dialog box shown below.

How to create ArcText

- 1. Draw an arc.
- 2. Select the Express Tools Tab.
- 3. Select the Arc Aligned tool.
- 4. Select the arc.

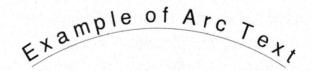

The ArcAlignedText Workshop - Create dialog box will appear.

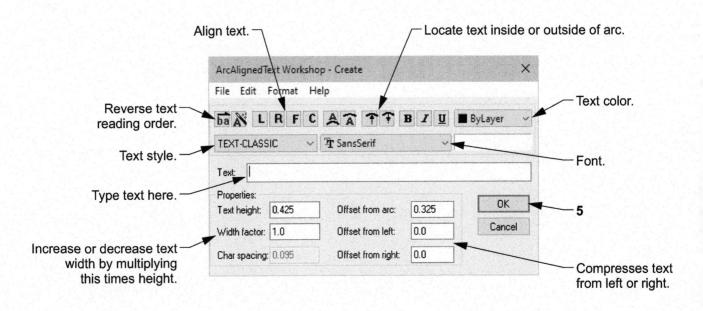

5. Select the options you want and then select the **OK** button.

How to edit the ArcText

- 1. Select the Arc Aligned tool.
- Select the existing text. The ArcAlignedText Workshop Modify dialog box will appear.
- Make changes and select the OK button.

Text – Modify Text

Modify Text has five options, **Explode**, **Change Case**, **Rotate**, **Fit**, and **Justify**, to increase your manipulation of existing text.

- 1. Select the Express Tools Tab.
- 2. Select the **Modify Text →** down arrow.
- 3. Select one of the options listed below.
- 4. Select the text to be modified.
- 5. Select < Enter> to stop.

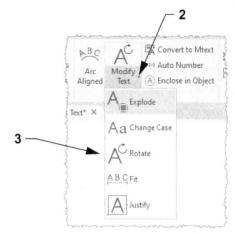

Explode: Text explodes into lines and arcs.

Change Case: Changes text case to one of the following:

Sentence case: The first letter of the sentence is uppercase. All others lowercase.

<u>Iowercase</u>: All letters lowercase. <u>UPPERCASE</u>: All letters uppercase.

<u>Title:</u> The first letter of each word uppercase.

tOGGLE cASE: Changes uppercase to lowercase and vice versa.

TCASE - change text case X

Sentence case.

Jowercase

UPPERCASE

Title

toGGLE cASE.

OK Cancel Help

Rotate: Allows you to rotate the existing text to the "most readable" orientation or to a specific angle.

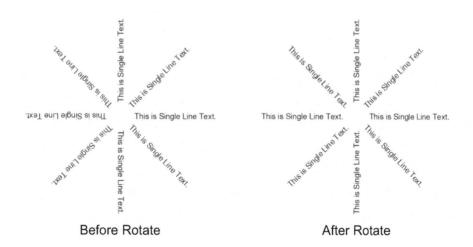

Fit: Allows you to compress or stretch text between two points.

I would like to fit this text inside the rectangle.

I would like to fit this text inside the rectangle.

Before Fit

After Fit

Justify: Allows you to change the justification. You also can do this with Properties.

Text - Convert to Mtext and Auto Number

Convert to Mtext allows you to convert text created with Single Line text command to Multiline text. This is very helpful if you would like to modify the single line text because multiline text editor includes many additional editing options.

- 1. Select the Express Tools Tab.
- 2. Select the Convert to Mtext tool.
- 3. Select the text to be converted.
- 4. Press < Enter>.

Convert to Mtext

(A) Enclose in Object

Auto Number allows you to add sequential numbers to existing text.

- 1. Select the Express Tools Tab.
- Select the Auto Number tool.
- 3. Select the text and then press < Enter>.

The following will appear on the Command Line:

Arc

Aligned

Modify

Text

Text -

4. Press < Enter>.

The following will appear on the Command Line:

5. Press < Enter>.

The following will appear on the Command Line:

Press < Enter>.

This is line one.

This is line two.

This is line two.

This is line three.

1 This is line one.

2 This is line two.

3 This is line three.

Before Auto Number

After Auto Number

Text - Enclose in Object

Enclose in Object allows you to place a circle, slot, or rectangle around text.

- 1. Select the Express Tools Tab.
- 2. Select the Enclose in Object tool.
- 3. Select the text to be enclosed.
- 4. Press < Enter>.

The following will appear on the Command Line:

5. This determines the offset from the text. It multiplies this number times the text height. Press < Enter>.

The following will appear on the Command Line:

6. Select the enclosure you require.

The following will appear on the Command Line:

If you select Constant, AutoCAD will select the largest text height and multiply it times the offset distance to
determine the size for all. If you select Variable, each offset distance will be calculated based on the individual
text height. Press < Enter>.

Example:

	Variable	Constant
Circle	A AAA	A AAA
Slot	A A AAA	A A AAA
Rectangle	A AAA	A A AAA

Draw - Break-Line Symbol

The Break-line Symbol command creates a polyline and inserts the break-line symbol.

How to create a Break-line Symbol

1. Draw three Lines as shown below.

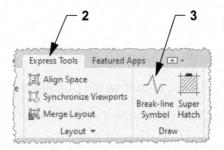

- 2. Select the Express Tools Tab.
- 3. Select the Break-line Symbol tool.

The following will appear on the Command Line:

4. Snap to the first point.

The following will appear on the Command Line:

5. Snap to the second point.

The following will appear on the Command Line:

6. Press < Enter> to locate the break at the Midpoint.

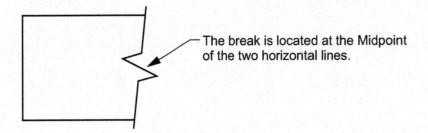

Options:

Block: You can select another block to be used instead of the Break-line Symbol.

Size: You can designate the size of the Break-line Symbol.

Extension: You can designate the amount the Break-line overlaps the existing line.

Tools – Command Aliases

Command Aliases

AutoCAD has many preset aliases for common commands. For example, **C** for **Circle**. These aliases are stored in the **acad.pgp** file. Using the **Command Aliases** tool, you can **Add**, **Remove**, or **Edit** an Alias.

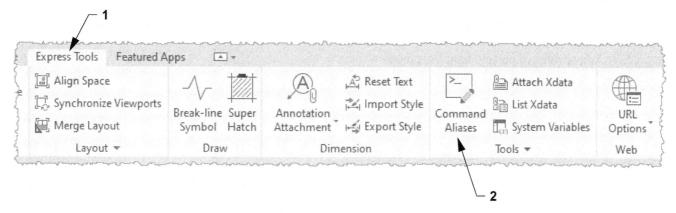

How to use the Command Aliases tool

- 1. Select the **Express Tool**s Tab.
- 2. Select the Command Aliases tool.

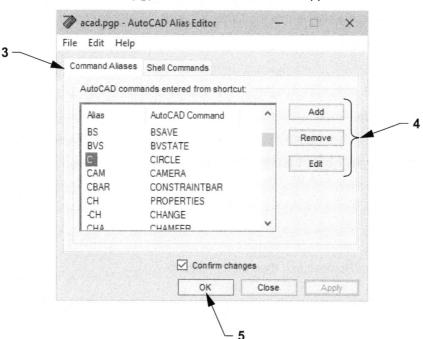

The acad.pgp - AutoCAD Alias Editor appears.

- 3. Select the Command Aliases Tab.
- 4. Select the Add, Remove, or Edit button.

Add: You will specify an Alias and select the corresponding command. Then select OK.

Remove: Click on the Alias and select the Remove button.

Edit: Enter the new Alias to replace the existing Alias. Then select **OK**.

5. Select the OK button.

Creating a Group

The **Group** tools allow you to group a set of objects and give them a name.

Select: Home Tab / Groups Panel

You may:

- 1. Create a group.
- 2. Ungroup.
- 3. Edit: Add or remove objects from the group.
- 4. On or Off: Temporarily turn the Group on or off. (Blue is on.)

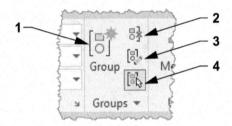

How to create a Group

- 1. Select the Create Group tool (1).
- 2. Select the objects to Group.
- 3. You may give the group a name now or use the Group Manager. (See next page.)

How to Ungroup

- 1. Select the Ungroup tool (2).
- 2. Select the group to Ungroup.

How to Add or Remove an object from the group

- 1. Select the Edit tool (3).
- 2. Select the group to edit.
- 3. Select Add or Remove.
- Select the object/s to Add or Remove and then press < Enter>.

How to turn a Group On or Off

- 1. Select the On or Off tool (4).
- Select the group to turn off or on.

Note: You may temporarily turn off a group, move an object within the group, and then turn the group On. The moved object will remain in the group but now will be in a different position.

Purge a Group

A Group, no longer needed, can be purged. (Refer to page 29-12.)

Managing the Group

1. Select the **Groups** down arrow **▼**

2. Select Group Manager or Group Bounding Box.

Group Manager

The Group Manager allows you to Identify, Create, and Change a group.

Group Bounding Box

When you select a previously created group, AutoCAD identifies it using a Group Bounding Box or grips. The default is a Group Bounding Box. If you want grips, unselect this option.

Group Bounding Box on

Group Bounding Box off

Import a PDF File into AutoCAD

PDF files are now a common way of sharing your designs and for receiving designs from others. AutoCAD now allows you to import the geometry and TrueType text of a PDF file of a design. There are various ways to import a PDF file.

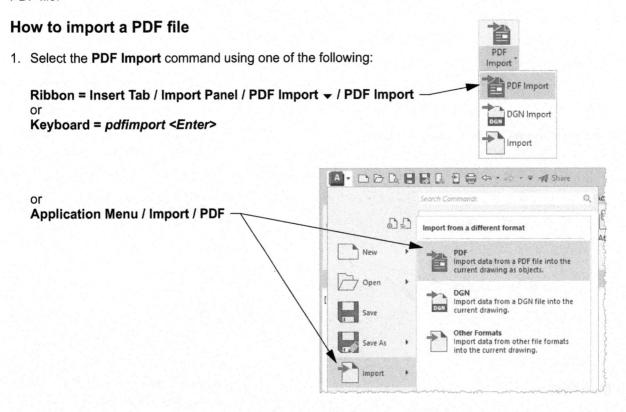

- Select the PDF file you want to import from the Select PDF File dialog box.
- Select Open.

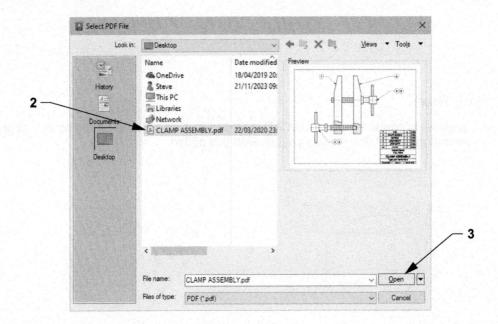

4. The **Import PDF** dialog box will appear with various options. Most of the options in the dialog box are self-explanatory, but there are a few that need explaining. The dialog box defaults are shown in the image below.

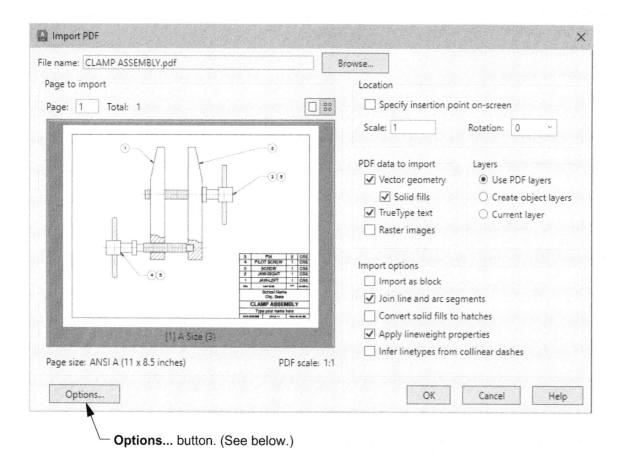

Import options

Convert solid fills to Hatches: If there are any solid filled objects in the PDF you want to import, they will be converted into Hatches when this **option is checked**, but it does add extra to the processing time.

Infer linetypes from collinear dashes: If you have any lines that are created using a linetype such as a Centerline or a Dash-Dot line, they will be converted to a single polyline when this **option is checked**. If the option is left **unchecked** and you have a Centerline or a Dash-Dot line in the PDF file to be imported, these lines will be converted to single dashes and dots. So it is best to check this option if you have any linetypes other than a single continuous line in the PDF file you want to import.

PDF Data to Import

Raster images: If there are any Raster images in the PDF file to be imported, these images will be attached to the drawing when this **option is checked**. You can specify a location for the attached images by selecting the **Options...** button, which will open up the **Options** dialog box, where you can specify a location for the attached images. It is good practice to save the attached raster images in the same location as you save the drawing in.

- A. Select the + sign next to PDF Import Image Location.
- B. Select PDF Images.
- C. Select Browse.
- D. Choose the location for the image.
- E. Select Apply when completed.
- F. Select OK.

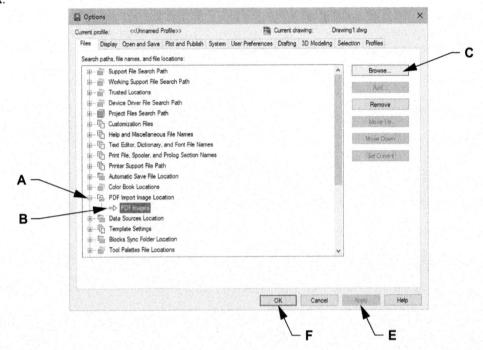

5. After you have made all your selections in the Import PDF dialog box, select OK to insert the PDF file.

The image below is an example of Exercise 29C - I - Clamp Assembly that was plotted as a PDF file and then imported into AutoCAD using the **PDF Import** command.

Note: Text with **TrueType fonts** are imported as text objects if they exist in the PDF file you want to import. This means you will be able to edit any text that is TrueType font text.

Import a PDF File with SHX Fonts

If you import a PDF file into AutoCAD that contains **SHX fonts**, they will be imported as separate polyline objects. AutoCAD can now convert those polyline objects to original SHX fonts by using the SHX font recognition tool.

How to convert the polyline SHX text imported in a PDF file

 Import a PDF file that contains SHX fonts. For this example, I have imported a PDF file that contains three different SHX fonts.

2. Select the SHX font Recognition Settings command:

Ribbon = Insert Tab / Import Panel / Recognition Settings

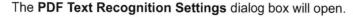

- 3. Select the fonts that closely match the polyline SHX fonts that you imported.
- If your SHX font is not listed in the SHX fonts to compare Window, select the Add button and then select a suitable font from the list of available SHX fonts included with AutoCAD. Or you may wish to add your own SHX font.
- 5. Select the **OK** button.

The following will appear on the Command Line:

6. Select the polyline SHX fonts using a Crossing Window selection and then press < Enter>.

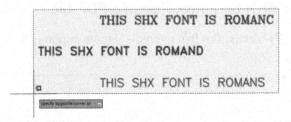

The **Recognize SHX Text** dialog box will appear informing you that the selected polyline SHX fonts were converted correctly.

7. Select Close.

If you double left click on any of the recently imported SHX fonts, the **Text Editor** Ribbon Tab will open up where you can now fully edit the SHX fonts.

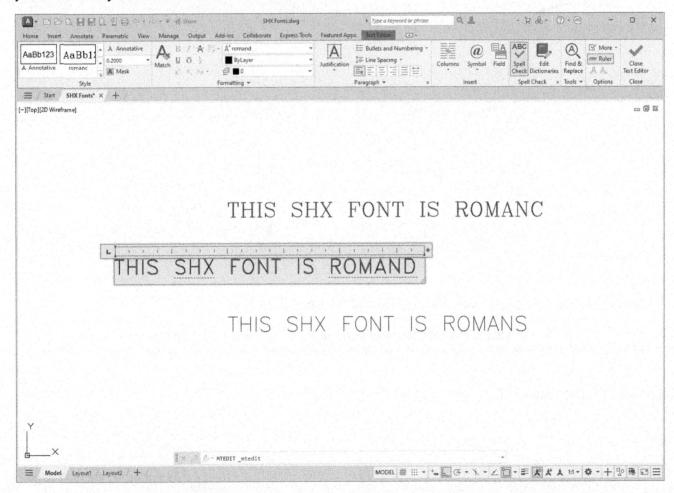

Drawing Compare

The **Drawing Compare** tool allows you to compare the differences between two versions of a drawing. You can edit the Base drawing (open drawing) with a Reference drawing while in the compare state. If there are any differences identified between the two versions of the drawing, the differences will be enclosed within Revision Clouds.

The example below shows two versions of a floor plan. There is a small yet critical change between the two versions, but it may be difficult to identify this small change. There is also a large change that can easily be identified.

After loading the two versions of the floor plan using the Drawing Compare tool, you can clearly see that the left-hand door opening has been moved to a different location. There is also an extra window added in the Floor Plan-Rev 2 Reference drawing that is not in the Floor Plan-Rev 1 Base drawing. Seeing the differences between the drawings, you can decide whether you need to make further changes in your current drawing.

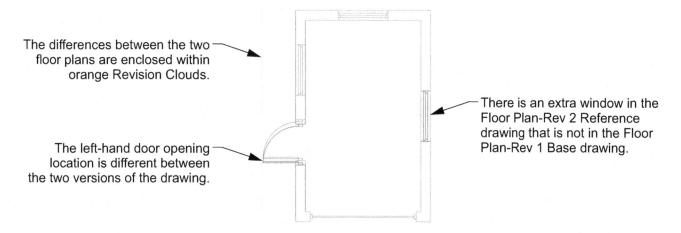

How to select the Drawing Compare tool

The Drawing Compare tool can be accessed from the main Application Menu if there are no drawings active. If there is a drawing active, select the **Drawing Utilities** Menu in the **Application** Menu.

Selecting Drawing Compare with no drawings active

- 1. Select the Application Menu.
- 2. Select the **DWG Compare** command.

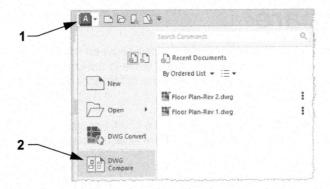

Selecting Drawing Compare with drawings active

- 1. Select the Application Menu.
- 2. Select the Drawing Utilities Menu.
- 3. Select the DWG Compare command.

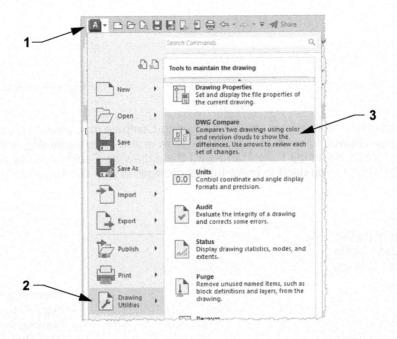

If a drawing is active, you may also select the Drawing Compare tool on the Collaborate Ribbon Tab.

- 1. Select the Collaborate Tab.
- 2. Select the DWG Compare tool.

Example of how to use the Drawing Compare tool

For this example, let's use the Floor Plan shown earlier.

- 1. Select the **Drawing Compare** tool.
- 2. In the **DWG Compare** dialog box, select the first drawing (Base drawing) you want to compare by selecting the browse button and then locating the file in the **Select a drawing to compare** dialog box.
- 3. Repeat Step 2 to select the second drawing (Reference drawing) to compare.
- 4. Select the Compare button.

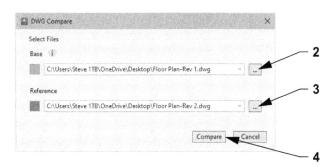

Note: The first drawing selected is called the **Base** drawing (open drawing). The second drawing selected is called the **Reference** drawing.

The Base drawing will open in its own drawing Tab and will be fully editable. The Reference drawing also will open in the same drawing Tab but will be overlaid and locked (non-editable). The **DWG Compare** Toolbar will automatically display at the top of the drawing area, with various tools that allow you to control the appearance of the compared drawing results. The available tools include the **Import Objects** tool, which allows you to import objects from the Reference drawing to the Base drawing.

If there are any differences between the Base drawing and the Reference drawing, the differences will be displayed in green on the Base drawing, and displayed in red on the Reference drawing. Any elements that remain unchanged between the Base drawing and the Reference drawing will be displayed in gray. You can change the colors if you want, by selecting the **Settings** button on the **DWG Compare** Toolbar.

The DWG Compare Toolbar tools and their functions

Settings Panel

Selecting the **Settings** button allows you to change the appearance of the Base and Reference drawings, and also choose whether to display Hatches or Text objects.

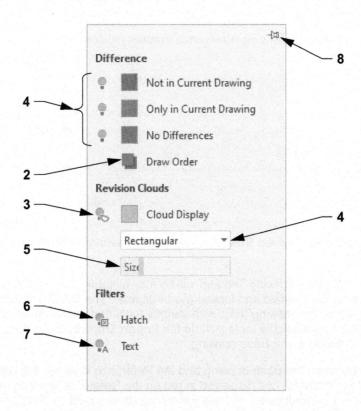

- 1. By selecting the appropriate **lightbulb**, you can turn off the graphics of the Base drawing, the Reference drawing, or the graphics common to both drawings. You may also change the color of the drawing graphics by selecting the appropriate color swatch.
- 2. Selecting the Draw Order allows you to bring the Reference drawing to the front and vice versa.
- 3. Selecting the **Cloud Display** lightbulb allows you turn the Revision Cloud graphics on or off. You may also change the color of the Revision Cloud graphics by selecting the color swatch.
- 4. By selecting the **Cloud Display** down arrow, you can change the shape of the Revision Cloud from Rectangular to Polygonal.

- 5. Selecting the slide bar allows you to change the size of the margins between the Revision Cloud and the compared objects. The bigger the number, the bigger the margin.
- 6. Selecting the **Hatch** lightbulb allows you turn on or off any Hatch objects that may be in the Base or Reference drawing. The Hatch Lightbulb is **off** by default.
- 7. Selecting the **Text** lightbulb allows you to turn on or off any Text objects that may be in the Base or Reference drawing. The Text lightbulb is **on** by default.

8. You may pin the **Settings Panel** so it remains open during the drawing compare session. You can also move the Settings Panel to any location on the screen.

Additional DWG Compare Toolbar Tools

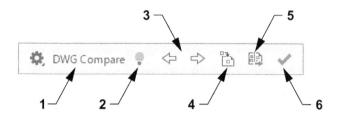

- 1. Hover the cursor over the **DWG Compare** text to see a **Color Key** for the Base and Reference drawings.
- 2. Selecting the lightbulb allows you turn on or off the compare graphics.
- 3. Depending on how many Revision Cloud sets there are in the compare session, you can select the left and right arrows to automatically zoom into each individual set.
- 4. Selecting the **Import Objects** tool allows you to import objects from the Reference drawing to the Base drawing. The following pages explain the Import Objects tool in more detail.
- 5. The **Export Snapshot** tool allows you to save a new drawing file with the comparison results of the Base and Reference drawings, including the compare graphics.
- 6. Select the **Exit Compare** tool once you have made any changes to the Base drawing, or when you are otherwise ready to close the compare session.

Example of Using the Import Objects Tool

In the previous Floor Plan example, the Reference drawing has an additional window and also the door location has moved. This example will show you how to use the **Import Objects** tool to add the additional window to the Base drawing and how to move the location of the door to match the Reference drawing using the **Stretch** command.

Adding the additional window to the Base drawing

- 1. Select the **Import Objects** tool on the **DWG Compare** Toolbar.
- Select objects: Use a Window selection from P1 to P2 to select the additional window and then press <Enter>.

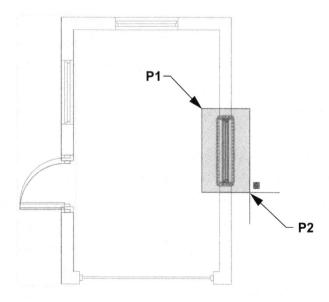

3. The **Import Objects** tool will end automatically. The Revision Cloud that encased the additional window will disappear and the additional window color will turn gray. The gray color of the window means that the additional window is now in the Base drawing as well as the Reference drawing.

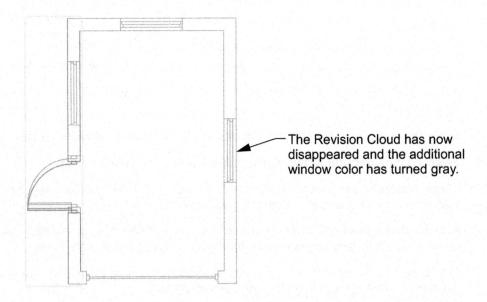

Moving the door location of the Base drawing to match the Reference drawing

- Select the Stretch command on the Modify Panel of the Home Tab.
- 2. Select objects: Use a Crossing Window selection from **P1** to **P2** to select the elements of the door and wall that need to be moved and then press **<**Enter>.
- 3. The selected objects will highlight blue. These are the Base drawing objects.

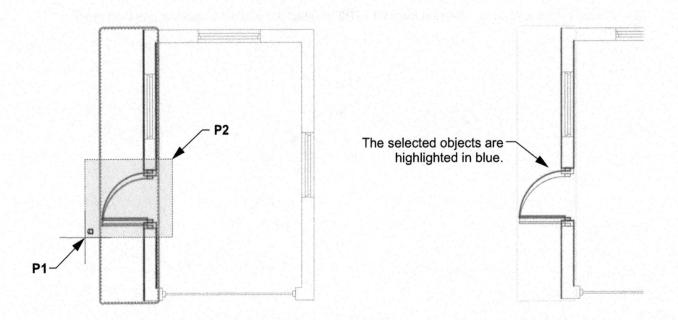

- 4. Using the Endpoint Object Snap, select a point on the door or wall (in blue), drag the objects to the new location on the Reference drawing (in red), and then left click to end the **Stretch** command.
- 5. The Revision Cloud that encased the door and wall will disappear, and the color of the door and wall will turn gray. The Base drawing is now identical to the Reference drawing.

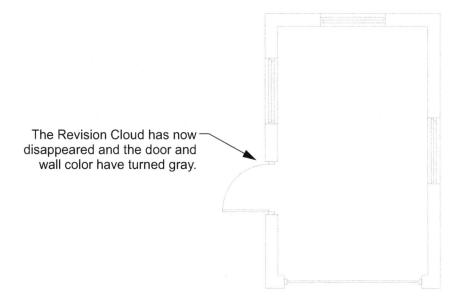

6. Select the **Exit Compare** tool to end the compare session.

Shared Views

The **Shared Views** tool allows you to store your designs in the Cloud for other users to view. Those you share your designs with can view, measure, and comment on the designs and share feedback with you. To use the Shared Views tool, you will need to sign in to your Autodesk® account and be a subscription user of AutoCAD. You must also be connected to the internet.

How to select the Shared Views tool

The Shared Views tool can be accessed from the main **Application** Menu or from the **Collaborate** Tab. You will need an active drawing to share the view.

Selecting Shared Views from the Application Menu

- 1. Select the **Application** Menu.
- 2. Select Publish.
- 3. Select Share View.

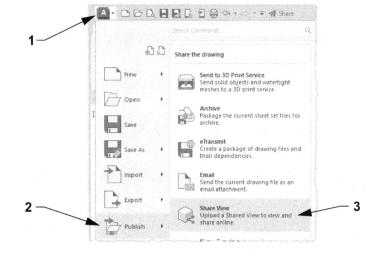

Selecting Shared Views from the Collaborate Tab

- 1. Select the Collaborate Tab.
- 2. Select Shared Views.

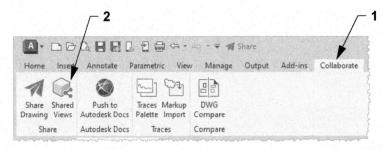

After selecting the Shared Views tool, the Shared Views Palette will open.

Creating a new Shared View to share on the Cloud

1. Select the New Shared View button.

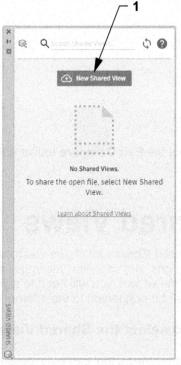

In the Share View dialog box, enter the name you want to call the shared view and check or uncheck any elements of the view you want to share.

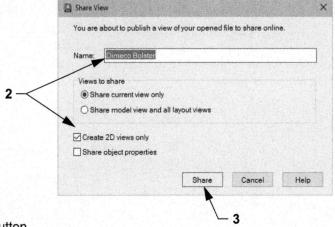

3. Select the Share button.

4. The Share View - Processing Ready to Start dialog box will appear. Select Proceed.

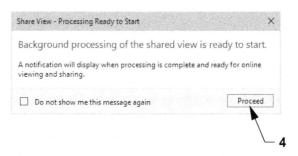

5. The Shared View tool will continue working in the background. When the view is uploaded to the Cloud, a bubble notification will appear at the bottom right-hand corner of the screen informing you that the share view upload is complete.

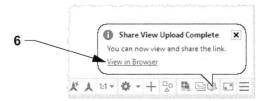

- 6. To view the shared view in the Cloud, select **View in Browser**.
- 7. Your internet browser will open showing you the shared view in the Cloud.

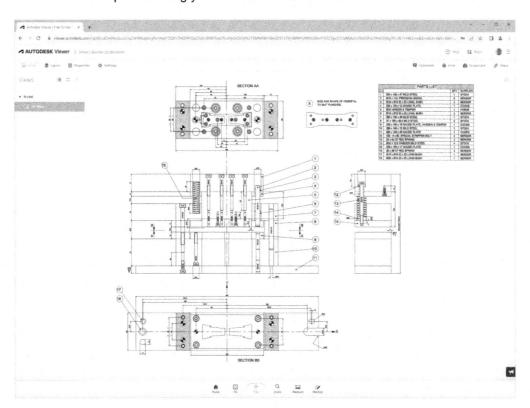

8. You will also receive an email notifying you that your file is ready to view. Click on **View File** to open your internet browser, which will automatically take you to your shared view in the Cloud.

Shared Views

9. Select the **Refresh** button on the Shared Views Palette and your shared view will appear in the Palette Window.

Adding comments to the Shared View and sharing your view

- 1. Select the shared view drawing in the Shared Views Palette Window.
- 2. Select Add a comment.

- 3. Your internet browser will open showing your shared view in the Cloud. Select Comments.
- 4. Type a comment in the Comment Window and then click Post.
- 5. Select Share.

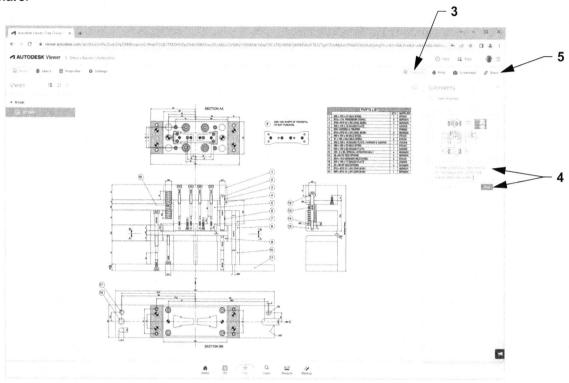

6. Select Copy, which copies the link to your shared view in the Cloud.

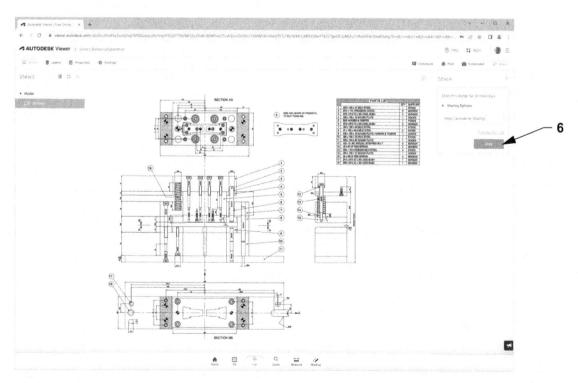

7. You can now send the copied link to another user so they can view your shared view and make any comments to share with you if necessary.

8. Select the Refresh button to see your comment in the Shared Views Palette.

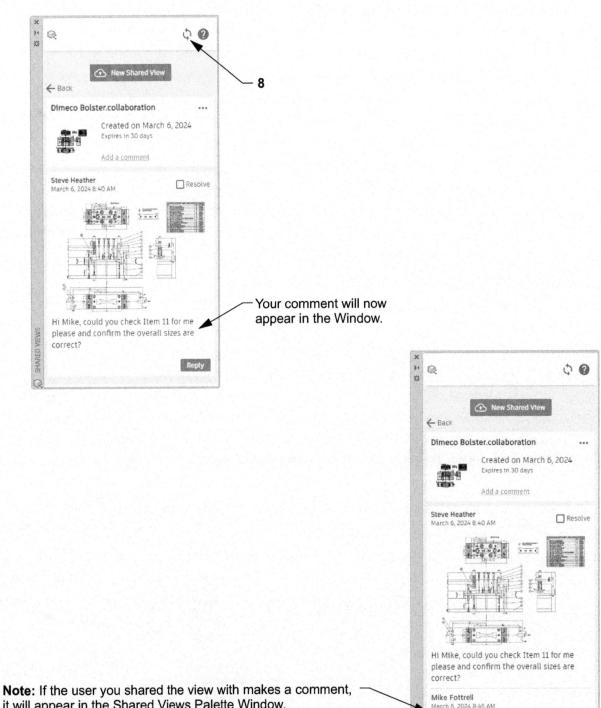

Yes, Steve: Overall sizes look correct.

Thanks for pulling this together.

Note: If the user you shared the view with makes a comment, it will appear in the Shared Views Palette Window. You will also receive an email notification that another user has made a comment on your shared view.

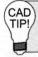

In the future, if you want to add a comment on the shared view, just click **Reply** to enter your comment in the Shared Views Palette Window.

Exercise 30A

Create the Arctext shown.

Instructions:

- 1. Start a New file using the My Decimal Setup.dwt.
- 2. Draw the arc shown using "Center, Start, End".

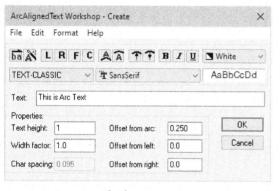

Inch users

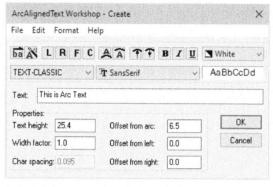

Metric users

4. Save as Ex-30A

Exercise 30B

Instructions:

- 1. Open Ex-30A (if not already open).
- 2. Add the text on the inside of the arc as shown.

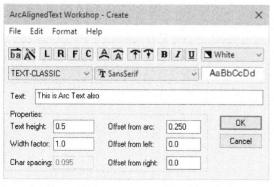

Inch users

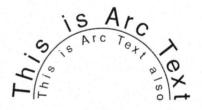

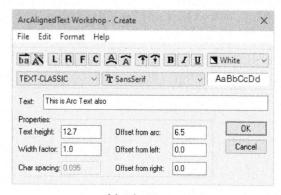

Metric users

Exercise 30C

Instructions:

- 1. Start a New file using the My Decimal Setup.dwt.
- 2. Draw the letters as shown below.
 - A. Use text style TEXT-CLASSIC.
 - B. Text height shown.

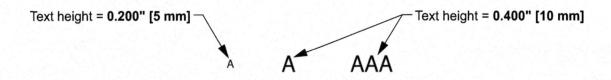

- 3. Copy the letters three times as shown below.
- 4. Enclose the letters as shown below.

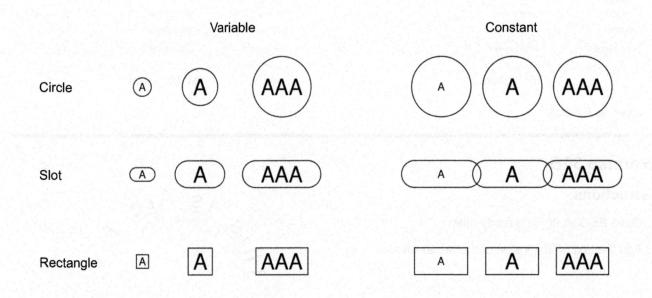

5. Save as Ex-30C

Exercise 30D

Instructions:

- 1. Start a New file using the My Decimal Setup.dwt.
- 2. Draw the objects shown below approximately as shown.

3. Add the Break-line Symbol to both lines as shown below.

Note: Use Object Snap Nearest to place the Break-line Symbol accurately on the line.

Size: 0.300" [7.6 mm]

Extension: 0.180" [4.6 mm]

4. Delete the Line under the Break-line Symbol and add the Hatch as shown below.

Hatch Type: ANSI31

Scale: 1.000

Delete the line before Hatch.

Exercise 30E

Exercise 30E

Instructions:

- 1. Open Ex-10B and then immediately save it as Ex-30E.
- 2. Erase the large center circle as shown below.

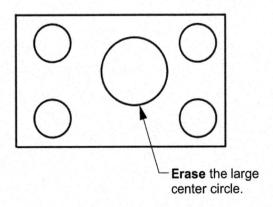

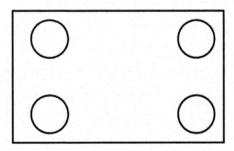

- 3. Select the Drawing Compare tool on the Collaborate Tab.
- 4. In the Select a drawing to compare dialog box, locate and select Ex-10B.
- 5. Select the Import Objects tool on the DWG Compare Toolbar.
- 6. Left click on the large center circle enclosed in a Revision Cloud and press < Enter>.

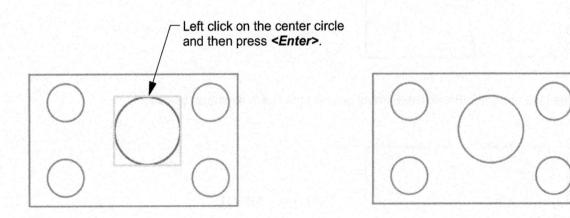

- 7. Select the Exit Compare tool on the DWG Compare Toolbar, to end the compare session.
- 8. Re-save as Ex-30E

Appendix A: Add a Printer / Plotter

The following are step-by-step instructions on how to configure AutoCAD for your printer or plotter. These instructions assume you are a single system user. If you are networked or need more detailed information, please refer to the Autodesk Assistant or AutoCAD Help Menu.

Note: You can configure AutoCAD for multiple printers. Configuring a printer makes it possible for AutoCAD to display the printing parameters for that printer.

- 1. Type in *plottermanager* and then press <*Enter*>.
- Select Add-A-Plotter Wizard.

Select the Next button.

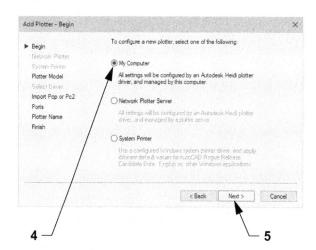

- 4. Select My Computer.
- 5. Select the Next button.

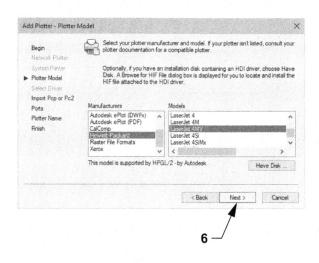

- Select the Manufacturer and the specific Model desired and then select the Next button.
 (If you have a disk with the specific driver information, put the disk in the disk drive and select "Have Disk ..." button, then follow instructions.)
- 7. Select the Next button.

Select:

A. Plot to a port.

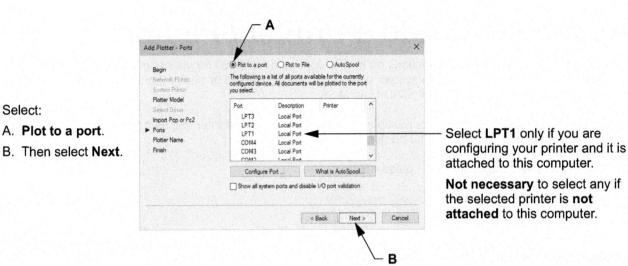

- The printer name that you previously selected should appear. Then select the Next button.
- 10. Select the Edit Plotter Configuration ... button.

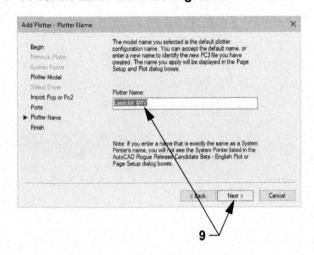

11. Select:

- A. Device and Document Settings Tab.
- B. Media: Source and Size.
- C. Size: (Select the appropriate size for your printer / plotter.)
- D. Select the OK button.

- 12. Select the Finish button.
- 13. Type in *plottermanager* and then press <*Enter*>.

Appendix B: Dynamic Input

To help you keep your focus in the "drawing area", AutoCAD has provided a command interface called **Dynamic** Input. You may input information within the Dynamic Input instead of on the Command Line.

The first point displays the (Absolute: X, Y) distance from the Origin.

Enter the **X** dimension, press the **<**Tab> key, enter the **Y** dimension and then press **<**Enter>.

The second and next points display (relative: distance and angle) from the last point entered. Enter the distance, press the <Tab> key, enter the angle, and press <Enter>.

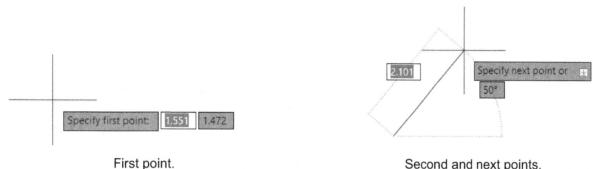

Second and next points.

Note: Some users find Dynamic Input useful, some find it distracting. After completing the steps on the following pages, you can decide whether you want to use it. It is your choice.

How to turn Dynamic Input on or off

Select the **Dynamic Input** button on the Status Bar or use the **<F12>** key.

Note: Refer to page 1-12 for adding tools to the Status Bar.

Dynamic Input has three components

- 1. Pointer Input.
- 2. Dimensional Input.
- 3. Dynamic Prompts.

You may control what is displayed by each component and turn each on or off.

Refer to the following pages for more detailed descriptions.

Pointer Input

Pointer Input is only displayed for the first point.

When Pointer Input is enabled (on) and a command has been selected, the location of the crosshairs is displayed as coordinates in a tooltip near the cursor.

Example:

- 1. Select the Line command.
- 2. Move the cursor.

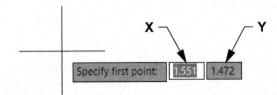

The two boxes display the cursor location as X and Y coordinates from the Origin. (Absolute coordinates.)

3. You may move the cursor until these coordinates display the desired location and press the left mouse button or enter the desired coordinate values in the tooltip boxes instead of on the Command Line.

How to change Pointer Input settings

- 1. Right click the Dynamic Input button on the Status Bar and select Dynamic Input Settings.
- 2. In the **Drafting Settings** dialog box select the **Dynamic Input** Tab.
- 3. Under Enable Pointer Input, select the Settings button.
- 4. In the Pointer Input Settings dialog box select:

Format: (Select one as the display format for second or next points.)

Polar or Cartesian format.

Relative or Absolute coordinates.

Visibility: (Select one for tooltip display.)

As soon as I type coordinate data. When pointer input is turned on, displays tooltips only when you start to enter coordinate data.

When a command asks for a point. When pointer input is turned on, displays tooltips whenever a command prompts for a point.

Always - even when not in a command. Always displays tooltips when pointer input is turned on.

Select **OK** to close each dialog box.

Dimensional Input

When Dimensional Input is enabled (on), the tooltips display the distance and angle values for the **second** and **next points**.

The default display is **Relative Polar** coordinates.

Dimensional Input is available for: Arc, Circle, Ellipse, Line, and Polyline.

Example:

- Select the Line command.
- 2. Enter the first point.

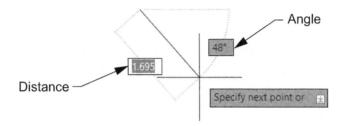

3. Move the cursor in the direction you desire and enter the distance, <Tab> key, and the angle <Enter>.

How to change Dimensional Input settings

- 1. Right click the **Dynamic Input** button on the Status Bar and select **Dynamic Input Settings**.
- 2. In the **Drafting Settings** dialog box select the **Dynamic Input** Tab.
- 3. Under **Dimension Input**, select the **Settings** button.
- 4. In the **Dimension Input Settings** dialog box select:

Visibility: (Select one for tooltip display.)

Show only one dimension input field at a time. Displays only the distance dimensional input tooltip when you are using grip editing to stretch an object.

Show two dimension input fields at a time. Displays the distance and angle dimensional input tooltips when you are using grip editing to stretch an object.

Show the following dimension input fields simultaneously. Displays the selected dimensional input tooltips when you are using grip editing to stretch an object. Select one or more of the check boxes.

5. Select **OK** to close each dialog box.

Dynamic Prompts

When Dynamic Prompts are enabled (on), prompts are displayed.

You may enter a response in the tooltip box instead of on the Command Line.

Example:

- Select the Circle command.
- 2. Press the right mouse button for command options or you may also press the down arrow to view command options. Select an option by clicking on it or press the up arrow for the option menu to disappear.

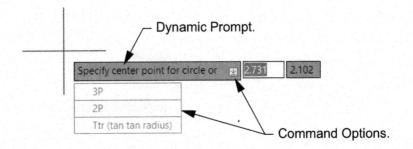

How to change the Color, Size or Transparency of tooltips

- 1. Right click the Dynamic Input button on the Status Bar, then select Dynamic Input Settings.
- 2. In the Drafting Settings dialog box, select the Dynamic Input Tab.
- 3. At the bottom of the dialog box, select the Drafting Tooltip Appearance button.
- Select the Colors button. Under Context: select 2D Model Space. Under Interface element: select Drafting tool tip or Drafting tool tip background. Select a color from the Color drop-down list. Then select Apply and then the Close button.
- 5. Under **Size**, move the slider to the right to make tooltips larger, or to the left to make them smaller. The default value, **0**, is in the middle.

(I like 2, a little larger than the default.)

- 6. Under Transparency, move the slider. The higher the setting, the more transparent the tooltip.
- 7. Under Apply to, choose an option:

Visibility: (Select one for tooltip display.)

Override OS settings for all drafting tooltips. Applies the settings to all tooltips, overriding the settings in the operating system.

Use settings only for Dynamic Input tooltips. Applies the settings only to the drafting tooltips used in Dynamic Input.

8. Select **OK** to close each dialog box.

Appendix C: Frequently Asked Questions

- Q. My Command Line has disappeared, how do I get it back?
- A. Press <Ctrl+9> on your keyboard. You can also use the same method to turn off the Command Line.
- Q. How do I change the Model Space background color?
- A. Right click with your mouse and select **Options / Display** Tab **/ Colors** button, in the **Context** Window select **2D Model Space**, then select the **Color** drop-down list and change the color. Select **Apply & Close**. You can restore the original colors by selecting **Restore classic colors**.
- Q. How do I change the AutoCAD theme color?
- A. Right click with your mouse and select **Options / Display** Tab, in the **Window Elements** Window select the **Color scheme** drop-down list, then change the theme color to either **Dark** or **Light**. Select **Apply**, then **OK**.
- Q. How do I reset AutoCAD to default factory settings?

WARNING: Resetting AutoCAD to default factory settings will remove any custom templates, Toolbars, Ribbon Tabs, and any modifications you have made. If you have any custom templates, it is advisable to save them in a different location before resetting.

- A. To reset AutoCAD to the default factory settings using Windows 10:
 - Select the Start Menu.
 - 2. Scroll down and select the AutoCAD 2025 folder.
 - 3. Select "Reset Settings to Default".

NOTE: While previous versions of AutoCAD could be used with earlier operating systems, AutoCAD 2025 is not compatible with anything before Windows 10.

Notes:

전 글로 가입니다. 문제를 수 없는 바다를 보고 가입하게 되고 있다면 하는데 다른데 되었다. 그 생각을 보다고

이 아이들은 사람들이 가장 있다면 하는데 그렇게 하는데 하는데 되었다면 하는데 하다.

마른 사용하다면서 우리 얼마 되었다면서 하다 가는 이 모든데 있는데 그렇게 되었다고 하게 살았다니다.

그 항상 나는 사람들이 되었다. 사이 얼마를 내려왔다. 하지만 살이 되었습니다. 그는 생각하다

l territoria (no comparatoria de la comparatoria de la comparatoria de la comparatoria de la comparatoria de l La comparatoria de la comparatoria La comparatoria de la comparatoria

ia, menerakan pengalah kerapatan dalah dalah dalah penganjaran bilan berapatah dalah pengan berapatah dalah da Menerak yang danggi salah dalah mengan pengan pengan berapatah dalah dalah dalah berapa dangan berapatah berapa

Transaction of the contract of

and the second second second of the second second second second in the Constant second of the Second second se The Constant second second

To regard a design to the action as commenced in the state of the stat

The Mark State Week

e de la como and separa actividad AD Participada. Se lacomente de Bartinos

a, 3905-BAChall A, smarket paperhoe rethier hilw bean enclosed TX, 2014-11 specified auch top eller A 1970 M But a control with strying paperhoe to a control of the control of the control of the control of the control of

INDEX

2D

2D background color, 1-4

2D drafting, workspace for, 1-5, 1-15

2D Model Space, Appendix B-4, Appendix C-1

2D navvcubedisplay, 1-21

2D Object Snap, 1-14, 1-16

2D offsetgaptype, 12-7

2D polylines and splines, offset, 12-2

3D

3D, Z axis, 1-13, 9-2

3D display driver, 1-16

3D drafting, workspace for, 1-5, 1-15

3D Dynamic UCS, 1-15

3D isometric drawing, 1-14

3D modeling, Intro-5, 1-5, 1-15

3D navvcubedisplay, 1-21

3D Object Snap, 1-15, 1-16

3D Plane, 1-15

3D Selection filtering, 1-15

3D Shaded viewport options, 26-14

Α

About the authors, Intro-1

Absolute, coordinates, 9-2

Acad.pgp, 30-7

Add a printer / plotter, Appendix A-1

Add Current Scale, 28-3

Aliases, 30-7

Aligned dimension, 19-6

All, Zoom, 4-7

Angle, Rotate, 14-5

Angular dimensioning, 18-5

Annotation Monitor, 1-15

Annotation visibility button, 28-2

Annotative Hatch, 28-6

Annotative objects, 27-4

Annotative property, 26-16, 27-4

Annotative scale, remove, 28-5

Annotative scales, multiple, 28-2

Application Menu, 1-6

Application Menu button, 1-6

Application Window, 1-4

Apps, Autodesk Exchange, 1-20

Arc, 22-2

Arc aligned, text, 30-2

Arc length, dimension, 22-2

ArcText, 30-2

Area, Drawing, 1-20

Area, Quick measure, 9-7

Array, Edit, 13-3

Array, Path, 13-8

Array, Polar, 13-6

Array, Rectangular, 13-2

Arrow, Flip, 18-9

Associative dimensioning, 16-2

Authors, about the, Intro-1

Autocomplete, 2-6

Autodesk 360 Online Services, 1-20

Autodesk Assistant, 1-23

Autodesk Exchange Apps, 1-20

Automatic Block Placement, 29-9

Automatic Save. 2-23

AutoScale, 1-15

Axis, X, Y, Z, 1-13, 9-2

В

Back up files, 2-23

Background color, 1-4

Baseline dimension, 16-5

Basic ToolTip, 1-22

Block, Purge, 29-14

Block, re-defining, 29-11

Block Editor, 29-11

Block Placement, Automatic, 29-9

Blocks, counting, 29-12

Blocks, creating, 29-2

Blocks, inserting, 29-5

Blocks and layers, 29-4

Blocks and multileader, 29-16

Blocks Palette, 29-5

Boundary, hatch, 15-2

Break, 6-2

Break, at point, 6-2

Break between 2 points, 6-2

Break-Line Symbol, 30-6

Breaks, dimension, 17-6

C

Cartesian Coordinate System, 9-2

Center, Object Snap, 4-3

Center Mark, automatic, 18-6

Center Mark, manual, 18-6

Centerline, 18-8

Chamfer, 7-8

Check spelling, 8-6

Circle, 3-2 Circle, 2-Point, 3-2 Circle, 3-Point, 3-2 Circle, Center Diameter, 3-2 Circle, Center Radius, 3-2 Circle, Tan Tan Radius, 3-3 Circle, Tan Tan Tan, 3-3 Clean Screen, 1-16 Cloud, online, 30-22 Cloud, Revision, 21-3 Collect, Multileader, 29-19 Color, background, 1-4 Color, hatch, 15-4 Columns, Text, 8-7 Command, selecting a, 2-5 Command Aliases, 30-7 Command history, 1-18 Command Line, 1-17 Command Line entry, 2-6 Compare, Drawing, 30-15 Configuring your system, Intro-2 Continue dimension, 16-4 Convert Mtext, 30-4 Coordinate display, 1-13 Coordinate input, 9-2 Coordinates, absolute, 9-2 Coordinates, Polar, 9-2, 11-2 Coordinates, relative, 9-3 Copy, 7-2 Copy, Array, 7-3 Copy, Multiple, 7-2 Count, blocks, 29-12 Count Palette, 29-12 Create blocks, 29-2 Create master template, 26-17 Creating a template, 2-2 Creating new text styles, 25-2 Crossing window, 2-10 Current Scale, Add, 28-3 Cursor, 1-20 Customize Quick Access, 1-10 Cycling, selection, 1-15

D

DDE (Direct Distance Entry), 9-5 Degree Clock, Polar, 11-2 Diameters, dimensioning, 18-2 Dim Command, 20-2 Dim-Arch, 27-20 Dim-Decimal, 26-20 Dimension, Aligned, 19-6 Dimension, Baseline, 16-5 Dimension, Continue, 16-4 Dimension, Linear, 16-3 Dimension, re-associate, 16-2 Dimension arc length, 22-2 Dimension breaks, 17-6 Dimension Center Mark, 18-6 Dimension jog line, 17-8 Dimension position, editing, 17-2 Dimension style, create, 16-7 Dimension style, modify, 17-3 Dimension style, override, 17-4 Dimension styles, 16-6 Dimension sub-style, 18-9 Dimension text editing, 17-2 Dimensioning, 16-2 Dimensioning a large curve, 22-4 Dimensioning angles, 18-5 Dimensioning diameters, 18-2 Dimensioning radii, 18-4 Dimensions, Paper Space, 27-8 Dimregen, 16-3 Dims, Associative, 16-2 Direct Distance Entry (DDE), 9-5 Directory, 2-15 Display choices, 1-7, 4-11 Display driver, 1-16 Divide, 25-6 Donut, 5-6 Downloadable files, 2-2 Drafting, workspace for, 1-5, 1-15 Drafting Settings, 3-5 Drag, 6-8 Drawing, isometric, 1-14 Drawing area, 1-20 Drawing Compare, 30-15 Drawing limits, 4-8 Drawing lines, 2-8 Drawing setup, 4-8 Drawing setup, precision, 4-13 Drawing setup, units, 4-13 Dynamic Input, 1-13, 1-16, 1-19, 11-3, Appendix B-1 Dynamic User Coordinate System (UCS), 1-15, 1-16 Also see UCS icon

E

Edit Array, 13-3 Edit blocks, 29-11 Editing dimension position, 17-2 Editing dimension text, 17-2 Editing hatch, 15-10 Editing text, 8-9 Ellipse, 5-3 Ellipse, Axis End, 5-3 Ellipse, Center, 5-4 Ellipse, Elliptical Arc, 5-4 Enclosed text in object, 30-5 Endpoint, Object Snap, 4-2 Entry, Command Line, 2-6 Entry, keyboard, 2-6 Erase, 2-12 Exiting AutoCAD, 2-24 Explode, 6-10 Exploded dimensioning, 16-2 Express tools, 30-2 Extend, 6-6 Extended Command History, 1-16 Extended tooltip, 1-22 Extents, Zoom, 4-7

F

Factor, Scale, 14-2 FAQs, Appendix C-1 Files, back up, 2-23 Files, multiple open, 2-16 Files, pinned, 1-7 Files, recovering, 2-23 Files, Save and Save as, 2-22, 2-24 Files to download, 2-2 Fill mode, 5-6 Fill mode, polyline, 23-3 Fillet, 7-6 Filtering, selection, 1-15 Flip Arrow, 18-9 Floating Command Line, 1-17 Floating File Tabs, 2-18 Floating Panels, 1-11 Folder, 2-15 Fonts, 8-4, 25-2, 30-10 Frame, viewport, 26-5 Function keys, 1-16

G

Gradient, hatch, 15-8 Graphics performance, 1-16 Grid, 1-13, 1-16, 3-5 Grid display and limits, 4-11 Group, creating, 30-8

H

Hatch, 15-2 Hatch, Annotative, 15-6, 28-6 Hatch, Associative, 15-6 Hatch, changing boundary, 15-10 Hatch, editing, 15-10 Hatch, ignoring, 16-11 Hatch, mirror, 15-10 Hatch, trim, 15-10 Hatch, user defined, 15-7 Hatch, without boundaries, 15-11 Hatch angle, 15-5 Hatch boundaries, 15-2 Hatch color, 15-4 Hatch creation, 15-2 Hatch gradient, 15-4, 15-8 Hatch objects, ignore, 16-11 Hatch Origin, 15-5 Hatch pattern, 15-4, 15-7 Hatch properties, 15-3 Hatch scale, 15-5 Hatch solid, 15-4, 15-8 Hatch spacing, 15-5 Hatch transparency, 15-4 Hatch type, 15-4 Help, Autodesk Assistant, 1-23 Help Menu, 1-16, 1-20

ı

Icons, Status Bar, 1-12
ID Point, 9-8
Ignore hatch objects, 16-11
Import a PDF file, 30-10
Import SHX fonts, 30-13
Increment Snap, 1-13, 3-5
Indents, 8-6
Infer Constraints, 1-13
Inferred Geometric Constraints, 1-13
Infocenter, 1-20
Input, coordinate, 9-2
Inserting blocks, 29-5
Intersection, Object Snap, 4-2
Isometric drawing, 1-14
Isoplanes, 1-16

J

Jog line, dimension, 17-8 Join, 24-3 Justification, text, 8-2

K

Keyboard entry, 2-6 Keyboard function keys, 1-16

L

Large curve, dimension, 22-4

Lasso selection, 2-11

Layer, color, 3-9

Layer, controlling, 3-7

Layer, creating a, 3-12

Layer, delete an existing, 3-9

Layer, Freeze, 3-7

Layer, how to select, 3-6

Layer, how to use, 3-6

Layer, lineweights, 3-10

Layer, loading linetype, 3-13

Layer, lock, 3-7

Layer, new, 3-12

Layer, not plottable, 3-8

Layer, on-off, 3-7

Layer, plottable, 3-8

Layer, Thaw, 3-7

Layer, transparency, 3-11

Layer, unlock, 3-7

Layer match, 21-2

Layer properties manager, 3-10

Layers, 3-6

Layers and blocks, 29-4

Layout, 26-3

Layout, using a, 26-12

Layout / Model Tabs, 26-7

Layout Tab, 26-3

Layout Tab, plot from a, 26-13

Layout Tab, rename, 26-11

Lavouts, 26-6

Limits, drawing, 4-8

Limits, grid display, 4-11

Line spacing, text, 8-8

Linear dimension, 16-3

Lines, closing, 2-9

Lines, drawing, 2-8

Lines, horizontal, 2-8

Lines, vertical, 2-8

Linetype loading, 3-16

Lineweight, 1-15

Lineweight, assigning, 3-10

Lineweight, display set, 3-10

Lineweight settings, 3-10

Lineweights, 3-10

Loading linetypes, 3-13

Lock user interface, 1-16 Locking a viewport, 26-9

M

M2P, Object Snap, 5-8

Match, Layer, 21-2

Match properties, 21-2

Mbuttonpan, Intro-6

Measure, 25-7

Measure tools, 9-5

Mid between 2 points (M2P), 5-8

Midpoint, Object Snap, 4-2

Mirror, 7-4

Mirror Line, 7-5

Mirror text, 7-5

Mirrtext, 7-5

Model / Layout Tabs, 26-3, 26-7

Model / Paper button, 26-7

Model Space, 26-3, Appendix B-4, Appendix C-1

Model Space, plot from, 9-12

Model Tab, 26-3, 26-7

Modeling, 3D, Intro-5, 1-5, 1-15

Modify Text, 30-3

Monitor, Annotation, 1-15

Move, 6-7

Moving floating File Tab, 2-20

Moving Origin, 10-2

Mtext, convert, 30-4

MTjigstring, 8-5

Multileader, 19-2

Multileader, add lines, 19-2

Multileader, align, 19-3

Multileader, Collect, 29-19

Multileader, remove lines, 19-3

Multileader, single, 19-2

Multileader and blocks, 29-16

Multileader style, create, 19-4

Multiline text, 8-4

Multiple copies, 7-2

Multiple open files, 2-16

Multiple open mes, 2-10

MV command, 26-6

N

Navbardisplay, 1-21

Navigation bar, 1-21

Navvcubedisplay, 1-21

New, Start page, 1-2

Node, Object Snap, 5-8

Non-Associative dimensioning, 16-2

Nudge, 6-9

0

Object enclosed text, 30-5

Object Snap, 1-14, 1-15, 1-16, 4-2

Object Snap, Center, 4-3

Object Snap, Endpoint, 4-2

Object Snap, how to use, 4-3

Object Snap, Intersection, 4-2

Object Snap, M2P, 5-8

Object Snap, Midpoint, 4-2

Object Snap, Nearest, 5-8

Object Snap, Node, 5-8

Object Snap, Perpendicular, 4-3

Object Snap, Quadrant, 4-3

Object Snap, running, 4-5

Object Snap, Tangent, 4-3

Object Snap tracking, 1-14, 1-16

Objects, annotative, 27-4

Objects, selecting, 2-10

Offset, 12-2

Offsetgaptype, 12-7

Online Cloud, 30-22

Online Services, Autodesk 360, 1-20

Open documents, 1-7

Open existing drawing, 2-15

Options, Intro-2

Order of Tabs, 1-11

Origin, 9-2

Origin, moving, 10-2

Origin icon, 1-20

Orthographic (Ortho) Mode, 1-13, 1-16

P

Page Setup, create a, 26-9

Page Setup Manager, 26-4

Palette, Blocks, 29-5

Palette, Count, 29-12

Palette, Properties, 12-3, 17-5, 22-3

Palette, Shared Views, 30-22

Palettes, 1-5, 1-16

Pan, 26-7

Panel, Quick Properties, 12-5

Panels, 1-11

Panels, floating, 1-11

Paper Space, 26-4

Paragraph, text, 8-8

Path, Array, 13-8

Pattern, hatch, 15-4, 15-7

PDF, import a file, 30-10

Perimeter, Quick measure, 9-7

Perpendicular, Object Snap, 4-3

Pick, selecting objects, 2-10

Pin files, recent documents, 1-8

Pin floating File Tab, 2-21

Placement of Automatic Block, 29-9

Plane, 3D, 1-15

Plot from a Layout Tab, 26-13

Plot from Model Space, 9-12

Plotter, add a, Appendix A-1

Point, 5-7

Point style, 5-7, 25-6

Polar, 1-13

Polar Array, 13-5

Polar coordinate input, 11-2

Polar Degree Clock, 11-2

Polar Snap, 1-13, 11-9

Polar Tracking, 1-14, 1-16, 11-6

Polygon, 5-2

Polygon, center radius, 5-2

Polygon, edge, 5-2

Polyline, 23-2

Polyline, edit, 24-2

Polyline fill mode, 23-3

Polylines and splines, 12-2

Precision, drawing setup, 4-13

Prefix and suffix, 19-8

Previous, Zoom, 4-7

Printer / plotter, add a, Appendix A-1

Printing, Intro-1, 2-3, 9-12, 26-9

Properties, match, 21-2

Properties button, Quick, 1-16

Properties Palette, 12-3, 17-5, 22-3

Properties Panel, Quick, 12-5

Property, annotative, 26-16, 27-4

Purge a block, 29-14

Q

Quadrant, Object Snap, 4-3

Quick Access Toolbar, 1-10

Quick Measure tool, 9-5

Quick Properties button, 1-16

Quick Properties Panel, 12-5

R

Radii, dimensioning, 18-4

Realtime, Zoom, 4-7

Recent documents, 1-7

Recent documents, pin file, 1-8

Recent documents, remove file, 1-9

Recovering a drawing, 2-23

Rectangle, 3-3

Rectangle, Area, 3-5 Rectangle, Chamfer, 3-4 Rectangle, Fillet, 3-4 Rectangle, Rotation, 3-5 Rectangle, Width, 3-4 Rectangular, Array, 13-2 Re-defining a block, 29-11 Redo, 2-13 Reference, Rotate, 14-5 Reference, Scale, 14-2 Relative coordinates, 9-3 Remove file from recent documents list, 1-9 Remove Quick Access tool, 1-10 Rename Layout Tab, 26-11 Revision Cloud, 21-3 Ribbon, 1-11 Rotate, 14-5

S

Running Object Snap, 4-5

Save, Automatic, 2-23 Save and Save As, 2-22, 2-24 Scale, 14-2 Scale, Add Current, 28-3 Scale, adjusting viewport, 26-12 Scale, remove annotative, 28-5 Scale factor, 14-2 Scale reference, 14-2 Scaled drawings, 27-2 Scales, multiple annotative, 28-2 Screen, Clean, 1-16 Search box, 1-20 Selecting a command, 2-5 Selecting lasso, 2-11 Selecting layers, 3-6 Selecting objects, 2-10 Selecting text style, 25-3 Selecting workspace, 1-6 Selection cycling, 1-15 Selection filtering, 1-15 Shaded viewport options, 26-14 Shared Views, 30-21 Shared Views Palette, 30-22 SHX fonts, import, 30-13 Single Line Text, 8-2

Snap, 1-13, 1-16

Snap, Increment, 1-13

Snap and Grid, 1-13

Snap, Object, 1-14, 4-2, 5-8

Special text characters, 19-7

Spell Check, 8-6 Starting AutoCAD, 1-2 Status Bar, 1-12 Stretch, 14-3 Styles, dimension, 16-6 Sub-style, dimension, 18-9 Suffix and prefix, 19-8 Switching workspace, 1-6, 1-15 Symbol, Break-Line, 30-6 System, configuring your, Intro-2 Т Tab order, 1-11 Tabs, 1-11, 8-6 Tangent, Object Snap, 4-3 Template, creating a, 2-2 Template, using a, 2-5

Template, create a master decimal setup, 26-17 Template, create a master feet-inches setup, 27-9 Text, arc aligned, 30-2 Text, columns, 8-7 Text, enclosed in object, 30-5 Text, indents, 8-6 Text, line spacing, 8-8 Text, Modify, 30-3 Text, Mtjigstring, 8-5 Text, Multiline, 8-4 Text, Paragraph, 8-8 Text, Single Line, 8-2 Text, special characters, 19-7 Text, Spell Check, 8-6 Text, Tabs, 8-6 Text border, 8-10 Text characters, special, 19-7 Text editing, Multiline, 8-9 Text editing, Single Line, 8-9 Text Editor, 8-5 Text numbering, 30-4 Text style, change effects, 25-5 Text style, delete, 25-4 Text style, selecting, 25-3 Text styles, creating, 25-2 Tool removal, 1-10 Tooltip box. 2-7 Tooltips, display, 1-19 Tracking, Polar, 11-6 Transparency, 1-15, 3-11 Transparency, hatch, 15-4 Trim, 6-4 TrueType fonts, 30-10

U

UCS (User Coordinate System) icon, 1-15, 1-20, 9-2, 10-2 Undo, 2-13 Units tool, 1-16 Unpin floating File Tab, 2-21 Unused blocks, purging, 29-14 User interface, lock, 1-16 Using a layout, 26-12 Using a template, 2-5

V

View recent documents, 1-7 Viewcube, 1-21 Viewport, locking a, 26-9 Viewport frame, 26-5 Viewport scale, 26-12, 27-2 Viewports, 26-5 Views, Shared, 30-21 Visibility, annotation, 28-2

W

Window, crossing, 2-10
Window, selecting objects, 2-10
Window, Zoom, 4-7
Windows 10, Appendix C-1
Wipeout, 21-8
Workspace, 1-5, 1-15
Workspace selecting, 1-5
Workspace switching, 1-6, 1-15
Workspaces, 2D and 3D, 1-5, 1-15

X, Y, Z

X axis, 1-13, 9-2 Y axis, 1-13, 9-2 Z axis, 1-13, 9-2 Zoom, All, 4-7 Zoom, Extents, 4-7 Zoom, In, 4-7 Zoom, Out, 4-7 Zoom, Previous, 4-7 Zoom, Realtime, 4-7 Zoom, Window, 4-7

Final Notes about AutoCAD®

Whether a student, teacher, professional, or home user, you can make efficiency a daily part of the task at hand with AutoCAD® software. Meticulously refined with the drafter in mind, AutoCAD facilitates efficient day-to-day drafting with features that increase speed and accuracy while saving time. No matter what you are drawing, you will find that AutoCAD will help you achieve an unmatched level of aesthetic precision and professionalism in delivering your final product.

AutoCAD 2025 Updates Included in this Book

Improvements in the 2025 release of AutoCAD make this program even easier and more efficient to use. The versatile features of AutoCAD 2025 are covered in this Workbook, with updated explanations, illustrations, and instructions to fully explain each feature.

One example of enhancements made to this latest AutoCAD release is the addition of the artificial intelligence (AI) driven **Autodesk Assistant** help system, which can help answer AutoCAD-related questions. In case the Autodesk Assistant does not sufficiently answer a question, it provides links to other sources, as well as the option to connect to an Autodesk agent. (See page 1-23.)

Other program enhancements include the ability to place a **hatch** without the previous requirement of a closed boundary. (See page 15-11.)

Preset Drawings Accompanying this Book

To get the supplied drawings that go with this book, download the file: workbook-helper.zip

from our website:

https://books.industrialpress.com/autocad/workbook-helper.zip

Enter the address into your web browser and the download will start automatically. Once the file has been downloaded, you can unzip it to extract both drawing files.

AutoCAD Versions

Note that newer editions of AutoCAD can exist with earlier versions of AutoCAD and AutoCAD LT. But you may be limited to using certain versions based on your operating system. AutoCAD 2025 can not be used with operating systems earlier than Windows 10.

For information on available trial versions and to purchase AutoCAD software, please visit Autodesk's web page at https://www.autodesk.com.

If you are attending a school, check with your instructor regarding potential educational discounts.

For More Information

For a list of other titles in this bestselling series of AutoCAD® Exercise Workbooks published by Industrial Press, as well as related digital offerings, see page iv at the front of this book.

For further information about these and other Industrial Press products, please visit us at https://books.industrialpress.com and https://ebooks.industrialpress.com.